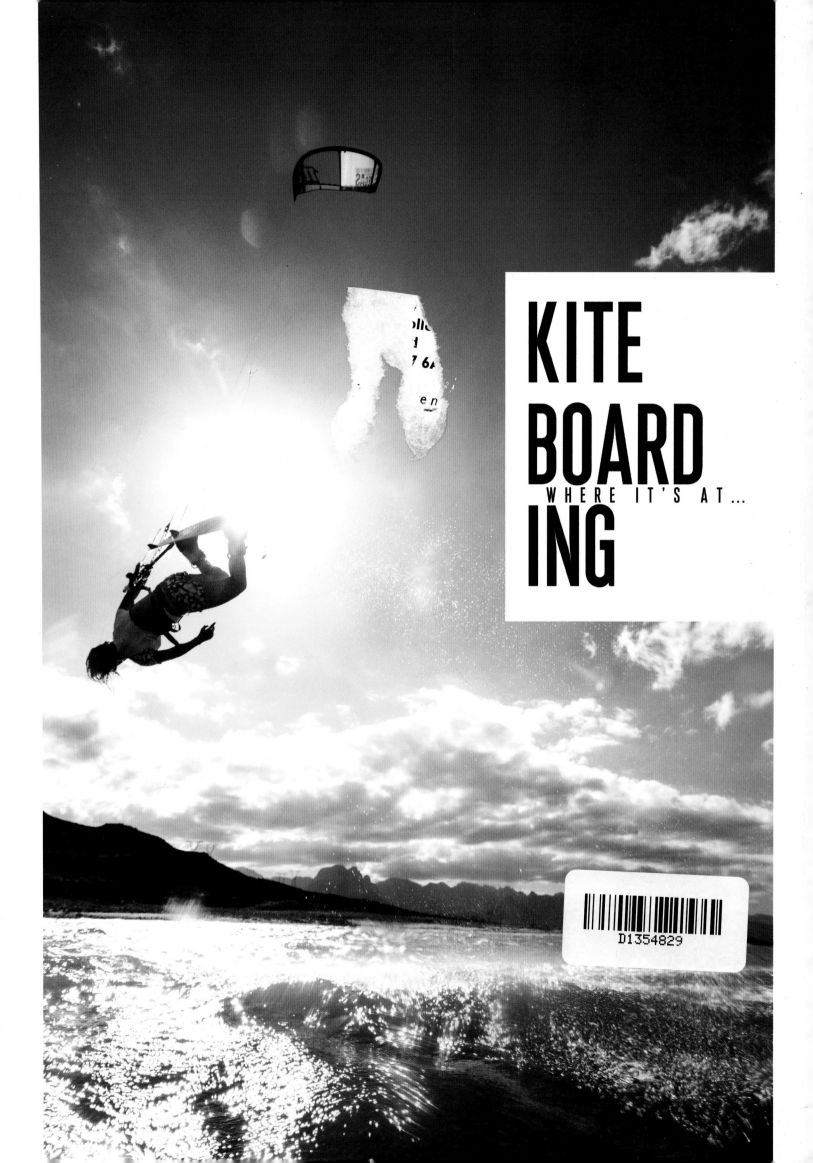

KITE
BOARD
WHERE IT'S AT...
ING

Published by Adlard Coles Nautical
an imprint of Bloomsbury Publishing Plc
50 Bedford Square, London WC1B 3DP
www.adlardcoles.com

Bloomsbury is a trademark of Bloomsbury Publishing Plc

First published by Adlard Coles Nautical in 2014

ISBN 978-1-4081-9196-5
ePDF 978-1-4081-9198-9
ePub 978-1-4081-9197-2

A CIP catalogue record for this book is available from the
British Library.

This book is produced using paper that is made from
wood grown in managed, sustainable forests. It is natural,
renewable and recyclable. The logging and manufacturing
processes conform to the environmental regulations of the
country of origin.

Typeset in 10pt Helvetica Neue
Printed and bound in China by RRD South China

Note: while all reasonable care has been taken in
the publication of this book, the publisher takes no
responsibility for the use of the methods or products
described in the book.

10 9 8 7 6 5 4 3 2 1

With thanks to:

PAGE 1: *Photo: Bianca Asher.*
PAGE 4/5: *Photo: Kolesky/Nikon/RedBullContentPool.*
BELOW: *Photo: Quincy Dein.*

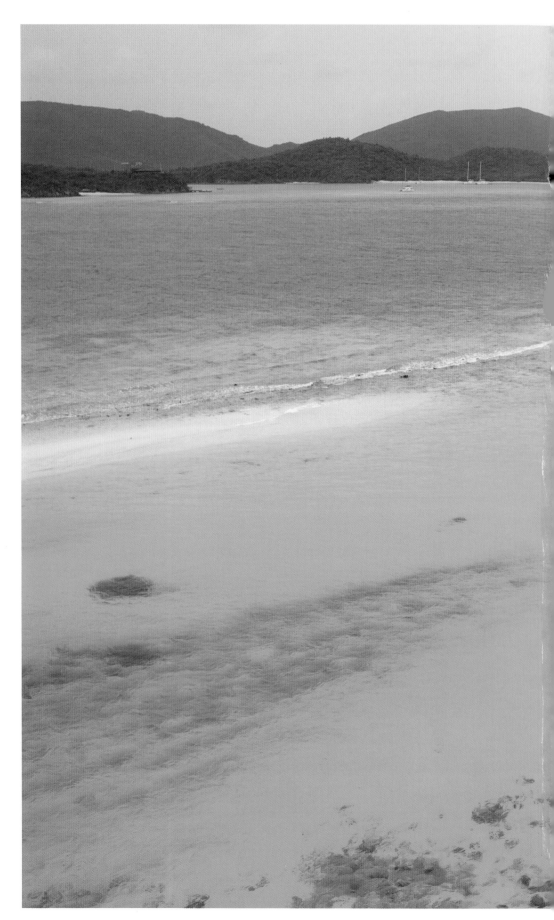

KITE BOARD ING

WHERE IT'S AT...

ALEX HAPGOOD

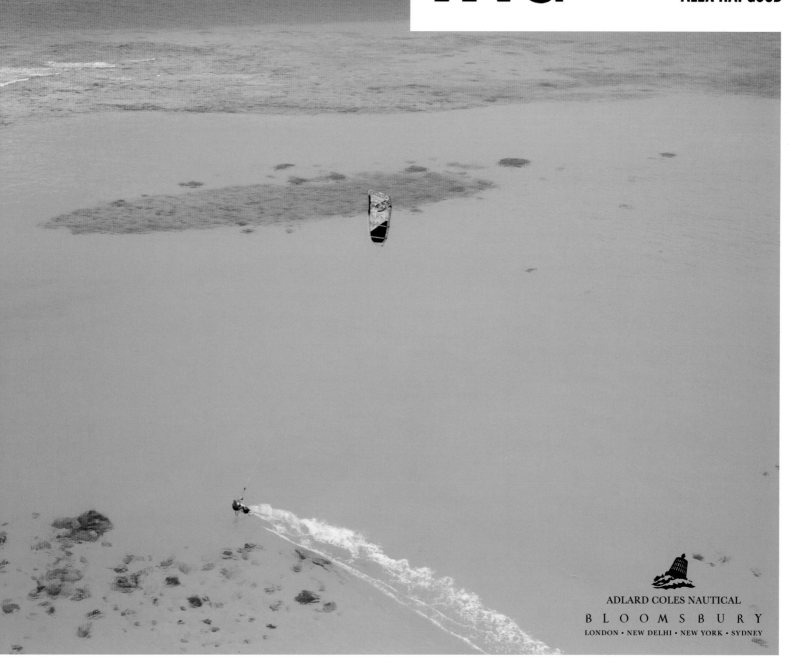

ADLARD COLES NAUTICAL

B L O O M S B U R Y

LONDON · NEW DELHI · NEW YORK · SYDNEY

CONTENTS

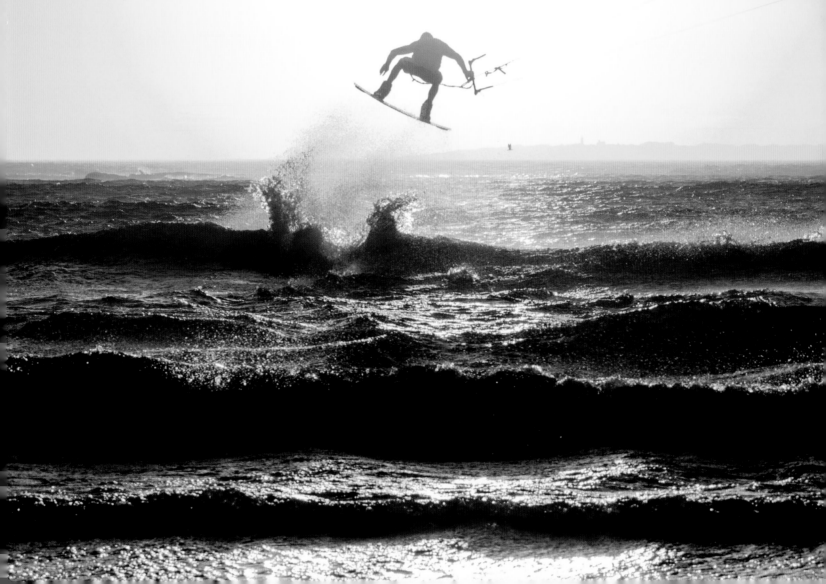

6 INTRODUCTION

1 8 **THE BACKSTORY**

2 **FREESTYLE**
16 **INTRODUCING**
24 **THE KIT**
26 **PLACES** – Cape Town; Dominican Republic; Perth; Northeast Brazil; Tarifa
48 **PLAYERS** – Aaron Hadlow; Gisela Pulido; Youri Zoon; Jesse Richman
56 **SESSION** – King of the Air 2013
60 **CONTEST** – Freestyle Tour

3 **WAVERIDING**
66 **INTRODUCING**
74 **THE KIT**
76 **PLACES** – Maui; Mauritius; Indonesia; Western Australia; California
96 **PLAYERS** – Mitu Monteiro; Keahi de Aboitiz; Kirsty Jones; Ian Alldredge
104 **SESSION** – Riding Cloudbreak
108 **CONTEST** – Wave Tour

4 WAKESTYLE

114 **INTRODUCING**

120 **THE KIT**

122 **PLACES** – Hood River; Cape Hatteras; Anapa, Russia

134 **PLAYERS** – Dre; Sam Light; Eric Rienstra; Tom Court

142 **SESSION** – Ro-Sham Throw Down

146 **CONTEST** – The Triple-S Invitational

5 COURSE RACING

152 **INTRODUCING**

158 **THE KIT**

160 **PLACES** – San Francisco; La Ventana

168 **PLAYERS** – Johnny Heineken; Bryan Lake; Steph Bridge

6 THE BRANDS

158 North; Airush; Slingshot; Naish, Nobile; Cabrinha; F-ONE;
Liquid Force; Flysurfer; Hiss-Tec

190 **INDEX**

Photo: Craig Kolesky

INTRODUCTION

I t seemed like a valid point, and an interesting idea. 'Hi Alex, I'm calling from Bloomsbury Publishing. We've been taking a look around and there aren't many books about kiteboarding out there. Do you fancy putting one together?'

I thought about it and actually, it's true. There really aren't many books about kiteboarding. Go into any decent bookshop and head to the sports section and you'll find dozens of surf-related books – books about waves, regions, sessions, riders – all photo-focussed and with that glossy goodness that makes you want to take yourself into a corner and, with careful fingers, immerse yourself for a few hours. But seek out the kiteboarding section in that same bookshop? All you find is a few instructional guides, or maybe nothing at all. Why? Our sport has an incredible history, a diversity matched by no other, and – most importantly for a sumptuous, highly illustrated book – it looks great! It is so photogenic. We can go to every corner of the globe and be found getting barrelled, hitting sliders, tweaking airs or topping 40 knots, and all against the backdrop of tropical beaches, shining cityscapes and grinding reefs. We have it all.

I sensed the injustice and got back to the publisher. 'Sure, there's a gap there. I can fill it. No worries.'

So now you sit, or stand (maybe in one of those aforementioned bookshops) and you hold in your hands that book – the book that fills the gap – and I hope it looks as good and as sumptuous as all of those other books it is keeping company with. And I also hope that – as well as enjoying all the glossy goodness – the places and the people and the stories inside inspire you and make you want to get out on the water and continue your journey as a kiteboarder.

But let's backtrack a minute. The advantage of this book – that it was the 'first on the water' so to speak – was also its biggest challenge. It could have done anything, it could have covered anything. It has thirty years of history, and fifteen years of events, riders, rivalries and fantastic photos to draw from. It could easily run to 1000 pages, 10,000 maybe. And so I sat, contract signed, with a blank piece of paper in front of me, a strange buzzing sound in my head, and the beginnings of a cold sweat. Where to begin? What to cover? What to do?!

In the end the philosophy for the book was staring right back at me, in the title. This book isn't a historical reference book, it isn't a meticulous assessment of the who-did-what-first background of our sport, or a blinkered evaluation of one or other aspect of kiteboarding. It looks at 'where it's at': at kiteboarding as it is now. It shows where the sport has ended up after thirty years or so. If you had told Bruno Legaignoux, back in 1984, that his inflatable kite would one day be responsible for a multi-million dollar industry, with tours, a vast dedicated media and riders making their living from it – a pastime with Olympic pretensions and ever-increasing respect as one of the most progressive sports on the planet – then he no doubt would have laughed into the waterlogged fishing line-tailored lines he held in his hands. But here we are.

In terms of making it happen, the brands' support has been instrumental in the book coming together. I know from my many years working in the magazine industry that the brands are as 100 per cent committed and passionate about the sport as I am. In addition, the photographers have captured perfectly all that is great about kiteboarding. It's a tough world out there nowadays, but these guys prove that you need more than a top-end DSLR to truly capture all that is great about kiteboarding. It is their dedication, skill and vision that provide the page-sifting sumptuousness.

And finally, an apology. This book is subjective. You *will* disagree with some of my choices. You will raise your eyebrows that 'x' rider, or that 'y' spot hasn't made it in. But I have done my best. I have canvassed the opinion of many people (from pro-riders and industry insiders through to kiters I meet at the beach) about each section. Of course, I could have written a whole book about freestyle riders, or about wave spots, but this is an overview – a snapshot – and although it looks at some of the icons of our sport, some of the indisputably epic places to go kiteboarding and some of the era-defining events, it can't cover everything. Please accept my apologies in advance.

So, that's the preamble, now for the main event. Here it is, here's *Kiteboarding: Where it's at...*

Alex Hapgood

THE BACKSTORY

1

The history of kiteboarding is short, yet its growth
has been staggering – it is by far the youngest
watersport to enjoy the kind of participation
numbers that it does, and is currently one of the fastest-
growing sports on the planet. Despite its relative youth,
however, the development and evolution of kiteboarding has
been as unpredictable as a rapidly approaching cold front, and
the story of how the sport has evolved to where it is now has
covered as many miles, and visited as many beaches, as the
average PKRA rider does in their entire career.

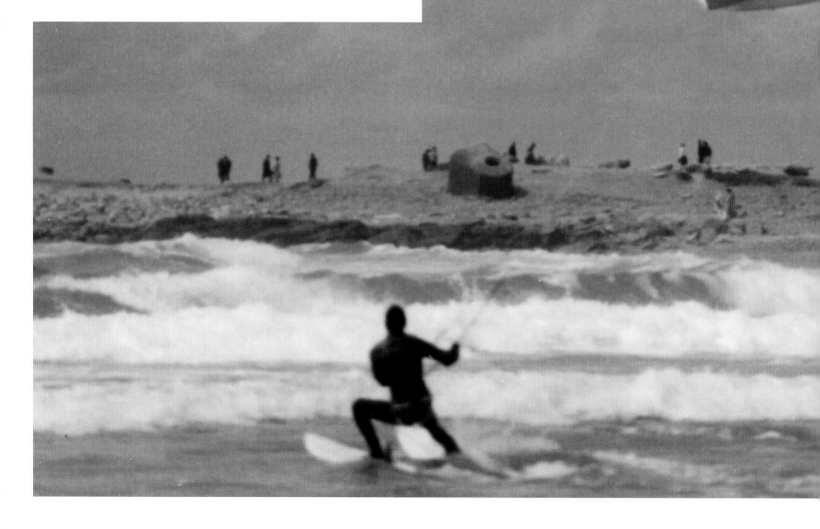

TOP RIGHT: The Legaignoux brothers test their new toy, 1984.
BOTTOM RIGHT: The WIPICAT kite-powered catamaran.
BELOW: Showcasing 'kiteboarding' at a windsurfing event in 1986.
All photos: courtesy Bruno Legaignoux.

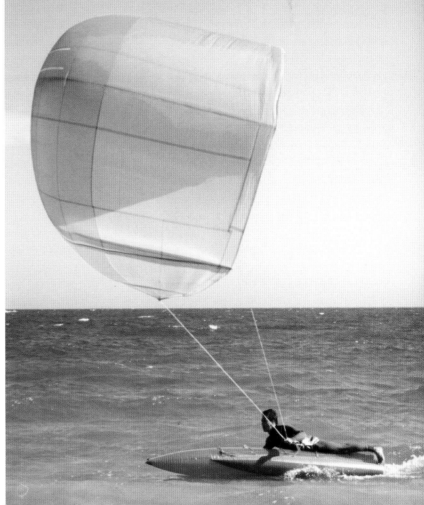

BRUNO LEGAIGNOUX: THE INNOVATOR

'It's the winter of 1984. With my brother Dominique as assistant, my wife as photographer and myself as tester we go to the beach of Beg-Meil in Finistère, France, for the first water test of our 5m, 100 per cent double-skinned C-shape kite.** The beach is long, rock-free and deserted in December. We walk about a mile and prepare the wing and the 60m line that starts from a wing tip, passes through a pulley attached to my windsurfing harness, and then returns to the other tip. Dyneema doesn't exist at that time, so we use a polyethylene braided fishing line. As it's not available in the required diameter, we pass one inside another. It's not very flexible but it has very little stretch and it floats, which is essential here because there is a lot of seaweed! We are using plywood water skis that are also homemade as we have no money to buy real water-skis, especially since this is our first test and we do not know if it's going to work.

The wind is slightly onshore and between 18 and 20 knots. I go as far as possible beyond the shorebreak holding the kite and I put on the skis and prepare myself, then I let go of the kite with its leading edge on the water. The lines stretch between my skis and I'm in the classic water-skiing pose, and in a comfortable position to get the kite to launch. I pull on one side, then on the other one. After several attempts, I manage to flip the kite and it takes off. Immediately it lifts me almost entirely out of the water. The wind seems strong enough – not too much effort but plenty of pull from the kite. I've never tried water-skiing before!

I speed the kite up and move it through the wind window and, suddenly, I start to slide and glide. It's that simple – I am powered by a kite.'

ABOVE: The WIPICAT exhibit at the 1992 Boat Show. *Photo: courtesy Bruno Legaignoux.*
TOP RIGHT: Flash Austin, Maui, 1997. *Photo: Erik Aeder.*
RIGHT: Robby Naish, Maui, 1998. *Photo: Erik Aeder.*

There is a clear starting point to the serious development of kiteboarding as a sport. On 16 November 1984 two French brothers, Bruno and Dominique Legaignoux, registered a patent for the first water-relaunchable kite or, as it was worded at the time, the first 'curved wing with inflatable structure'. The brothers, both keen sailors, had been experimenting with various watercraft since their childhoods and had always been intrigued by different types of wind propulsion. It was in 1983, while on separate round-the-world sailing expeditions, that the brothers met in Senegal and began considering in more detail a plan to develop a kite that could be effectively used on the water. After many hours of drawing out plans and developing fibre-framed prototypes, they felt sure that they had arrived at something workable and, excited by the prospect, abandoned their trips and returned home to Brittany to begin developing their first inflatable prototypes.

Over the course of the next few years the Legaignoux brothers experimented with a range of kites and explored in detail the best way to harness the kite's power. Their first attempts saw them experimenting with surf, windsurf, and with 'bi-directional' boards, but for the initial 'take-off' with the two-line kite, the brothers found that water-skis were the most effective option. These were used to very good effect at 'exhibitions' during windsurfing and speed events in France in the mid-1980s. At this time, however, windsurfing was at the height of its popularity and –

although the kite and skis could be used in less wind and showed impressive potential – there was no commercial or broader interest in this new sport. So, the brothers continued developing their ideas alone and began to explore other markets for their kite. They built and tested many different craft and also looked at other potential uses for their kites, including as a 'safety kite' to be deployed in the event of engine failure on a ship.

By 1989 (having produced around 100 prototypes) the brothers had arrived at a kite design that they were happy with and that they felt could be produced commercially. Over the next four years this design remained essentially unchanged, and the brothers focussed on developing the product they felt offered the largest potential market for harnessing their kite's power: an inflatable catamaran. By 1993 they were happy with their set-up – both the kite and the catamaran – and, with no real interest from watersport brands or manufacturing companies, they accepted that if their dream was to become a reality, they would have to begin producing them themselves. And so they began their own manufacturing company in Brittany, which would produce both their kites and their inflatable crafts. WIPICAT (Wing Powered Inflatable Catamaran) was born, and the first commercially available inflatable kite was on the market.

Meanwhile, as the Legaignoux's kite odyssey was taking place in the North Atlantic, it was over in the heart of the Pacific, on Maui, that another Frenchman,

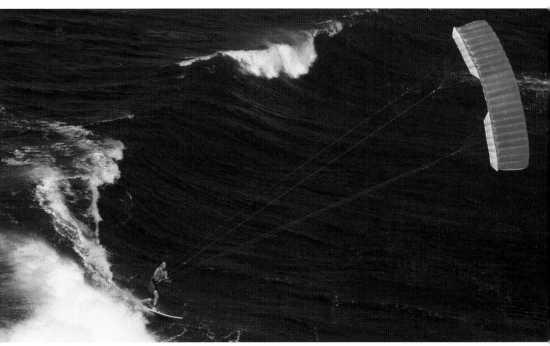
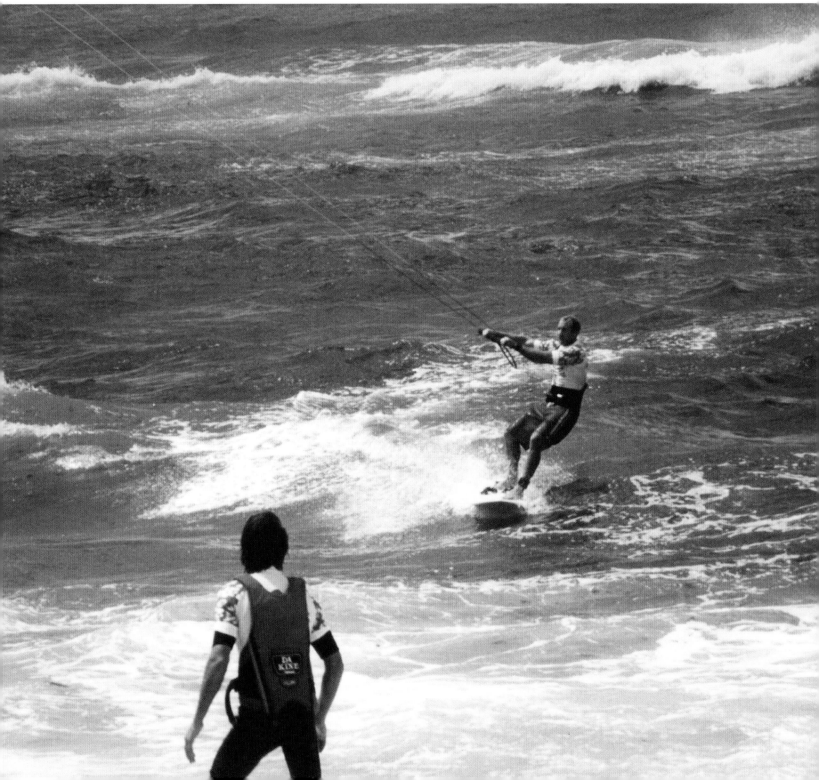

Manu Bertin, was exploring ways to power himself with kites in the island's challenging surf. His first attempts were with ram-air kites and, teaming up with fellow Maui resident and big wave-riding legend, Laird Hamilton, the pair spent two months experimenting and learning how to fly the kites on land, before heading seawards with one of Laird's tow-in surfboards. However, mainly due to the session-ending consequences if the kites were crashed into the sea, the pair's success was limited. Manu was not deterred though, and towards the end of 1994 he read about the Legaignoux brothers and the water-relaunchable inflatable kite they had developed. He was on the next flight to France.

Manu met his countrymen in Brittany and they compared their experiences and their shared passion for kite flying. Manu was keen to demonstrate his skills on the towboard, but did not believe that the ability to stay upwind was important – feeling that making long downwind runs in the surf would be the future of the sport. The brothers did not think that this was the case, but were impressed by Manu's experimentations on Maui and the fact that there had been interest from the media and – perhaps more importantly – from the windsurfing community. They agreed to help him out, and so Manu returned to the Hawaiian island with one of the brothers' prototype 'Wipika' kites. It was the final piece in the puzzle, and from here the rise of kiteboarding began and the now-legendary cast of early riders began to assemble.

Back on Maui, Manu also stopped in to catch up with Don Montague, the chief designer at Naish (which at this time was riding

DON MONTAGUE, THE DESIGNER

'I had seen Cory Roeseler and his Kite Ski system back in 1993. He was trying to convince me that this was the next big thing but I was sceptical. There were a lot of lines and this heavy bar and all these carbon battens – but he was flying upwind. I saw him get worked at Ho'okipa, all his battens broke and I just thought that this just wasn't ready for mass production, there was no way we could sell it.

Not long after, we started noticing the ram-air kites – Laird and some other people were playing around a bit, but no one was going upwind except Cory. One day Manu Bertin, one of our team riders, showed up at the loft with an inflated leading-edge kite that had been built by Bruno Legaignoux. The workmanship was phenomenal and I had never seen anything like it. I had played around with putting condoms inside ram-air kites to try to get them to float and had sewn together some pool mats! But Bruno was way ahead.

At that point I had invested a lot into developing the most insane sail design software so I called Bruno and explained our set-up and asked him to come to Maui, and a few weeks later he was at my house and we developed the first kite-design software together. It was fully three-dimensional, made all the patterns, the whole deal, and we became the first licensee of his kite patent.'

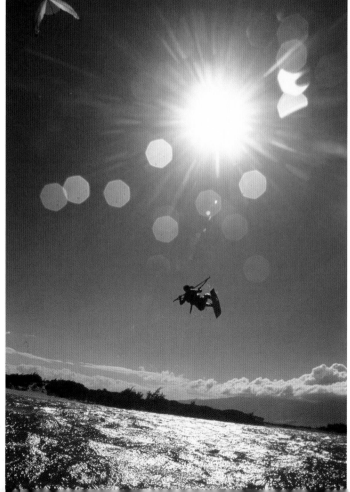

LOU WAINMAN: THE RIDER

'The late 90s were a very cool time on Maui. When people first saw kitesurfers they would either go for it and get into it, or you would hear them say, "Man, I'm going to wait until other guys figure it out, then I will get into it for sure!"

I could understand why – we looked pretty clueless and were often trekking up beaches looking like we got beaten up due to some of the long swims or the hard crashes.

Back then we used to just go for these long sessions and ride the waves in every spot down the coast, and this one day we were setting off from Ho'okipa and were going on a downwinder to Kannaha, nine miles away. In those days a few of us were using standard wakeboards, and part of the problem we had was that the kites were ultra-powerful and had no depower or safety systems, which made it really hard to get into the bindings. This day it was huge surf, like 15-foot Hawaiian, and 25–30 knots of wind, and I launched my kite with sand on the wing tip and got dragged straight to my board, which I'd prepared with dishwashing soap in the bindings so I could get in without a struggle. The beach at Ho'okipa is mostly coral with a small opening for getting into the water, and just downwind is a wall of rocks, so you better make it or else things get real interesting ... The soap worked great getting the board on, but I forgot to wash it out. So I was hauling ass right off the beach and this monster wave was building up in front of me right in the channel. I went for a huge air to get over it but with all this soap in my bindings the board just flung right out and got caught up in the lines about 50 feet up! Somehow the board didn't take

my head off, or snap the lines, or send me into a kiteloop, and it came off and I was able to body drag to it before it ended up on the rocks. By that time the soap was washed out and I remember having an epic run with my bro Elliot all the way down the coast, with the silver light that shines around 5pm here. It was an awesome time back then – there was so much energy for development and a real friendly vibe.'

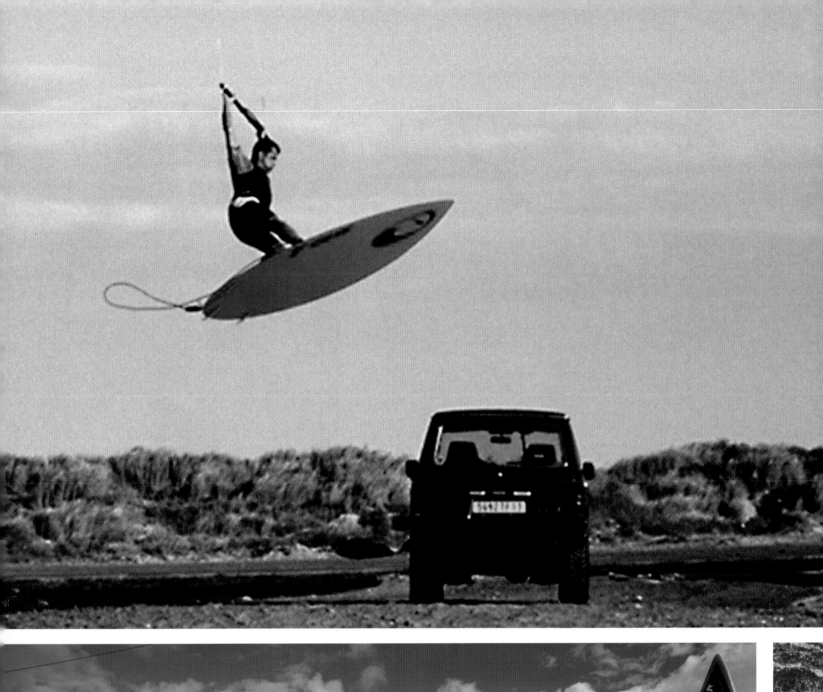

the crest of the windsurfing phenomenon). He knew that Don had been experimenting with kites and, as Manu had been, Don was blown away by the quality of the Wipika kite, which was light years ahead of his own efforts. He put a call in to Bruno and, within a month, Bruno was on Maui and the two designers set about applying to kite design the cutting-edge software that Don had developed for designing windsurfing sails. Bruno and Don worked tirelessly and within a year, in September 1999, Naish became the second brand licensee of the Legaignoux's kite patent and immediately released their two-line AR3.5, a similar kite to the Legaignoux's Wipika Classic.

It was from here that the two 'competitors' began evolving their respective four-line kites (something that the Legaignoux brothers had initially trialled in the early 90s), and these proved to be the missing link. With the capacity to depower the kite, consistently staying upwind – the Holy Grail until then – was suddenly achievable, and the vast potential of this new sport opened up before them. As Naish embarked on their AR5 Series, the Legaignoux's Wipika brand (which had now transferred production to China) developed their four-line Airblast and Freeair kites. Kiteboarding's stratospheric rise in popularity, and the journey to now – to *where it's at* – had begun.

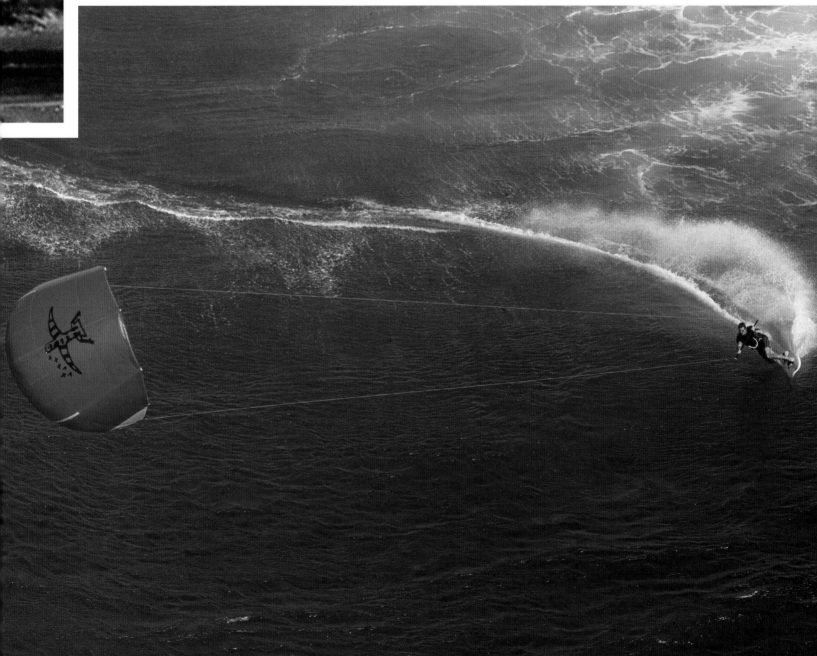

FREESTYLE

Wherever your kiteboarding journey has taken you, the chances are that it began with you staring nervously at your kite in the sky, and with a twin-tip strapped to your feet. Freestyle is the starting block, the beginning. And the first time that you truly appreciated the power of a kite and understood the potential of the sport was probably when you first sent the kite through the window and were fired upwards, with your twinnie twitching nervously beneath you and the water looking a long, long way away. The fact is that freestyle is the source and, despite the fact that the sport has since headed off in a few different directions, freestyle is still – by far – the most popular discipline and has been at the core of the sport of kiteboarding since twin-tips first emerged.

The involvement of more brands in the sport and the rapid progression of kites, which enabled ever more control and upwind potential, meant the evolution of boards happened in the blink of an eye compared to the comparatively slow development of kites over the previous couple of

RIGHT: Sam Medysky, Brandvlei, South Africa. *Photo: Ydwer van der Heide.*

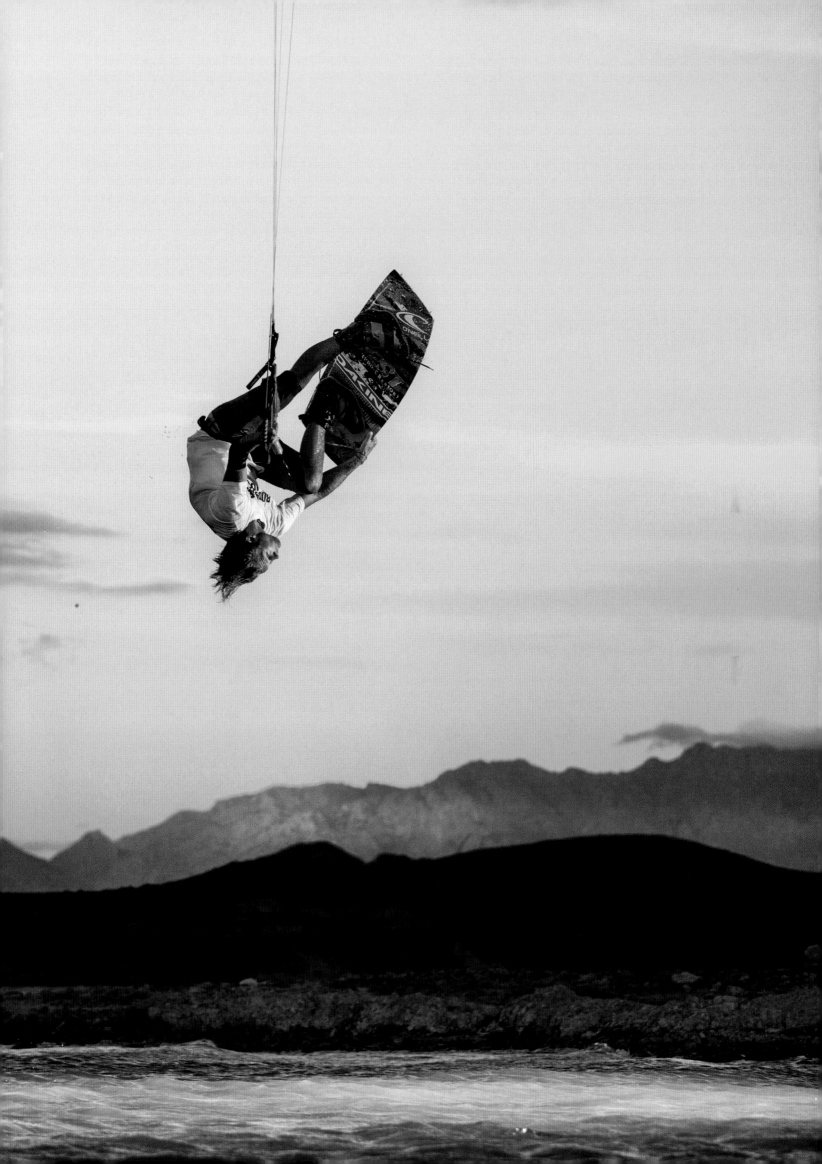

decades. Sure, early twin-tip sizes varied between 190cm at the top end down to 123cm at the bottom, and have yo-yoed around a little since then (before settling around the 135–145cm standard we have today), and construction techniques have improved in line with other boardsports but, since 2001, a twin-tip has been a twin-tip, and has been the easiest way to power yourself around behind a kite.

Having found the best tool for the job, freestyle then faced a question: what next? The answer was 'going big'. Big airs, multiple board spins, ever-bigger kites to get ever higher. The power of the sport was unleashed to the masses, and the pros and the brave early adopters went higher and harder, trying to work out increasingly more intricate ways to hang, to spin and to get the board off and then back on in the increasing amount of time that they had in the air. Visually it was impressive, but it quickly became clear that there was a limit, a ceiling, to this aspect of the sport. It was time for freestyle kiteboarding to take a long hard look at itself.

The fact was that there were heaps of riders at beaches on every corner of the planet trying other moves and pushing the sport in a fresh direction, but it took something special to draw the 'new school' side of the sport together, and to smash the perception

RAPHAEL SALLES, FOUNDER F-ONE

'**W**hen I started kiting in 1996 there weren't any boards available so I started making my own. I tested many different options and ended up with a surfboard outline, but with a rocker-line more from windsurfing. I was shaping and building all my windsurfers at that time and this new challenge was exciting! Our first F-ONE production boards arrived at the end of 1997 – there was a red 215cm and a yellow 230cm, with a traditional EPS epoxy core made at Cobra, the leading windsurf factory at that time. The next range at the end of the 90s was built in Epoxy PVC sandwich because we needed lighter and stronger boards for our jumps. Things quickly become shorter and shorter and then twin-tips arrived.

Our first real twin-tips were built in 2001 in France in a snowboard factory – it was a new process for kitesurfing. They were made in full Herex core with a top sheet like snowboards. Snowboard construction gave strength and durability to our kiteboards, which we needed because we were jumping higher and higher. The next innovation was the full wood core, which is still used today by most twin-tip producers. In 2004 we put out the SK8, with a full wood core and a thickness of only 10mm, which was much thinner than any other brand at the time and the SK8 stayed in our range for 10 years. Nowadays, the board shapes are similar, but there are constant evolutions with different combinations of wood, fibreglass and carbon, or with rail shapes – such as the three-part Helical rail we introduced to our range. One thing is for sure: there will always be new innovations with kiteboards!'

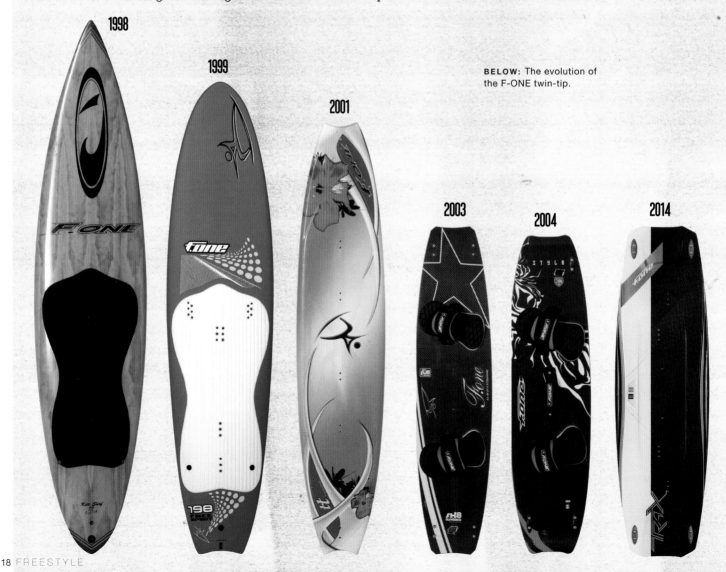

BELOW: The evolution of the F-ONE twin-tip.

1998
1999
2001
2003
2004
2014

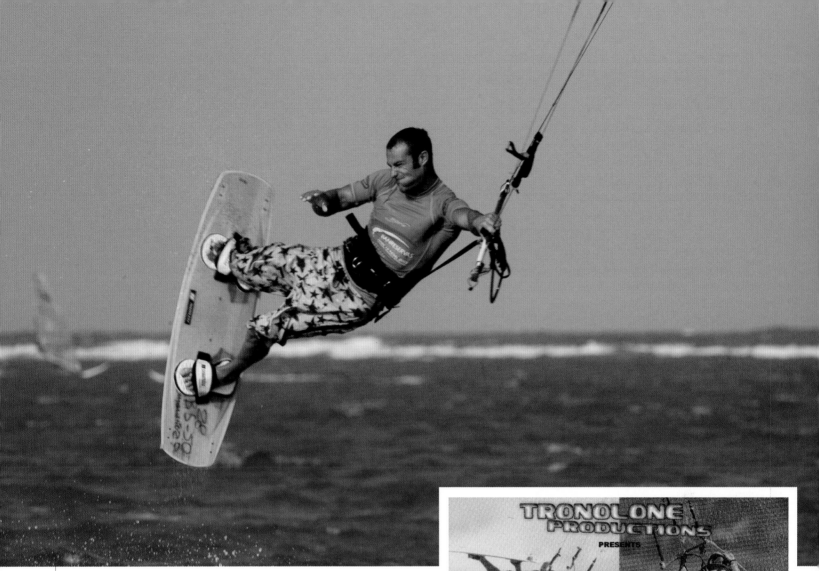

ABOVE: Original Space Monkey, Jaime Herraiz. *Photo: courtesy PKRA.*

RIGHT: *Space Monkeys* video cover.

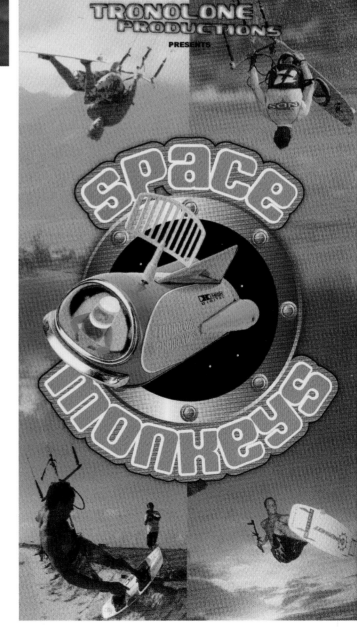

of kiteboarding as a sport of danglers. That something was *Space Monkeys*. The film, released in 2001, followed Jeff Tobias, Jamie Herraiz, Will James and Martin Vari on an odyssey around Los Roches, Venezuela. Travelling together they pushed each other harder and harder, before taking their newfound skills back home and developing them. Videographer Chris Tronolone then caught up with each of the crew again a few months later to chart their development. That was the format of *Space Monkeys*, and in one stroke the video introduced kite loops, handle-passes, barrel-riding and technical wakestyle trickery to the kiteboarding masses. Any aspiring pro worth their salt wore out at least two copies of the film with all the rewinding, pausing and 'ah, then you pass the bar' usage it received. It was a revolution, and it changed the direction of the sport completely and set it on the path to what we now expect from freestyle kiteboarding.

As the popularity of kiteboarding skyrocketed, it also began seeking the best competitive outlet for showcasing itself. The PKRA and KPWT tours were established and ran alongside each other until the KPWT was wound up in 2010. Competition riding drove kiteboarding forwards at breakneck speed (with guys often having to attempt 'new' tricks they had seen in previous heats, just to keep up) and has taken it through a few different phases to where it is now, with technical, powered and booted being at the impressive pinnacle of the PKRA World Tour at this moment in time.

Outside of this style of competitive riding, freestyle riding has continued to prove itself as versatile as ever and has embraced various sub-genres – the main one being the slider- and kicker-focussed world of wakestyle – but the reincarnation of the King of the Air and the mainstream-media-friendly antics of guys such as Ruben Lenten and Lewis Crathern certainly seems to suggest that a more stylised return to the world of spectator-pleasing big air and megaloops could be the story of the next few years. Or it could be an entirely new innovation. Who knows? This is what makes freestyle such an exciting hub of the sport.

RIGHT: The Hadlow Years, 2007.
Photo: Courtesy PKRA.
FAR RIGHT: The Hadlow Years, 2003.
Photo: Courtesy PKRA.
BELOW: The Hadlow Years, 2014.
Photo: Toby Bromwich/PKRA.

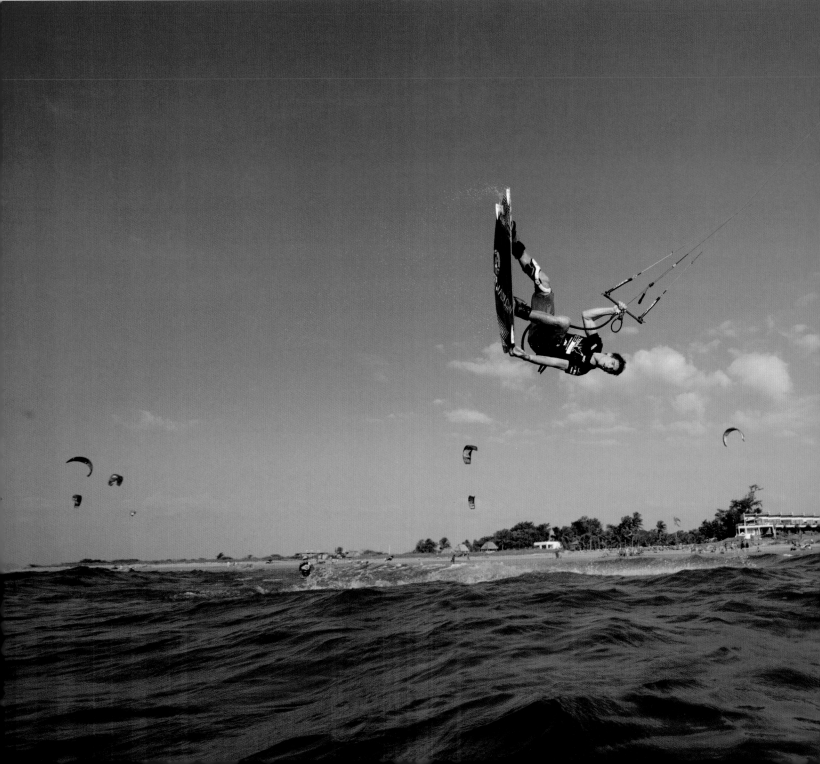

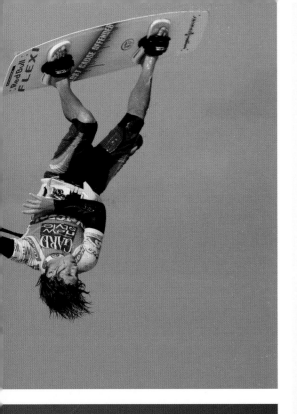

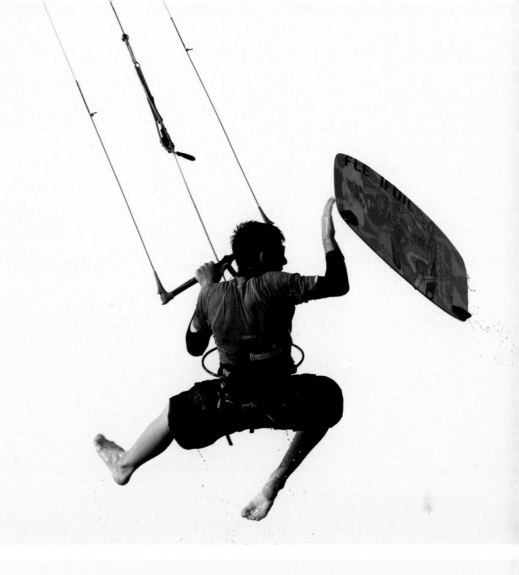

FIVE-TIME PKRA WORLD CHAMPION, AARON HADLOW

'**W**hen I first started in the PKRA, in 2003, it was the Space Monkeys crew who were on top and had just started to change from board-offs to handle-passes.** It was all new. It was those guys who came in and dominated everything, and it was basically whoever came in and caught up the quickest who had a chance, and it took until halfway through the season, in the Dominican, when I started getting things and I just practised really hard and managed to get on the podium by the end of the year. By the time the 2004 season came around a lot of the younger guys had been practising solidly over the winter and it was game on after that. I won my first title that year. Then in 2005 the moves really started to develop – we were out in Venezuela for the first event and the conditions were perfect. Everyone was bringing all that they had learnt over the winter and we could see the progression. It was mainly the younger generation then, with most of us under 18, and it was obvious that things had really stepped up a level. I was riding well and I guess it got to the point where there was no one but myself to copy, so I'd just add this and add that, and things just evolved. It was kind of natural at the time and it would have been the same for anyone else. The development seemed pretty obvious – you'd try something with a double handle-pass, then the next one with a grab, or with the kite lower, just trying to make it more challenging for yourself and to stay on top of the other guys. So, yeah, obviously I was in a good place myself and it was a great time to be in the sport.'

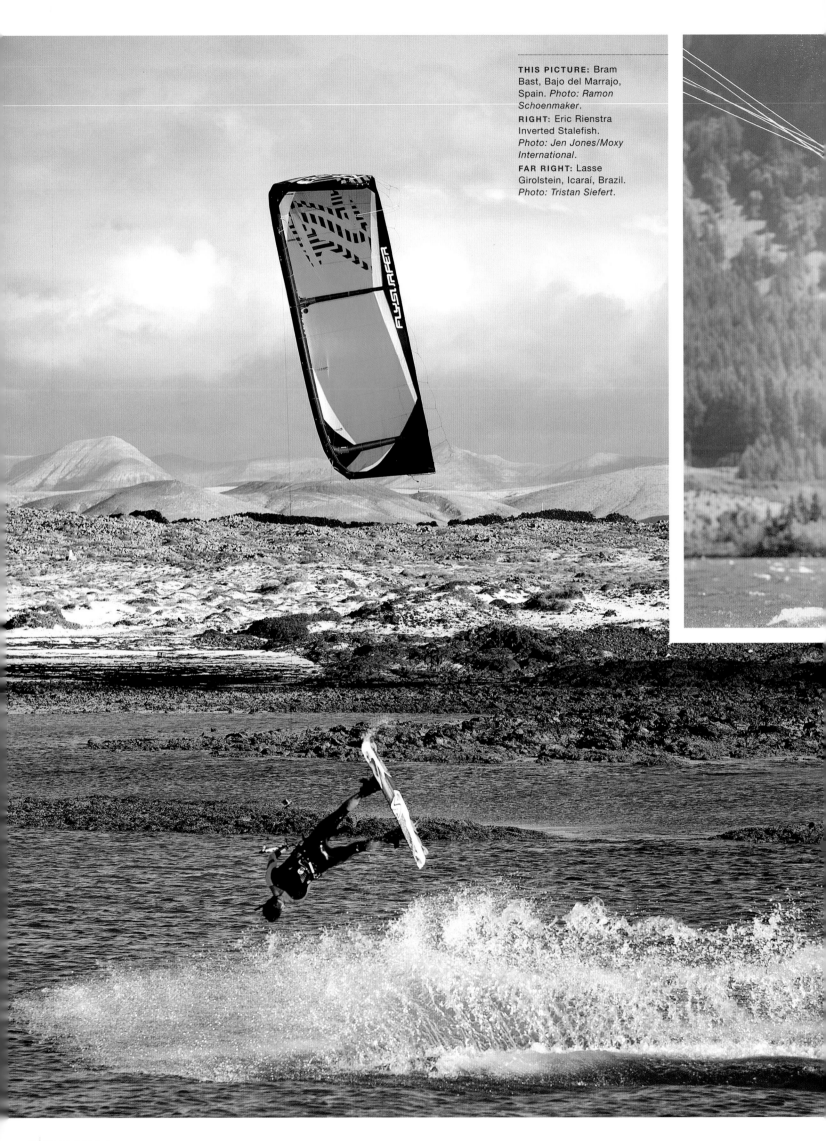

THIS PICTURE: Bram Bast, Bajo del Marrajo, Spain. *Photo: Ramon Schoenmaker.*
RIGHT: Eric Rienstra Inverted Stalefish. *Photo: Jen Jones/Moxy International.*
FAR RIGHT: Lasse Girolstein, Icaraí, Brazil. *Photo: Tristan Siefert.*

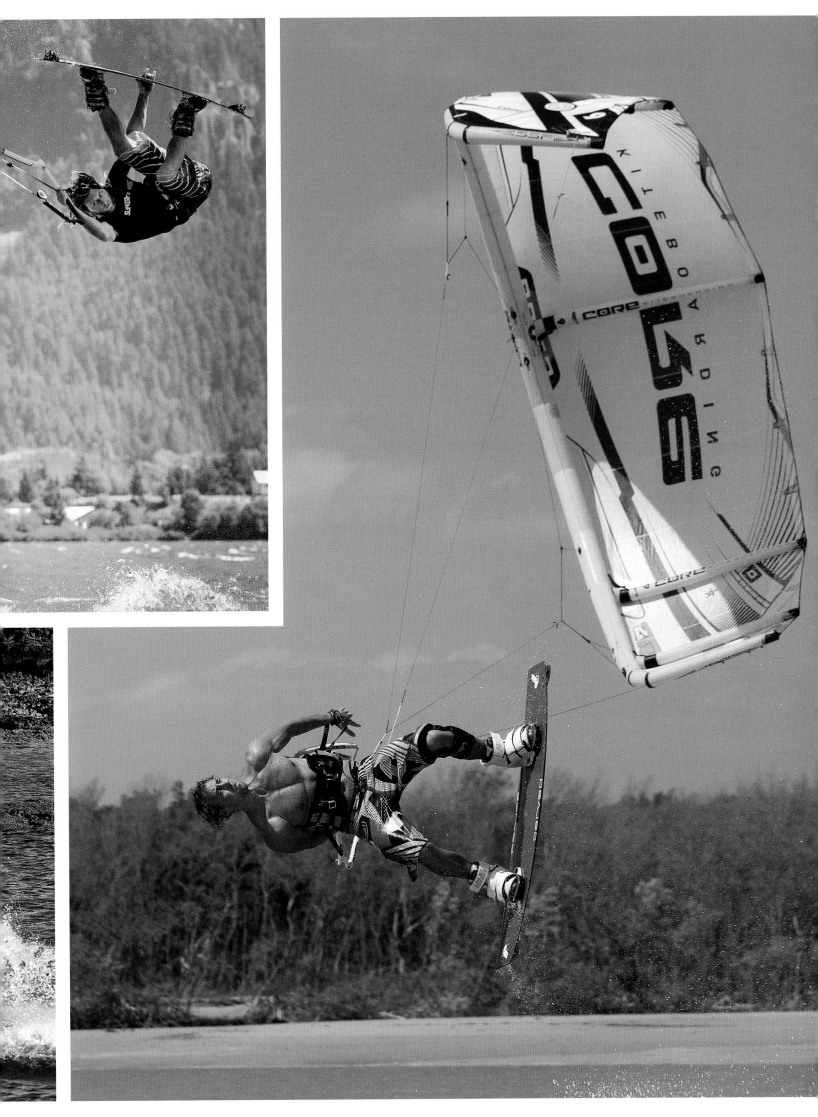

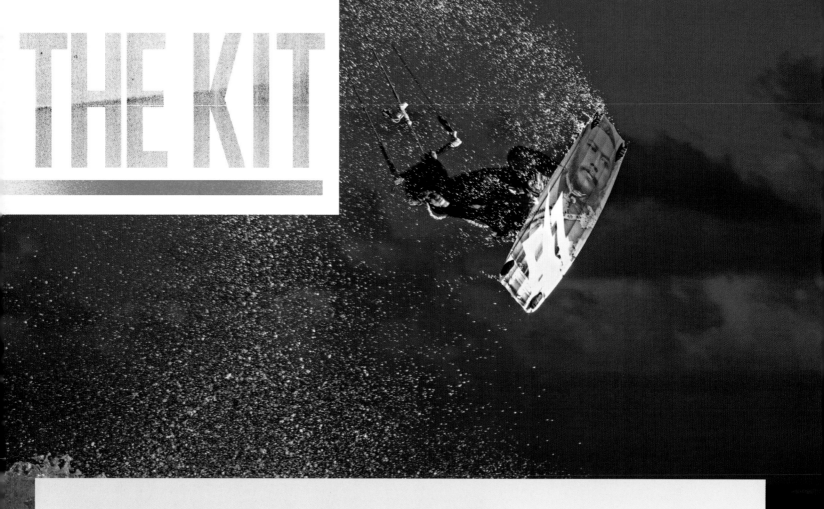

Photo: courtesy Naish.

FREESTYLE BOARDS

LARS MOLTRUP, NAISH KITEBOARDING

IN THEORY

'The main driver behind the evolution of boards is the top riders pushing the sport to new levels. More and more powered riding, with the kite low, has increased the requirements of a freestyle board. Thankfully the use of better and higher-quality materials has also really raised the performance of freestyle boards and fine-tuning of the different parameters means that boards are getting better every year.

There are a lot of things to consider when you sit down to start designing a freestyle board. Great pop and forgiving landings are the priority. To improve pop you need a board that's easy to handle so that you can go fast and edge hard, then you want the board to pop out of the water, so for that you want a board with good stiffness and lots of reflex. Soft landings are produced by the rocker and bottom-shaping. Bottom-shaping will allow efficient water disbursement and a high rocker will soften the landing, but it will also be harder to carry enough speed in order to have the good amount of pop, so a balance between the two factors is required. With regard to construction, you need a board with a good reflex and high strength. This is generally obtained by using carbon fibre, strategically placed in order to create the desired characteristics.

The overall parameters of a lot of freestyle boards are comparable now, but within that framework you can have boards that behave very differently. As an example, you only need to increase the tip width by a centimetre in order to get a very different feel and behaviour in a board.'

IN PRACTICE – THE MONARCH

'When starting to draft the design objectives and initial sketching of the Monarch, it was clear that we wanted to raise the bar of what a freestyle board can be, especially with regard to bottom- and deck-shaping, as well as construction. With the Monarch we went for low rocker, low flex and wide tips, which provide it with radical pop and maximum control as well as early planing and speed. The bevelled edges also give the board a comfortable ride in choppier conditions and the comparatively low flex of the Monarch has allowed us to have a lower rocker. The rocker is highest at the stance area and relatively flat in the centre section.

We had a lot of team riders involved when designing this board, including Jesse and Shawn Richman and Paul Serin, but mainly we worked with Kevin Langeree, especially on the construction. Kevin puts exceptional demands on his board so his input was pretty instrumental in us getting the flex characteristics and performance right.'

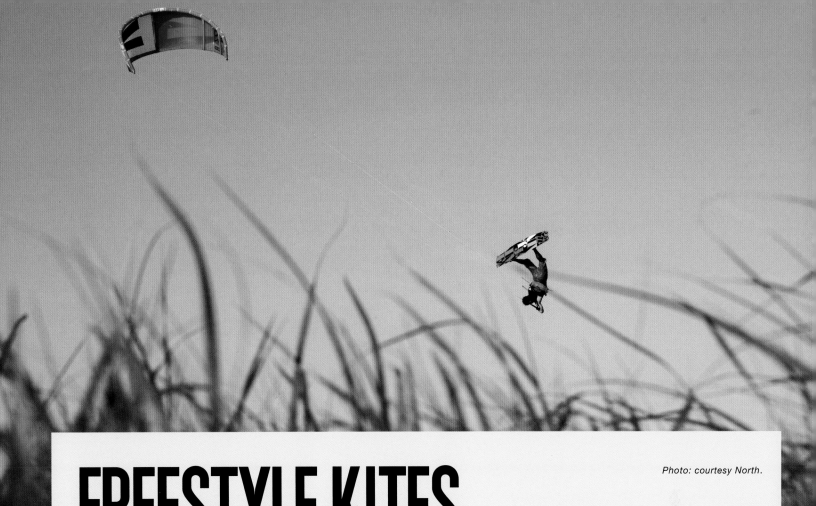

Photo: courtesy North.

FREESTYLE KITES

RALF GROESEL, NORTH KITEBOARDING

IN THEORY

'Most kites preferred for freestyle riding are C-kites. These are high-aspect kites, which provide more consistent and predictable power than other kite shapes because of that iconic C-shape. This allows the kite to sit deeper in the wind window, giving them a grunty and direct feeling. The angle of the tip of the kite is usually squared off to allow the lines to be connected directly, which provides the rider with direct feedback from the kite. C-kites traditionally have five struts to keep the kite solid in the air, eliminating any movement and also making them tough enough to deal with the high impact of freestyle tricks.

A freestyle kite has the most pure and direct feel of any kite. There are normally no bridles on the kite, so the energy is felt more directly at the bar. The kite will sit further forwards in the window, allowing it to drive more effectively upwind and also enabling it to make longer and more powerful transitions through the window, thus generating more power for the rider.

It is important that the handling is very intuitive with a freestyle kite. For freestyle competition riding, where the kite remains low and powered up, the rider must have complete confidence in the kite and in the fact that it will be in the same place at the end of a trick as it was at the beginning. It is also important that the feeling at the bar is very direct so that a rider can tell exactly how much power they have and can make quick and effective adjustments.

For modern riding, the amount of 'slack line' that a kite has following the rider's pop has also become one of the most crucial features. For riders to perform passes and to have the time to undertake more complicated moves, this feature is key and something that kite designers have increasingly focussed on.'

IN PRACTICE – THE VEGAS

'The Vegas has been in North's range since 2005. In 2006, when other brands were looking at bow kites, we focussed on bringing more depower to our range, and the Vegas became a really iconic kite that year. With the loaded fifth line you get a lot of the benefits of hybrid kites, but still keep that genuine C-kite responsiveness. And, due to the loaded fifth line, you get an incredibly compact kite, although the aspect ratio is quite high for a kite of this style. The amazing handling and pop are key, and are the result of many years of evolution.

Just like the sport, the expectations of customers have changed over the years and the Vegas has also developed. It has become much more comfortable, with more depower, and is much easier to use. Depending on your riding style and level, it can be a really extreme kite, but most riders just love the precise handling and performance so have stuck with the Vegas for many years.'

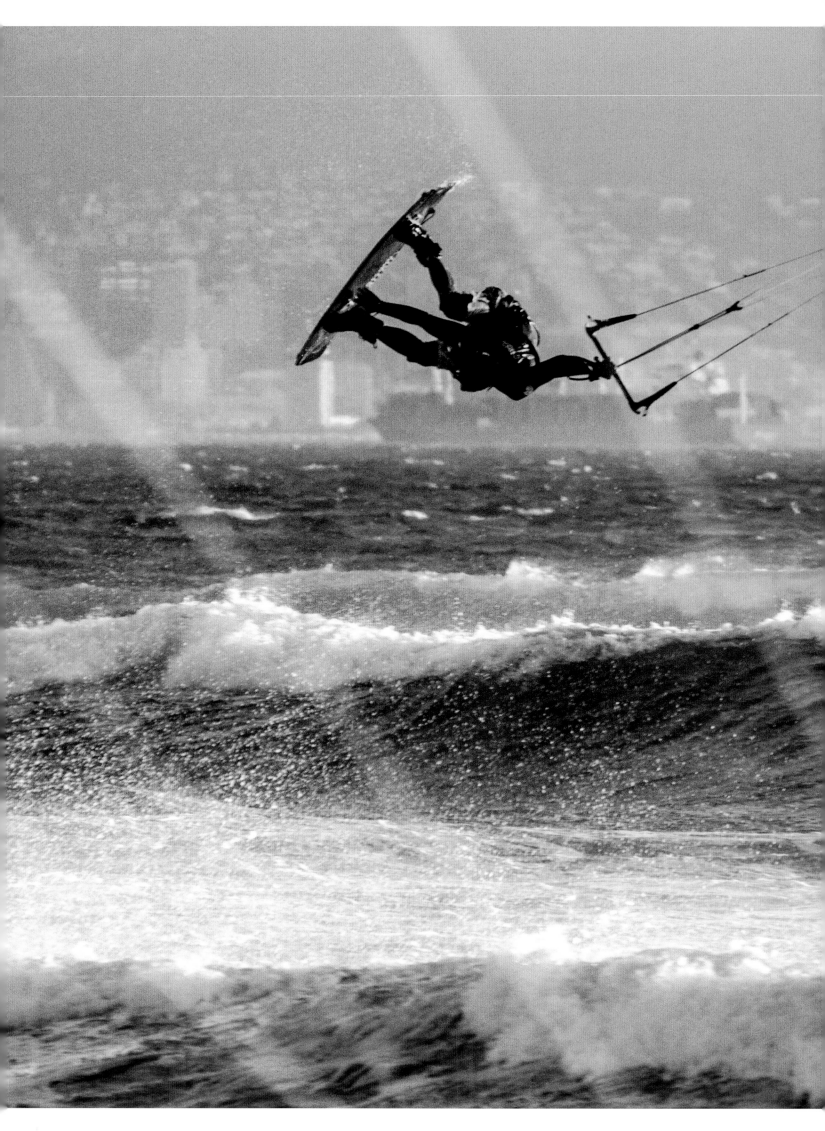

PLACE

CAPE TOWN

The frontier

GRAHAM HOWES, *DIRTY HABITS*
BOARDRIDERS MAGAZINE

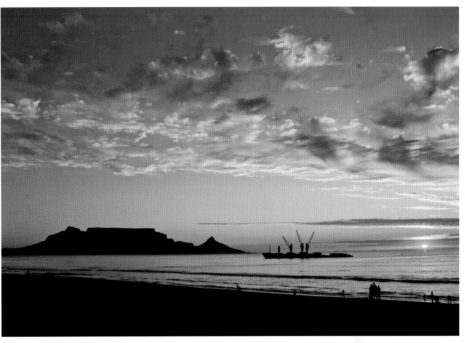

ABOVE: *Photo: Bianca Asher.*
LEFT: Oliver Umpierre, Big Bay. *Photo: Bianca Asher.*

'There's nothing else like it. No island, no city, not the Caribbean, not Indonesia, not even close. People travel around the world to find the perfect place, they search year after year to find something different, something new, but there is something about Cape Town that brings people flocking back every year.

I'm not even from here. I spent five years travelling to the best kite spots in the word: Cabarete, Cali, NZ, Indo, and Asia, and swore never to visit the same place twice ... Five years later I'm married to Cape Town. She's no Paradise Beach in the Bahamas, with warm, turquoise water and palm trees swaying in her light tropical winds. Cape Town is harsh and windy, and the water's icy and sharky: it's as real as it gets. But South Africa's "Mother City" is an old pro at capturing people's hearts. And who wouldn't swoon at the sight of magnificent Table Mountain, its summit draped with cascading clouds, its flanks coated with unique flora and vineyards, its base fringed by golden beaches. These are just some of the many reasons more kiteboarders call Cape Town home for the summer months than any other place in the world. Aaron Hadlow, Ruben Lenten, Kevin Langeree, Youri, the UK crew – they've all shared their Cape Town retirement plans with me, sitting on our deck that overlooks the iconic kite beach and Table Bay. We even had the Hood River boys, the Canadians and the kids from Oz too. They just can't get enough of the good life we have got going here. They own cars here,

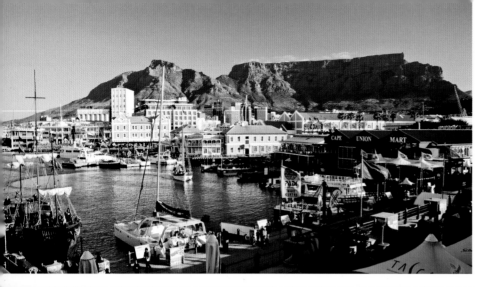

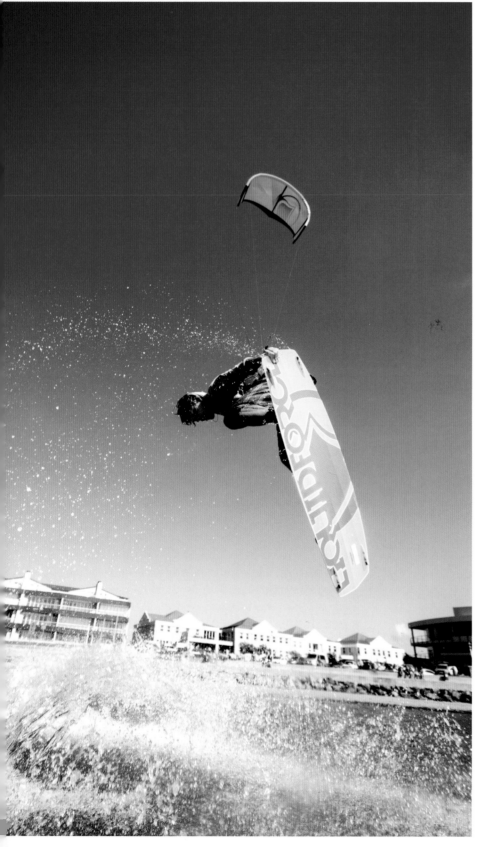

and some own houses, to go along with their season girlfriends. And thank goodness for winter, otherwise I'd have to use a big stick to get them to leave.

Cape Town is a surreal place – first-class quality at third-world prices. Bring your euro or dollar to Cape Town and you'll be eating the juiciest steak and sipping the smoothest wines on your beachfront balcony – usually after a glassy morning surf, followed by a flat-water freestyle session on your 10m and ended by a megaloop boost session on your 6m. It's a lifestyle that is truly hard to beat. At the end of the day it boils down to diversity, and if the Mother City doesn't have it, chances are nowhere else will. It would be a daunting task to list a world-class spot somewhere else on the planet, and not find a spot here that could match if not better it.

The beauty of this city is that it is as grand as you need it to be – most people rent a villa on kite beach and don't leave it for two weeks. They just kite, surf, eat, party and play along the kilometre stretch that is Blouberg Kite Beach. Here the wind blows straight down like clockwork, with wide sandy beaches and with kickers on standby every day in summer. But you don't have to stay local – with a banged up rental Merc you have a 150km radius that has more rough diamonds than West Africa and, with some local knowledge, you can find yourself slicing through butter-flat fresh water in boardshorts with 15 knots of wind, surrounded by one of the most stunning mountain ranges in the country. Or, just 45 minutes in the other direction from the centre of town, you could find yourself at the notorious Cape Point for big winds and big kickers. Follow the Cape Doctor wind north, and paradise awaits you with waist-deep turquoise water in the middle of a nature reserve. Yes, there are spots like this all over the world. Yes, South Africa has crime, and yes, it is too far for most of you to be bothered to sit in a plane for. However, once your day on the water is done, there are five-star hotels and stunning guest lodges less than a kilometre from these picturesque spots; there are some of the world's best DJs playing in some of the hottest clubs and festivals; there are more beautiful people here than there are in California; there are less rules than in the Dominican Republic; we have more plants species on Table Mountain's 22 hectares than there are in the entire United Kingdom or New Zealand; and we have more culture and variety than you'd know what to do with. Cape Town is a city to be explored, and the only negative about planning a trip to this magnificent place is that you might fall into the trap experienced by many others and get so lost in the sheer magnificence of the city and what she has to offer, that you forget to unpack your kite.'

RIGHT: Steven Akkersdijk in the Bay. *Photo: Marcel Würfel.*
ABOVE LEFT: *Photo: Bianca Asher.*
LEFT: Brandon Scheid, Milnerton Lagoon. *Photo: Craig Kolesky.*

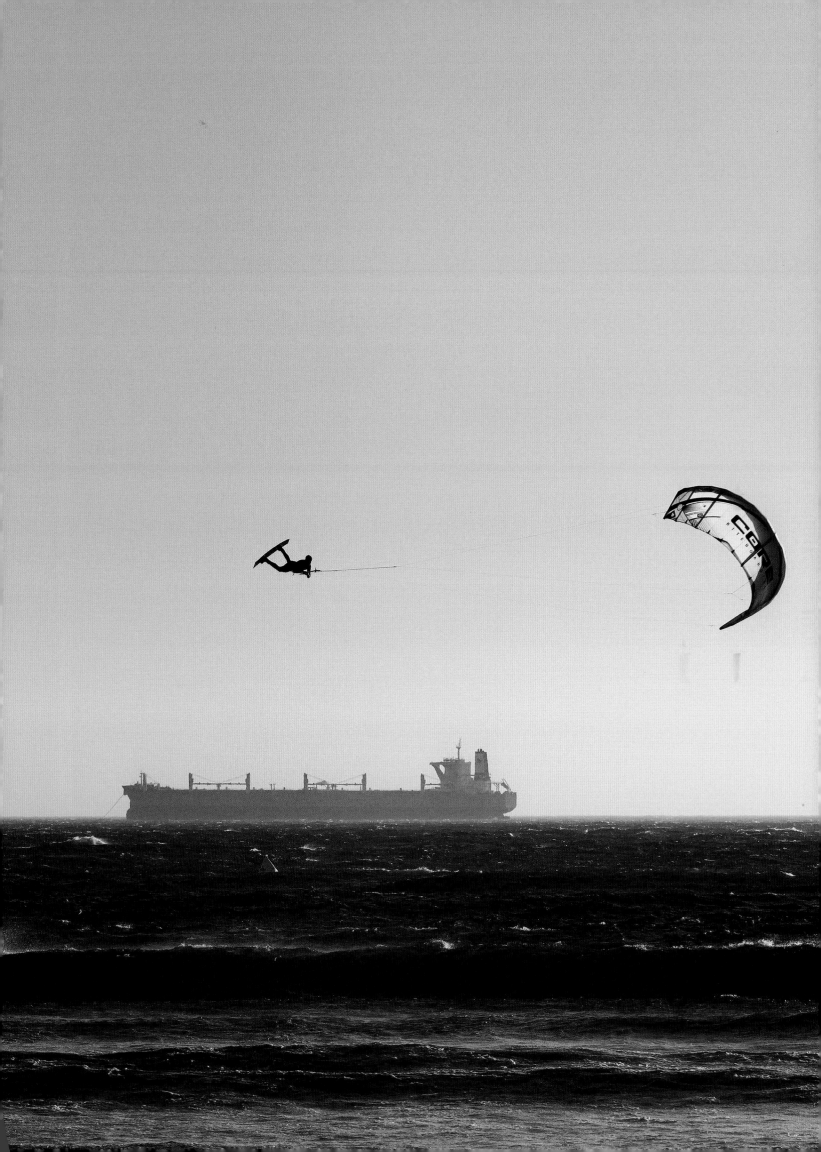

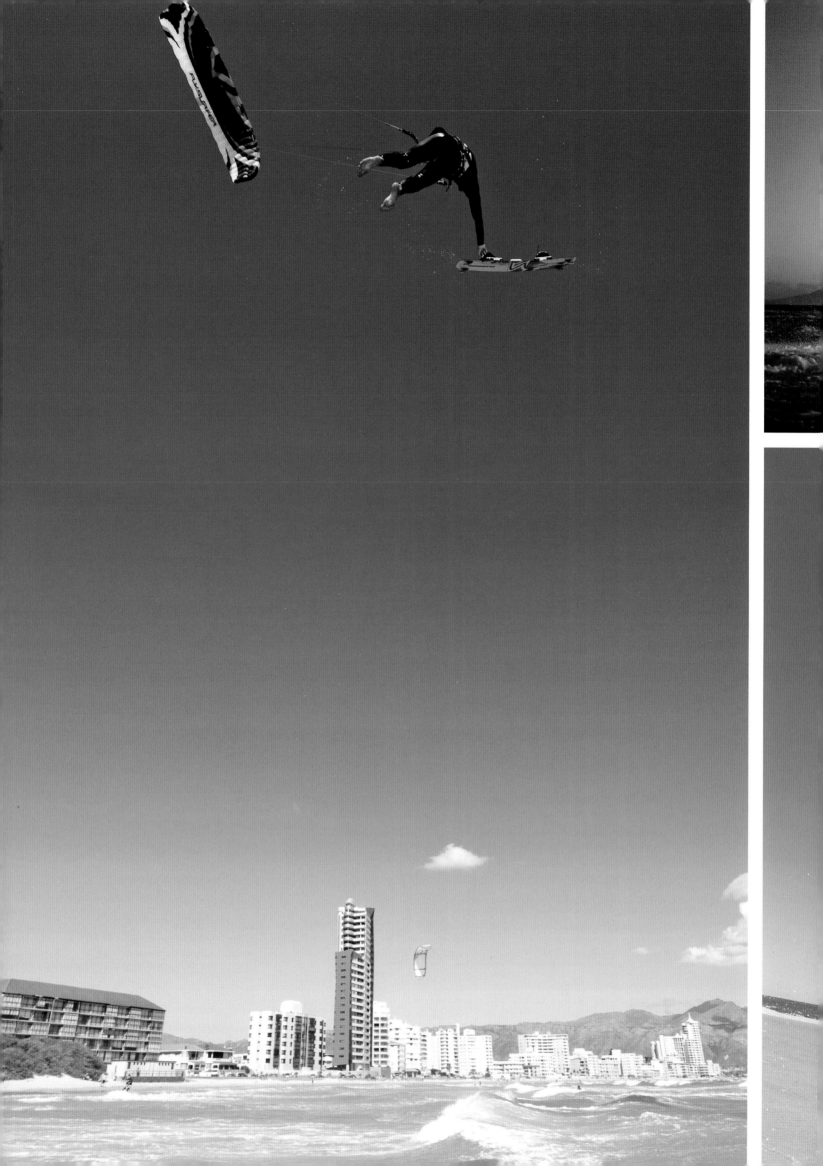

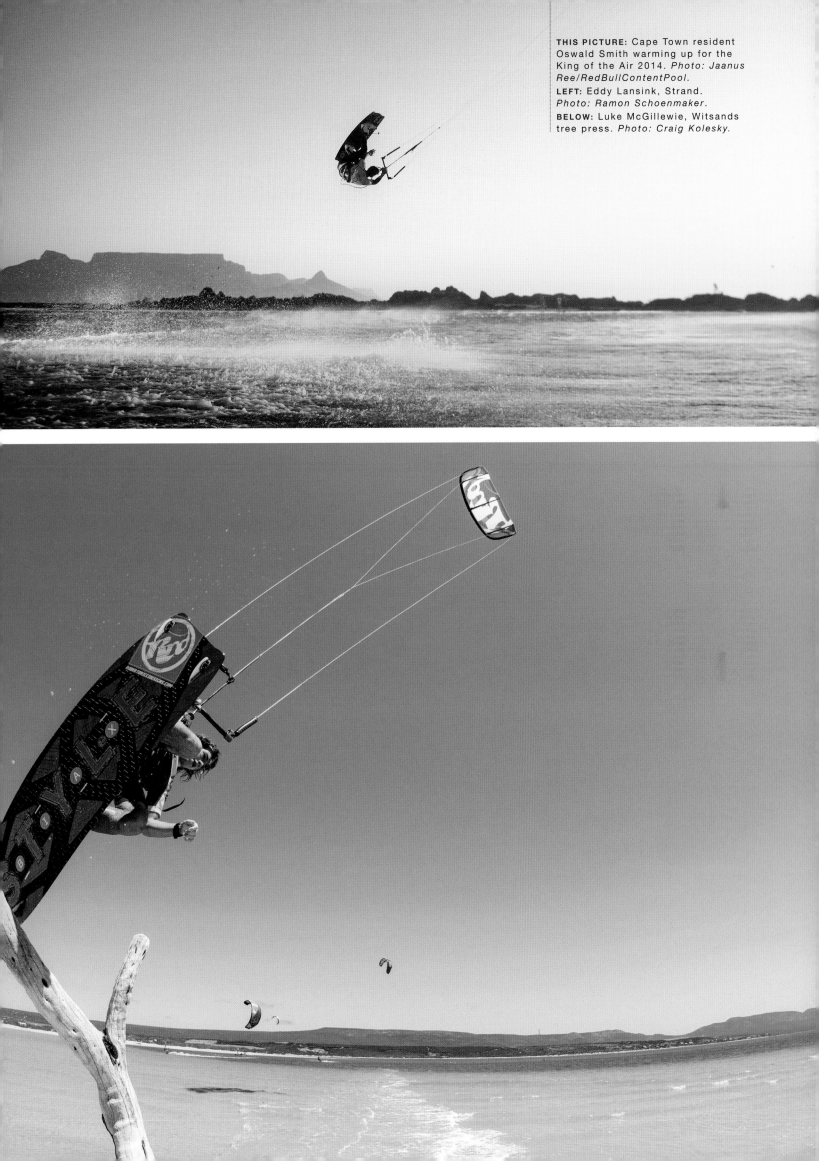

THIS PICTURE: Cape Town resident Oswald Smith warming up for the King of the Air 2014. *Photo: Jaanus Ree/RedBullContentPool.*
LEFT: Eddy Lansink, Strand. *Photo: Ramon Schoenmaker.*
BELOW: Luke McGillewie, Witsands tree press. *Photo: Craig Kolesky.*

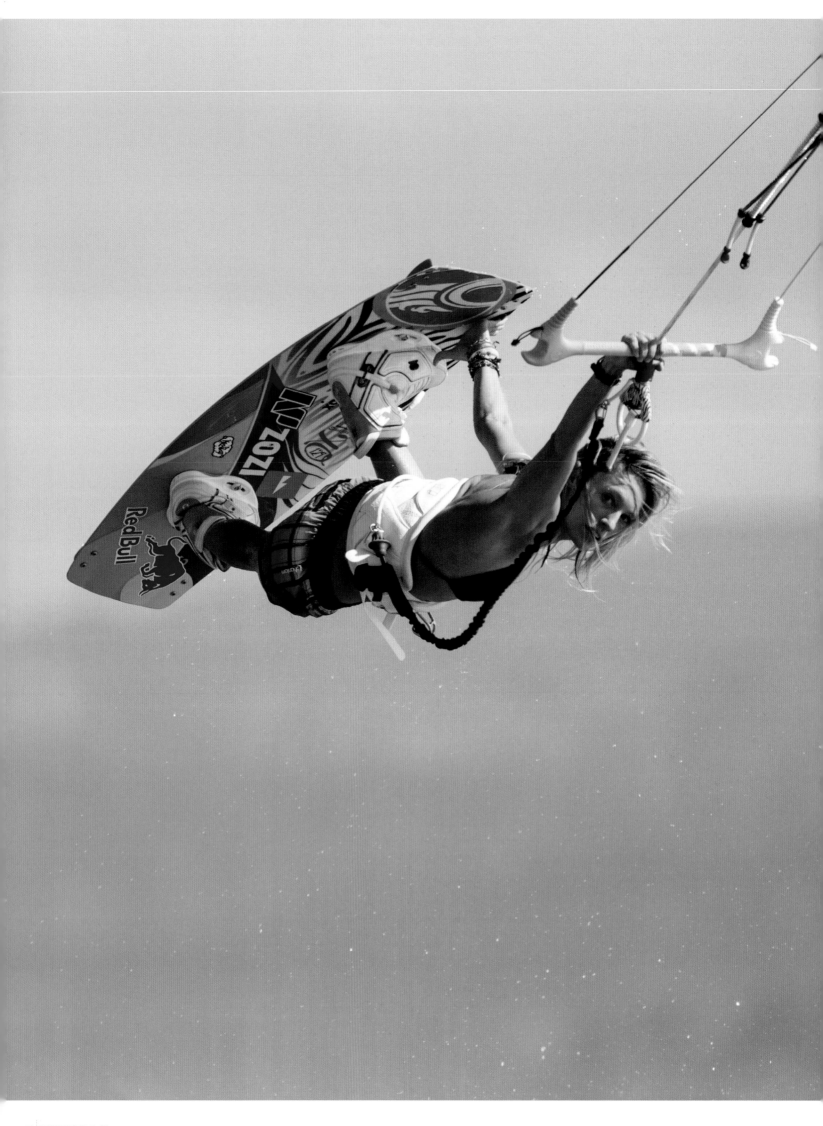

DOMINICAN REPUBLIC

Caribbean kiteboarding nirvana

SUSI MAI, CABRINHA RIDER

'**If you flew into the Dominican Republic's main airport, Puerto Plata, and were given a map and told to drive to where you thought would be the best kiteboarding spot on the island, you would probably drive right through the inconspicuous little town that is Cabarete.** It doesn't look like much at first, and I think that is the reason why, even after all these years, I still consider it to be the best-kept secret freestyle spot in the Caribbean.

The town doesn't look that special. There is only one mile-long street, and there are no traffic lights. The street is strewn with tiny shops and restaurants, and there is the constant chaos of loud mopeds whizzing past you at precarious speeds, and people going about their lives with a random chicken or pig being carried down the street. It's not surprising that the first question that many people ask is, "Where the hell have I ended up?"

The truth is: it grows on you. Not in the way that something that is kind of substandard becomes bearable, but in a way that once you spend some time there and discover all the hidden treasures, you fall in love with it. It's like the ugly duckling that turns out to be a beautiful swan. And that feeling is the same when you get to the beach. It looks like there are way too many people on the water, with a bit of shore-break and

FAR LEFT: Susi at home. *Photo: Quincy Dein.*
TOP AND BOTTOM LEFT: *Photos: Quincy Dein.*

then uncomfortable-looking chop. And then you launch your kite and go out for a session and realise what an amazing place it really is.

There are four main kite spots, two of which are still so "undiscovered" by the general crowds that you rarely encounter another kiter there – even in peak season. First up is Kitebeach, which is beginner-friendly with plenty of flat water and with the reef closer in than in the main bay of Cabarete. The beach itself is covered in little bars and restaurants and pretty much every single person there is a kiter so there's a great little community. Then you have Cabarete's main bay, "Bozo Beach".

I have no idea why it was originally named this, but it's quite appropriate, as there seem to a lot of bozos mincing around there! It's one of those places where the bikini-clad girls on the beach end up attracting all of the show-ponies and wannabes, so I usually steer clear of kiting there as it can get quite crazy.

For surf you can head to Outer Reef, which is one of the deeper reefs and can hold some pretty serious waves. Out here we share that reef with the windsurfers and, while they are usually very friendly and welcoming, it's good to make sure they don't feel invaded. Alternatively, you can head to Encuentro. This is the local surf spot and the reef system here is at a perfect angle and works on any swell direction – it's pretty special. For freestyle, the kickers can be so perfect that they'll spit you out and have you landing Flat 3s pretty much guaranteed. Plus you can head here on a sunset downwinder from Kitebeach or Cabarete, and after an ice cold beer on the beach jump on one of the lurking moto taxis and catch a ride back into town.

But despite all of these great options, for me there's one spot that beats them, and that's La Boca. It is by far my favourite kite spot in the world. There is one prerequisite for riding here though: you need to be able to relaunch your kite in under a minute flat. Boca is Spanish for 'mouth' and at La Boca a river that comes down from the mountains empties out into the sea. The actual mouth of the river is a big butter-flat water lagoon, with a small sand bank and trees on the far side, hence the need to be able to relaunch as otherwise you will end up in the trees pretty quickly. The great thing about La Boca is that on the nearside of the bank the wind is slightly offshore, allowing you to take off pretty much right before the sand and do your tricks super-close to anyone who came along to watch. And with piña coladas and fresh fish served right on the edge of the water, this is the ultimate peanut gallery!

And so, despite initial appearances, the spots around the Dominican Republic's special little town of Cabarete really do have it all.'

BELOW
LEFT: *Photo: Christian Black.*
CENTRE: Local hero Robinson Hilario. *Photo: Hege Holt.*
RIGHT: Jesse Richman, La Boca. *Photo: Quincy Dein.*

ABOVE: *Photo: Christian Black.*
RIGHT: Tom Court, Club Punta Cana. *Photo: Christian Black.*

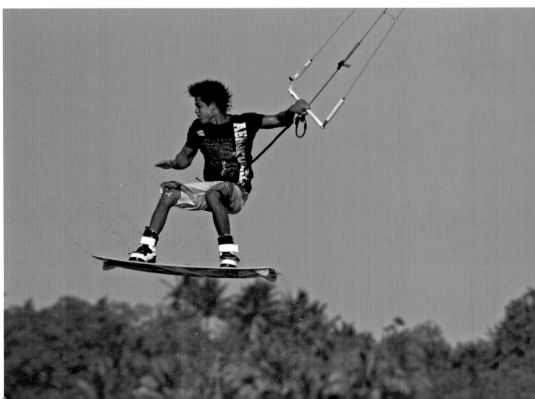

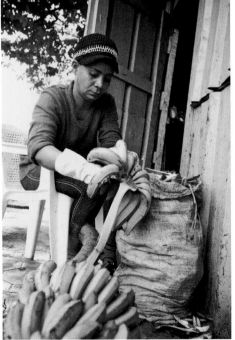

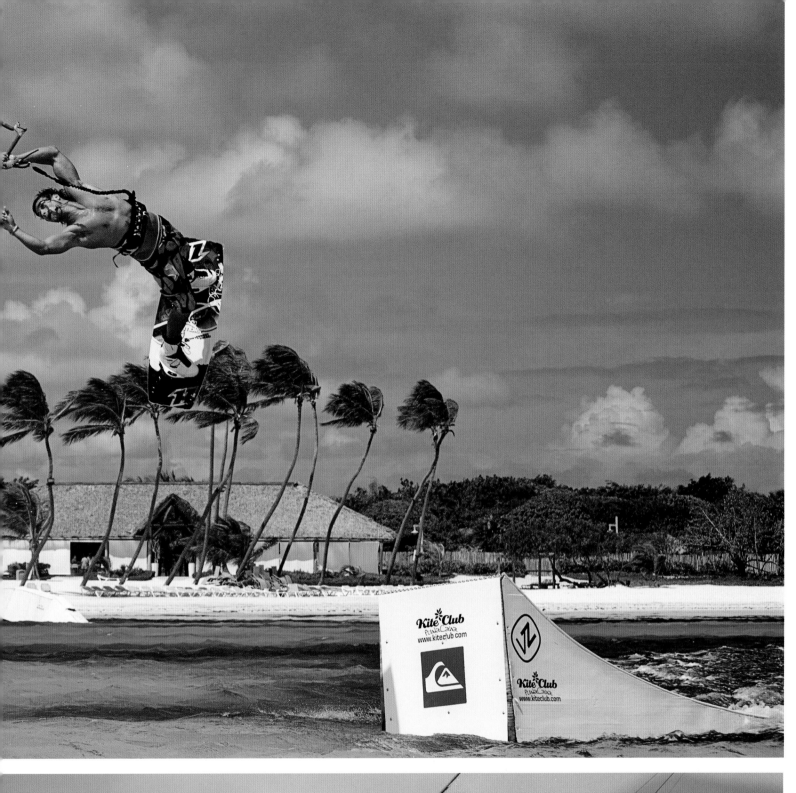
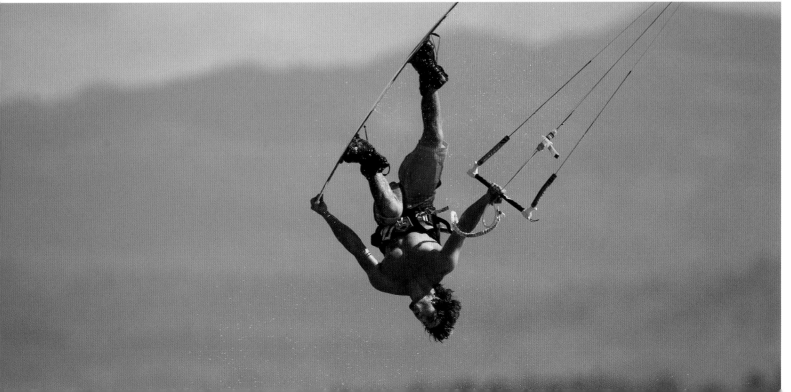

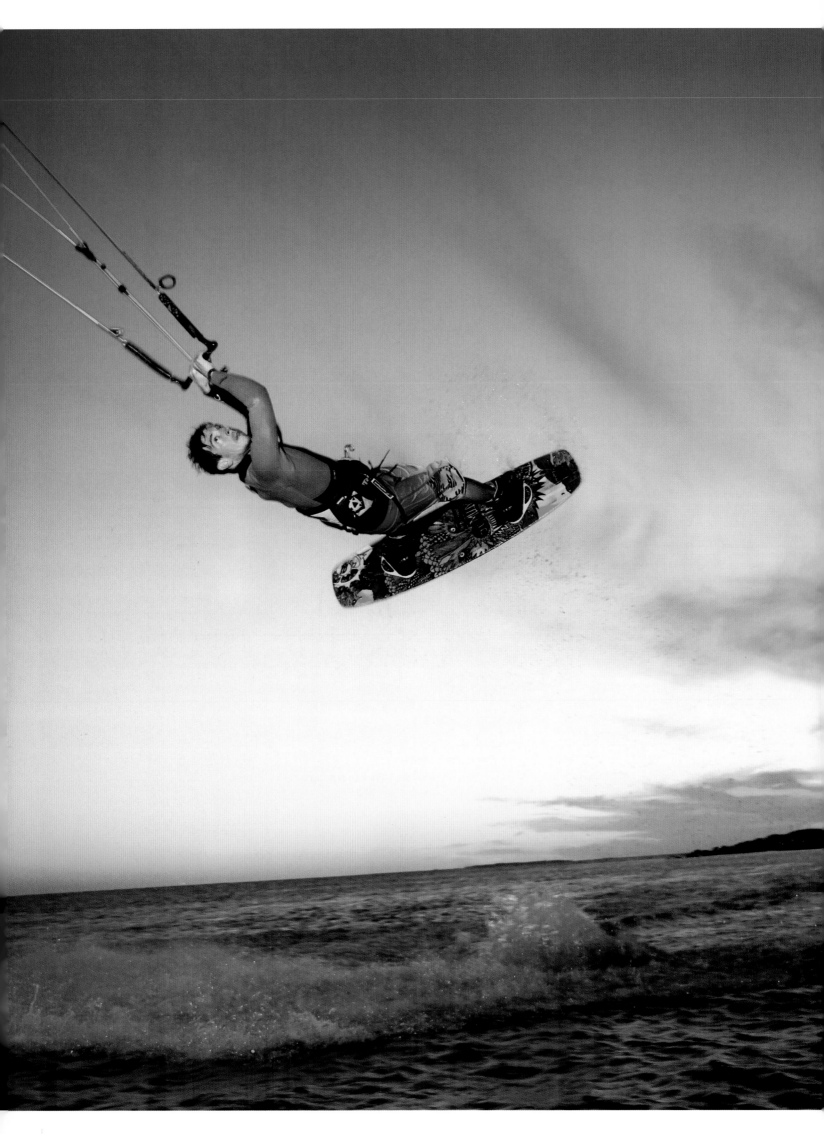

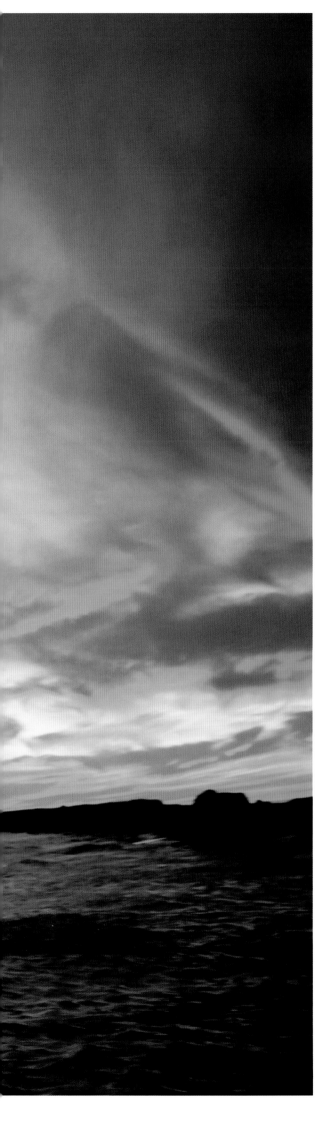

PLACE PERTH

City living, with perks

ALEX PARKER, PHOTOGRAPHER

'**W**hen asked about what Perth means to them, your average person in the street will probably say "a city in the desert",** or "a city that's consistently in one of those top-ten 'best places to live' lists". Ask any kiter the same question, and you will be told about the startling abundance of first-class kiteboarding spots.

This relatively small metropolis is positioned where the west coast of Australia meets the Indian Ocean, and is a three-and-a-half-hour flight away from the next large city. Despite this seclusion, Perth offers possibly the best combination of conditions and urban civilisation to be enjoyed by the roaming kiteboarder anywhere on the planet. There are very few other destinations where you can go from enjoying a sunset session on flat water to experiencing a vibrant nightlife such as the one that Perth has to offer, with restaurants, live music and a cosmopolitan vibe to cater for pretty much any taste.

The popularity of this city among kiteboarders is evident at the beginning of the windy season as you wait by the baggage carousel of Perth airport, where board-bag after board-bag passes by, to be eagerly claimed by a fresh-faced European

ABOVE: *Photo: Gwen Velge.*
LEFT: Ali Barrett, Woodies.
Photo: Alex Parker.

kiter. These Euros, as the locals call them, arrive in throngs as the sea breeze begins to blow in November. And by December, the local kite spots begin to resemble the English Riviera, or the German Sylt coast as these temporary expats make Perth their home for the coming season.

There may be spots on this planet that can match Perth's almost mechanically reliable summer sea breeze and glassy-smooth water, however there are few that provide such a large variation of activities for those who find it hard to kite for seven days in a row, week after week. For the early risers, there are multiple surf spots within the city limits that can yield clean waves when the early morning offshore desert wind is blowing. However, if you do not have the stamina of the waterman, there is a multitude of land-based activities such as golf, or wine tasting, or a hundred others.

The beaches of Perth have been well documented by numerous kiteboarding professionals, and many have spent a season or more frequenting Woodies or Safety Bay in order to train for upcoming competitions, or maybe just to film the next iconic kite video. Many international riders have spent time in this "home from home", and have paved the way for the aspiring kiteboarder looking to improve their craft. And with big kiteboarding names come avid photographers and videographers, looking to improve their own game, and to shoot that elusive magazine cover-photo. Barely a kiteboarding magazine gets published without showcasing the sunny white beaches and blue lagoons of one of Perth's breaks within its pages.

Perth's daily climate pattern is well suited to the lazier kiteboarder, who can afford to get out of bed just before lunch, and chill inside, under cover, until the land-cooling sea breeze begins to blow in the early afternoon. The two most popular freestyle spots, Woodies and Safety Bay, offer the exact combination of conditions that any freestyle junkie wishes for: ripple-free water, white sand, clear blue skies, an almost guaranteed breeze and even the occasional kicker … It is these elements that separate these spots from the rest. Those conditions – along with a friendly, welcoming vibe – where your kiting skills are really pushed and encouraged, are why people keep coming back for more. I've never kited anywhere else with such a community feel, and you can kite safely in the knowledge that your kite will never be lost in the offshore wind, or that your board will be left to drift while you are struggling to relaunch in the dying late-evening wind. Someone will always have your back.

Perth may not have the diversity of Sydney, or the culture of Melbourne, but it certainly has enough to keep even the most inquisitive of kiters constantly occupied both on and off the water. For me, the reason that I have been able to make Perth my home is because it offers the civilisation and bustling nature of a city, combined with the best conditions that a kiteboarder could ever wish for – all right on my doorstep.'

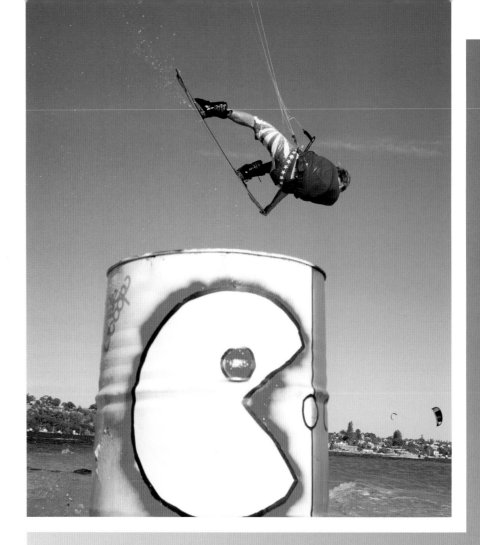

TOP: James Boulding, Point Walter.
Photo: Tom Court.
RIGHT: Simon Wichtermann, Woodies.
Photo: Paul Smythe.

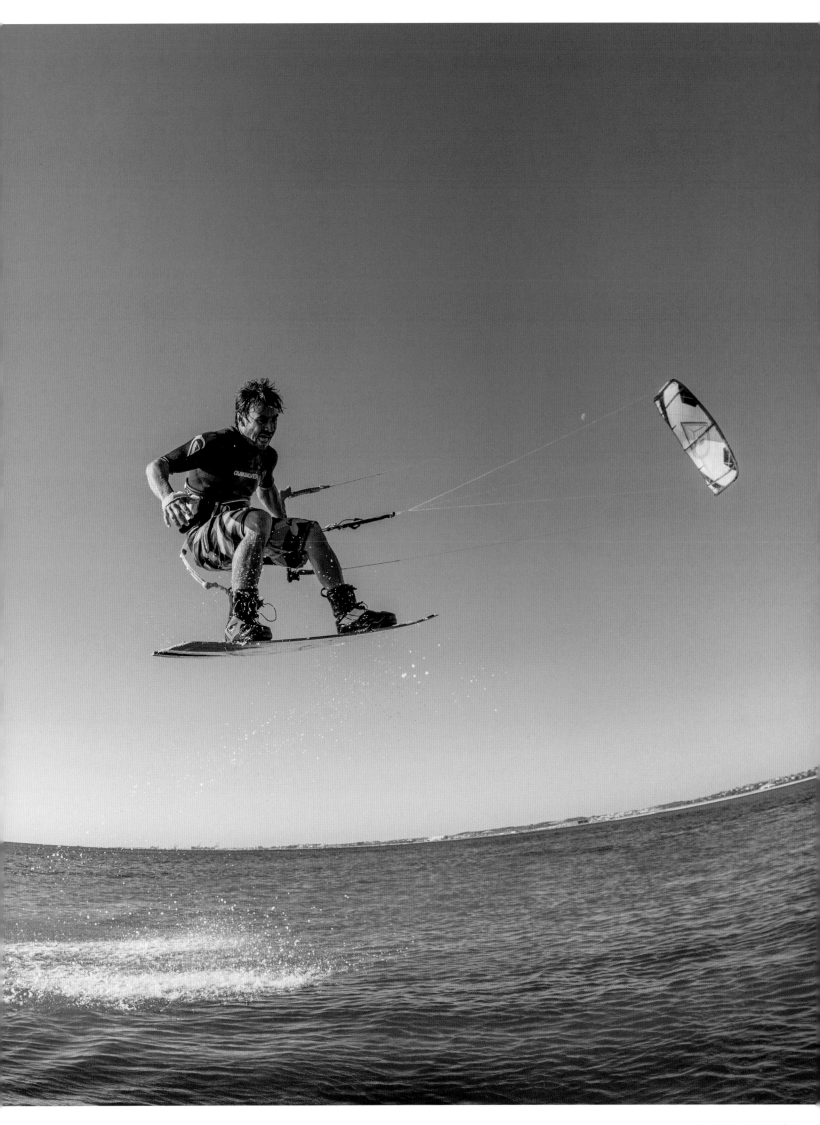

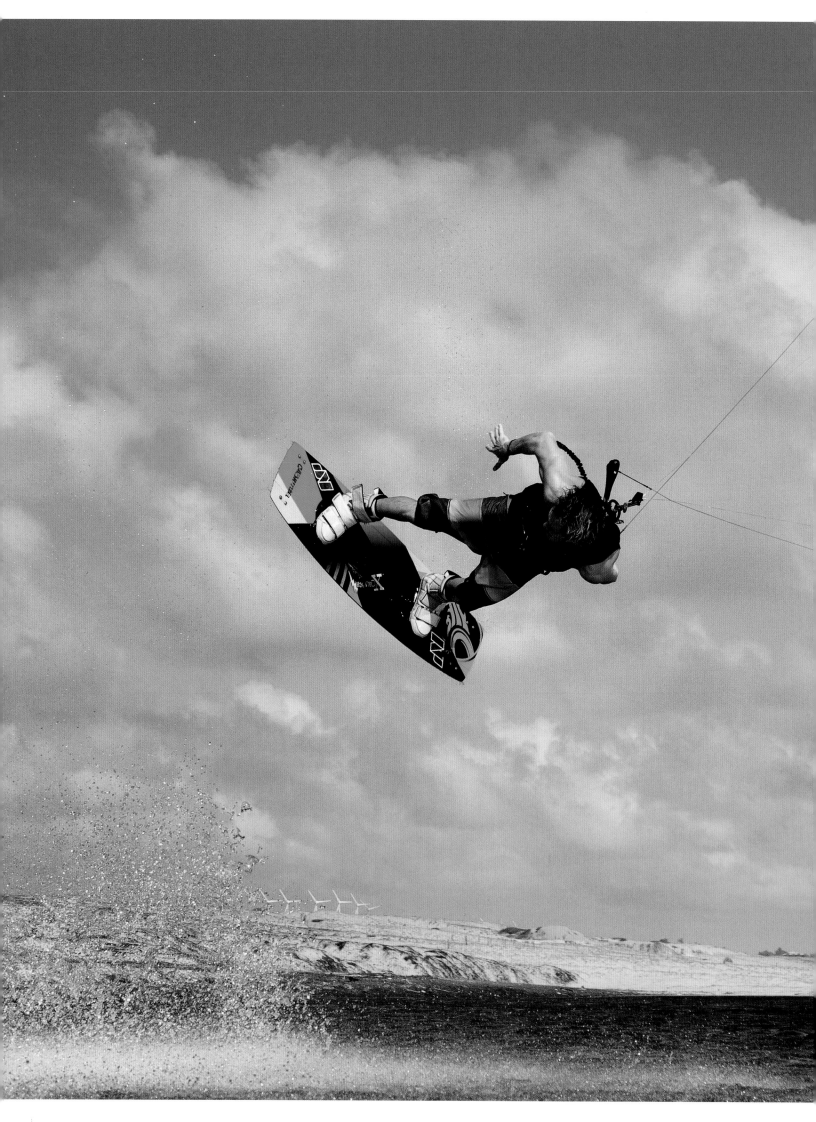

PLACE

NORTHEAST BRAZIL

Cruisey living, perfect kiting

ALBERTO RONDINA, CABRINHA RIDER

'I've been going to Brazil for over ten years. That's every single year for at least a month over the European winter. When I went there for my first trip back in 2003, I was one of the first kiters in Jericoacoara, Prea and Cumbuco. People were shocked when my friends and I launched our kites and jumped in the water. Right now they would probably be more surprised if there was nobody out.

In 2003, the fishing villages that line the coast were so tiny and local that it was hard to find a decent place to sleep, and you would normally expect some weird animal to keep you company in the night. The rent, the fuel, the food – everything was so cheap

and so good that you could live for a week on what you would spend in Europe in a day. These were probably the main reasons for such a fast-growing kiteboarding scene in Brazil. Well that, and the most steady and consistent wind I have ever seen, a windy

ABOVE AND RIGHT:
Photos: Nick de Bruijn.
LEFT: Alby. Uruau, Ceará.
Photo: Andre Magarao.

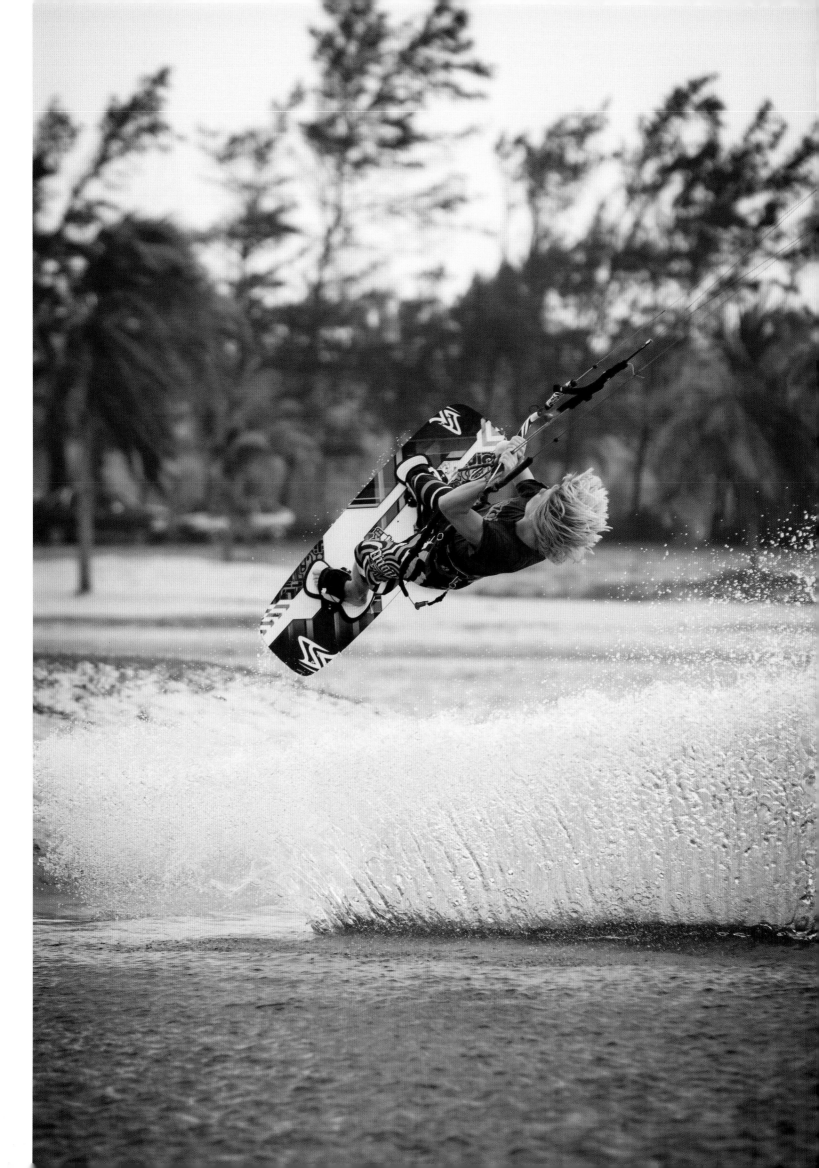

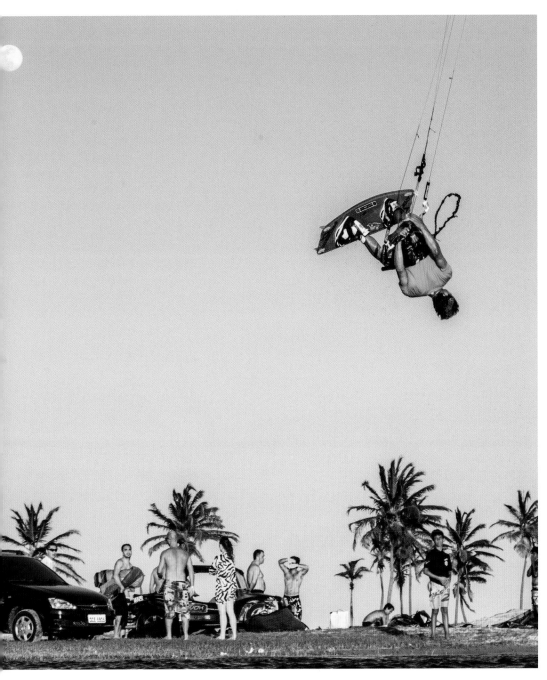

season that doesn't stop one day in nine months, endless flat-water spots and lagoons, miles of deserted beaches and hundreds of beach buggies to carry you around!

The wind usually comes in early in the morning, drops a little around lunchtime (to give you a little break) and then picks up again for sunset, for what we call the golden-hour session – without doubt the best time of the day to go out kiting. As far as I know, it's the longest windy season you can find, and any kite video from Brazil will have been shot in that window. That's another cool thing about a trip to Brazil – you are guaranteed to see and to hang out with some of the many pro riders that you've heard of. They spend time in Brazil because it is by far the best and easiest place to learn tricks and push their riding to the next level.

I used to love downwinders as a beginner, and I still do. Brazil is just the place for it as the trade winds are from the right so, starting off around Fortaleza where you land on the plane, you could theoretically kite all the way up the coast for hundreds of kilometres, past Jericoacoara and on up towards Venezuela. The number of spots along the way is just insane and, depending on the wind angle, sand bar or lagoon, every single place is different and unique.

Off the water, finding accommodation is easy – *pousadas* (bed and breakfasts) are everywhere, ranging from a really basic level to a luxury set-up. The breakfasts are pretty amazing – everything is always sustainable and uses only natural ingredients. In Brazil I think fruit has a totally different taste: everything is just so sweet and delicious. The pineapple, the *abacaxi*, is one of my favourites. I can eat them all day long! When it's dinner time, there's yet another massive variety of food, but this time it's seafood. The ocean is so abundant in fish that there are always some great options, from big fresh tunas to little shrimps and world-famous lobsters. You can try them all at any of the *baracas*, the typical restaurants that you find all along the coast.

The locals are probably some of the mellowest people you'll ever meet. They're used to having amazing weather all year long, good food and a really relaxed life ... They have no idea what stress means. And if a tourist comes for food or accommodation but it's after hours or is more work than it should be then they just don't do it: they stick to their lifestyle – I respect them for that!

I can't imagine a better place than Brazil for kiteboarding, and for freestyle kiteboarding it just has the perfect set-up. Coming from Europe, everything is more relaxed, the people are more chilled, the weather and the water are warm all year, the flat-water lagoons are the perfect place to learn how to kiteboard or throw down your hardest tricks, and the wind? Well, that never stops.'

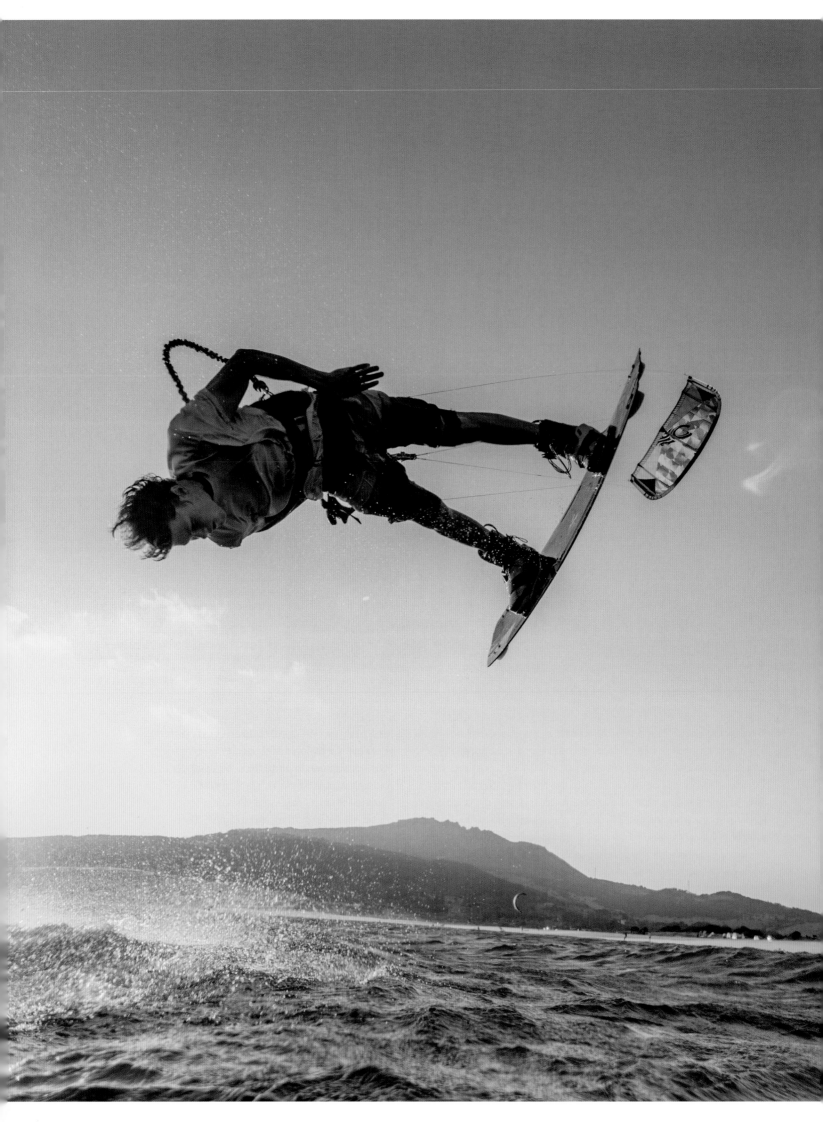

PLACE
TARIFA
Europe's kiteboarding heartland

JIM GAUNT, EDITOR OF *KITEWORLD INTERNATIONAL* MAGAZINE AND PRESENTER OF *THE KITE SHOW*

'Once you've skirted around the edge of Algeciras, the remaining 16 miles or so along the E-7 heading south to the small Andalucian town of Tarifa must be one of the most breathtaking approaches to a kiteboarding venue in the world. The undulating carriageway weaves you up, down and around the rugged green Spanish hills and on a clear day you can see Morocco roughly 20km across the Straits of Gibraltar off to your left and troops of energy turbines lining your route to the right; a sure sign that you've come to the right area for wind.

The crazy mid-season holiday period is during July and August and can see a thousand kiters marauding the Tarifan waters. However, if you're not looking to hook-up and party your ass off every single night then visit outside of this time as you can ride here just about all year. In fact, if you speak to many of the locals, they'll tell you that their favourite conditions can be found in October, November and even December. Tarifa is of course an excellent kitesurfing destination, but it's also gaining a reputation as the adventure capital of Europe with so many exciting sporting and recreational options to keep you fit and active, from mountain biking and climbing to SUPing, paragliding or golf.

Walk down the high street and you'd think that kiteboarding had been here forever, with several kite shops at the top end of town and then a further nine huge shop fronts as you drive through the new section of town towards the beaches. On top of that are streams of vans operating as unofficial mobile kiting schools.

The old town inside the city wall consists of an enchanting maze of cobbled alleyways and a mixture of tall, narrow and tightly packed whitewashed and stone-walled shops, restaurants, bars and homes. In the height of summer, numerous big wooden doors open up to reveal lively cocktail bars to fuel the young holidaymakers that come to the coast to join the kiters and to escape the intense heat inland in cities such as Madrid and Seville.

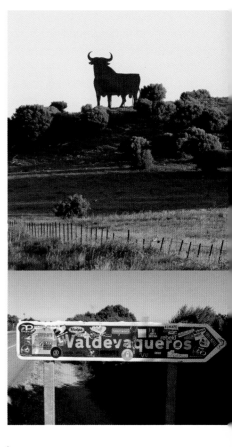

ABOVE TOP AND BOTTOM:
Photos: Jim Gaunt. **OPPOSITE PAGE:**
Liam Whaley in his backyard.
Photo: Ben Walsh.

When the windsurfers first started invading Tarifa in the late 80s and early 90s they found wide open beaches, regular winds, plenty of space to park their camper vans and a traditional but vibrant little Spanish community away from the developing centres for mass tourism to the north. Simon Harvey shapes Nomad custom carbon kiteboards, and moved to Tarifa in 1990. "It started with windsurfing. It was fantastic!" he remembers. "It was the place to be. It was cheaper to come here than America and Hawaii for the Europeans and Brazil didn't even exist as a destination in those days. Some of the world's top windsurfers were training here and that's what made Tarifa fashionable – you could go to the beach and windsurf with the top-level guys."

There are two wind systems in Tarifa: the Levante and Poniente. The Poniente is a steady wind from the west that blows cross-onshore from the right for several days and can be very consistent. Ask most local pro kitesurfers about their favourite wind and they'll say Poniente, but for the pro windsurfers with their small sails it often isn't as strong as they'd like. Their preference is the Levante, the hotter, drier wind coming over the land, cross-offshore from the east, and very strong.

On the classic days the place comes alive and the town is abuzz in the evening with euphoric riders. Look for a Poniente wind with a swell and you'll be in Tarifan heaven. If it's a howling 40-knot Levante, head north for an hour to Caños de Meca for an insane down-the-line wave session. The main conditions found off the golden sands of Tarifa offer a variety of bump and jump or flat water, depending on the tide. The coastline is clean, the water's clear, and there is an array of opportunities.

Many young Tarifans have inherited passionate watersports genes from either one or both of their parents, who came here themselves in pursuit of windsport enjoyment. The grom situation is pretty hard to beat, and continues to produce new generations of kitesurfing stars, with Gisela Pulido being the most successful, with multiple world titles. She is held in high regard by the community, and has her own school in the town. Like many more pro riders, Spaniard Alex Pastor also spends a large part of his year in Tarifa.

However, as many kitesurfers as there are that descend on the area each year, you can still come here on holiday and experience the Tarifa that they all enjoyed "back in the day". Jaime Herraiz explains: "The spots have perhaps become a little busier, but Tarifa has largely remained the same for the last 20 years because the area is surrounded by natural parks, and the real locals are simply content with their local lifestyle and resist changing for tourism. Tarifans will always be Tarifans.'"

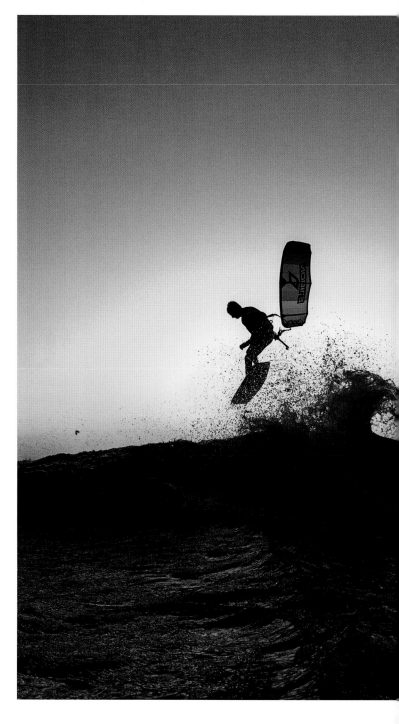

TOP LEFT: Nobile's Rafael Vilches. *Photo: Ludovic Franco.*
FAR RIGHT: Mallory de la Villemarque, Rio Jara. *Photo: Ludovic Franco.*
LEFT AND CENTRE: *Photos: Jim Gaunt.*

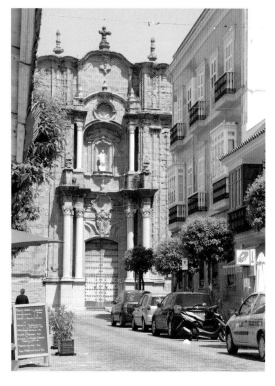

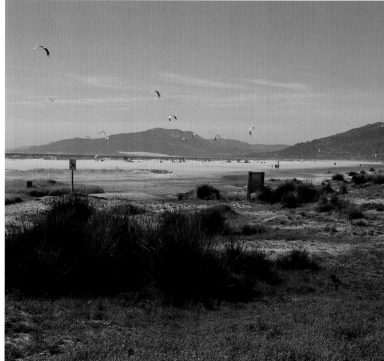

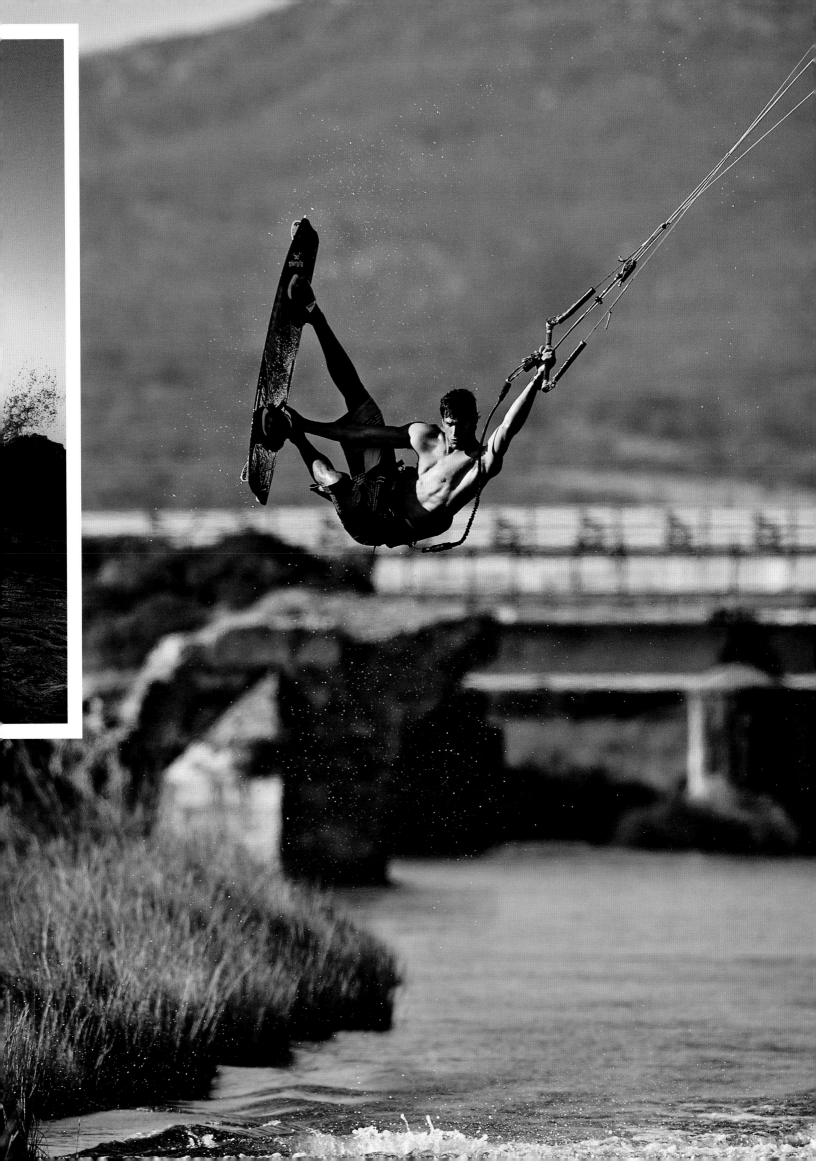

AARON HADLOW

If there is one rider who needs no introduction, then it is five-time World Champion Aaron Hadlow. There is nobody else who has dominated freestyle kiteboarding so comprehensively, or whose progressive approach has dictated the direction of the sport for so long. Originally from west Cornwall in the UK, Aaron started flying kites aged ten, when he would grab his dad's kite after his session. He first got to grips with the board during a two-week holiday to Cabarete and the touch paper was lit. His enduring relationship with Flexifoil began during his first season in Cape Town in 2001 and Jason Furness – who went on to be Aaron's long-time manager – got him on the team. Red Bull have also been at the heart of Aaron's career and helped Aaron to develop his profile and pursue projects that match his ethos.

PKRA domination was the story between 2004 and 2009 where, despite some riveting rivalries along the way, Aaron dominated the tour. Since then Aaron has been at the cutting edge of the wakestyle scene, where the effortless style and 100 per cent commitment he brought to the world of freestyle is proving just as instrumental.

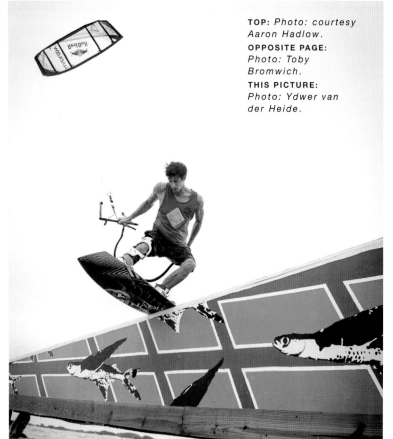

TOP: *Photo: courtesy Aaron Hadlow.*
OPPOSITE PAGE: *Photo: Toby Bromwich.*
THIS PICTURE: *Photo: Ydwer van der Heide.*

ALL ABOUT ME...

- **Trophy cabinet:**
 5 x PKRA World Champion 2004–2009
 Slick Triple-S 2009 – 1st
 Slick Triple-S 2010 – 1st
 Ro-Sham Throw Down 2010 – 1st
 Slick Triple-S 2011 – 1st
 Ro Sham Throw Down 2011 – 2nd
 Slick Triple-S 2013 – 1st
 Rail Masters Russia 2013 – 1st
- **Best spot:** Cabarete, DR. This place has one of my favourite kicker spots: With wind from the right, I can spend the whole day hitting a kicker on every run. Also down the road is a perfect flat-water spot for all the Raley based tricks
- **First set-up:** Wipika Classic 4m and custom 6' directional
- **Proudest kiting moment:** Obviously making my goal of World Champ for the first time was unbelievable, and every year after that was incredible. They have to be some of my best moments – all the work had finally paid off and all the effort to make it happen was worth it. Returning from injury in 2013 and making it to the final of the PKRA in France and beating the current World Champ on the way through was probably as good a feeling. I was so happy to make a strong return after such a long time off the scene and out with injury.

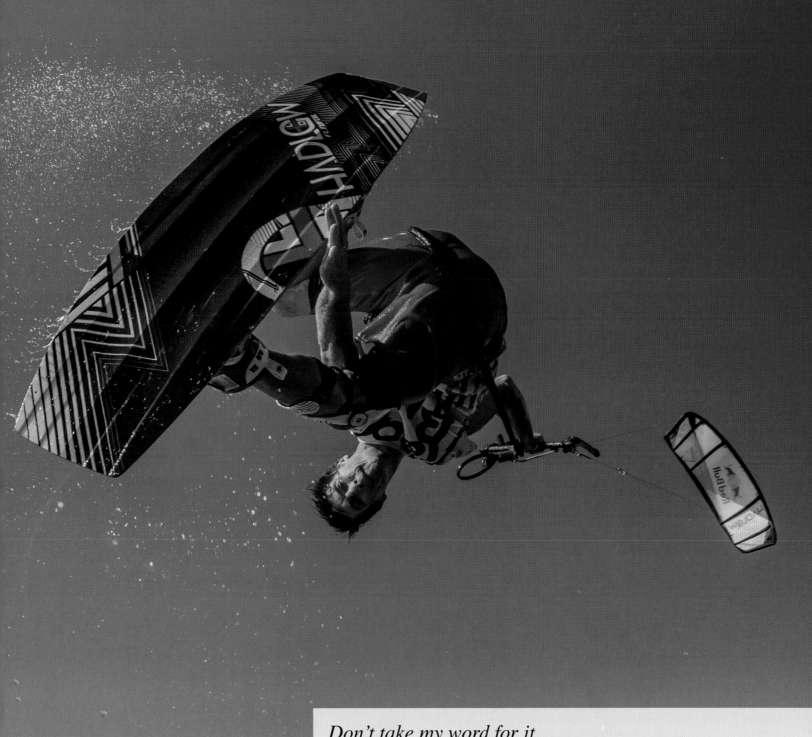

Don't take my word for it…
ALEX FOX

I first met Aaron in France for a rail contest. I remember being super-intimidated. I didn't know much about him other than the fact that he was the undisputed king of the kiteboarding world and he had five world titles under his belt. I was pleasantly surprised by how great a person he was – super-friendly and humble. I think that kind of humility says a lot about a person, but what is equally as impressive is his work ethic. It only felt like a few weeks between news of his blown ACL ringing around the kiteboarding world and him being back on form, and scoring a podium on his first event back on the tour. That deserves a lot of respect.

Aside from being a good friend and a great person to party with, Aaron's also done so much for our sport. He is one of those guys that will always be at the forefront, he does new tricks and then we all pretty much copy him and bastardise whatever he has done. People can compare him to all the current World Champions, or all of the 'style' guys, but what he has done will ensure his status as the best ever.

GISELA PULIDO

Gisela has more freestyle world titles than anybody else on the planet. Even more – through competing in both the PKRA and KPWT tours – than Mr Aaron Hadlow. Not bad going. She began kiting aged eight and showed serious potential from the outset so, to give her the best possible opportunity, her father moved the family to Tarifa so that she could develop her skills at the European hub of the freestyle scene. It was a gamble that paid off and in 2004 – aged just ten – Gisela won her first KPWT world title. Three years later she was old enough to begin competing on the PKRA, which she won for four of the next five years. It is fair to say that Gisela has dominated the competitive side of women's kiteboarding. Her achievements have gained her more than kiting titles too: she holds a Guinness World Record for the Youngest World Champion in any sport, and has secured various other sporting accolades in Spain, where she is something of a national hero.

Despite having grown up in the glare of the kiteboarding and wider media, Gisela has a reputation as being very well grounded and now, when not on the tour circuit, spends much of her time managing the pro centre in Tarifa bearing her name.

ALL ABOUT ME...

- **Trophy cabinet:**
 KPWT World Champion 2004, 2005, 2006, 2009
 PKRA World Champion 2008, 2009, 2010, 2011, 2013

- **In the bag:** 6, 7, 8, 9, 11, 13m BEST GP; 135x41 Armada

- **Best spot:** Brazil for sure. I love the lagoons and flat water and Brazil is also a warm place with steady winds. I love training there with a few other riders, which makes it more fun

- **First set-up:** Wipika 4m and Palmer custom board

- **Proudest kiting moment:** The happiest moment was when I landed the Front Blind Mobe for the first time. It's a very technical trick that no other female rider can do, so for me it was my greatest moment without doubt!

TOP: *Photo: courtesy Gisela Pulido.*
OPPOSITE PAGE: *Photo: Quincy Dein.*
RIGHT: *Photo: Toby Bromwich.*

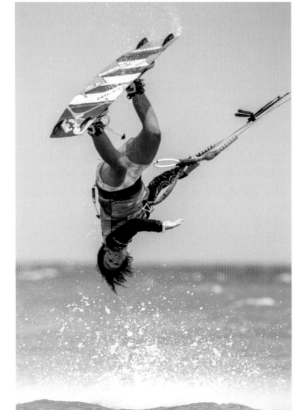

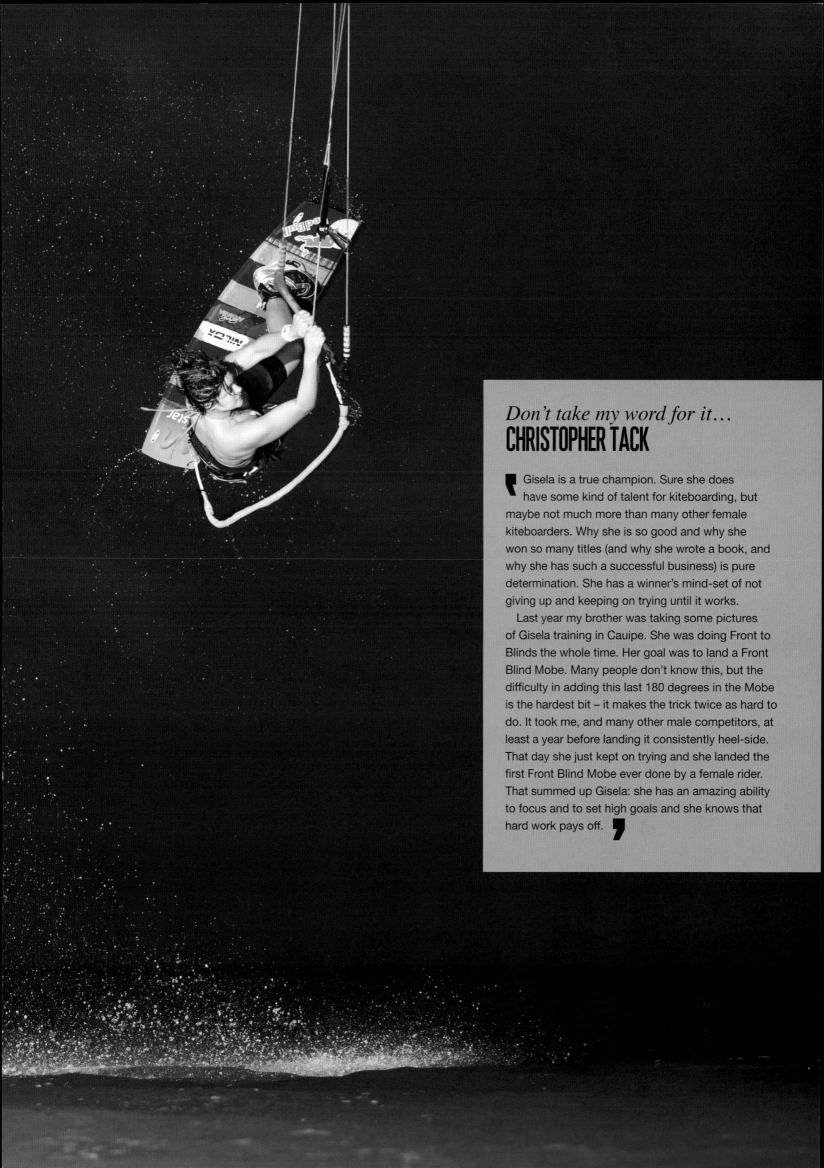

Don't take my word for it…
CHRISTOPHER TACK

❝ Gisela is a true champion. Sure she does have some kind of talent for kiteboarding, but maybe not much more than many other female kiteboarders. Why she is so good and why she won so many titles (and why she wrote a book, and why she has such a successful business) is pure determination. She has a winner's mind-set of not giving up and keeping on trying until it works.

Last year my brother was taking some pictures of Gisela training in Cauipe. She was doing Front to Blinds the whole time. Her goal was to land a Front Blind Mobe. Many people don't know this, but the difficulty in adding this last 180 degrees in the Mobe is the hardest bit – it makes the trick twice as hard to do. It took me, and many other male competitors, at least a year before landing it consistently heel-side. That day she just kept on trying and she landed the first Front Blind Mobe ever done by a female rider. That summed up Gisela: she has an amazing ability to focus and to set high goals and she knows that hard work pays off. ❞

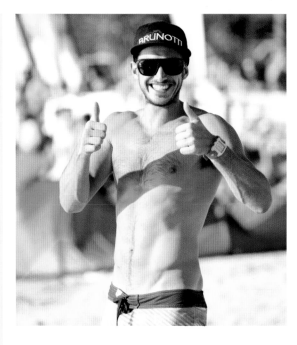

Youri has developed a well-earned reputation as one of the fittest and toughest riders ever to compete in the PKRA. He began kiting when he was 13 and entered his first event, the European Championships, in 2004. It was clear that a promising career awaited Youri, but in 2007 he pushed too hard and suffered a career-threatening knee injury, which took him out of the picture for two years. His return in 2009 saw him back on even more threatening form and scoring second place, which he followed with a third place in 2010. When the 2011 season began it was as if a new super-Youri emerged, and he dominated the year and sealed the title with an event to spare, looking more supreme and dominant than anyone had since the time of Aaron Hadlow's reign. Youri then went on to retain the title (after the closest final in the history of the PKRA) in 2012.

Out of season and Cape Town and Brazil tick all the right 'training' boxes for Youri, and off the water he always seems to have a smile on his face and to be goofing around. But when the horn goes it's game-face on and you'd better be ready: Youri is a truly fierce competitor.

ALL ABOUT ME…

- **Trophy cabinet:**
 PKRA 2009 – 2nd
 PKRA 2010 – 3rd
 PKRA 2011 – 1st
 PKRA 2012 – 1st
- **In the bag:** 13, 11, 9m BEST GP; Brunotti YZ Pro 138x41
- **Best spot:** Uruau, Brazil. The wind is dead steady every single day, it's not too crowded and for me it is an ultimate playground. Best of all the food from chef is amazing. Nothing beats a nice plate of Italian pasta after your session and a well-prepped steak at night!
- **First set-up:** Wipika Hydro 7.5, Wipika Apocalypse.
- **Proudest kiting moment:** The moment when I won my first world title in Germany. It was a dream that I had always been training and fighting for, and at that moment it was not only the title, but I had also won six events in a row – something that had never been done before.

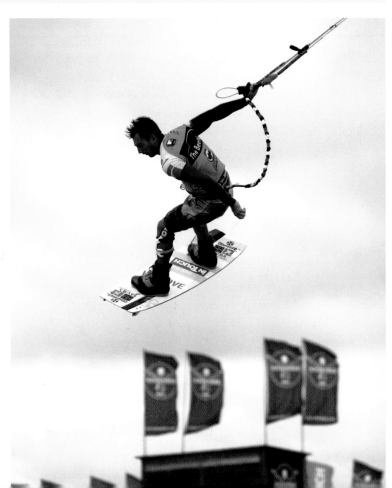

LEFT AND TOP: *Photos: Toby Bromwich.*
OPPOSITE PAGE: *Photo: Quincy Dein.*

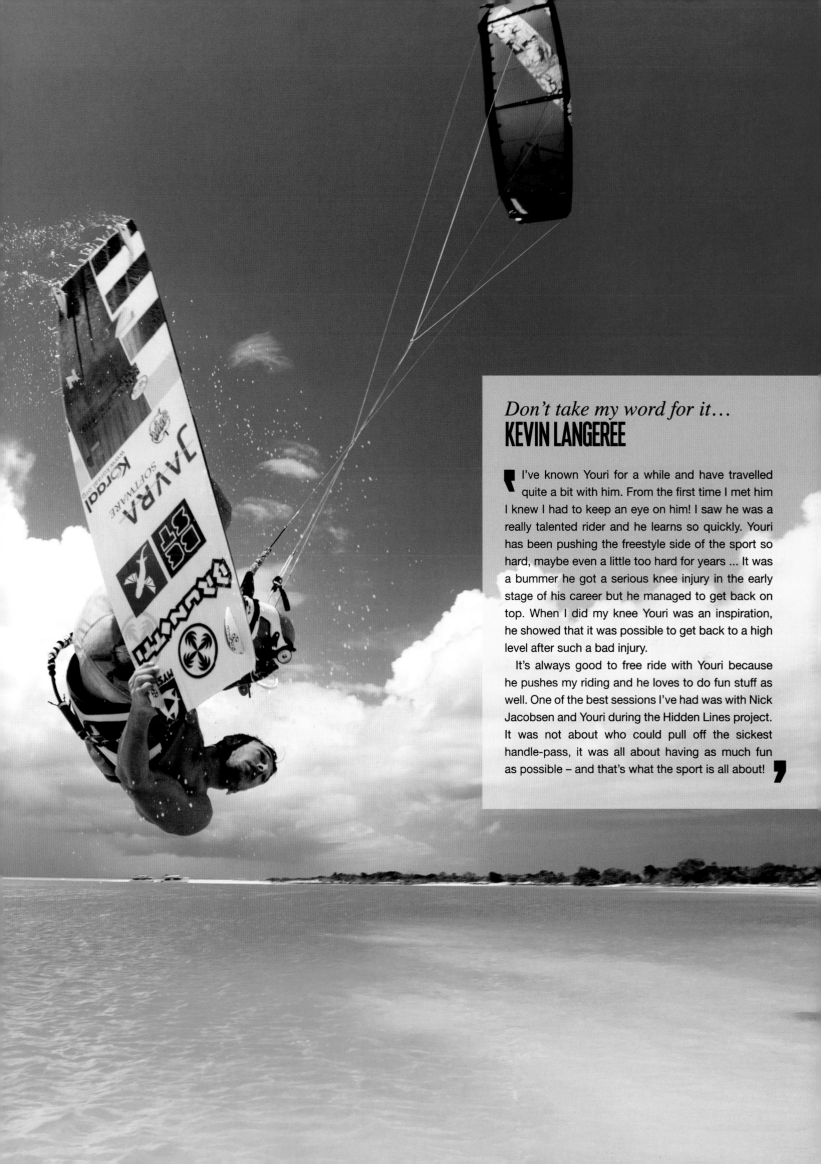

Don't take my word for it…
KEVIN LANGEREE

❝ I've known Youri for a while and have travelled quite a bit with him. From the first time I met him I knew I had to keep an eye on him! I saw he was a really talented rider and he learns so quickly. Youri has been pushing the freestyle side of the sport so hard, maybe even a little too hard for years … It was a bummer he got a serious knee injury in the early stage of his career but he managed to get back on top. When I did my knee Youri was an inspiration, he showed that it was possible to get back to a high level after such a bad injury.

It's always good to free ride with Youri because he pushes my riding and he loves to do fun stuff as well. One of the best sessions I've had was with Nick Jacobsen and Youri during the Hidden Lines project. It was not about who could pull off the sickest handle-pass, it was all about having as much fun as possible – and that's what the sport is all about! ❞

JESSE RICHMAN

To be a legend is one thing, to be a legend on an island of legends is quite another. Maui's Jesse Richman is the full package. He has the hardcore waveriding skills that seem to come as standard when you grow up on Maui, throws down freestyle with as much power and commitment as anyone else on the planet, and his competition riding skills saw him on the top of the podium at the resurrection of the Red Bull King of the Air. Add in the insane level of self-belief and commitment that you need to be towed up 790 feet behind a speedboat and then kite back down again, and you need no further proof that Jesse Richman is one of kiteboarding's finest all-round watermen.

Jesse has been with Naish since 2003 and, alongside brother Shawn, is an indispensable asset to the brand, as well as to the image of kiteboarding and to the reputation of Maui as the crucible for kiteboarding development. Aside from the exceptional kiting skill-set, Jesse's enthusiasm for the sport and evident love of life are sure to be right at the core of the kiteboarding scene for many moons to come.

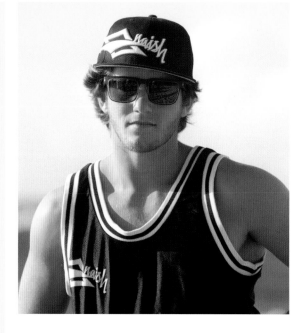

ALL ABOUT ME...

- **Trophy cabinet:**
 Red Bull King of the Air 2013 – 1st
 KPWT 2008 – Overall World Champion
 KPWT 2009 – Overall World Champion
- **In the bag:** 10m and 8m Torch, Park 7m; Naish Dub 134 and boots, Naish 5'8 Global
- **Best spot:** Woodman Point, Perth, is really fun. Probably the best freestyle kite spot in the world.
- **First set-up:** Naish 2.5m Saber with a custom 140cm board with boots. Plus a seat harness, helmet and a lifejacket. I looked like a boss.
- **Proudest kiting moment:** The Red Bull King of the Air has always been the standout kiteboarding event to me. It's unlike any other out there. To win it was awesome.

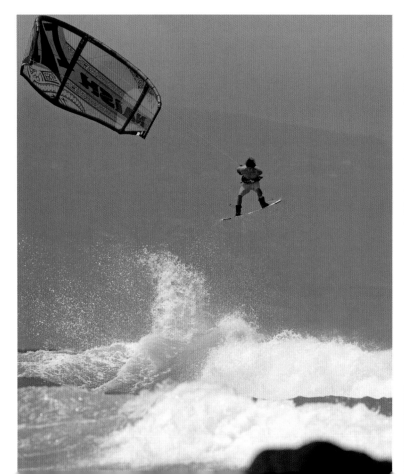

All photos: Stephen Whitesell.

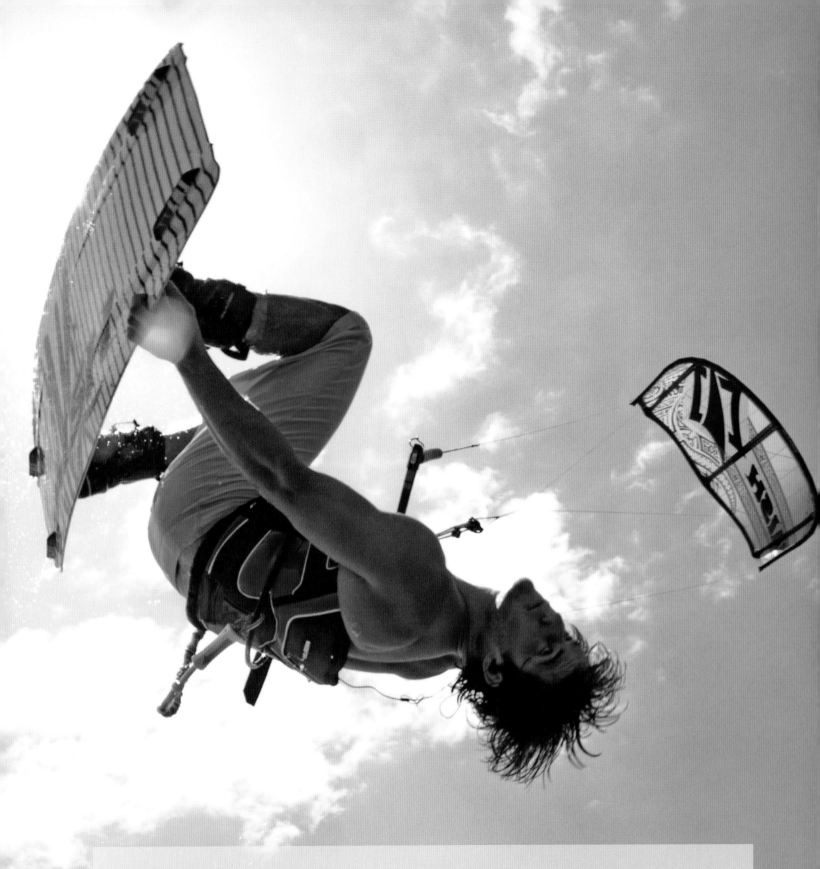

Don't take my word for it…
RUBEN LENTEN

Jesse Richman, what a dude. The first time I met Jesse was at the Red Bull King of the Air 2005 right in his backyard. He was 12 and I was 17. I was amazed then to see how energetic and motivated this kid was. Now, several years later, we've been travelling, riding and doing business together a lot and it has always been a blast. Whether it's brainstorming new ideas, working out a new trick, hunting down the ladies, figuring out the business side, or just a buddy to talk to, thanks to Jesse's outgoing and very positive personality, he's the man for the job. On the water he's an all-round powerhouse, no matter whether you serve him some double overhead waves, tow him up to some ridiculous height or ask him to bust out a non-existing trick, he nails it all like a boss and with a smile on his face! To me Jesse is the buddy I want to team up with, as he is inspiring people, bringing the sport to new heights and growing as a person each time I see him. I can't wait to see what the near future has offer – the world had better be ready. And "safety third"!

SESSION
KING OF THE AIR 2013
RUBEN LENTEN

'The return of the Red Bull King of the Air came in 2013 and I was stoked to play my part in one of the greatest sessions that kiteboarding has ever seen.

The King of the Air has plenty of history and was an iconic event when the sport of kiteboarding was just taking off, running from 1999 to 2005 on Maui. At the time it was the most extreme kiteboarding event, and it had the world's best riders competing in a big air competition focussed on the most spectacular jumps. For those years the contest drove the sport to new heights, but by 2005 our sport had developed in many different directions and we saw more and more riders focussing on technical jumps like they do on the PKRA World Tour, more and more riders starting wave riding, and the wakestyle and racing disciplines also really starting to take off. So with a sport having to settle in so

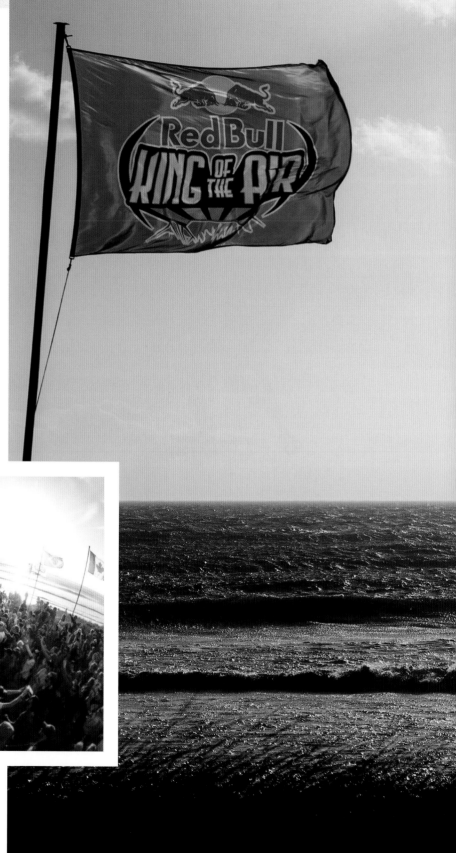

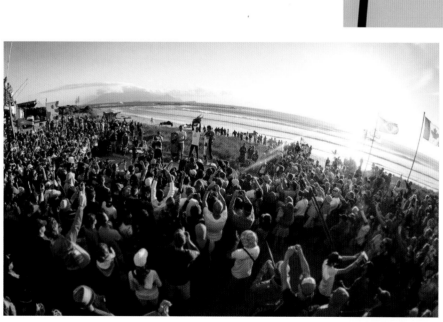

TOP: Susi Mai and Jim Gaunt assessing the action. *Photo: Kolesky/ RedBullContentPool.*
ABOVE: One of the biggest ever crowds at a kiteboarding event. *Photo: Ydwer van der Heide.*

RIGHT: Jesse Richman as the event moved towards the final stages. *Photo: Kolesky/ RedBullContentPool.*

many directions Red Bull decided to hold back and see what would be next for kiteboarding.

As extreme kiteboarding had been my game for many years I really missed a contest like the Red Bull King of the Air, so in 2012 Red Bull and I decided to see where extreme kiteboarding was at by throwing two events: the Red Bull Boven N.A.P. in the Netherlands, and the LEN10 Megaloop Challenge in South Africa. Those two events were very successful with big action from some very talented riders. This convinced us that the Red Bull King of the Air needed to return.

I was stoked to have the contest back, and in the seven years since it had last run we all knew that the sport had developed a lot. Compared to 2005 the equipment makes riders feel so comfortable and safe, allowing them to really focus on expressing themselves the way they like. Riders really enjoy riding in this type of contest as it displays the "wow" factor of our sport perfectly. Plus we were stoked to get to run it in South Africa. Big Bay is a pretty sick location for an event, the riders were really pushing it for some new massive tricks, and the beach was packed with spectators for the whole event – everyone was amazed by all the flying humans! Plus a lot of the media were really stoked by all the action and the event got great coverage. A big plus was having Robby Naish heading

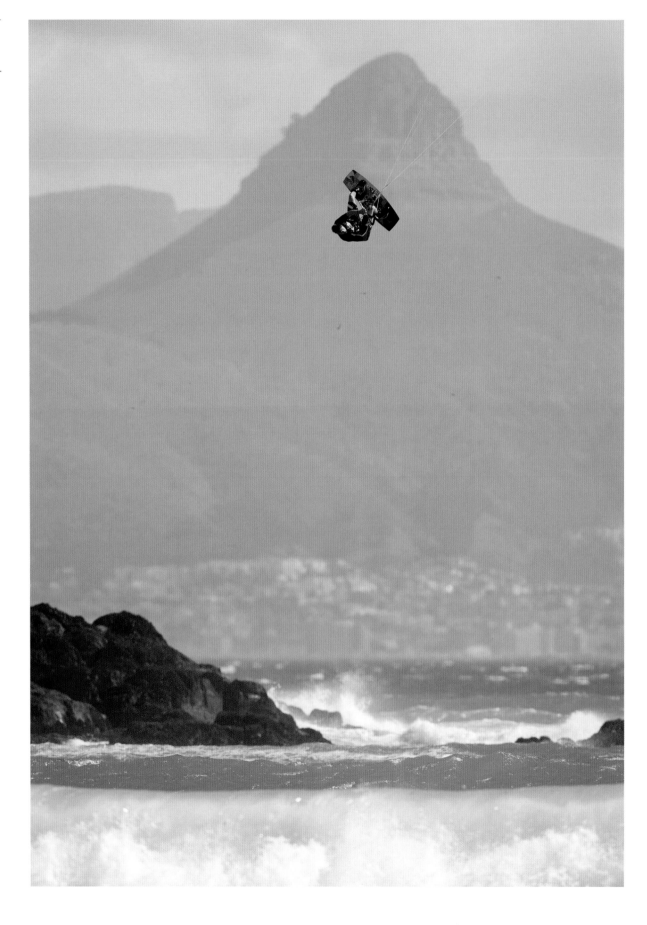

RIGHT: Ruben lining up the scenery. *Photo: Kolesky/ RedBullContentPool.*

over for the event, as he's such a legend and a great ambassador for our sport. It was a pleasure to have him around, especially as he was the initiator of the first King of the Airs.

When we were planning the event we decided to have a two week wind window to make sure we could secure a solid day of wind, and we decided that it could only run with wind speeds above 30 knots. It was a great group of riders who came together and Red Bull had taken care of all the accommodation and food for the riders. As we kept a close eye on the forecast, it seemed like the classic Cape Doctor was going to blow on Sunday, the third day of the waiting period, so on the Friday everyone got the green light and, as forecast, on the Sunday the wind and waves were on fire and the beach was absolutely packed.

We decided to introduce a new format to the King of the Airs of old – we wanted something that really pushes the rider to the limit and would also be easy to follow for the spectators. We came up with the flag-out format, so each rider wears a coloured vest that corresponded with a flag. Four riders go out on the water, and after ten minutes the rider with the lowest score gets flagged out. The heat goes on, but scores for the remaining riders go back to zero, and after another ten minutes the next rider gets flagged out and the two riders left advance.

Having the top riders in the world attending this event we knew that we were guaranteed to see some exceptional big air action. Everyone had their gear well prepared as the wind was getting stronger throughout the day. In the first rounds the wind was okay for riders to go big on their 9s, and we saw some stunning moves from Lewis Crathern from the UK, Youri Zoon from Holland, Nick Jacobsen from Denmark and some experienced local riders were in their comfort zone too. As the day progressed the wind and waves picked up by the hour, heart rates picked up a beat or two, and riders really began to up their game … Kevin Langeree and Jesse Richman in particular were pleasing the crowd with some insanely high jumps and technical rotations, and riders were pushing the limits of their body, gear and minds to make it through to the next round. They were taking risk after risk to make sure they wouldn't get flagged out, and this caused some of the most intense wipe-outs that kiteboarding had ever seen.

The display of extreme big air tricks kept the audience entertained for the whole afternoon, with the prize giving taking place as the sun went down. Jesse Richman was crowned King of the Air 2013 and the Red Bull King of the Air was very much back on the kiteboarding calendar.'

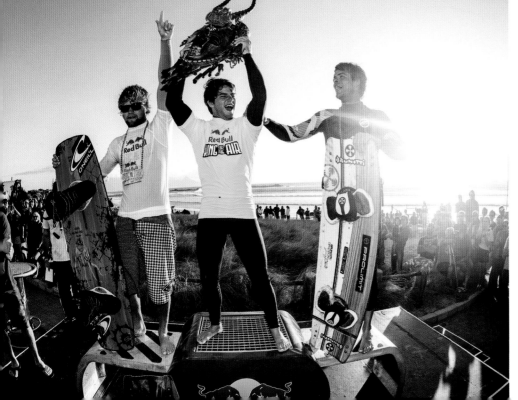

TOP: Kevin Langeree board-off. *Photo: Ydwer van der Heide/RedBullContentpool.*
BOTTOM: The results: 1st Jesse Richman, 2nd Nick Jacobsen, 3rd Sam Light. *Photo: Kolesky/RedBullContentPool.*

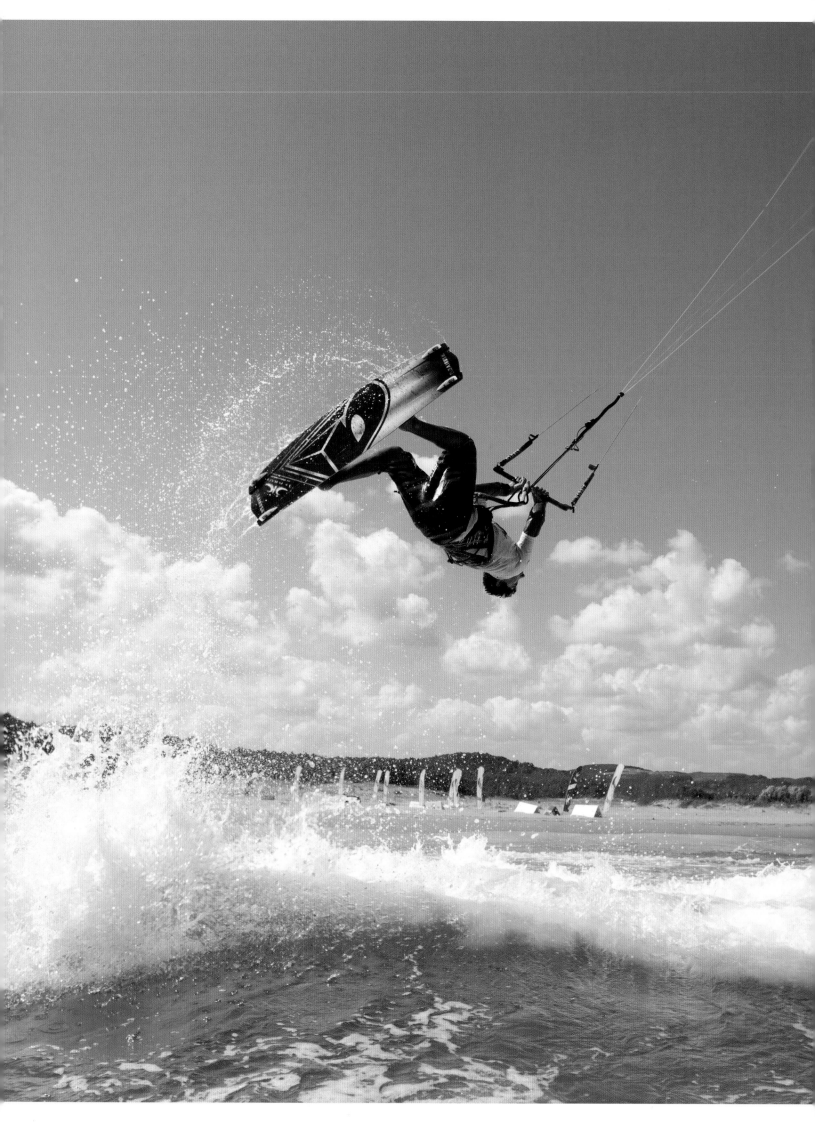

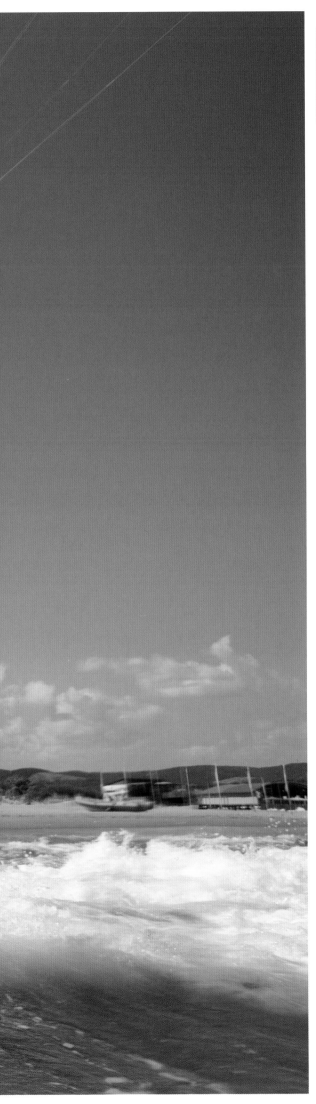

CONTEST
FREESTYLE TOUR

'**The Professional Kiteboard Rider Association (PKRA) was set up in 2001. Its goal was to find the best freestyle kiteboarders in the world using a judging system devised and controlled by the riders.** The PKRA's slogan is 'For the riders, by the riders', and the rules on the PKRA are decided and voted on by the best kiteboarders in the world. They are not made by a committee or a brand looking to sell a product and the only purpose of the PKRA is to give the riders the best possible platform on which to showcase their skills and to determine who is the World Champion. Since 2001 there have been well over 100 competitions and there has been over $3,000,000 in prize money. The PKRA is where kiteboarding champions are made.

When kiteboarding began taking off in the late 90s, several one-off contests were held but, before long, if was clear that a multi-stop tour was needed – as you would find in other comparable sports – to determine who were the best kiteboarders in the world. The PKRA emerged to meet that need. From day one, the PKRA's rules were determined by the riders so that they could compete on their own terms, and this format ensured

LEFT: Anthar Racca, Turkey.
Photo: Toby Bromwich.
BELOW: Aaron Hadlow midway through his reign, 2007. *Photo: courtesy PKRA.*

that the best riders are scored on criteria relevant to the sport at any given time. The winner of a PKRA event is not the rider that necessarily jumps the highest or the rider that does not crash – the best PRKA riders are the ones that are developing the sport and pushing the limits. The rules are set up to encourage innovation and to reward the most radical moves and the best kiteboarders at any given time.

In the first year of the PKRA, 2001, the goal was to jump as high as possible and to do as many rotations and grabs as you could. At this point the tour manager, Mauricio Toscano, was both a competitor and an organiser. Things developed the following year, with board-offs becoming the latest moves to be pulled off, and Mark Shinn and Cindy Mosey were crowned World Champions. These first two years were spectacular, with riders going incredibly high, and everyone watching could understand who was going the highest and doing the most variation with his board. But it became clear that this side of the sport had its limits.

In 2003, things changed – riders started doing handle-passes in competition. Handle-passes had been around since the early days of kiting – with riders such as Lou Wainman, Bertrand Fleury, Shannon Best and many more making technical passes – but had not found a way to be introduced into competition. That year, Martin Vari, Jeff Tobias, Will James and Jaime Herraiz had been training together and attaching the leash directly to the chicken loop, so were able to do handle-passes without losing the bar. This revolutionised kiteboarding competition – where if you lost your kite it was game over – and set the basis for today's modern freestyle. This also made kiteboarding much more physically demanding, and brought in new blood. Events in Cabarete with Jose Luis, Martin Vari and Andre Phillip took things to the next level.

In 2004, Aaron Hadlow emerged as the main force on tour and changed the sport of kiteboarding forever. He was 15 when he first began competing on tour, and had already kited for five years. He could do all the board-off tricks, all the freestyle tricks, and had developed his own style and his own moves. The sport moved in a more powered direction and Aaron was at the forefront of this. Riders no longer wanted to go high in their tricks, they wanted to add power and style. The wakeboard influence was clear, with Mobes, KGBs, Blind Judges, 313s and many more tricks becoming favourites. This evolution kept developing every year, with more power, more stylish grabs and new moves.

The main players between 2005 and 2010 were Aaron Hadlow, Kevin Langeree and Youri Zoon. Youri Zoon eventually took time out for knee surgery, and Langeree secured the title in 2009 after finishing as runner-up for many years. Aaron then took a break from competition and the title race was wide open, with Andy Yates winning the title in 2010. Youri then returned, hungrier than ever, and reset the standard

BELOW: It's not all work... *Photo: Toby Bromwich.*

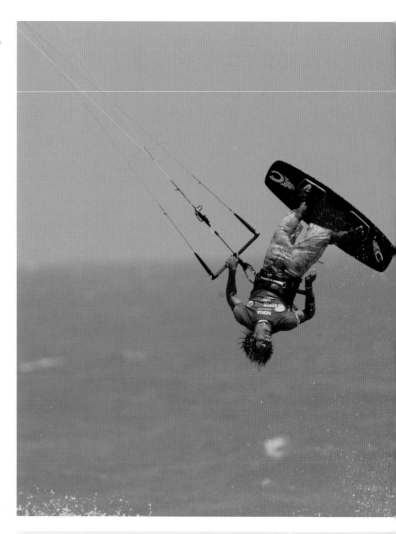

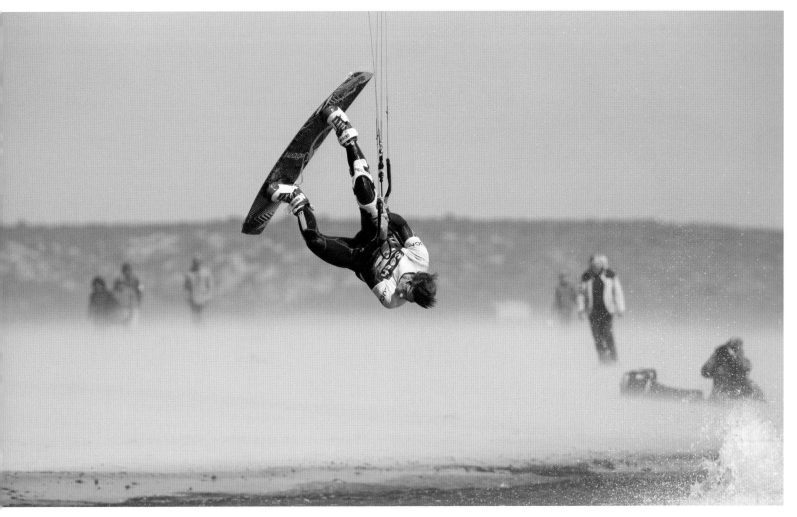

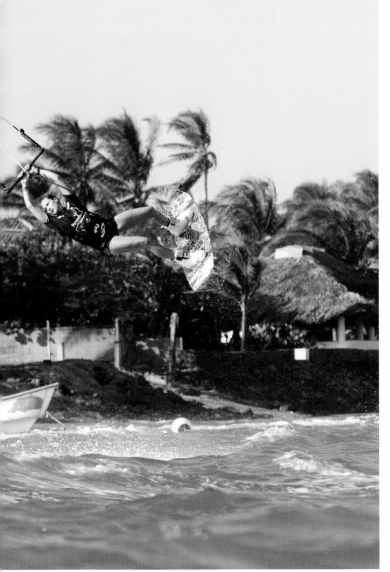

TOP LEFT: Martin Vari on his way to the title in 2003. *Photo: courtesy PKRA.*
LEFT: Karolina Winkowska. Nitro City, Panama. *Photo: Toby Bromwich.*

ABOVE: Aaron Hadlow returns to the tour, 2013. *Photo: Toby Bromwich.*

for power in kiteboarding with his fully committed approach. And this is essentially where freestyle kiteboarding is today. Riders are going for big technical moves where the kite position and execution of the tricks are the key factors.

The PKRA World Tour is well travelled, and has between six and ten events each year at locations all around the globe. At the core of the event are the stops of Fuerteventura, Germany, Morocco and France, which occur every year. These have well-established infrastructures and are highly anticipated by all of the riders. Other stops have come and gone over the years and the PKRA are always seeking out new locations to provide new challenges for the riders. Stops in New Caledonia, Venezuela, Argentina, China and Australia have all proven very popular. The only guarantee on the PKRA is that there will be a variety of locations and conditions, and that the champion at the end of the year will have had all of their kiteboarding skills challenged.

The range of conditions means that riders may use kites of all sizes between 5 and 15 metres over the course of the year. When the tour hits the lagoons of Brazil or the flat-water spots of New Caledonia the level goes through the roof because the freestyle conditions are just perfect, whereas in the gusty Tramontane wind of Leucate, when it is only 8°C, just landing a Blind Judge 5 in 30 knots can win a heat.

2012 saw the biggest shake-up of the judging criteria in the event's history. The "overall impression" format that had been in place for ten years was abandoned, and scoring moved to a "points" system whereby every trick is scored between 0 and 10. For men, the maximum number of tricks is 12, of which seven count, and for women the best five of a maximum

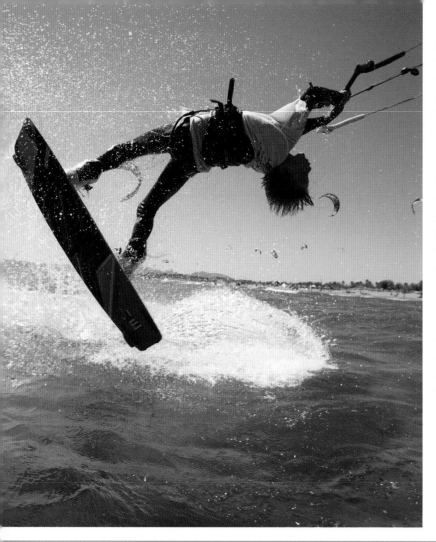

nine tricks are scored. This changed the focus more on to the quality of the tricks, as well as providing a more 'viewer friendly' framework so that 'live updates' are possible for the riders, the spectators on the beach, and for those following the live stream.

Kiteboarding is an extremely diverse sport and the PKRA has provided the perfect platform for competitors to develop their skills and to chase the prestigious world title. During its short history, the PKRA has seen all the best kiters in the world perform at some point, and has provided hundreds of riders with the opportunity to prove themselves against the best in the world and to become World Champion. The PKRA tour is certain to be at the apex of the world of competitive freestyle for many years to come.'

Antoine Jaubert

LEFT: The future: Tom Bridge. *Photo: Toby Bromwich*.
BELOW: Mario Rodwald, Mondial Du Vent, France. *Photo: Toby Bromwich*.

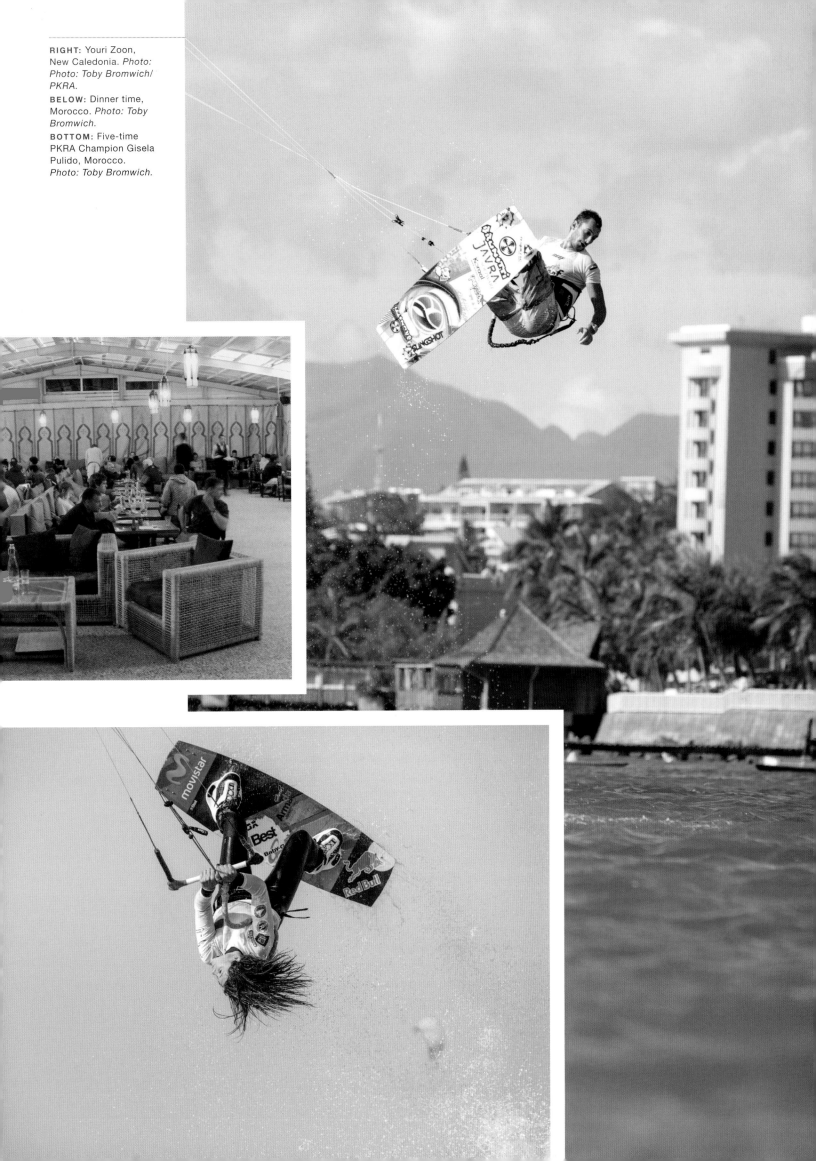

RIGHT: Youri Zoon, New Caledonia. *Photo: Photo: Toby Bromwich/ PKRA.*

BELOW: Dinner time, Morocco. *Photo: Toby Bromwich.*

BOTTOM: Five-time PKRA Champion Gisela Pulido, Morocco. *Photo: Toby Bromwich.*

WAVERIDING

Anyone coming in to the sport of kiteboarding in the last few years could be forgiven for believing that it has always been a sport of two halves: flat water and waveriding. But those who have been around the block a few times will recall that in the not-so-distant past the idea of riding in the surf – let alone riding strapless in the surf – was, for regular guys at least, inconceivable. The early days, the late 1990s, saw shots seeping out from Maui and other iconic surf destinations of watermen pushing themselves in genuine surf, but for the other 95 per cent of the kiteboarding community, who came into the sport as its popularity exploded through the early 2000s, it was all about twin-tips. Look around today though, and the surfboard is a staple. Whether kiters are 100 per cent surf or like to mix it up, riding waves with kites is now almost as popular as riding twin-tips.

In reality, kiteboarding has simply gone full circle. Before the incredible explosion of twin-tip riding, the sport began on directional boards. The pioneers of the sport on the Hawaiian side, guys like Alan Cadiz, Manu Bertain, Robby Naish and Pete Cabrinha, all began riding tow-in boards with straps back in the 1990s and – despite having no depower – were dropping in to some bombs and still managing to draw a few lines in the surf. From these beginnings, the sport has now developed to the point where, as long-term Hawaiian kiter Niccolo Porcella reflects, 'On a lot of photos, if we were to Photoshop out the bar, it just looks like surfing.'

This relatively quick progression was driven by two main factors: the evolution of kites, and the crossover of surfers into the sport. Riders such as Mauricio Abreu in Hawaii, Grant 'Twiggy' Baker in South Africa, and Ben Wilson in Australia had been using kites to have fun in the waves since the early days, but when more depowerable kites became available they realised the true potential of riding waves with kites, and the stars were aligned for this element of the sport to really take off. In a few short years it succeeded in becoming a genuinely 'surf-styled' offshoot of kiteboarding.

RIGHT: Kai Lenny, Tahiti.
Photo: Ben Thouard.

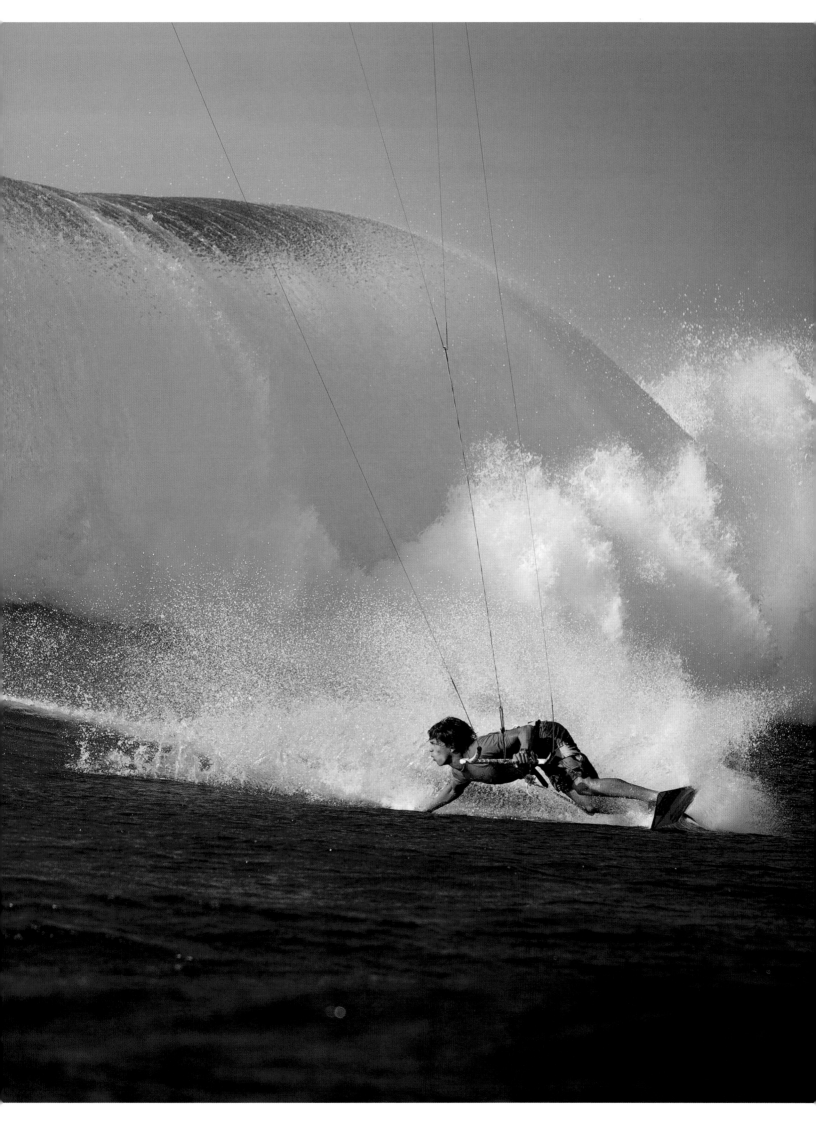

JOHN BILDERBACK, PHOTOGRAPHER

'**I**n the early years of this century, kiteboarding and particularly kite "surfing" seemed poised to explode. The feeling was that when the surfing masses saw that you could tow into a wave by yourself, without a ski, without fuel, or a partner; without polluting, making noise or spending thousands of dollars, it would be the next big thing. No paddling, no sitting, no waiting, and as many waves per hour as you could chase down, surfers would love it. And as a by-product we'd all become rock stars.

So it was, in 2004 and 2005, that I joined Martin Vari, Jeff Tobias and Ben Wilson on a quest to show that the world's best waves were ripe for the picking. The Banzai Pipeline, Shipstern's Bluff, Cyclops, Teahupoo – they all appeared on the team itinerary.

These were the days of unforgiving C-kites and heart-pounding launches. Bridles were for horses, 'depower' was the name of some rapper, and the idea of not using straps hadn't occurred to anyone. Some of the boards were these little five-foot things and getting dragged down the line, super-lit by your kite, was the standard problem. There was a shared vision, however, of riding waves correctly: gouging deep bottom turns and smacking proper off the lips. And in the far future we even saw that we might surpass what windsurfers were doing, namely ride in the tube. It was the Holy Grail, and the waves we targeted were picked on the basis of that. But the glory shots, and my main interest, were of these madmen tucking under some heaving ledge that would be difficult or impossible to paddle a surfboard into. The boys were psyched. They knew the beatings they were in for and, feeding off the group's energy, each tried to be the first to get a legitimate barrel. I was in awe really.

One early assault was Tasmania's Shipstern's Bluff, a freezing-cold patch of ocean that cops undiminished lickings from the great low pressures of the Southern Ocean. The bottom focusses the waves' energy on to a rock shelf at the base of a 300-foot cliff that juts out into the break as if it were the stern of an enormous ship. It is known for merciless, slabbing waves that mutate and wrench forwards with ledges and gurgles before washing into a massive set of boulders. Beyond the sharks and the nearly unmanageable lurching wave, the real challenge is the fact that the wind is unlikely to be at all usable because of the monstrous looming cliff. Yet there we sat, in a wet-deck Tasmanian abalone boat waiting for a puff of wind for the boys to launch in. Hours went by. Sometime in the afternoon, a bit of texture appeared (your wind criteria can become distorted after sitting in a rocking, cold, wet boat for hours wondering if you've spent thousands of dollars of your budget for nothing). And in an instant three guys were trying to balance on a tiny bit of foredeck on the bow of a 20-foot boat, feet on pumps. It would have been comical were it not so serious. Stumbling on top of each other, racing to be the first on the water, three close friends nearly knocked each other overboard as they attempted to get the first opportunity to commit aquatic suicide.

Martin was the first one in the water. He limped towards the break as Ben and Jeff tried to finish connecting their

RIGHT : Martin Vari, Shipsterns Bluff, 2005. *Photo: John Bilderback.*

lines and get over the side of the boat. He got to the top of the line-up, and looked to be the first kiter ever to ride Shipsterns. The other kites went into the air, but the anaemic wind in the channel left them stranded. They drifted downwind, away from the wave, desperately trying to keep their kites in the air. Martin, meanwhile, saw a lump approaching the line-up and put everything he had into connecting with it. The swell approached the headland, and Martin found just enough wind to get his board down the ledgy face. I know Ben and Jeff were simultaneously beaming for their friend and in agony over it not being them, as they watched Martin make it to the bottom of the wave and find enough speed to ride it to the channel. The camera clicked, and I barfed all over the rail of the boat.

During the following year, Jeff rode Pipeline, Ben tackled Cyclops, and the list of firsts grew. Surfboards became the norm. Twin-tips were lost in the back of the garage, relics of a silly, misguided upbringing. Waves were valid, and riding them with kites began to look like surfing. The explosion happened, but in slow motion, and it is still booming...'

ABOVE: Ben Wilson, Australia. *Photo: Stu Gibson.*

So bow kites, and then deltas and hybrids, were the main drivers behind this new, friendlier, way to ride waves with a kite. Being out in the waves was one thing, but being out in the waves when you can't really depower, when dropping in to even a shoulder-high wave feels like plunging off the top of a roller coaster, is a different ball-game, and there were only a few riders willing to put themselves through the pain for a few sketchy seconds of actual surfing. With this new breed of kites, everything changed. You could drop on to a wave, ease out the bar and, wow, you're not wrestling the kite, you're really surfing the wave! For hardcore kiters who had been in the directional game in the early days, this was what they had been waiting for, and smiles replaced grimaces as they dropped freely in to overhead sets before using the kite to drive ever more powerfully off the lip or to sneak around that close-out section. This new surf-styled approach also distanced kiters from the windsurfers – they could ride waves in the more critical part of the wave, more like surfers, and suddenly they had their own style.

So the pro riders were happy, but perhaps the biggest difference was for the regular rider, the guy looking to score some waves without the many years of pain required when learning to paddle-surf. The penny dropped: after a few sessions, you could be out there, really surfing. The brands were quickly on to the game and directional boards were rolled out and snapped up by a kiting community hungry for a slice of this new slant on the sport. For many kiters from a surfing background, however, the production boards – employing similar construction techniques to the windsurfers that had preceded them – were just too heavy and too stiff.

It took the next 'mini-revolution' to bring us to where we are now: the strapless revolution. People had been riding strapless for years, but even the most hardened kiters would generally screw on straps when the waves got overhead. But then, towards the end of the 2000s, there seemed to be an epiphany across the kitesurfing community: 'Hey, this isn't actually much more difficult without the straps?!' Within a year or two straps became the minority option and the whole waveriding landscape changed. This fed in to board design and, as strapless riders were placing less stresses on their boards and demanding less weight and more responsive

flex patterns, the brands responded. The weight of a standard production board halved in around three years and suddenly the 'surf-style' game was really on.

Since then it hasn't taken long for kiters to make an impression at many of the hallowed surf breaks around the world – Indo has become a hotspot, and iconic waves such as Teahupoo and Cloudbreak have now been ticked off the list – and the 'surf in the morning, kite in the afternoon' potential for waveriders is doubling water time and, slowly, persuading a few more surfers that maybe it is worth sticking a 9m in the coffin bag.

The final piece in the jigsaw that has led to the stratospheric standards we see now was the aerial revolution in the paddle-surf world. A new breed of surfer was suddenly packing an ever-more impressive array of aerial manoeuvres and rotations, and this fed directly into our sport, and into the 'above-the-lip' impossibilities that meld freestyle and waveriding and are driving this side of the sport yet further and proving, once again, that with kiteboarding you should always expect the unexpected.

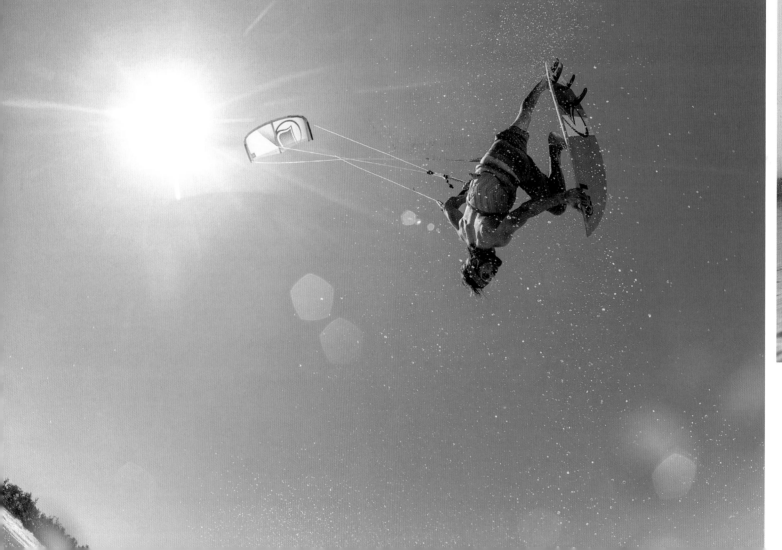

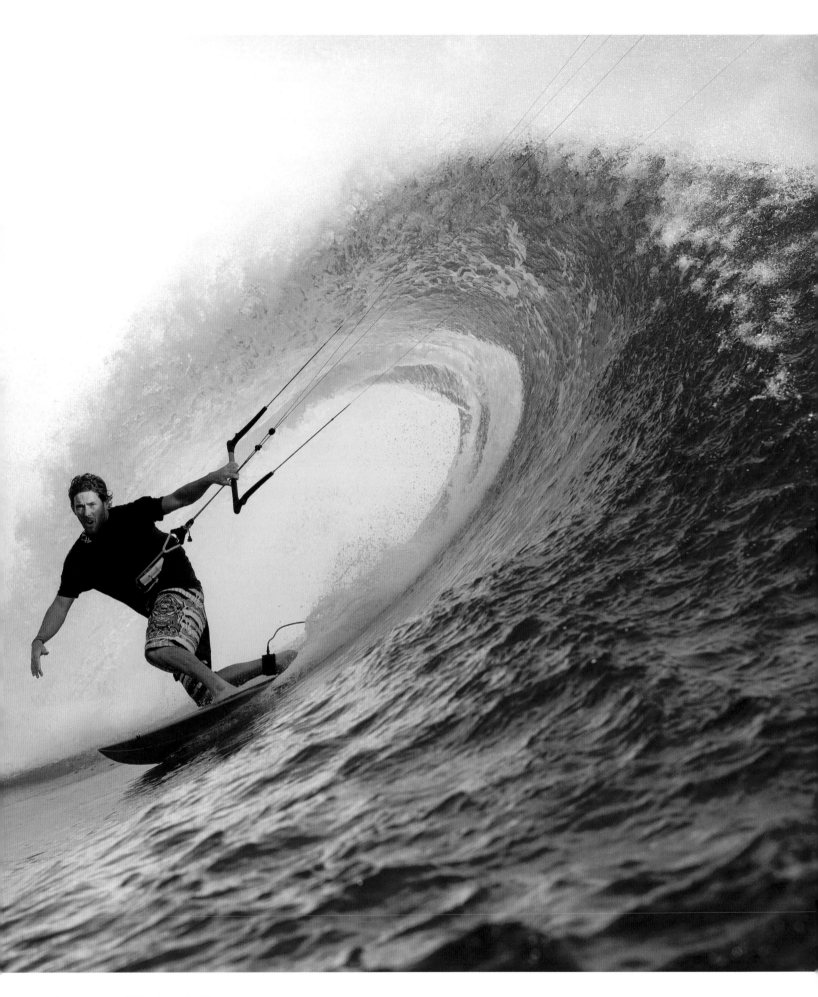

ABOVE: Ian Alldredge, Tahiti.
Photo: Ben Thouard.
LEFT: Julien Fillion, Maui.
Photo: Lukas Prudky.

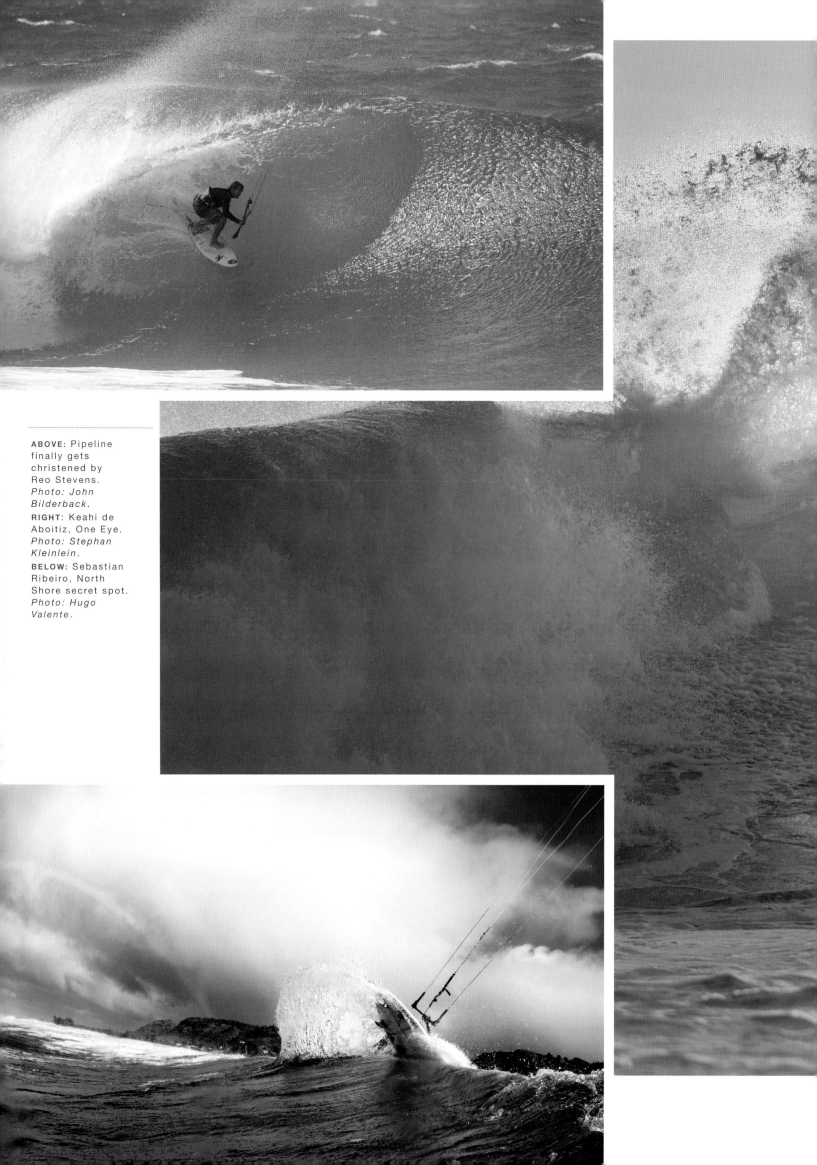

ABOVE: Pipeline finally gets christened by Reo Stevens. *Photo: John Bilderback.*
RIGHT: Keahi de Aboitiz, One Eye. *Photo: Stephan Kleinlein.*
BELOW: Sebastian Ribeiro, North Shore secret spot. *Photo: Hugo Valente.*

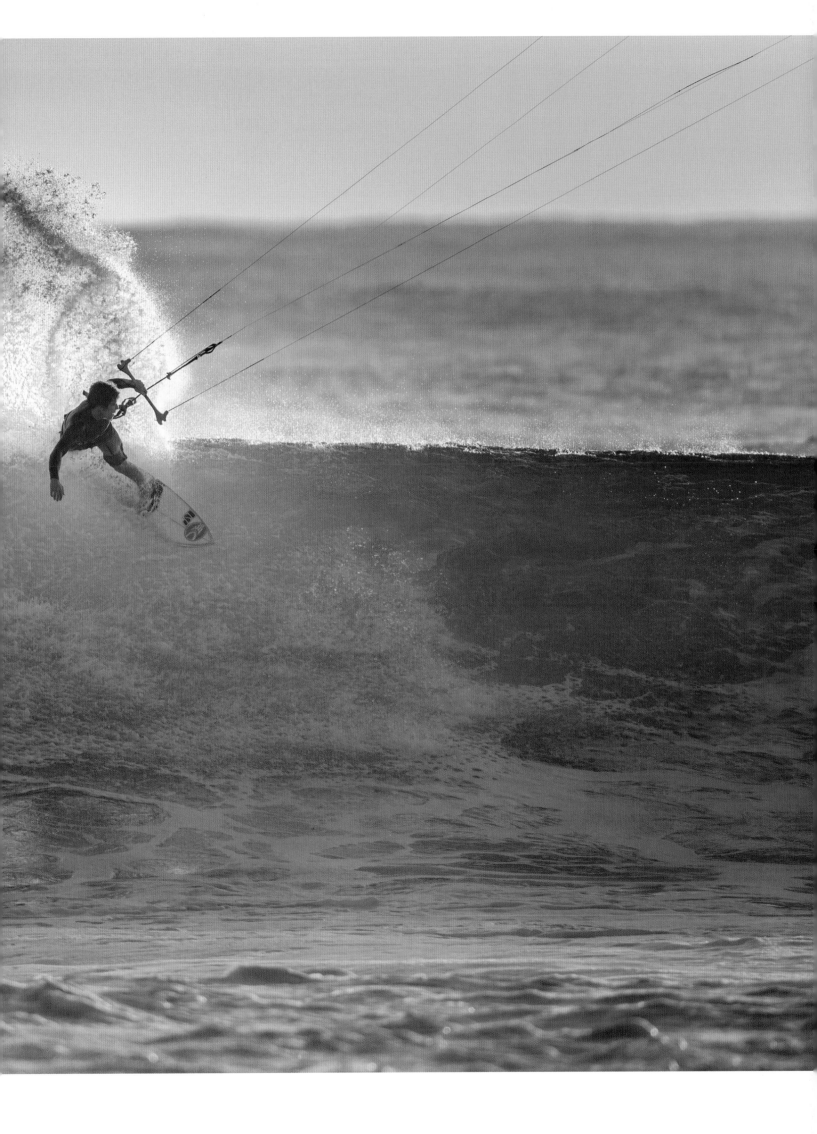

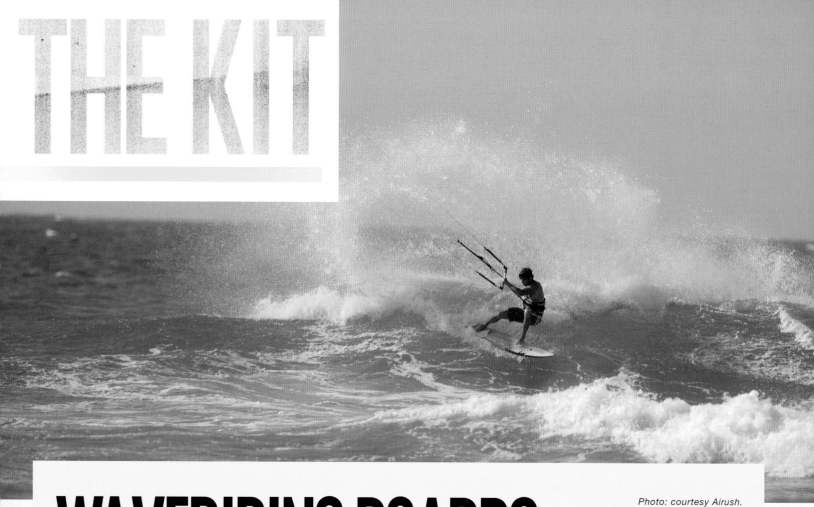

THE KIT

WAVERIDING BOARDS

CLINTON FILEN, AIRUSH

Photo: courtesy Airush.

IN THEORY

'Fundamentally there is not a huge difference in the shape of waveriding boards when compared to a standard surfboard. The main area that needs to be accounted for is the additional power that can be created by the kite, which results in the rider generally going faster than when surfing, so the designer needs to consider the additional stability that might be needed. The kite also means you can rely less on the drive from the wave.

In terms of construction, the board needs to be stronger to deal with the additional speed and jumping that come with kiting, especially if the rider is using straps. The main challenge is understanding the typical use and conditions that each rider may have. On one side you may have a rider who enjoys riding strapped and powered and on the other there is the rider who wants to ride strapless and rely on the kite as little as possible.

Generally, sandwich-style constructions can deal with the abuse from hard riding much better than ones with a single-skin lamination, and reduce the board weight for the same given strength. Different brands have different approaches to building strong but light boards, but most begin with an expandable polystyrene (EPS) blank and then various different lay-ups (layers of materials to produce the best strength-to-weight ratio). Materials such as bamboo (which has positive strength and dampening effects while still being relatively light-weight), Kevlar, cork and carbon fibre are all utilised in the search for the perfect strength-to-weight ratio.'

IN PRACTICE – THE COMPACT

'At Airush we have developed our Flexible Carbon Sandwich boards, which have a patented active stringer. These boards are around the same weight as a regular polyurethane (PU) surfboard but significantly stronger and can double as a regular surfboard. My objective with the Compact was to create a versatile shape for the rider looking for one board to cover everything from onshore to down-the-line. The tail has a lot of vee, which allows for smooth rail-to-rail transitions, while the fuller nose area and extra width help increase planing speed over flat sections. This maintains the low end of what a rider would find in a much longer board. Its narrow tail and reduced hip give it more control in high wind, which, in conjunction with the bottom shape, ensures a smooth ride even in the toughest conditions.'

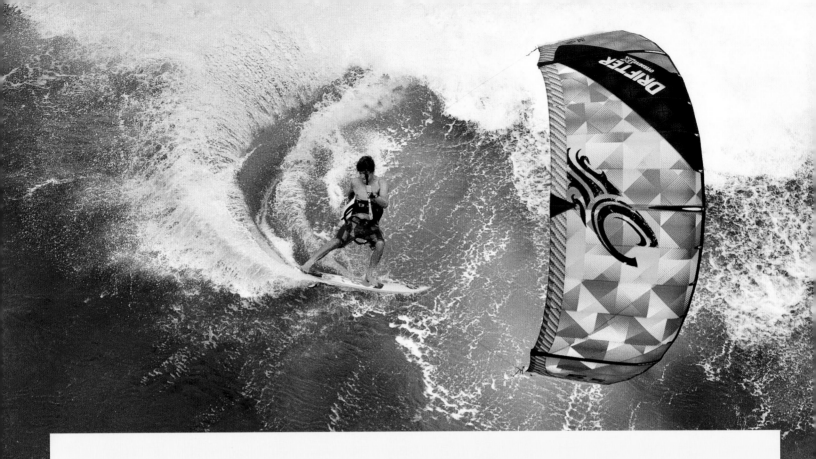

Photo: courtesy Cabrinha.

WAVERIDING KITES

PAT GOODMAN, CABRINHA

IN THEORY

'A waveriding kite needs to do a lot. The priorities would be drift-stability, fast steering, instant power and depower, durability and an easy relaunch.

In the sky the look is somewhat compressed. Generally the kites have a medium arc shape with a low overall height-to-width ratio (not too "leggy" at the wing tips, unlike a C-kite), and with a low- to medium-aspect ratio with slightly wider wingtips. In most cases, surf kites have a compact, simple bridle and this, combined with thin profiles, a lower aspect-ratio and wider wing tips, produces a kite with an incredible range of depower and super-responsive steering.

Other technical elements keep the wing tips flying evenly at low attack angles, which also help the kite drift well and depower down the line without nosing over as the rider heads towards the kite.

A good waveriding kite also needs to work well in onshore conditions, so also requires more bottom-end power and better upwind performance. In onshore conditions you are often riding towards the wind, requiring a kite that handles and behaves nicely, sitting really far forwards in the window at low attack angles. The same kite when riding off the wind must fly at really slow apparent wind speeds without stalling, since you are riding nearly directly downwind towards the kite. This is where a full, stable kite comes in handy.

The entire sport has dramatically evolved in recent times. How often did you see cover shots of guys getting fully barrelled a few years ago? This is common practice these days and the kites have evolved to help these kiters be comfortable in critical situations. For the most part, the improved handling and drift stability is what general consumers would notice the most. But overall kites have got much stronger, lighter, faster and more stable and they relaunch better than ever before. Which is what you need from a waveriding kite.'

IN PRACTICE – THE DRIFTER

'The Drifter started as Pete Cabrinha's vision. He was continually asking for a fast-steering kite that could park itself in a comfortable position. It had to depower extremely well, relaunch easily, and drift – really drift along with him – so he could focus entirely on riding the wave. His goofy-foot stance makes surfing a bit challenging for Maui, as he is always riding backside. This exaggerates the need for a responsive kite that reacts quickly and has stable slack-line drift. Thus came the name "Drifter".

The Drifter has gone through small design and construction refinements over the years, with big changes in the bridling and control system resulting in better handling, steering and sheeting, making it very direct and responsive and perfect in the waves. Having input from Pete Cabrinha and Dave Hastilow, along with additional feedback from Reo Stevens and Keahi de Aboitiz, has taken the Drifter to the level it is at now.'

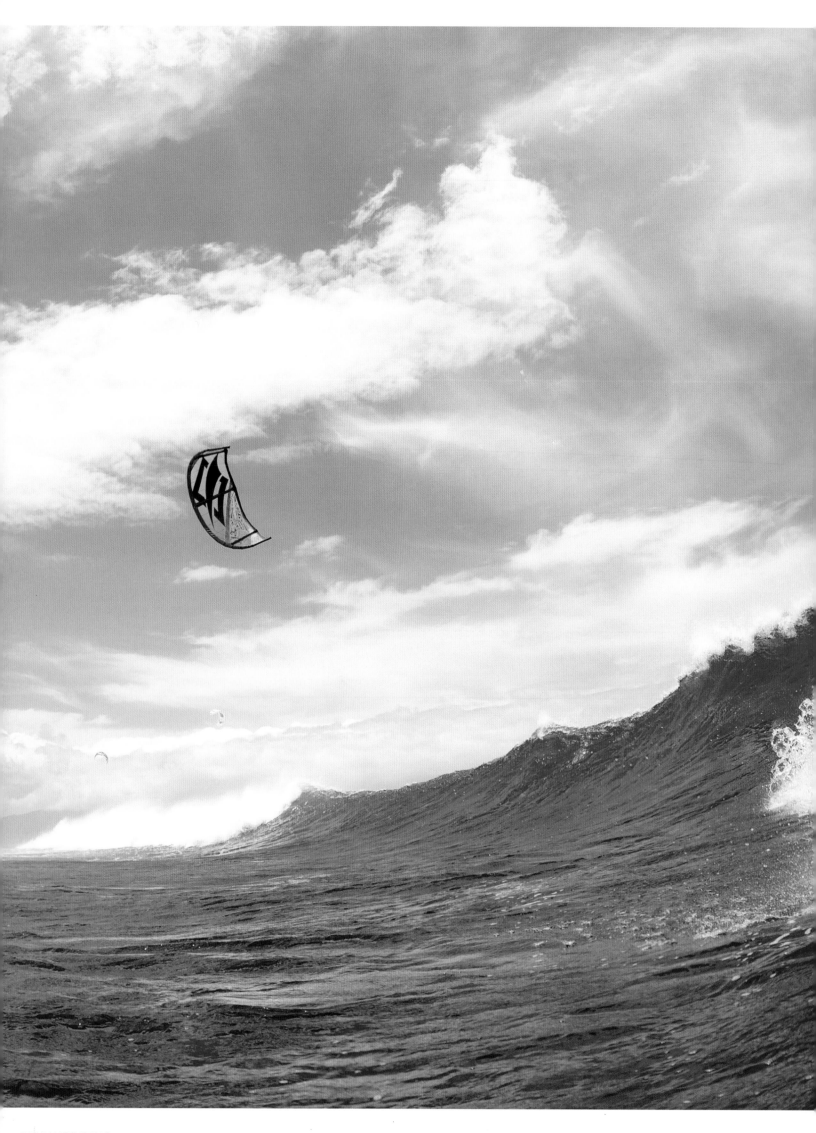

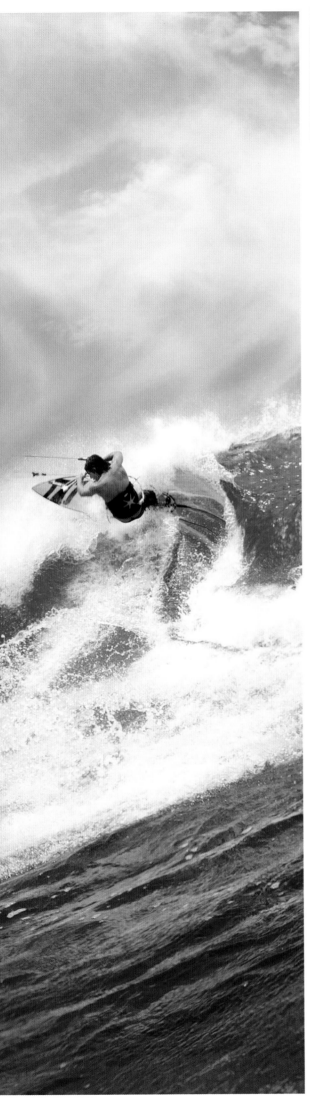

PLACE
MAUI

The spiritual home

QUINCY DEIN, PHOTOGRAPHER

'**One of the most amazing things about living on Maui is the diversity of climates, conditions and activities.** Just when you think you have done it all, Maui finds a way to surprise you and make you reconsider everything you thought you knew. From the dry grasslands of Kaupo to the lush jungles of the West Maui Mountains, Maui is like an entire *Planet Earth* DVD boxset on one island. In fact, out of the 13 recognised climate zones, Maui has seven, making it one of the most climatically diverse islands in the world.

For kiteboarders, the conditions are equally as diverse. While Maui may not have the world's best conditions for each discipline of kiting, it makes up for it with the wide range of conditions and brutally consistent trade winds. Maui's north shore alone has a spot for every type of kiter. Kite Beach has the butter-smooth pro pool perfect for unhooked wakestyle.

LEFT: Jesse Richman, boardies and blue skies. It must be Maui.
Photo: Quincy Dein.
BELOW: *Photos: Quincy Dein.*

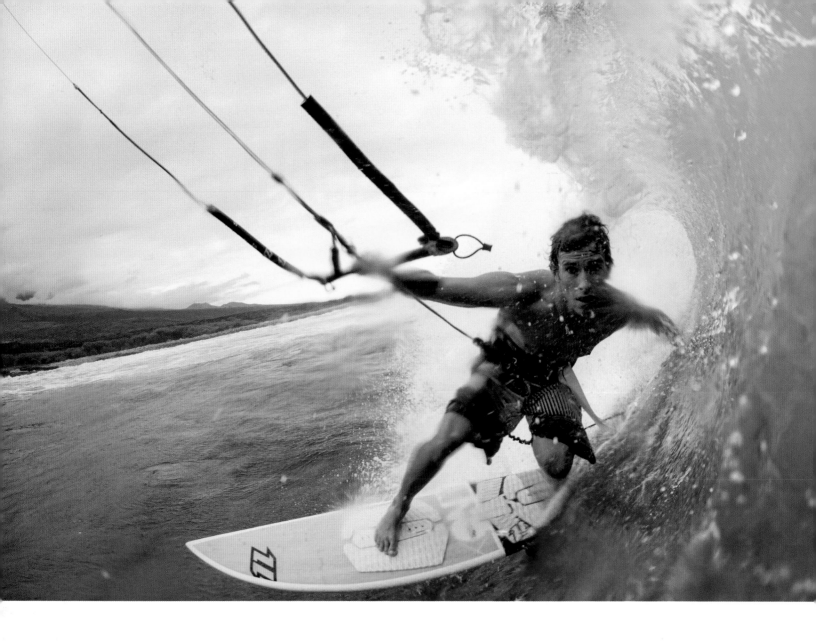

Just up the coast, Sugar Cove offers slow, cresting ramps perfect for freeriding, and a little farther up the north shore, Lanes offers wavekiters the perfect arena in which to push their limits when the big north swells fill in every winter.

But you don't need to stick to the main spots. For the more adventurous kiter looking to try something different, Maui's south, east and west shores offer fewer crowds and equally enticing conditions. Waiehu features perfect ramps for strapless airs; Kaupo offers advanced kiters world-class freeriding through dramatic exposed lava rock pinnacles with breathtaking views of Mount Haleakala; Ma'alaea features super-charged gusty offshore wind and smooth water, ideal for speed runs and for testing race gear; and Ka'anapli offers fun freeriding in waves. Or – with a little planning – those looking to do something different can cross the channel to Molokai. In addition there's always Maui's south shores, which offer epic summer surf and world-class wavekiting if you know where to look and don't mind hiking across the jagged lava.

Another great thing about the island is that, for such a well-tracked piece of kiteboarding real estate, Maui can have its fair share of surprises. Just the other week we were exploring and turned a corner to see this wave emerging out of deep water – the lip projected horizontally before imploding on to the slab, and offshore winds groomed the face with the wave staying hollow all the way through the end bowl. We stared in disbelief from the jet ski while windsurfers, oblivious to our discovery, casually sailed past only a few hundred yards away. This spot had been right in our back yard, yet until then none of us had given it a second thought. Everyone was pretty amped and Jesse Richman, Patri McLauglin, and Sky

Solbach quickly began tacking upwind and into position. We all looked on as Jesse's first wave ended with him getting spat out of a frothy barrel, which confirmed our initial excitement. This wave was perfect for kiting and another one to add to Maui's enviable list of world-class waves.

As kiteboarding continues to evolve as a sport, Maui's conditions will take on new meanings. As gear and styles develop, spots that were once written off as second tier are now the first stop for a lot of riders. Waiehu is the perfect example. Until the strapless movement it was just an average spot with onshore slop. Now riders such as Niccolo, Keahi and Lou consider it one of the best wave spots in the world. Onshore is the new offshore, and it doesn't just stop there. Gusty wind is no longer the beast it once was thanks to high-tech depower systems and better canopy designs. Wind that was once considered too light to ride is now easily within the capabilities of super-efficient light-wind foils.

In terms of its history, Maui was the birthplace of modern kiteboarding and it will continue to be the sport's iconic home. In the early days, Maui used to get the majority of the attention from kite magazines and the wider media. As the sport continues to be pushed out to all corners of the globe, media attention is now heavily divided among multiple world-class locations, such as Morocco, Turks and Caicos, and the Dominican. Yet, despite all of the new discoveries, Maui still holds a special place in the hearts of the sport's top athletes and brands. From professionals training for the freestyle world title to beginners looking to learn how to body drag, Maui will continue to capture the imaginations of kiters for generations to come.'

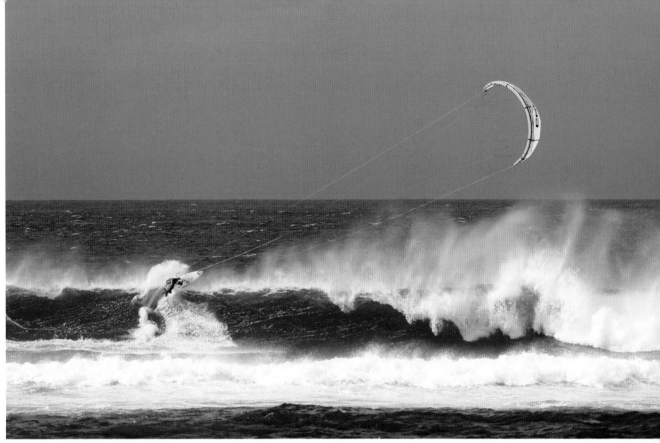

ABOVE: Patri McLaughlin in deep. *Photo: Quincy Dein.*
TOP RIGHT: Rob Kidnie going left... *Photo: Thorsten Indra.*
RIGHT: Kai Lenny blowing up. *Photo: Stephen Whitesell.*
BOTTOM RIGHT: *Photos: Quincy Dein.*

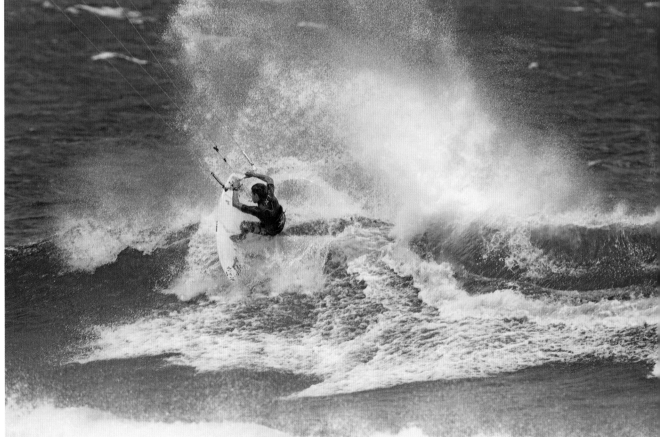

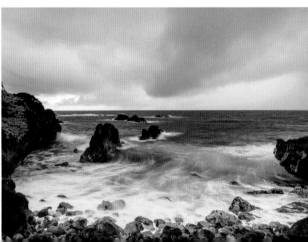

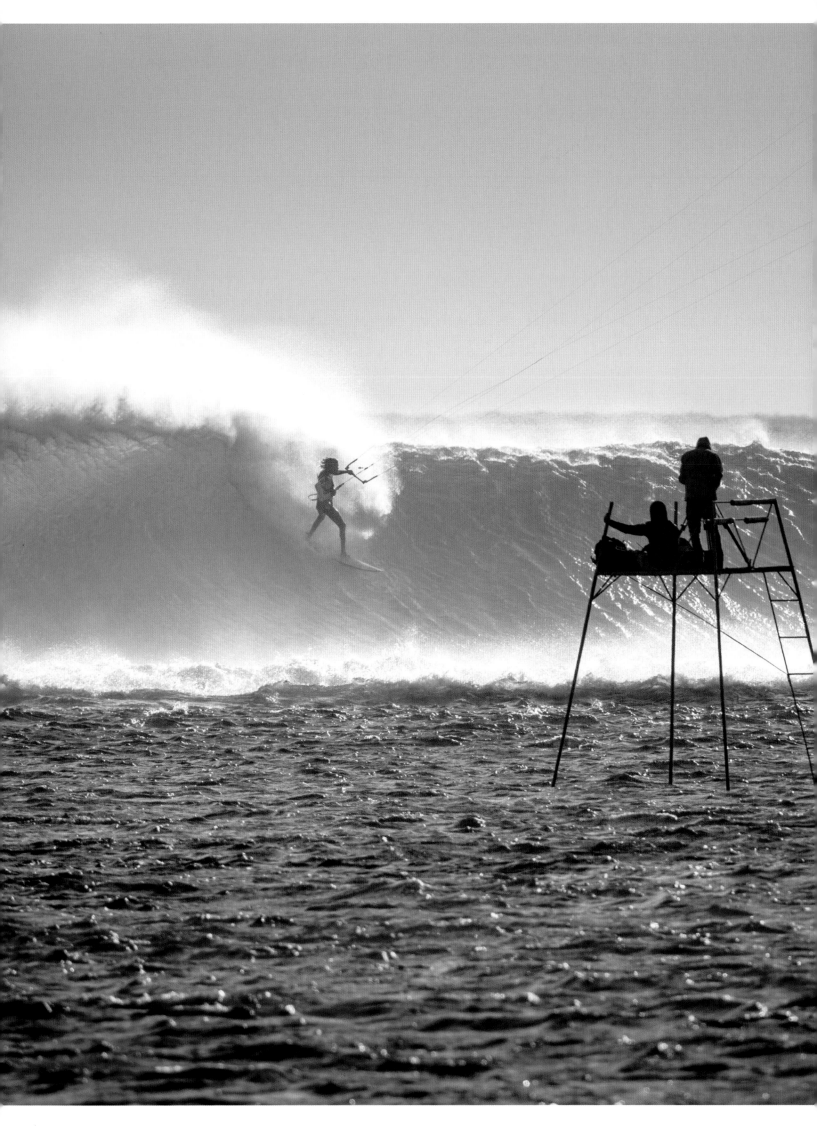

PLACE MAURITIUS

MAURITIUS

The ultimate proving ground

NINJA BICHLER, NORTH RIDER

'**Mauritius has a deserved reputation for its big-wave kiting options. All around the island you can find great kite spots as well as a lot of great spots to surf, windsurf and SUP.** There are plenty of wave spots, flat-water lagoons, beach breaks and reefs. And you can find side-shore wind, onshore wind and cross-off winds, all on one island. For me this is probably the best place in the world for diversity and for the most perfect waves.

There are places to kitesurf all over the island, but for waveriding there is one area of the island that is best known: Le Morne. Le Morne is a peninsula surrounded by a big lagoon that is sheltered by a reef, and it is here that you find the famous waves. To the left of the main channel, is Manawa, which is a great wave – especially if you are starting out or just finding your feet. The wave peels around the edge of the reef, so if you get caught out you will end up in the channel, not on the reef. Moving to the other side of the channel you get to Chameaux. This is very shallow and is bigger than the rest of the spots and can link up with the main break. The reef then straightens out, and you get to the most famous wave of all: One Eye. Here the wind is mostly cross-offshore, going around to straight-off in an easterly wind. The wave is fast and clear and breaks on a very shallow reef, so if you are in there is no getting out. This means that if you get washed, then you

ABOVE: *Photo: Stephan Kleinlein.*
LEFT: Airton Cozzolino, One Eye.
Photo: Stephan Kleinlein.

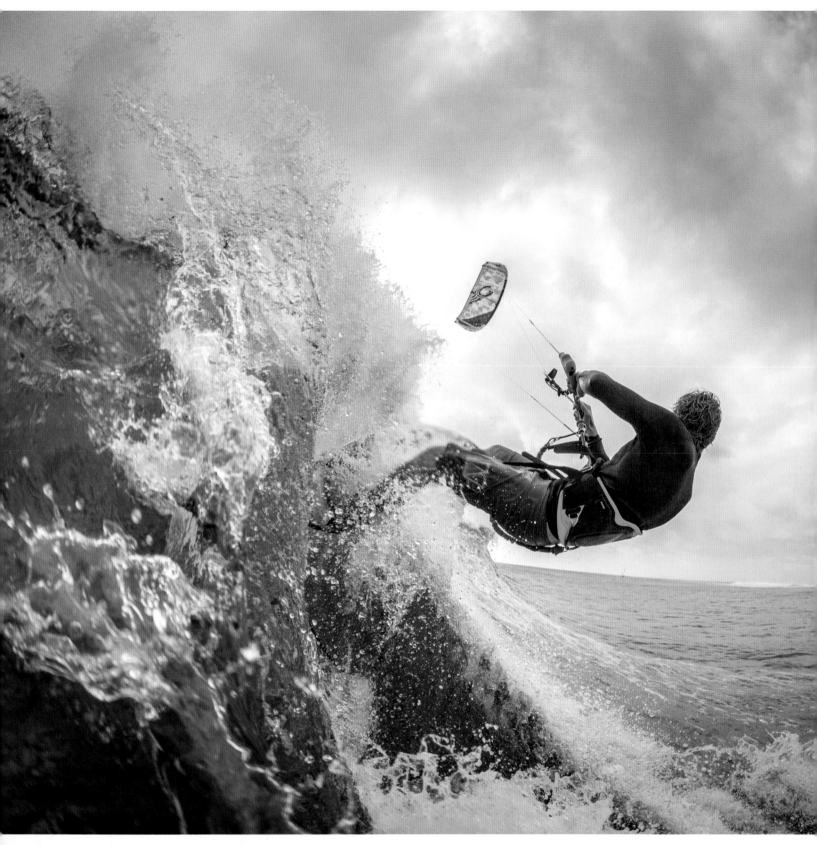

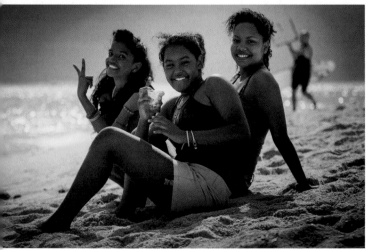

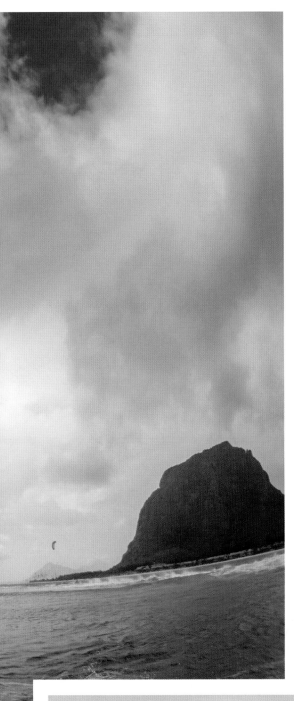

go over the reef and, eventually, back into the lagoon. It's best not to stand on the reef though, as there are urchins and sharp coral! If the wave closes out at high tide you can ride over the reef, or you can chase it down the line and get around the section. One thing is for sure, One Eye is not a beginner's spot: you need to know what you are doing and be able to read the wave very well.

You can kite almost any day of the year in Mauritius. The high season is June to December when it's more consistent, especially with waves – but that does not mean you won't score in January or April – you probably will and there will be less people out. But for kiters who wait for the really big waves, like I do, the most exciting time of year, when the biggest swells roll in, is our winter time – so July until October. I still get so excited when I know there is a good swell coming and have the same thrill I had when I had just started kitesurfing. I check to see if all my kit is ready and then cross my fingers and hope that I will have time to ride when I am not working. I just can't get enough of it!

Kiteboarding and windsurfing are the main businesses around Le Morne. The first windsurfing club was situated at the former Beryaja Hotel, now the St Regis. The club wasn't there long following problems with localism and with safety issues – with guests getting lost at sea! In 2003 the Indian Resort hotel opened and chose Club Mistral as its partner, and they are still the main provider around Le Morne.

But it's not only about big-wave kitesurfing here on Mauritius. I enjoy the relaxed lifestyle and the peaceful way of life. In my eyes, Mauritius should be an example for the rest of the world. All cultures (and we have a real mixture here) live peacefully together, in harmony, whatever their skin colour or beliefs might be and the atmosphere is colourful – imagine being in the Caribbean with a touch of India and you get the idea. The scenery is a bit like Hawaii, with tropical green mountains, but we also have stunning beaches and beautiful lagoons, a bit like Tahiti, and most days you see rainbows.

And if you're on a trip then there is plenty for family members who are not addicted to kiting to enjoy on this little paradise in the Indian Ocean – as long as they are prepared for the fact that they might not see you around a lot!'

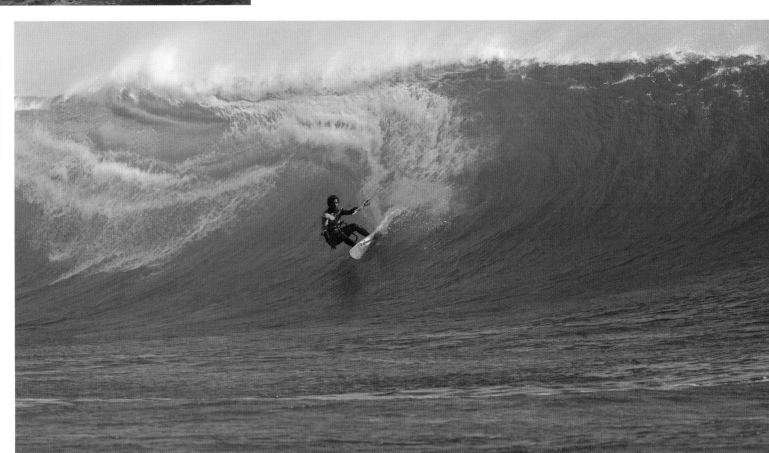

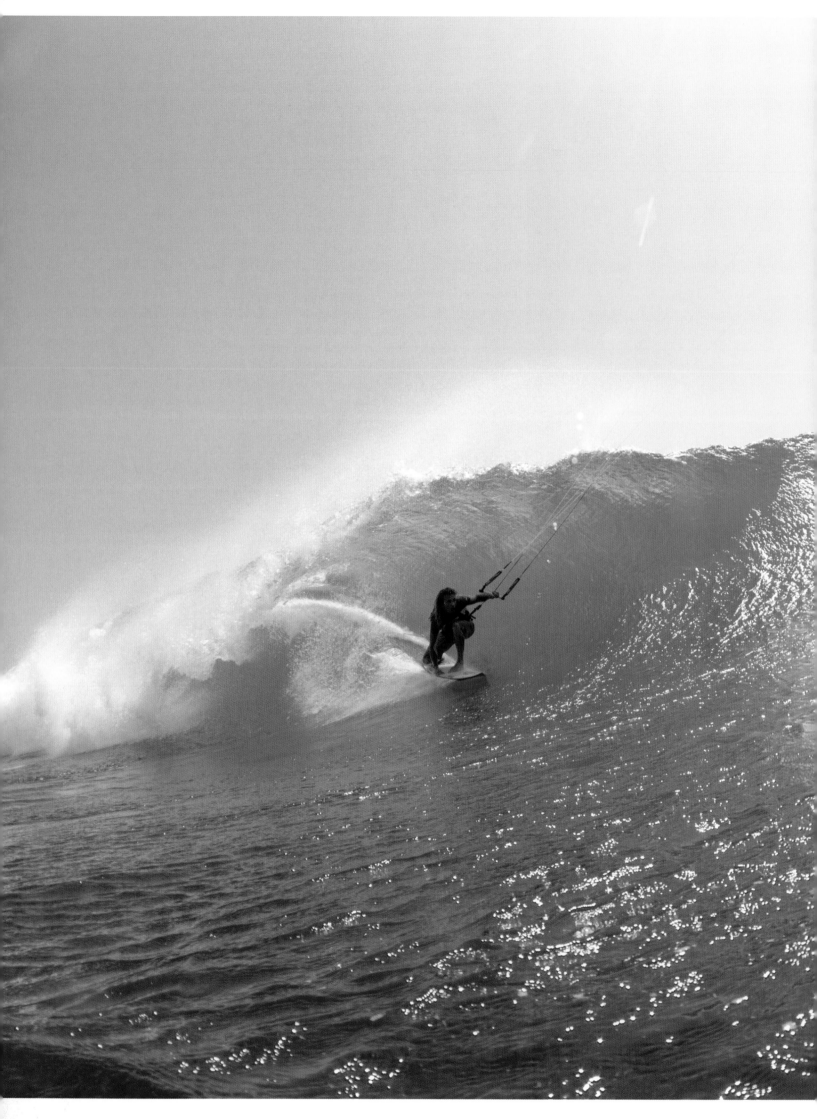

PLACE
INDONESIA

Islands of Gods (and barrels)

JASON WOLCOTT, PHOTOGRAPHER

'**If you have not been to Indonesia, you have not really travelled. You may say, "Well I have climbed Everest, walked through a crowded market in Sudan and drank coffee in view of the Eiffel tower".** But I would have to say, "Have you smelled the sweet scent of incense as an elderly woman blesses the street? Have you drunk java with a Javanese? Have you seen the mist drift across a clear volcanic lake? Have you tacked upwind and seen 300 Balinese attending a beach ceremony? Have you been chased at a dead run by a two-feet-tall monkey through the magical forest in Ubud? Have you seen five humans and a dog on a moped? Have you seen a six-foot transvestite trip over a mangy dog and break their high heel?" I may lose this argument, but really, if you are a world traveller and have yet to see the beautiful chaos that is Indonesia, then you should book a flight.

Aside from the culture there is, of course, the kiting. Long lines of energy march up from the southern Indian Ocean meeting the reefs and points of some 17,000 islands with staggering results. Some of the most perfect waves in the world can be found in Indonesia. From Papua to the west, to the Mentawai Islands to the east, there is more surfable coast in Indonesia then almost any place on the planet. The southeast trade winds arrive in May, and in eastern Indonesia they are known as some of the most ferocious around, often sinking ferries and taking the lives of foolhardy fisherman. There is world-class waveriding and flat-water kiteboarding throughout the massive Indonesian archipelago. There are well-known spots in Bali, such as Sanur, Canggu, and Balian, but the real magic is found off the beaten track. There are rumours of wind on nearby islands that far exceeds that of

LEFT: Patrick Rebstock, somewhere in Indo. *Photo: Jason Wolcott.*

BELOW: *Photos: Jason Wolcott.*

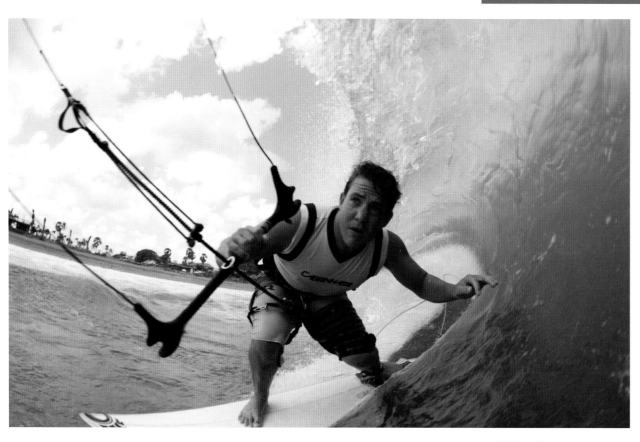

Bali. It is worth a look to the east and west of the Island of the Gods if you find yourself with some time and an adventurous spirit. You could certainly check out the Gili Islands, Java, and northwest Bali for starters.

I have called Bali my home for many years now and have become somewhat immune to the beauty and chaos that attacks your senses the second you leave the airport. Millions of motorbikes buzz around the streets of southern Bali like swarms of locusts. Bali is one of those places that is almost impossible to put into words. It is so many things to so many people. It is a surf Mecca for thousands of travelling surfers who want to get the wave of their life and party until daybreak; it is a relaxing spiritual retreat and health and yoga haven; it is a place where ancient culture is as strong with the local people today as it was 500 years ago – a place where there are spirits and demons roaming the night, where there are thousands of Balinese Hindu ceremonies every week, and where there are nightclubs that don't start going until 2am. You can come to Bali and be who and what you want to be. Kuta is a mix of Vegas, Waikiki and Tijuana all mixed into one huge tourist trap. But it is not your typical kiteboarding travel destination.

As one would expect of such a wave-rich area of the world, the list of pro kiteboarders is an illustrious one. As a kiteboarding journalist and photographer, living in Bali has allowed me to work with many of the world's top pros. From Ben Wilson – who has been making the pilgrimage to Indo since he was a young surfer (with no idea that one day he would be one of the most respected waveriders in the sport) – to ex-pro surfer Mauricio Abreu – a one-time wakestyle master turned surf-style legend – both have spent plenty of time in Indo. The likes of Reo Stevens, Ian Alldredge, Bear Kerry, Patrick Rebstock, Keahi de Aboitiz, Greg Norman Jr, Ryland Blakeney, Mark Ramseier, Bertrand Fleury, Tuva Jansen, and even the rider who started it all for me, Wes Matweyew (my first instructor, and also the subject of my first cover shot) have all paid visits to my humble little house in the wilds of Bali. Whether sleeping on my floor, eating dinner at Jimbaran Bay with my wife and family, or charging the hellish gusty nightmare of a spot I make them ride, they have all left a mark on Indo in some way. I look forward to each dry season and the annual pilgrimage they make to the little corner of the world I have chosen to expatriate myself to.'

ABOVE: Reo Stevens eyeing up the exit. *Photo: Jason Wolcott.*
TOP RIGHT: CORE Kiteboarding's Rob Kidnie staying low. *Photo: Jason Wolcott.*
FAR RIGHT: Old meets new... *Photo: Jason Wolcott.*
RIGHT: *Photo: Jason Wolcott.*

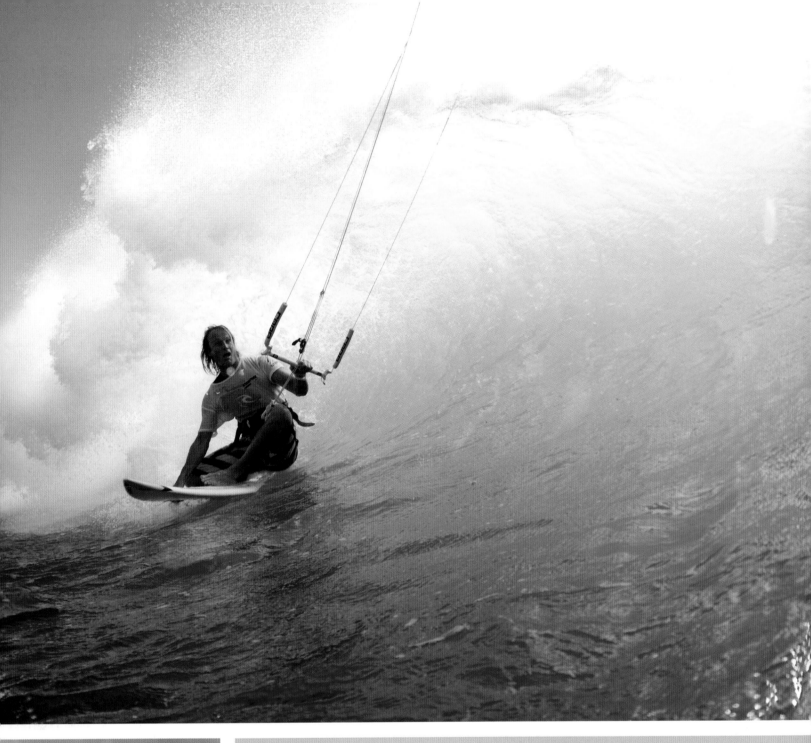

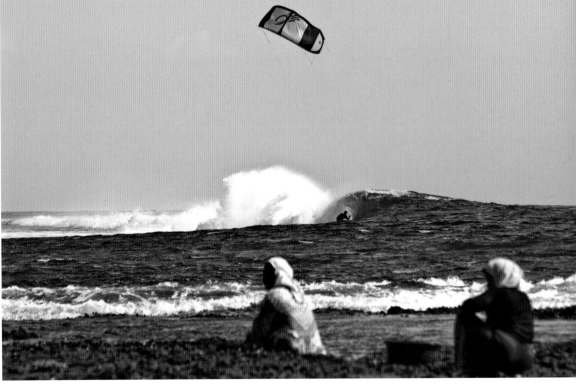

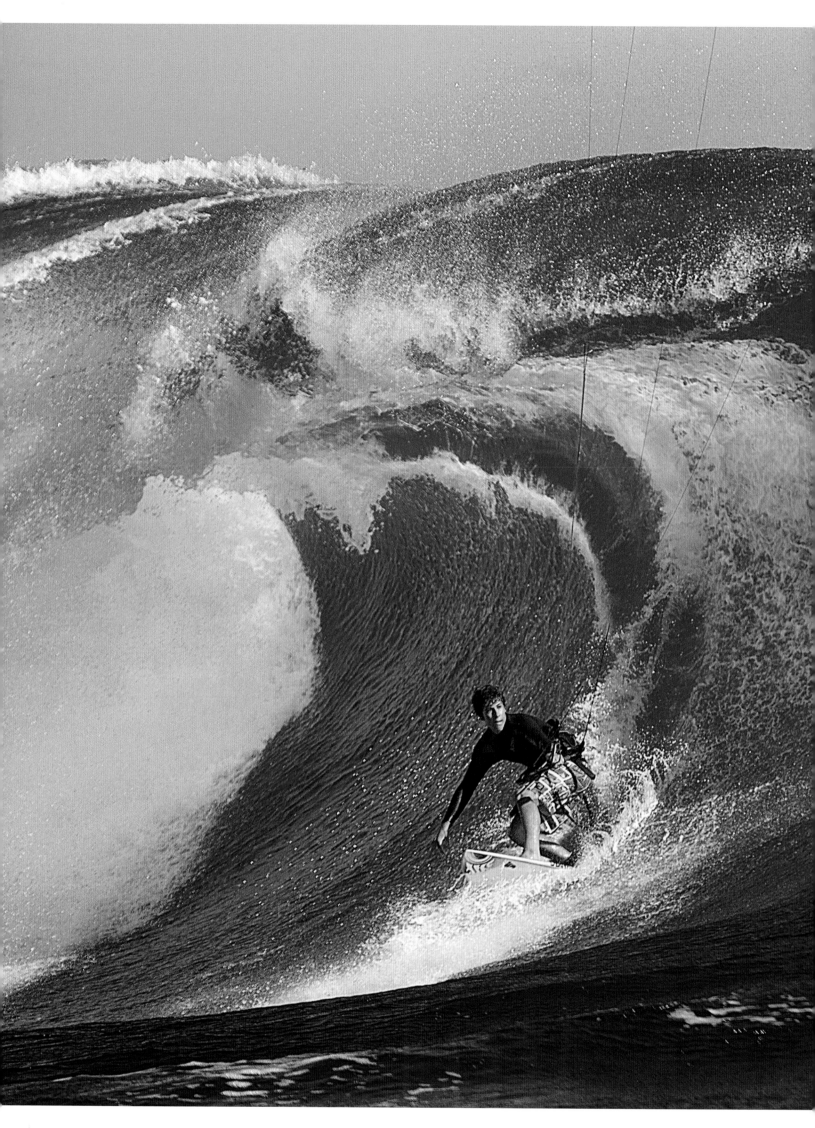

PLACE

WESTERN AUSTRALIA

Great waves, great whites

RYLAND BLAKENEY, WEST OZ 'LOCAL'

'**We have all heard of Western Australia's crocodiles, snakes, spiders, great white sharks and the famous drop bears.** But what WA is better known for in the kiting world is its great wind and waves. I've been lucky enough to have lived in WA my whole life and have always been by the ocean. I started kiting back in 2000 when kiting first came to Australia. I used to get annoyed when I wanted to go for a surf after finishing work in the summer only to find it was always small and blown-out, so I just decided that if you can't beat 'em you might as well join 'em! Once I got the hang of it I was hooked and so the addiction grew.

Plenty of the world's top riders and professionals call WA home for six months or so of the year. They are attracted by the warm waters, great winds, solid waves up and down the coast, beautiful women, and good food and pubs. The best way to get stuck in to the wind and waves of WA can be summed up in two words: road trip. Nothing is better than packing the car and hitting the road, and I'm out of here as soon as I see a good forecast, and will drive a whole day if the conditions look good. You may have heard of world-class locations like Gnaraloo, Margaret River, the crystal-clear waters of Esperance and the south coast. Well, these are all between three and twelve hours' drive from Perth and on their day are as good if not better than any other spot I've been to around the world. Don't get me wrong, it does get crowded, but if you have a sense of adventure and a reliable car then hit the road. You will be sure to find some epic locations – uncrowded and with clear waters – and consistent wind. I'm talking about the kind of sessions you read about in mags and see in videos – those sessions you remember for a lifetime!

ABOVE: *Photos: Jason Wolcott.*
OPPOSITE PAGE: Keahi de Aboitiz, West Oz slab. *Photo: Jason Wolcott.*

The only slightly negative thing is that WA has lately got a reputation for having the sharkiest waters in the world. For the last few years, as soon as our windy season starts, so does our shark season. And not just little sharks, but dirty great 4–6 metre great whites. There have been a few fatal attacks over the last few years and the waters are now monitored regularly – so if you see one of the choppers slow down and hover then stay well away as the chances are it's following something.

Every year we try to discover a new spot that hasn't been kited yet, or some crazy wave that the surfing tow crew have found, and we study maps to work out when and if it's kiteable and if we can launch nearby or if we need our jet skis as back up. One of the best trips I've done in WA was the BWS trip shooting for the Filthy West movie. It was off-season and I was super suss on the whole trip's timing as it was two months out of season, but we ended up scoring 13 out of 14 days on the water kiting. I guess that's the bonus when you have a 4x4 there and can hit the road and follow the best forecast. It was a trip I'll never forget, and I was stoked to score some fun sessions with some mates from other parts of the world, and to show them some of the spots we try to score. One session in particular was at a long left beachie point. It goes for a few hundred metres and can be sectiony to surf, but perfect for kiting. It's a super gusty spot, but on the right wind direction it goes off, and that trip we scored it as good as I've seen it with no one else in sight and the clearest water you can imagine – it was pretty special!

So, be sure to visit WA at least once in your lifetime, the locals are usually pretty friendly and it will be a trip – or should I say an adventure – that you will never forget.'

ABOVE: *Photos: Jason Wolcott.*

TOP RIGHT: Josh Mulcoy, somewhere near Esperance. *Photo: Jason Wolcott.*
BOTTOM RIGHT: Gabi Steindl, Margaret River. *Photo: Jamie Scott.*
BELOW: Ben Wilson, sharky secret spot. *Photo: Jason Wolcott.*

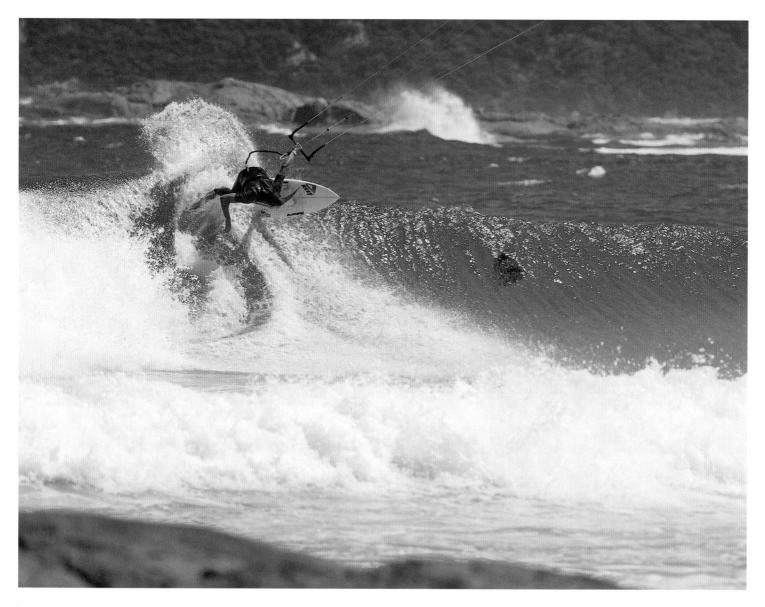

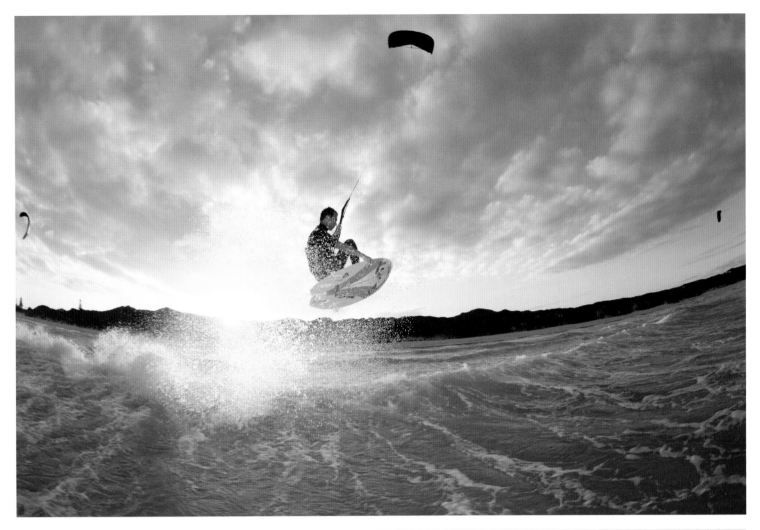

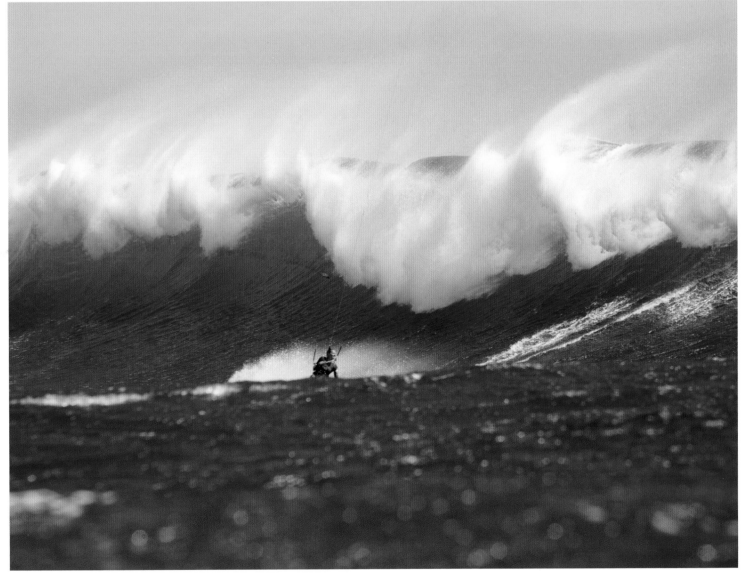

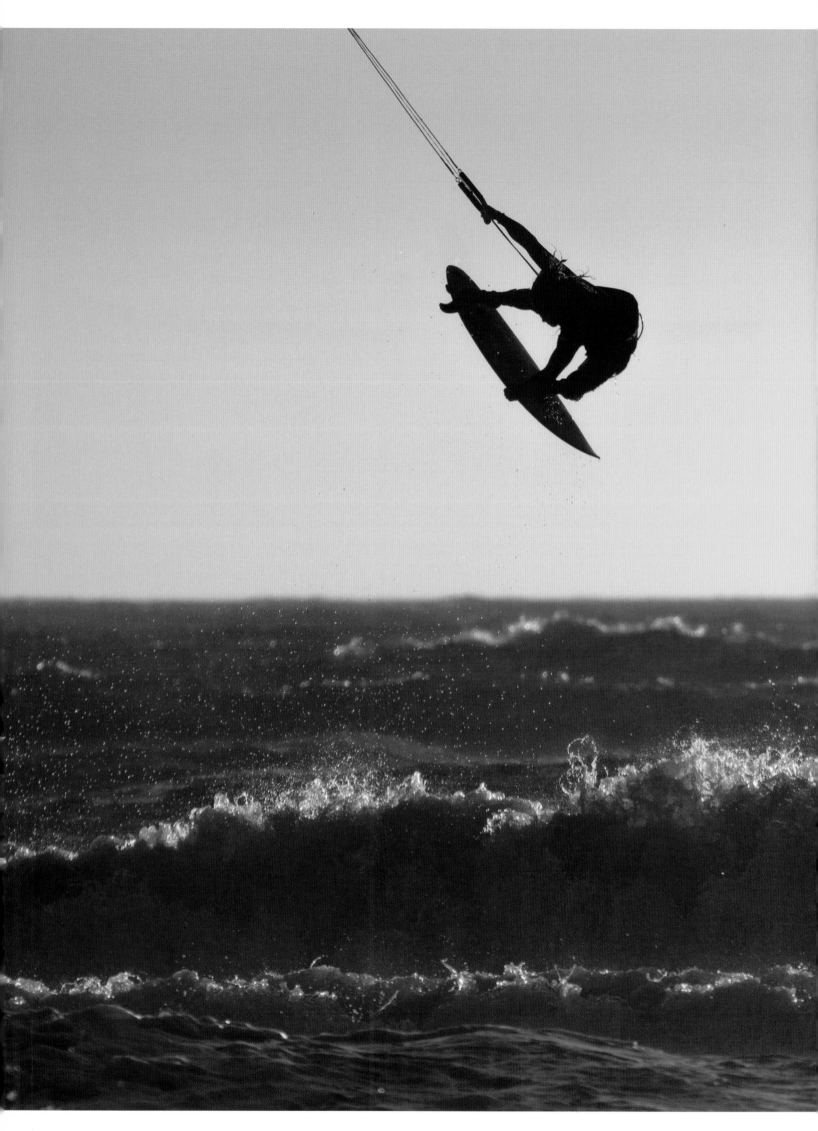

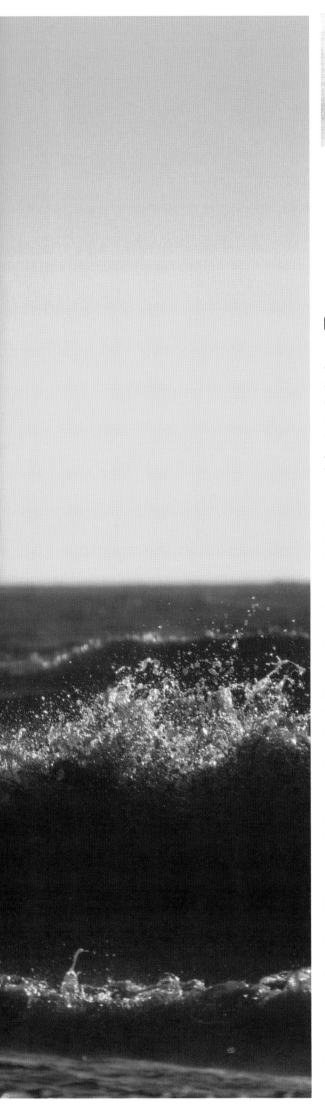

PLACE

CALIFORNIA
Kiteboarding's Golden State

PAUL LANG, PHOTOGRAPHER

'**W**hen I mention that I'm from California while travelling far from home I am often confronted with all of the typical stereotypes of California: sunny beaches, good surf, Hollywood, and women so hot they'll melt your popsicle, are typical conversation topics about my home state. All of that is true, but mainly these things are true because basically everything you've ever heard about California is true. This state is so large and so varied that literally anything you are looking for can be found here. Of course, it's also home to a lot of wind and waves, especially if you know where to go.

A challenge I have when talking to others about California is getting people to understand the size of the state and how much variety there is here. California is almost double the size of the United Kingdom, but with 40 per cent fewer people. The Californian coast stretches for 840 miles. California is home to both the highest (Mt. Whitney, 14,495 feet) and lowest (Death Valley, 282 feet) points in the lower 48 states of the US. There are places in the state that get more than 20 feet of snowfall in a year, while other places average less than 3 inches of annual rainfall. California is a land of extreme variety and the kiteboarding is just as varied as the state itself.

There are a few popular flat-water kiting locations in California, but kiteboarding here is mainly focussed on waveriding. Throughout the state, riding happens year round, but the best time of the year to find wind and waves depends on the spot ... Many spots receive their highest wind days from springtime, clearing winds that follow storm systems. A lot of other spots are thermally driven and so get their best wind when the inland valleys heat up in the summer and draw in the cool ocean air. The biggest waves usually come in winter when the wind is inconsistent for most riding spots. Autumn and spring can both deliver great surf, with summer usually being a little

ABOVE: *Photos: Paul Lang.*
OPPOSITE PAGE: Patrick Rebstock, sunset punt. *Photo: Zac Baxter.*

flatter. Those are gross generalizations though, and the session of the year can happen in the middle of summer just as easily as in the dead of winter.

One aspect of the riding here that surprises many visiting kiters is the water temperature. I think the classic TV show *Baywatch* convinced the rest of the world that our water is warm year-round, but the truth is that the water is cold in California. In some places it's very cold. The water gets warmer the farther south you go and Los Angeles and San Diego kiters might even get a few late-summer sessions without a wetsuit, but for the rest of the state year-round full-length rubber is the norm. North of Los Angeles expect to use a 3/2 or 4/3 suit most of the year with the water getting progressively colder as you travel north. Typical wind conditions and kite sizes vary greatly across California. In light-wind San Diego, many riders have a 17m for their everyday kite. In the Santa Cruz area the average size is closer to 8m.

More than any other place I've travelled to, kiteboarders in California take wave etiquette seriously. At some beaches it is taken extremely seriously. There are not many official restrictions on kiteboarding here, but there are many unwritten rules that exist to keep the peace between kiters and other water users – and to prevent conflict between kiters themselves. Asking other kiters about any local rules will go a long way to help keep everyone happy, and familiarise yourself with wave etiquette before charging into a crowded line-up. If you are not an experienced waverider, do yourself a favour and avoid the main break. Some spots can get crowded and riders fall into a rotation. Not following the rotation is a guaranteed way to get yelled at on the water and receive a stern talking-to back on land.

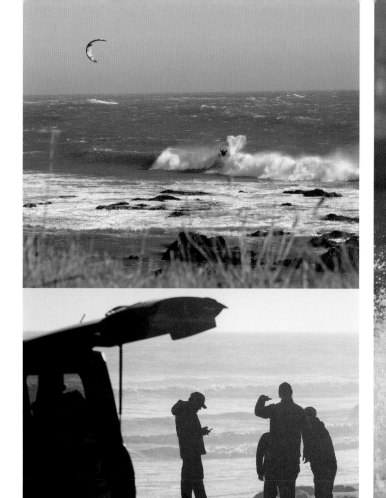

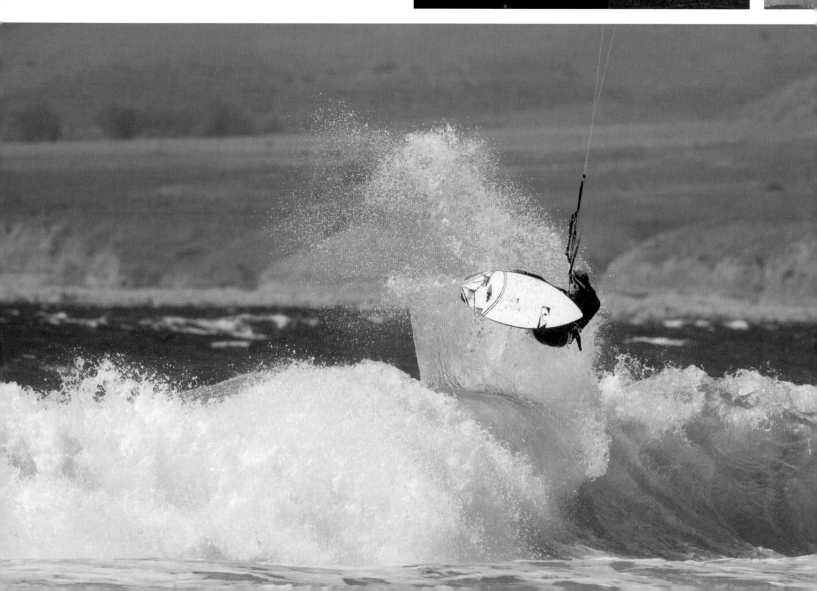

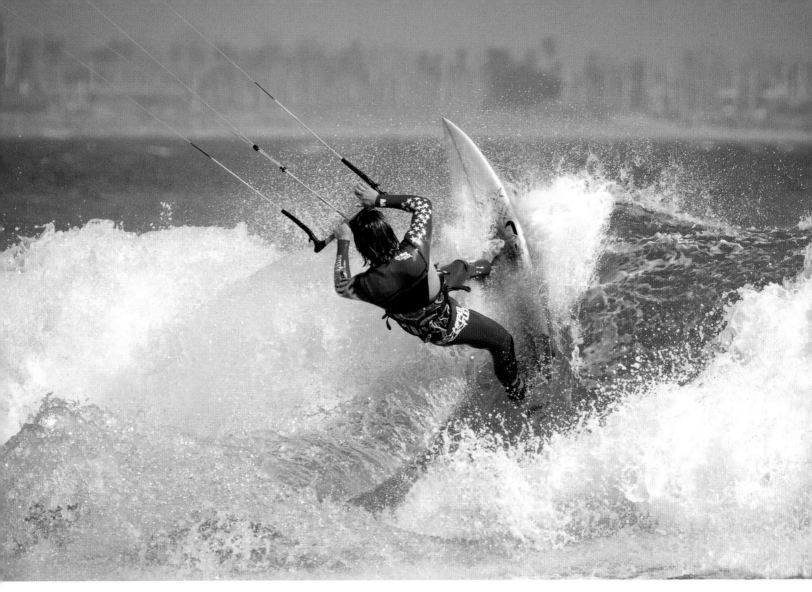

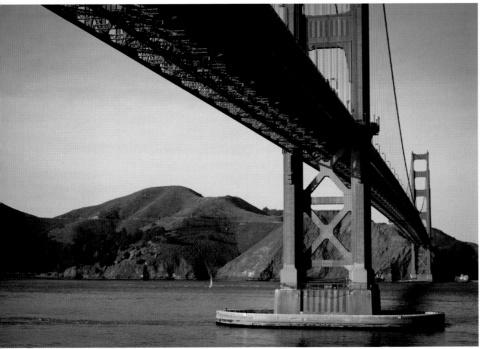

The wide variety of conditions, coupled with year-round riding, has resulted in California generating some of the world's best strapless kiteboarders. The roster of Californian kiteboarders includes names such as Patrick Rebstock, Ian Alldredge, Josh Mulcoy, James Ropner, Josh 'Cornfed' Nehf, Alec Dektor, Peter Trow, and a long list of super-talented riders that you will never have heard of.

Most kiteboarders dream of hollow waves and side-off wind, but those conditions are rare in California. Much of the coast sees side-shore, side-on, or onshore wind coming from the right combined with mushy, blown-out beach break. These conditions might not lend themselves well to down-the-line riding, but they've been instrumental in driving the freestyle strapless movement. Every once in a while the wind direction, swell and tide all line up to create banner days with clean down-the-line riding at some of the point breaks. Goofy footers live for the occasional south-wind days that happen only a few times a year. Surf conditions can range from ankle-high mush to clean well-overhead faces. The shape of the coast creates a number of different microclimates, meaning that the wind can be radically different on two beaches that are only a few miles apart, while the direction a beach faces has a huge impact on whether it receives a particular swell. The big bonus of this set-up is that at any given moment the conditions are good for kiteboarding somewhere in California. That's pretty much guaranteed in the Golden State.'

MITU MONTEIRO

As in all sports, there will always be those who stand taller than the rest, those who seem like they were born to do their thing and could never have done anything else. In the world of waveriding with a kite, Mitu Monteiro is one of those people. The Cape Verdean has been at the pinnacle of the sport for many years, and has provided the gold standard for effortless surf-driven style. Mitu has been a stand-out for many years, but perhaps his most remarkable performance was at the KSP One Eye 2011. On the biggest day of the event, when most riders were content just to make a couple of solid turns and to survive, Mitu could be found seeking out the biggest set waves, hitting the most critical sections, switching stance at will, and pulling into the brutal, spitting barrels – it was a masterclass.

Behind Mitu every step of the way have been F-ONE Kiteboarding and Raphael Salles, and Mitu has been dedicated to the brand and to developing their highly respected range of surfboards, and to each new incarnation of the Bandit.

Aside from his kiting prowess, Mitu has also been a great ambassador for the sport and for the islands he calls home, and in his wake have followed other impossibly gifted waveriders brought up on Mitu's diet of commitment, skill and generous spirit.

ABOVE: *Photo: Marc Rowley.*
OPPOSITE PAGE: *Photo: Ben Thouard.*
BELOW: *Photo: Max Houyvet.*

ALL ABOUT ME...

- **Trophy Cabinet:** KPWT Wave Masters 2008 – 1st
KPWT Wave Masters 2009 – 4th (having missed one stop)
PKRA Wave tour 2010 – 2nd
KSP World Tour 2011 – 2nd
KSP World Tour 2012 – 2nd
KSP World Tour 2013 – 5th
- **In the bag:** 10, 8, 6m Bandit 5'10 Mitu Monteiro Pro Model, F-ONE 5'11.
- **Best spot:** Ponta Preta. It is the best wave I have ever seen. It is close to the shore, it gives us perfect barrels, the water is so transparent and at sunset you feel part of the sea and the sky.
- **First set-up:** Wipika 11m and directional custom with three straps.
- **Proudest kiting moment:** Riding Teahupoo in May 2013. I know it is the heaviest wave in the world but I so wished to surf it! I got some perfect barrels, and in one of them the lines of my kite were almost caught in the wave but fortunately I got the right timing to escape from it – I can still feel the thrill when remembering the power of that wall of water above me.

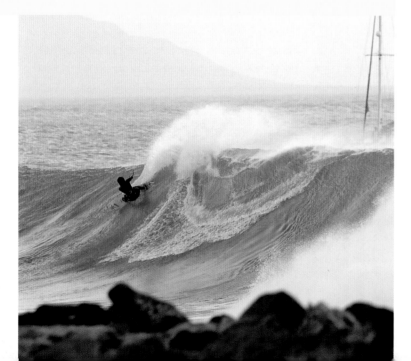

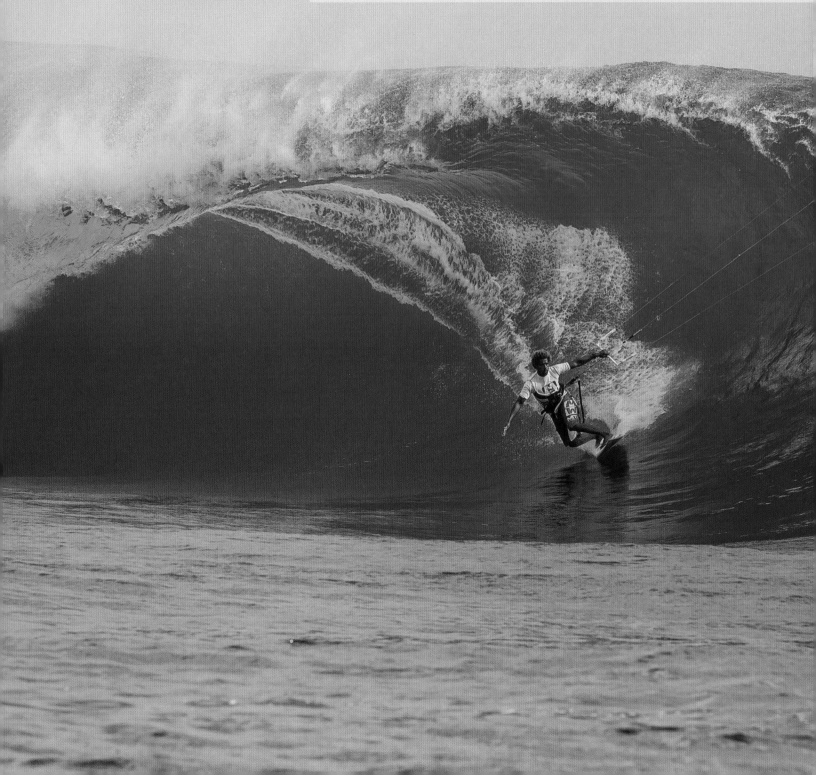

Don't take my word for it…
ABEL LAGO

The first time I met Mitu was in Gran Canaria on the windsurfing world tour in the '90s. He was already a very talented and stylish windsurfer, surfer and SUPer, and since then we have met many times kitesurfing.

Mitu is always happy and having fun in life. Whether the conditions are good or bad he is always enjoying himself and making the people around him smile, and after the kiting is over he takes his guitar and plays for everybody. I remember when I was training in Cape Verde he came to me and started teaching me how to do the frontside 360 air – this is not normal for someone who you are used to competing against!

Mitu is a national hero on Cabo Verde, and if you go with him to the beach there then you feel that all the locals love him and look to him as an idol. I have competed with him in a lot of spots around the world, but when I saw him riding in Ponta Preta I have to say that I was most impressed by how he rides in his home spot. With all my respects to the other riders, for me Mitu is the best waverider when the waves are big and with consequences. I totally respect him and he is a great inspiration for me.

PLAYER
KEAHI DE ABOITIZ

Freestyle had been Keahi's competitive focus through the late 2000s, before he switched direction and blasted on to to the waveriding scene in 2011, winning the PKRA waveriding title. This was followed by the KSP title in 2012 and 2013. His super-progressive surf style seemed to be in a different league to that of most of the competition. This style has continued to develop and evolve and has been stamped on his KSP performances, where Keahi's skill-set equips him as well for shoulder-high onshore mush and strapless freestyle as it does for double-overhead One Eye. Sponsored and supported by Cabrinha since his first contest in 2006, Keahi is one of the most progressive younger riders on the scene and promises to continue driving the waveriding side of the sport forwards over the coming years.

When he's not on the contest circuit, Keahi now generally spends his winters on Hawaii where he regularly pushes the limit of what is possible strapless on a surfboard at the toughest proving ground of all. Despite his staggering skills kiteboarding, and a similarly glittering SUP career, for Keahi there is still one experience that beats them all: 'Nothing beats a good barrel when you're surfing!'

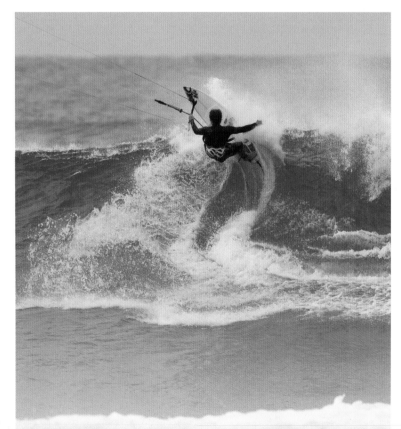

ALL ABOUT ME…

- **Trophy cabinet:**
 Australian Freestyle Nationals U18 2007 – 1st
 Australian Freestyle Nationals U18 2008 – 1st
 Australian Freestyle Nationals Open division 2009 – 1st
 Australian Freestyle Nationals Open division 2011 – 1st
 Australian Wave Nationals 2011 – 1st
 PKRA Wave World Tour 2011 – 1st
 KSP World Tour 2012 – 1st
 KSP World Tour 2013 – 1st
- **Best spot:** I'd have to say Indo – the waves are just amazing. You can have fun walling waves or slabbing barrels, and there are strong onshores for airs. Also, if there is no wind then the surf is pumping. It doesn't get much better.
- **In the bag:** 11, 9, 7m Drifter; 5'6 Skillet, 5'10 PC Pro.
- **First set-up:** Wipika 6m Wipika twin-tip
- **Proudest kiting moment:** Winning the 2012 KSP world tour in Maui was a pretty amazing feeling. It was a goal of mine for some time and to finally accomplish it felt great.

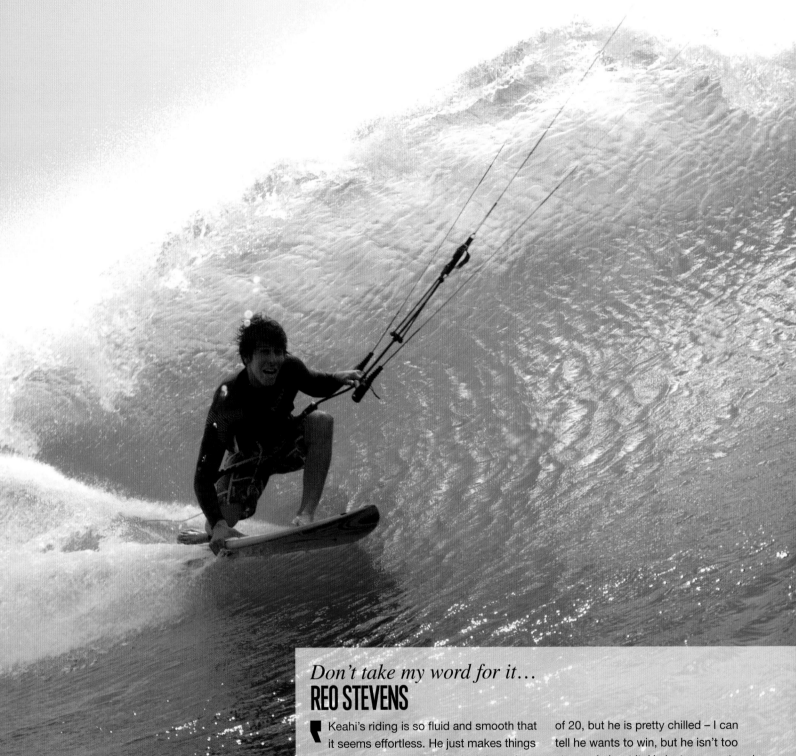

Don't take my word for it…
REO STEVENS

❝ Keahi's riding is so fluid and smooth that it seems effortless. He just makes things look easier than they are. He is right at the forefront of strapless tricks, but I'd have to say he's most solid at getting barrelled – he can find barrels on days when there are barely any decent waves. It bugs the life out of me to see him getting shacked while I can barely find a decent lip to hit!

On the competition circuit, it's pretty amazing that he had PKRA and KSP waveriding titles under his belt by the age of 20, but he is pretty chilled – I can tell he wants to win, but he isn't too stressed about it. He just goes out and has fun, does 'his thing' and is talented enough to usually walk away with a win. In my opinion though, one of his best achievements (I say one as he has several other noteworthy achievements) is the fact that, like me, we are travelling around making a living doing what we love and avoiding the pressures of a "real job". ❞

PLAYER
KIRSTY JONES

Welsh-born waterwoman Kirsty Jones was drawn to the sea as soon as she could walk. She was sailing dinghies with her dad from the age of three, and at the age of 16 discovered windsurfing and surfing and became hooked on the energy of the ocean. She went on to turn her dreams into reality by competing in the World Windsurfing Championships and surfing for the Welsh team in the Europeans. Kirsty discovered kiteboarding in Hawaii while windsurf-training in 2001 and immediately made the transition. British titles followed and then the PKRA where, at her first event, she secured second place in the freestyle and first in the waves. In 2008, Kirsty won every stage of the KPWT Wave Masters World tour and became Kitesurf World Wave Champion, a title she retained in 2009.

Aside from the competitive side of the sport, Kirsty has also completed long-distance kiteboarding trips to raise money for charity – she kiteboarded from Ireland to Wales, and in 2006 from the Canary Islands to Morocco, a nine hour non-stop crossing of 140 miles.

Kirsty now competes less, and spends much of her time combining kiteboarding with her other passion, yoga, through her Kirsty Jones Experience courses, which take place in Mauritius, Morocco and at home in Lanzarote.

ALL ABOUT ME...

- **Trophy cabinet:**
 UK Champion 2003
 KPWT Wave Masters World Cup, Portugal 2006 – 1st
 KPWT Wave Masters World Cup, Morocco 2007 – 1st
 KPWT Wave Masters World Cup, Portugal 2007 – 1st
 KPWT World Champion 2008
 Red Bull Master of the Oceans 2009 – 1st
 KPWT World Champion 2009
- **In the bag:** 10, 8, 6m North Dice, North Pro Series 5'8', Soleil 136cm.
- **Best spot:** Madagascar. For me it is just unbeatable for a few reasons – the wildness, the amazing natural life and of course the waves!
- **First set-up:** Wipika Classic and O'shea custom twin-tip.
- **Proudest kiting moment:** Competing against the men in the Red Bull Master of the Ocean event in the Dominican Republic in surfing, windsurfing and kitesurfing, and winning the overall title. I was really happy when I realised I could win the women's title for this, but then people started telling me towards the end of the event that I had a big chance of winning overall out of the men as I was doing so well in all three disciplines. It was such a cool, proud moment to be on the podium with some of the best watermen in the world.

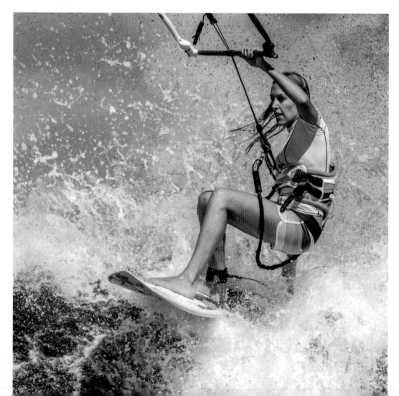

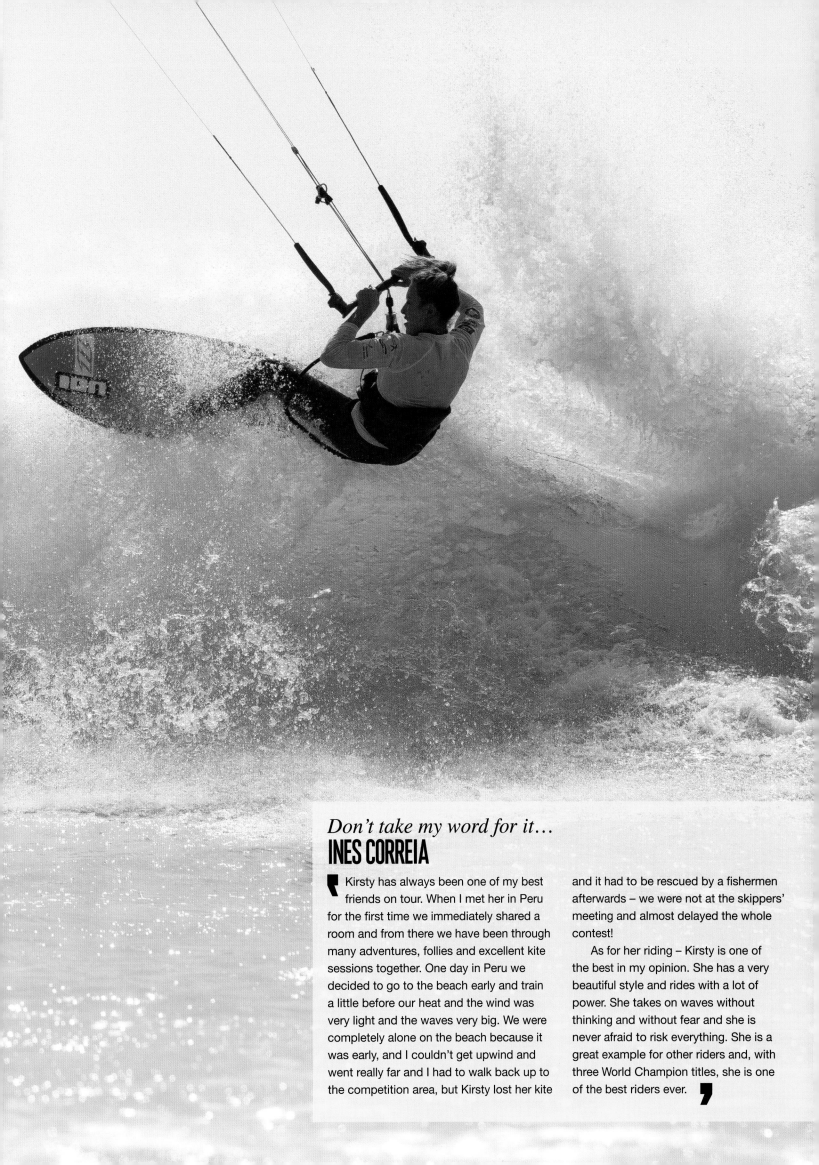

Don't take my word for it…
INES CORREIA

Kirsty has always been one of my best friends on tour. When I met her in Peru for the first time we immediately shared a room and from there we have been through many adventures, follies and excellent kite sessions together. One day in Peru we decided to go to the beach early and train a little before our heat and the wind was very light and the waves very big. We were completely alone on the beach because it was early, and I couldn't get upwind and went really far and I had to walk back up to the competition area, but Kirsty lost her kite and it had to be rescued by a fishermen afterwards – we were not at the skippers' meeting and almost delayed the whole contest!

As for her riding – Kirsty is one of the best in my opinion. She has a very beautiful style and rides with a lot of power. She takes on waves without thinking and without fear and she is never afraid to risk everything. She is a great example for other riders and, with three World Champion titles, she is one of the best riders ever.

PLAYER IAN ALLDREDGE

In a world of contracts and competitions, it's great to see guys making a living out of just kiting. **For fun.** And with the primary aim of driving the sport forwards. Ian Alldredge is one of those men. Since he had his first lesson near the yacht club at Ledbetter beach in Santa Barbara, kiting has been Ian's life. Perhaps unsurprisingly, Ian's kiting has progressed in line with childhood friend and fellow envelope-pusher, Patrick Rebstock, with the two Cali-based riders driving each other and the sport forwards through their sessions together at the many and varied spots along that stretch of prime kiteboarding real estate. With a too-easy-looking riding style, Ian seems to squeeze himself in to and out of impossible-looking sections and to always be one step ahead of the wave. Above the lip and he has also been right at the front of the new school of aerial-driven riding, helping to open up the potential of this new dimension to the sport.

Now supported by the brand that perhaps best reflects his attitude, BWS, Ian can generally be found where the waves and wind are best: Tahiti, Fiji, West Oz, or just styling it at home in Cali.

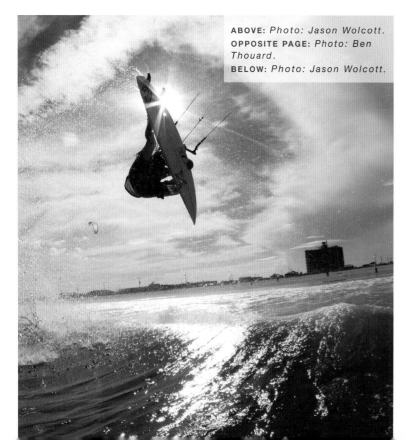

ABOVE: *Photo: Jason Wolcott.*
OPPOSITE PAGE: *Photo: Ben Thouard.*
BELOW: *Photo: Jason Wolcott.*

ALL ABOUT ME...

▪ **Trophy Cabinet:** Pot-hunting isn't really Ian's thing, but when he enters events such as the Triple-S or the mellow Merimbula classic he normally wins.

▪ **In the bag:** 8, 6, 4m BWS Noise Pro; BWS Pat Rawson 5'7, 5'11.

▪ **Best spot:** Namotu Island, Fiji. It has everything you could ever ask for. Namotu Island is out of this world. It has the most epic waves and wind for kiting and surfing and, to top it off, it also has, hands-down, the best food on the planet.

▪ **First set-up:** Two-line Liquid Force kite and a boogie board.

▪ **Proudest kiting moment:** Anytime I have an insane session on stuff I helped design. I work very closely with Dano See at BWS on developing new products and ideas and getting out on the water and feeling how well it works is pretty unbeatable.

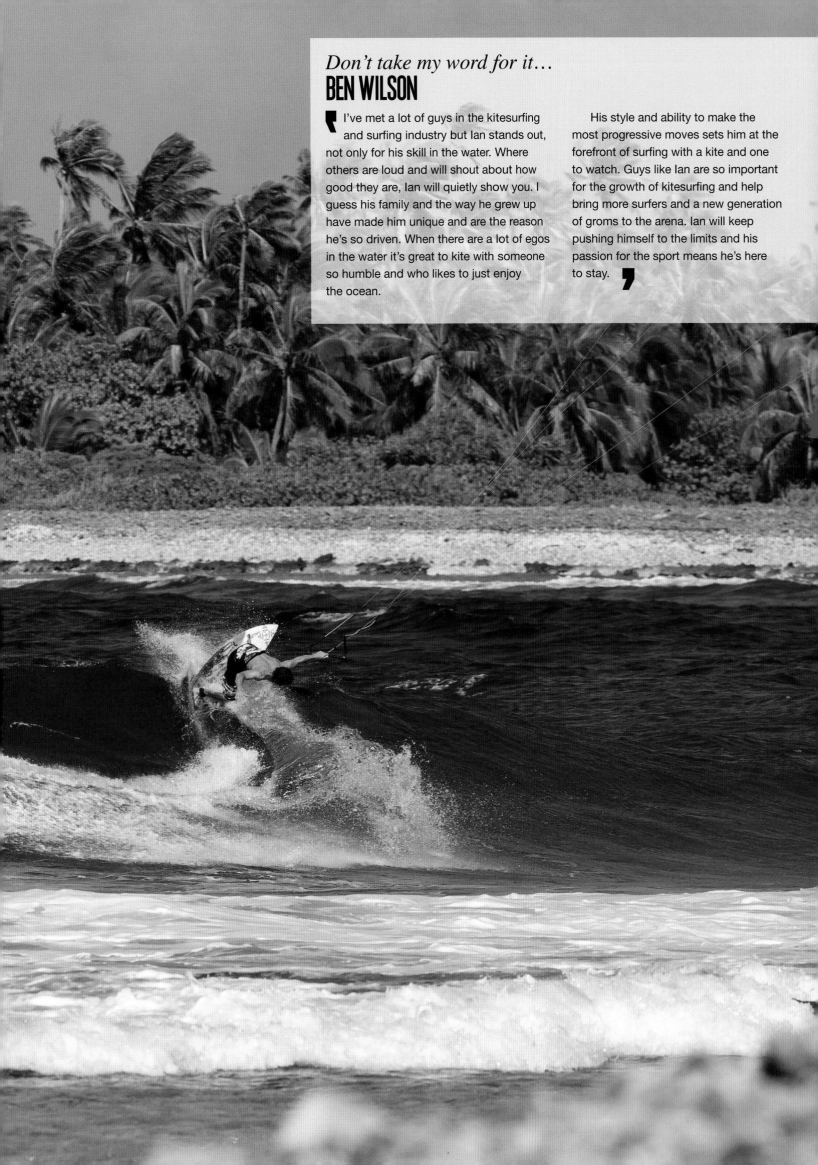

Don't take my word for it…
BEN WILSON

I've met a lot of guys in the kitesurfing and surfing industry but Ian stands out, not only for his skill in the water. Where others are loud and will shout about how good they are, Ian will quietly show you. I guess his family and the way he grew up have made him unique and are the reason he's so driven. When there are a lot of egos in the water it's great to kite with someone so humble and who likes to just enjoy the ocean.

His style and ability to make the most progressive moves sets him at the forefront of surfing with a kite and one to watch. Guys like Ian are so important for the growth of kitesurfing and help bring more surfers and a new generation of groms to the arena. Ian will keep pushing himself to the limits and his passion for the sport means he's here to stay.

RIDING CLOUDBREAK

BEN WILSON

'**Cloudbreak is such an iconic wave but nobody had attempted to kite it at that kind of size before. I'd been looking at it for five years, getting to know the wave and local weather patterns and understanding what it takes to make sure I was there at the right time.** I studied the conditions constantly and it seemed like maybe twice a year something would pop up and look good, then it would come to nothing. To be honest the whole process is super-draining. Even on the day I was completely drained! For a week it was a roller coaster of 'it's going to happen' or 'maybe there's not enough wind'. But during those times there were a lot of good moments when it wasn't that big, just a good warm-up session. On the day, I knew it was looking right so I brought the whole team in – helicopters, videographers, photographers. A lot of logistical preparation went into that wave.

Personally I'd spent a lot of time training, ensuring I was fit and healthy so I'd be physically ready for anything when the time came. Emotionally, I'm really into visualising so I imagined riding that wave long before the actual day. I considered my state of mind, what would happen if I got to the bottom of the wave and wiped out, all the possible scenarios. Of course confidence is everything, especially when it comes to my gear and preparations. In the lead-up I spent heaps of time in the water, both surfing and kiting, so I didn't doubt myself. Everything was in place so I could just get out there and catch a wave.

In the weeks before, everything was looking good. I was super-confident about the forecast model we were using, and the day before I knew it was on for sure. We had the tides and wind worked out and our plan was to tow-surf it first and feel out the waves. We also had a helicopter booked to get the best footage possible. I looked at the swell for about an hour and tow-surfed it beforehand. I knew the sets were about every 45 minutes and the second wave was always the biggest of the set. I tied everything in to give us the best chance of being in the right spot at the right time and it all seemed to be coming together perfectly. And then – in the first ten

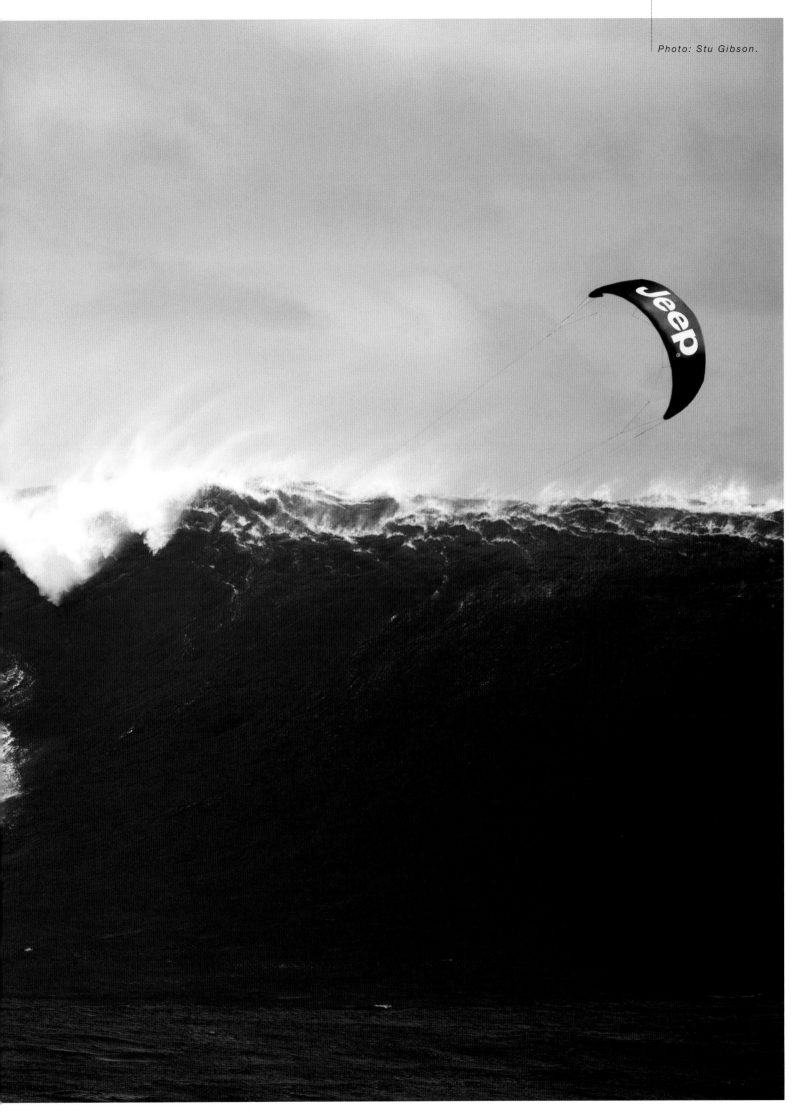

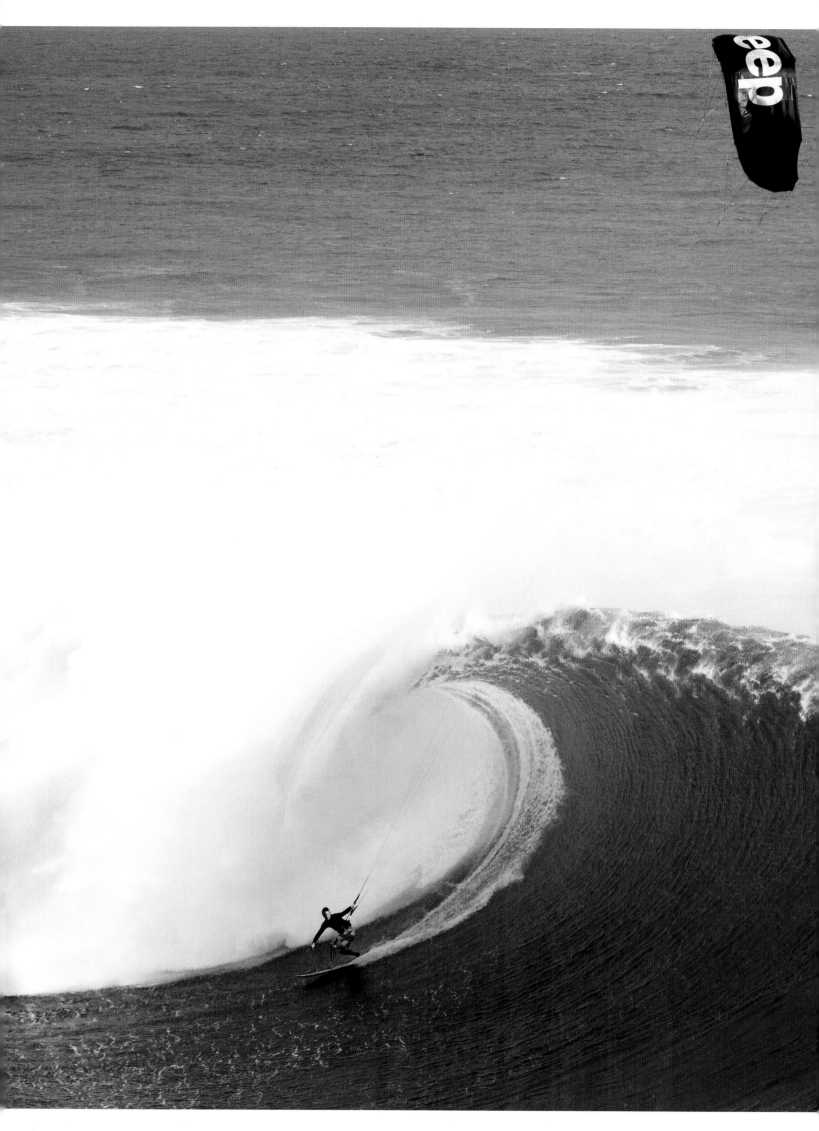

minutes out there – a bird flew into my kite and popped it! That made me doubt everything. I had to change my mindset and regroup, so I swapped out my kite and after that it was all good.

Then I was just waiting – I know a place in the reef where the really good big sets stack up. I waited out there tacking back and forth for 40 minutes, letting the wrong waves go past and the other guys get them. I knew when the sets came through I'd take the second wave, the biggest. By knowing what was going on I was giving myself the best chance, and with only one wave every 40 minutes I had to be ready when it came. On days like that, everything is super-calculated.

When that wave came I knew it was bigger than anything I'd seen. I was in the right spot and everything was perfect. I still remember clearly thinking, 'I just need to get from this spot here, to that spot down the line'. What I didn't anticipate was just how much water would be drawn from the reef. It actually felt like a motionless wave that kept sucking me up the face. It's one of those moments that are really hard to describe – it just seemed to keep on drawing back from under me. Afterwards I felt that maybe I wasn't on the right board. I was on tiptoes and felt it was going to explode! But it didn't, and I ended up making the wave. I probably shouldn't have ridden my standard 6'1 shortboard, next time I'd use a narrower 6' board, which is slightly thinner with more of a pintail, and I'd set the fins straighter.

Looking back now it's still one of the best days of my life kiting or surfing for sure. It changed things for me in terms of endorsements – I've built a relationship with Jeep based on that wave – and overall it's helped me with other sponsors and with furthering the BWS brand philosophy: "Our search for perfection never ends".

I want to keep going out there and kiting something bigger and better. It's just about finding the right wind and swell. I have huge ambitions for the future, to see what's possible with big-wave riding on a kite. I actually believe that the biggest waves can only be ridden with a kite – a jet ski can't get in there. That's my vision for the future. I'm never happy, I always want more!'

Photo: Stu Gibson.

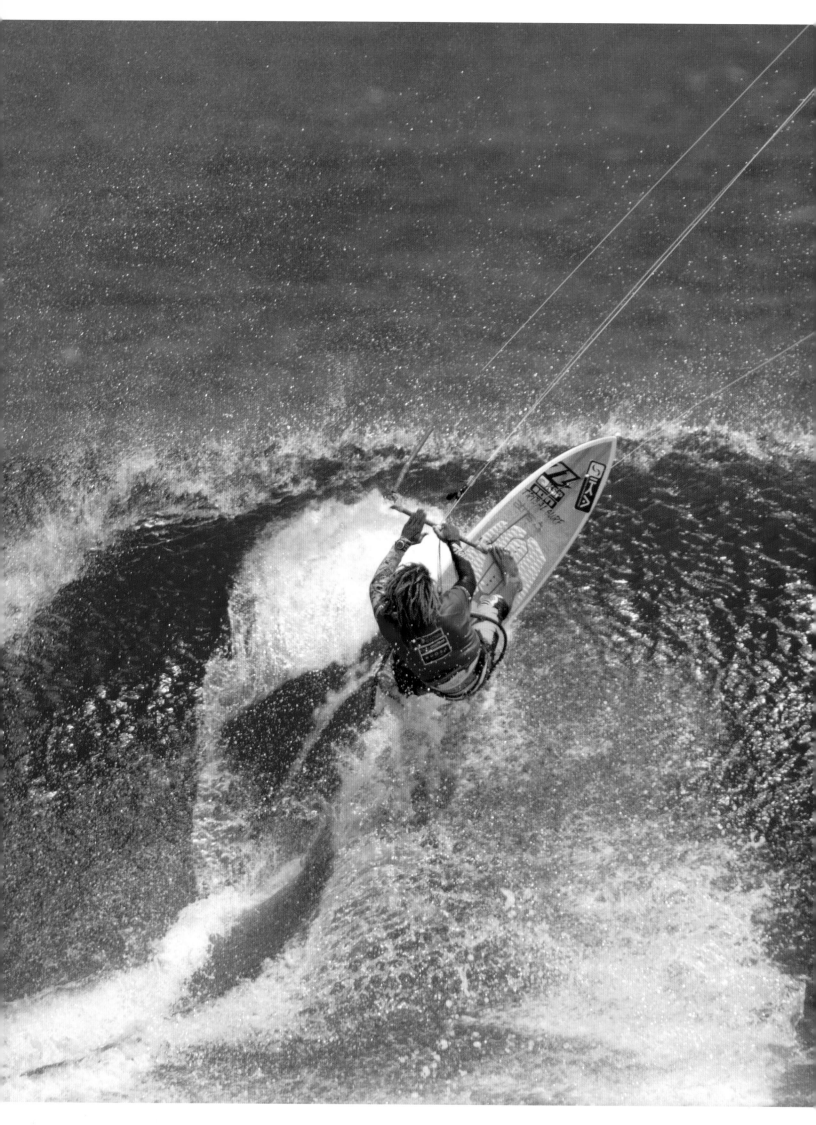

CONTEST WAVE TOUR

Fans of freestyle have long had that essential ingredient required to truly validate a sport: a competitive circuit. For over a decade riders have been able to prove themselves against the best of the rest, and brands and other sponsors have embraced competitions and provided an exciting and professional forum for kiteboarding's true athletes to push the sport ever further.

Waveriding, as a newer arrival at the party, is still striving to truly define itself in this department. It has had wave tours running in tandem with the PKRA (and previously with the KPWT) but these didn't really visit any of the truly iconic waveriding spots at which riders could truly show their worth. Unlike the world of freestyle, you need more than 'just' wind for wave events – you need quality waves too. And the fact was that many of the stops on the more freestyle orientated tours did not deliver this.

There has long been the desire and the commitment for a dedicated wave tour. There is the calibre of riders, and the quality of locations. But as the economic crisis of the late 2000s tightened its grip, it proved to be a tougher proposition than ten years ago, when

RIGHT: *Photo: Courtesy KSP.*
LEFT: Airton Cozzolino on his way to winning the first ever KSP event, 2011.
BELOW: One Eye, 2011.
Both photos: John Bilderback /KSP.

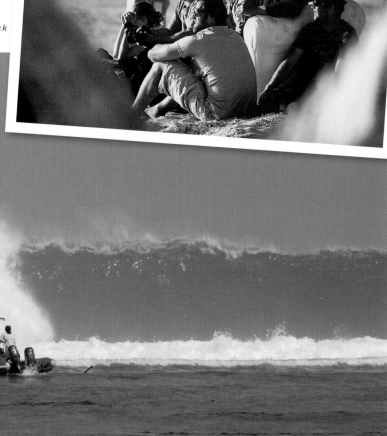

the freestyle tours established themselves with relative ease and succeeded in securing the sponsorship dollars required to sustain a tour.

The initial seeds, however, have been planted, and the epic potential of a true wave tour has undoubtedly been shown. In 2011, frustrated with the limited wave events on the current tour, some of the most respected waveriders in the game got together and stepped up. They approached the IKA with a proposal: let us arrange waveriding events at some of the best kiteable waves on the planet so that we can showcase exactly what can be achieved by surfing with a kite. The IKA were receptive and the KSP was born.

Numbers on tour were limited to 24 men and 12 women, and were drawn from around the world – ensuring a fair spread of riders and giving regional associations a role in selecting competitors, thus nurturing fresh talent. There were also wildcard entrants for each event to showcase local riders, and to give those who knew the waves the best a chance to shine.

Judging was modelled on competitive surfing with the two best waves, both scored out of ten, counting. Factors that contribute to the difficulty of the ride were considered, such as whether the rider is strapless and whether they're riding hooked or unhooked although, in reality, nearly all the KSP competitors rode strapless and hooked in. The focus of the judges was very much on the 'surf-style' of the riders, so tight

THIS PAGE
BOTTOM: *Photo: John Bilderback/KSP.*
All other photos: courtesy KSP.

OPPOSITE PAGE
TOP: *Filippe Ferreira, Ho'okipa, Maui.*
Photo: courtesy KSP.
BOTTOM: *Kristin Boese, Pacasmayo, Peru.*
Photo: John Bilderback/KSP.

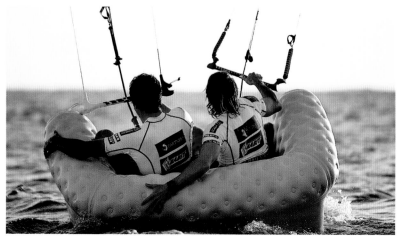

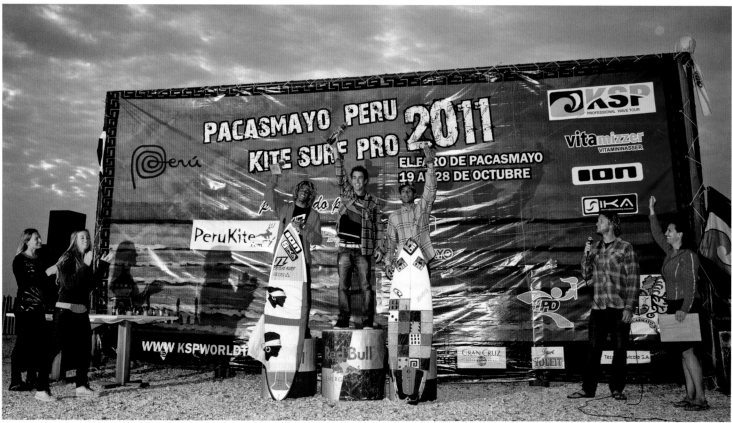

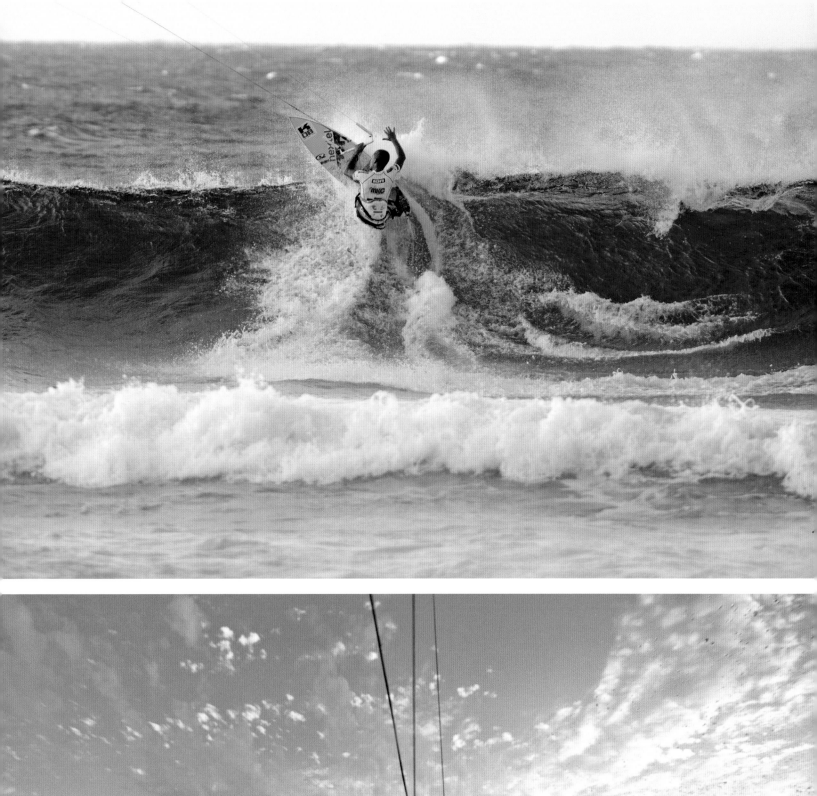
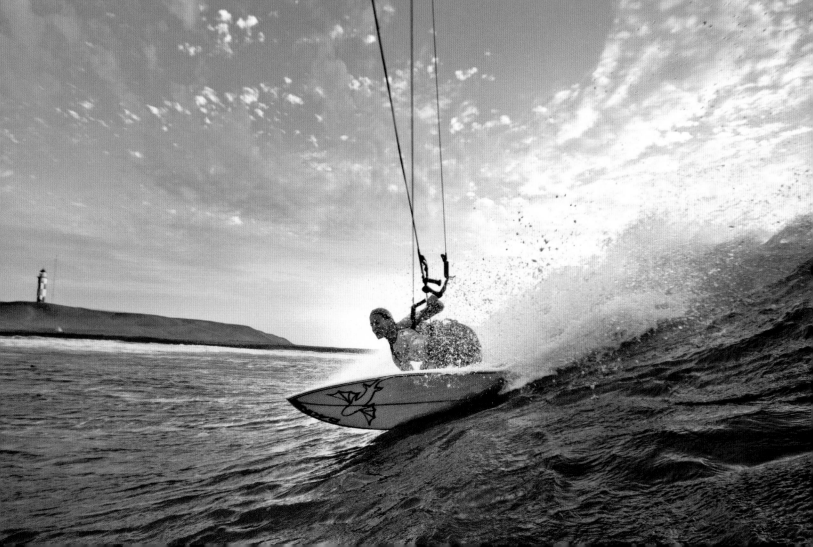

'in-the-pocket' surfing and critical turns were rewarded, and riding too far out on the wave face or not utilising the power of the wave were scored down. Many of the KSP's judges came from a surfing background and the transition to the world of kiteboarding was relatively straightforward, as they could effectively forget about the kite and just focus on the rider and the wave. The format was a success from the outset, with very few complaints from the riders in terms of the scoring system, and few disputing the fact that the winner of the competition was generally the best rider at the event.

Aside from recognising that quality waves were the essential ingredient to a successful tour, the KSP also realised from the outset that the key to growth was effective live streaming and media output. Their daily edits were slick and timely, ensuring plenty of hype about the events, and the live stream also incorporated live scoring (a first in the world of kiteboarding), enabling viewers to see in real time which rider was winning and the score required to take the lead.

The first-ever stop of the KSP Tour took place in September 2011. Anticipation was high in the run-up to the event as most of the top riders had not followed the PKRA Wave Tour and so had never competed against one another. They were only known to each other through the numerous clips seeping out from various waveriding hotspots around the world, and through features and shots in magazines, so it was intriguing to see how riders and styles matched up. Excitement levels were raised yet higher by the location of the first stop: One Eye, Mauritius. A contender for the most high-performance wave on the planet to kite, and the ultimate proving ground.

The surf gods also seemed to have sensed that there was something in the air, and the forecast for the waiting period of the event was exceptional. Having already warmed up in some massive surf in the early rounds, day five of the contest provided some of the most staggering shots and footage in the history of the sport. The surf was huge and some exceptional performances went down. The KSP could not have asked for more – although they were probably most happy that all of the riders got through the day without serious incident. The day of the finals was a little smaller, but cleaner and without a drop of water out of place – and the perfect backdrop for the crowning of the winner of the inaugural KSP Tour event. Eventual runner-up Mitu Monteiro stole the show in the later stages of the contest but was squeezed out by 0.63 of a point in the final by long-time friend Airton Cozzolino (who went on to win the tour in 2011). And so the KSP had arrived in style.

Since that first stop, the KSP tour put in a few miles and visited some of the most iconic waveriding destinations on the planet. Pacasmayo, one of many perfect swell-blessed left-hand point breaks that line this stretch of the Peruvian coast, proved to be a staggering experience for the riders, providing most of them with the longest rides of their lives – with ten plus turns possible as the wave trundled along the point. While at the other end of the temperature scale, Ireland introduced the competitors – most from warm-water climes – to the joys of 5mm wetsuits, hoods and, on the plus side, Guinness.

Perhaps the most significant event though, the event at which it felt as though the KSP had truly arrived, was the final date of the 2012 tour at the spiritual home of waveriding, the fabled Ho'okipa

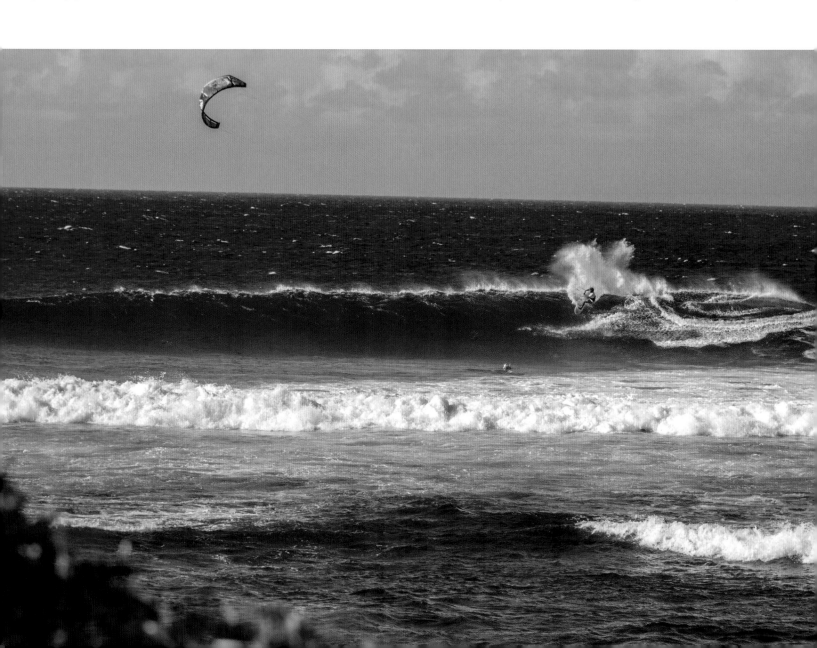

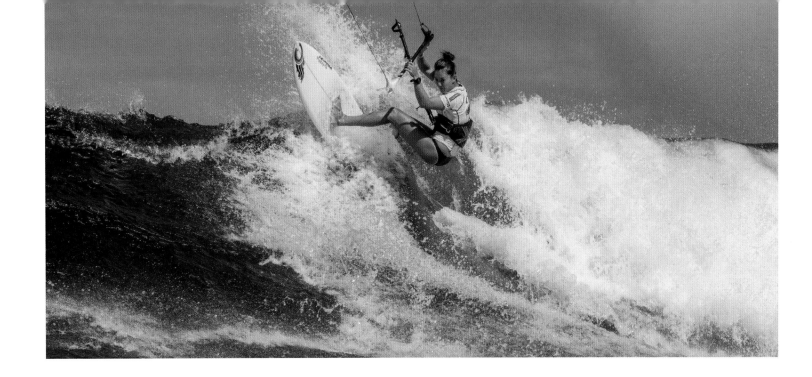

Beach on Maui. This was made all the more special due to the fact that kiters are usually restricted in their use of the wave, but for the duration of the contest they would have exclusive access. On the beach you couldn't turn around without spotting another wave-riding legend or kiteboarding icon, and windless periods on the live stream were filled by the likes of Robby Naish and Pete Cabrinha discussing the tour and life on Maui. The KSP riders

ABOVE: Moona Whyte, KSP Maui winner 2012, 2013.
LEFT: Mitu Monteiro, Ho'okipa.
All photos: courtesy KSP.

were clearly stoked to be involved in such an epic event at such an iconic location, and the conditions delivered. The final few days of the waiting period saw a solid head-high swell gracing the event, and the best waveriders in the world going head to head. The event returned to Maui in 2013 when, once again, the surf gods seemed to be showing their respect and a poor run of conditions came to an abrupt end when the KSP arrived. The event was rewarded with another fantastic run of waves and an ever higher level of competition. One thing was for sure, these events perfectly showcased how far the sport has come since those first tentative kiteboarding attempts at Ho'okipa in the mid-1990s.

Of all disciplines of the sport, it is the waveriding side that has perhaps seen the swiftest progression over the last few years – the evolution in kite and board technology has enabled kiteboarders to really 'surf' waves and to catch 30 waves in an hour, rather than the 10 or so you might get paddle-surfing. The competitive side of the sport has not developed at quite such a staggering pace, but the potential is clear to all who have followed the KSP and some of the truly epic events that have been held. The future is surely bright and – who knows – maybe one day the wave tour will be the biggest show in town.

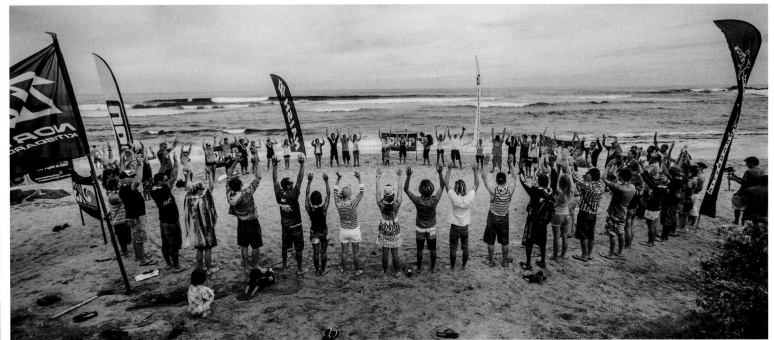

WAKESTYLE

As a sport, some would argue that kiteboarding has sometimes struggled to find its own identity. This was perhaps most obvious in the wakestyle side of the sport but now, thanks to the commitment of the old guard and the vision of the new school of riders, wakestyle has confirmed itself as one of the most legitimate and respected elements of kiteboarding.

One thing wakestyle has in its favour is that, from a media perspective, it's a very 'good-looking' discipline. Whereas it can be hard to establish exactly what a freestyle rider is up to from a photo, with wakestyle it's obvious. This has helped the wakestyle scene and its tight-knit crew of riders to box above their weight in terms of media exposure, which has in turn set a whole new generation of kiters off along the wakestyle road.

Wakestyle is a precursor to 'freestyle' as we now know it. Lou Wainman kicked off in Maui riding a wakeboard and using boots at a time when the rest of the early riders were on directional boards with footstraps. Until the early 2000s, the wakestyle crew were a separate, more underground entity, but then it became clear that a twin-tip was the most efficient way to ride with a kite. The twin-tip revolution began and the brands started producing boards similar to the wakeboards of the wakestyle crew, but with footstraps.

Although twin-tips became the standard board design for the kite industry, the riding styles were still very far apart. The Kite Beach crew on Maui were directly influenced by wakeboarding, whereas the rest of the kiteboarding world took a direction more like freestyle motocross, with big jumps and board-offs. From here these two interpretations of the sport followed different paths, with freestyle becoming more competition-focussed, and the wakestyle-riders concentrating on travelling to build rails and shoot videos.

RIGHT: Eric Rienstra, Hood River. *Photo: Paul Lang.*

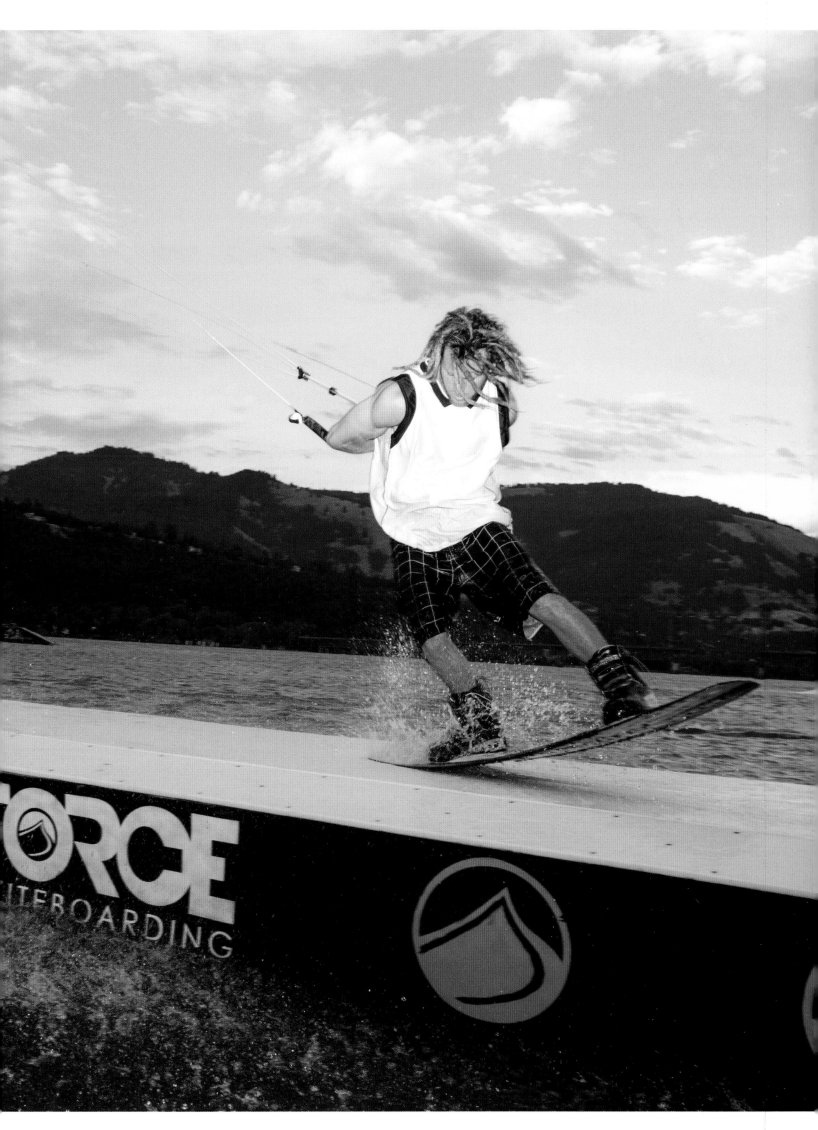

FORCE
WAKEBOARDING

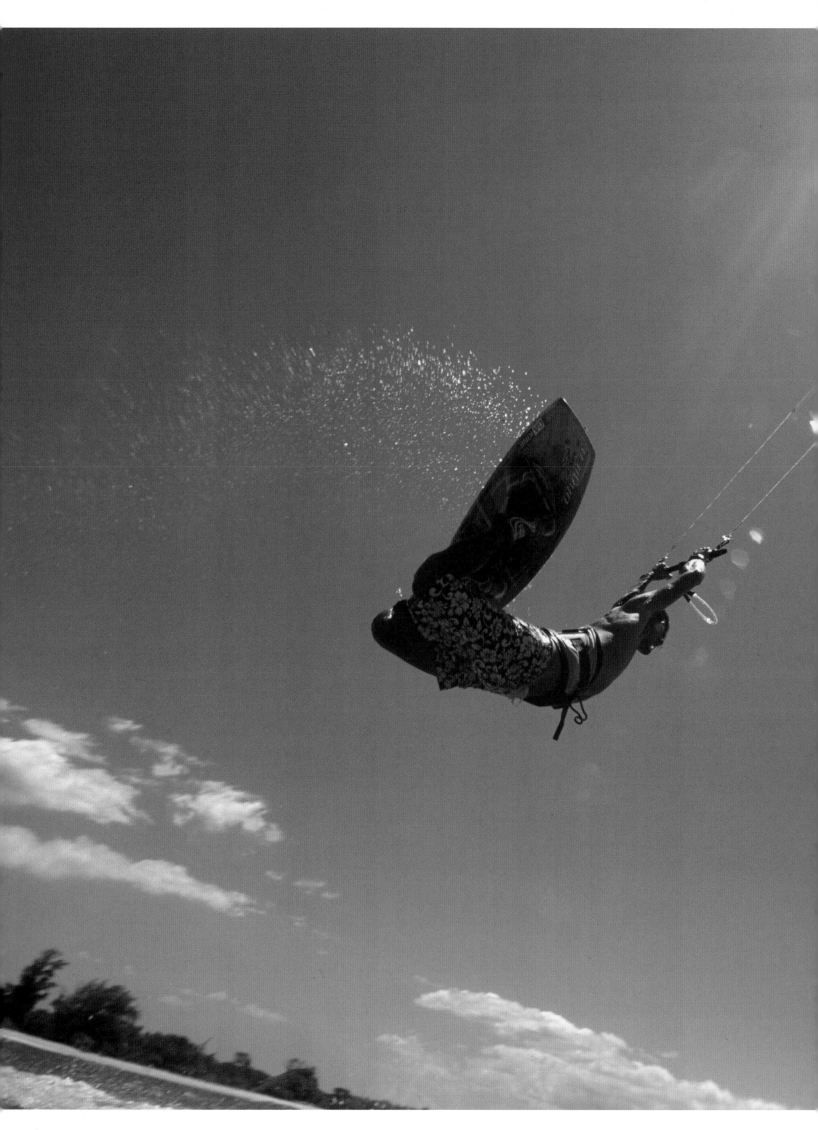

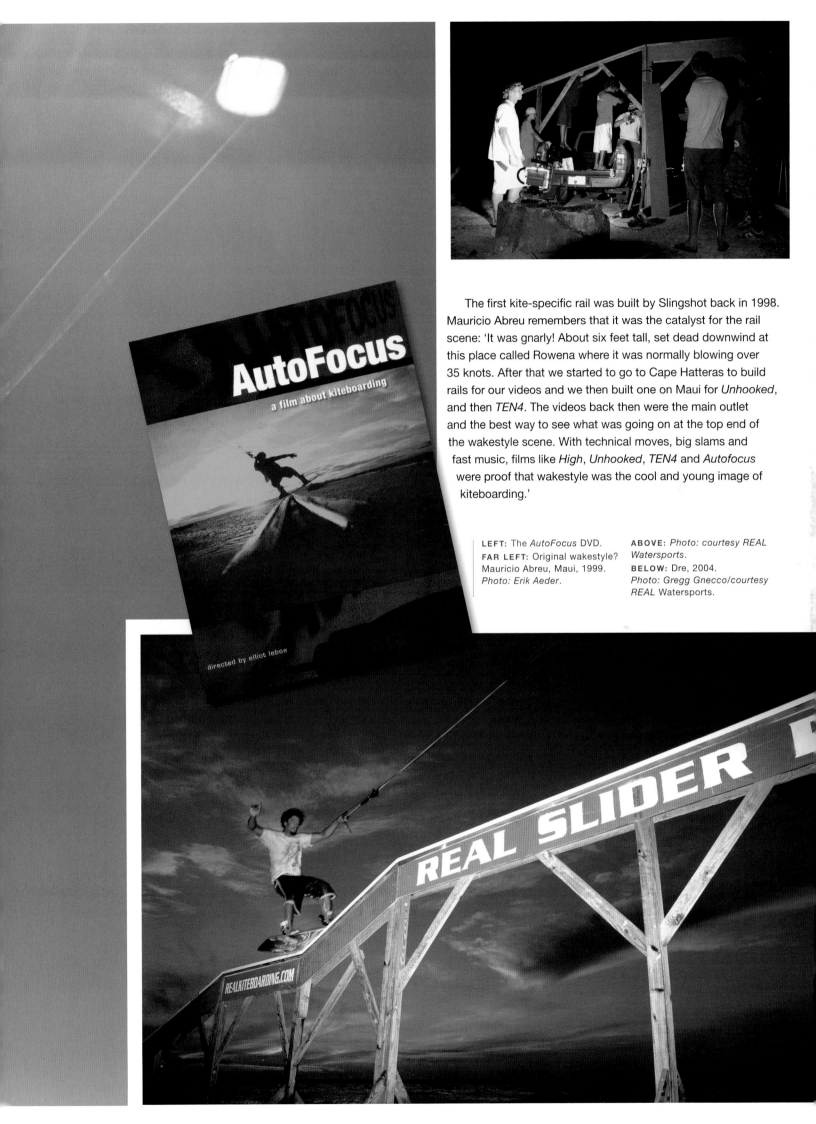

The first kite-specific rail was built by Slingshot back in 1998. Mauricio Abreu remembers that it was the catalyst for the rail scene: 'It was gnarly! About six feet tall, set dead downwind at this place called Rowena where it was normally blowing over 35 knots. After that we started to go to Cape Hatteras to build rails for our videos and we then built one on Maui for *Unhooked*, and then *TEN4*. The videos back then were the main outlet and the best way to see what was going on at the top end of the wakestyle scene. With technical moves, big slams and fast music, films like *High*, *Unhooked*, *TEN4* and *Autofocus* were proof that wakestyle was the cool and young image of kiteboarding.'

LEFT: The *AutoFocus* DVD.
FAR LEFT: Original wakestyle? Mauricio Abreu, Maui, 1999. *Photo: Erik Aeder*.
ABOVE: *Photo: courtesy REAL Watersports*.
BELOW: Dre, 2004. *Photo: Gregg Gnecco/courtesy REAL Watersports*.

Of all of these iconic films, the one that had the biggest impact on the slider movement came out at the end of 2005: *Autofocus*. It was the first full-length film featuring kiteboarders exclusively in rail parks. The crew spent three months on the road building rails and waiting for the right conditions to session, and they ended up building full parks in Antigua and Venezuela. The effort was worthwhile and the film was an instant hit, giving a new generation of wakestyle-riders a riding style – and attitude – to model themselves on.

Since those early days, Cape Hatteras has been at the hub of the wakestyle scene, with the REAL Slider Park a true Mecca for wakestyle-riders. The journey to today's set-up there began when a lot of the early wakestyle purists visited the park in 2003 and helped Trip Foreman and Matt Nuzzo of REAL put some features together. Mauricio remembers: 'We went to Hatteras to film *Unhooked*, and that was when we built the first rails out there. We then went back

filming for Elliot's first video, but this time we built a whole park. The following year Trip wanted to do a camp for his clients to teach them to ride surf, slick and sliders. I was the pro rider that was going to teach REAL clients, but what ended up happening was that, as soon as the news got out, all the wakestyle crew called and asked to be there too, so we had one client and eight pros! The next year the first Triple-S was born.'

The Triple-S provided a legitimate outlet for the wakestyle riders to compete against each other, and also brought riders from across the world together. True, the outcome may not have mattered too much, but the chance to learn from and ride with like-minded kiters (and the parties) made it all worthwhile, and allowed this side of the sport to really generate some momentum. Alex Fox, one of the new school of wakestyle-riders, reflects that: 'For the wakestyle scene now events like the Triple-S are pretty vital. I hate to say that about any contest, but for anyone else to recognise a part of the sport you

need a champion. I think it's a great format and what they have done sets a precedent for other people to follow. It's grass roots at the moment, and those guys work their asses off to put that event on, but it's great for the profile of the sport.'.

Of all the tangents that kiteboarding has taken, the wakestyle scene probably has the most tight-knit crew of riders. There is no doubt that park-riding requires massive commitment on a day-to-day basis and, although the top riders make it look straightforward, there are consequences to hitting a rail wrong at speed, and bringing the most technical elements of both wakeboarding and kiteboarding together is as challenging as it sounds.

There is no dispute now though. Thanks to the years of work put in by the early crew of riders, wakestyle has emerged as one of the most important elements of kiteboarding, with an ever-increasing crop of exciting new riders emerging on to the scene. But don't forget the old guys. Alex Fox remembers: 'When I started out I

could tell what the wakestyle scene was. I didn't really put that terminology with it, I could just tell there were the guys wearing boots and freeriding as opposed to the guys who were more involved with the contest scene. I looked up to and admired a lot of them – Lou, Dre, and Mauricio for starters – I idolised those guys throughout my youth, and without them there wouldn't be this side of the sport. We would all just be doing board-offs still! Those guys were true visionaries and I hope they are stoked by the younger riders that have begun to carry the torch.'

THE KIT

WAKESTYLE BOARDS
TONY LOGOSZ, SLINGSHOT

IN THEORY

'Wakestyle kiting puts different strains on a kiteboard. This side of the sport is characterised by not generating lift from your kite, but keeping it low and using board speed and edge to generate pop. Unlike freestyle boards, which a lot of kiters ride with straps, you can expect wakestyle riders to all be wearing boots and this puts a lot of additional strain on a board. This needs to be considered as they are loading a considerable extra amount of energy into the rail when compared to a "traditional" freestyle set-up. Wakestyle boards also need to perform in the park where they are going to be hitting sliders and kickers, so they need to have a durable and smooth sliding base and for it to be possible to ride them without fins.

Stiffness, core, rocker and the board's outline are the main ingredients for creating the perfect load and pop for a wakestyle board. I might want a board that has 46mm of continuous rocker, but if stiffness doesn't match the performance, then the rocker number is not relevant. When you stand on it, it will go flat or won't change at all if it's too stiff. Stiffness controls the rocker and stores the energy for powerful pop. So the key to building a perfect wakestyle board is to look at the rocker, stiffness and outline and how they work together, it's not just one number.'

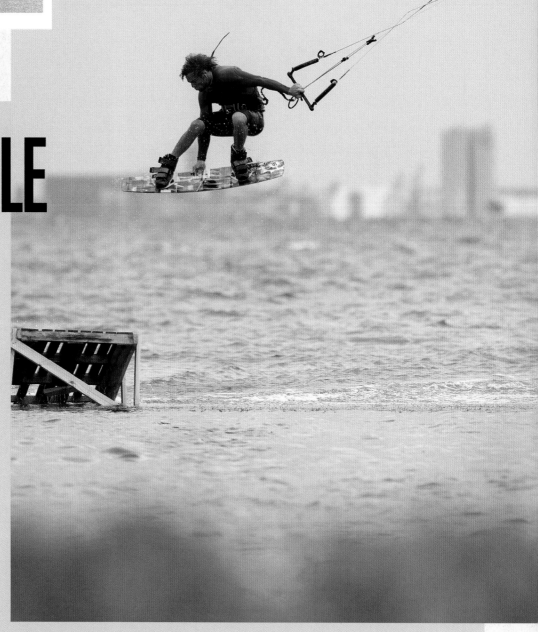

Photo: courtesy Slingshot.

IN PRACTICE – THE VISION

'The Vision adopted proven concepts from our wake line-up. We made changes to the rocker and flex to provide the ideal performance kiteboard, and the new performance outline allows for unmatched performance no matter what the discipline. The style channels allow for great traction with or without fins and provide an innovative approach to water displacement. Riders such as Sam Light have worked hard to prove that this board will meet riders' needs when it comes to wakestyle, freestyle, and free riding. As with all of our boards the Vision is handmade in our USA factory, giving us unlimited options for hands on research and development.'

WAKESTYLE KITES

GARY SISKAR, LIQUID FORCE

IN THEORY

'For a wakestyle kite, stability is the number one factor and this is the only type of kite where being slower in the turn is better. Wakestyle riders are on the quest for a "direct" pull from the kite. They don't want a jerky-type of feel. So you might look at having additional adjustment to the kites in the lower pigtails and on the wing tip so that you can go from a crisp, fast responsive kite to an ultra-stable, slower direct pull. If you were to make a pure wakestyle kite it would be called a cable! But if there were a 100 per cent "pure" wakestyle kite out there it would be too slow for the majority of the kiteboarding population. This is why adjustability is key. Also important is the pop and slack – you want to have a nice controlled power pop out of the kite, while the slack is important to keep the kite where you want it and when you want it.

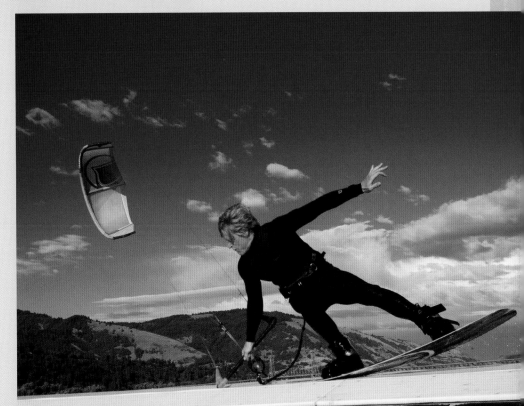

Photo: courtesy Lukas Prudky.

In terms of the shape, medium-aspect kites seem to be the best as they combine the best of both worlds in terms of grunt and stability, and a medium-aspect ratio allows for greater adjustability in terms of speed and feel. Also, where the kite sits in the wind window is important. You don't want it to sit too far forwards or the kite will want to surge out of the wind window when unhooking. Equally, if it sits too deep, control on sliders could be compromised by an indirect pull. So a medium-aspect kite is the best option

There have been two big improvements over the past five years. First, the stability has got better and better, and second, the durability has improved. Let's face it, riding wakestyle is not only demanding on the rider, but also the equipment. Now that better materials and construction techniques are being used we have much tougher kites, which not only benefits the wake crew but also every kiteboarder out there.'

IN PRACTICE – THE ENVY

'Our main wakestyle kite is the Envy, which was revolutionary at a time when the trend was to add struts to kites. Julien Fillion, the Liquid Force kite designer, had a vision for less and was looking to create a lighter platform that was efficient and ultra-stable. This is where it all started in 2009 and since then the Envy has evolved a lot. The overall profile of the kite has stayed the same, but the bridles and wing-tip profiles have changed. It still has the same three strut platform and retains all the characteristics and advantages of this design, but now it has evolved into a highly adjustable kite in terms of feel – it has the wide range of being able to go from a parked, stable, drifting kite to a fast, crisp and reactive kite.'

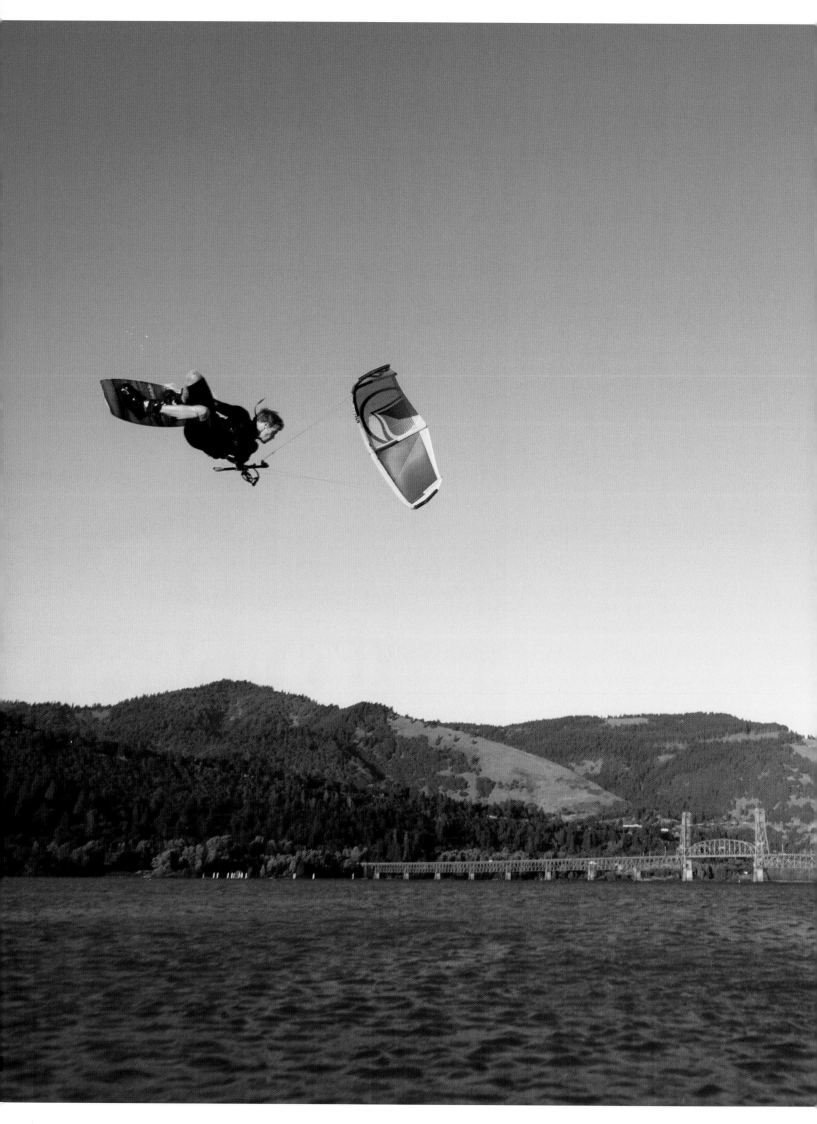

HOOD RIVER

The Gorge

ERIC RIENSTRA, SLINGSHOT RIDER

LEFT: Brandon Scheid setting the scene. *Photo: Cole Elsasser.*
RIGHT: *Photo: Lance Koudele.*

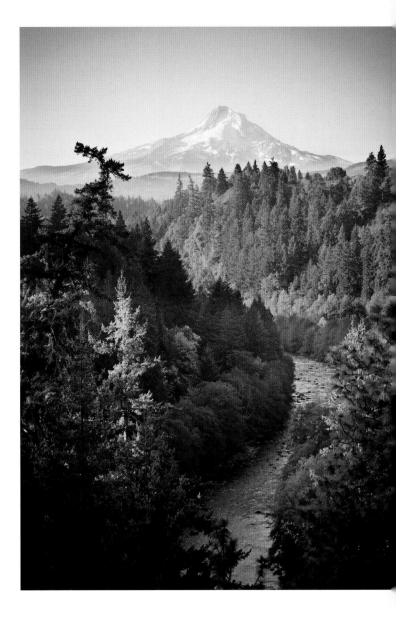

'**K**iteboarding has invaded the "windsurfing capital of the world". And for good reason. The Columbia River cuts the only sea-level passageway through the Cascade Mountain Range and the narrow Gorge funnels wind upstream with incredible consistency.** Ever since Cory Roeseler flew past all the sailboarders in the Gorge Blowout on the first "kite ski", kiteboarding has slowly infiltrated the small river town. Now kites are just as numerous as sails and the world's only sanctioned kite park sits front and centre at the Hood River Spit, marking kiteboarding's claim and establishing the area as the epicentre for wake- and park-style riding.

The Gorge transitions from temperate rainforest to dry grasslands in only 80 miles. In the summer, atmospheric pressure differentials east and west of the Cascades create a wind-tunnel effect that often generates well over 25 knots of wind. Have you ever

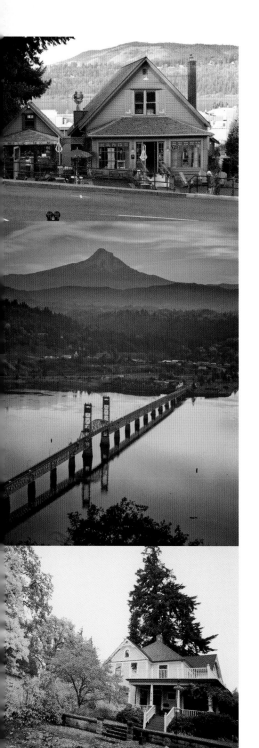

heard someone say the wind is nuking or nuclear? Well, odds-on that term was coined here ... The city of Hood River is located at the mouth of the glacier-fed Hood River, where it meets with the Columbia. The small windsurf shops that once lined the streets have transformed gradually into larger multisport shops littered among coffee shops, restaurants, bars and breweries. The global headquarters for two of the largest kite equipment manufacturers, Slingshot Sports and Dakine, can be found just a few blocks from downtown.

Even if there is no wind, there is always something exciting to do. There is awesome mountain biking, kayaking, climbing and hiking, as well as an amazing skate park, and the ski resort stays open all year atop Mount Hood. It seems like everyone in the whole town is some sort of adventure-sport participant, their stoke and anticipation ringing harmoniously as they grab a bagel and coffee in the morning before running off for an exciting day of activities, returning as the sun retreats to share their exploits over a beer and a fat burger. Even if things do not go as planned or the weather is not perfect, no one ever has a bad day.

A stone's throw from downtown is the Hood River Sand Bar, a large sand and rock bar created by sediment flowing down the Hood River. Over time it has grown to span more than halfway across the Columbia. It can be accessed by one of three beachfront parks: the Event Site, the Spit and the Marina. Throughout the summer, events and demos are held regularly at these locations, and kite schools are constantly getting new riders on the water. If there is no wind in Hood River it does not always mean the day is lost for kiting. Sometimes the pressure has just shifted and moved up or down the river. If the clouds have set in and it's cold in Hood, driving east to spots like Rufus or 3 Mile will often warm things up. If it is hot in the Hood, you can go west and check out Stevenson or Rooster Rock, or even make the trek all the way to the coast.

The eastern side of the Sand Bar is protected from the Columbia's massive rolling swells, making the water perfectly flat and ideal for a riding park. The Slider Project, led by Joby Cook and Forest Rae, has worked tirelessly to establish the world's first and only sanctioned kite park, securing permits from the Port of Hood River as well as building and maintaining the park's features. The park has attracted almost every pro park rider from all over North America and Europe. From 2010 to 2012, The Slider Project hosted the Ro-Sham Throw Down, one of two park-oriented events held in the United States. Kiteboarding's first slope-style format was implemented in the event's third year, raising the standard of competition to that of other board sports like wakeboarding and snowboarding, and influencing its east coast counterpart, the REAL Triple-S, to do the same.

With everything there is to do it is no wonder that most people who visit Hood River never want to leave, and sometimes don't. It is one of if not the world's greatest sport and recreation destinations. No one can really tell which sport reigns supreme in the windy city, but one thing is for sure: it's all good in the Hood.'

RIGHT TOP: Victor Hays enjoying the space.
RIGHT BOTTOM: Eric Rienstra ticking the 'mountains' box.
All photos: *Lance Koudele*.

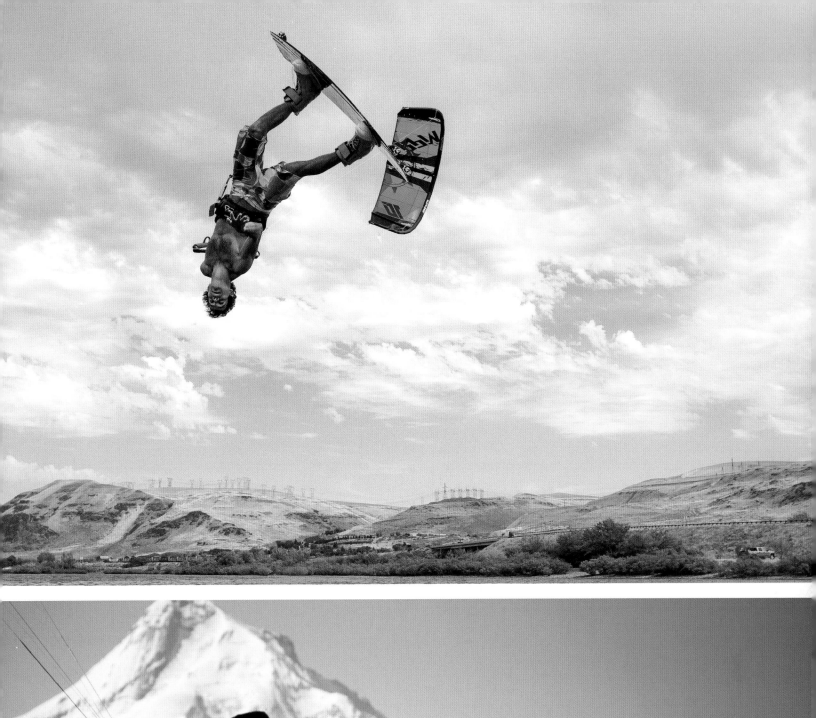

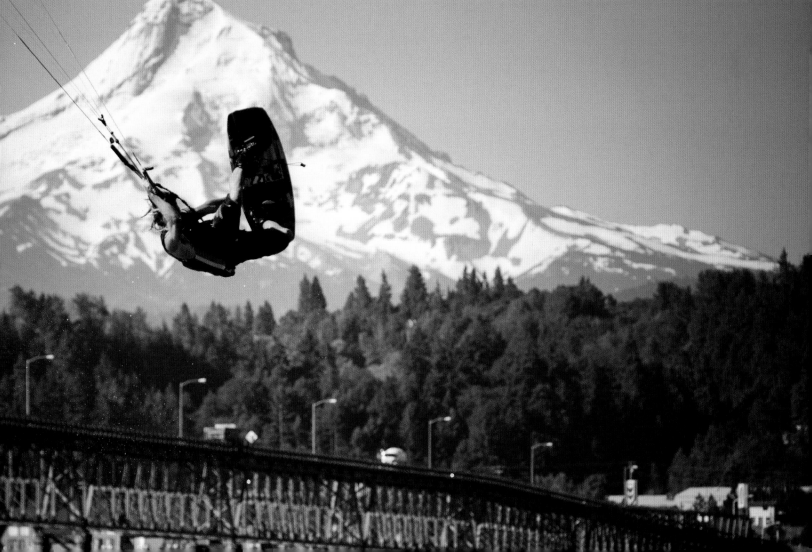

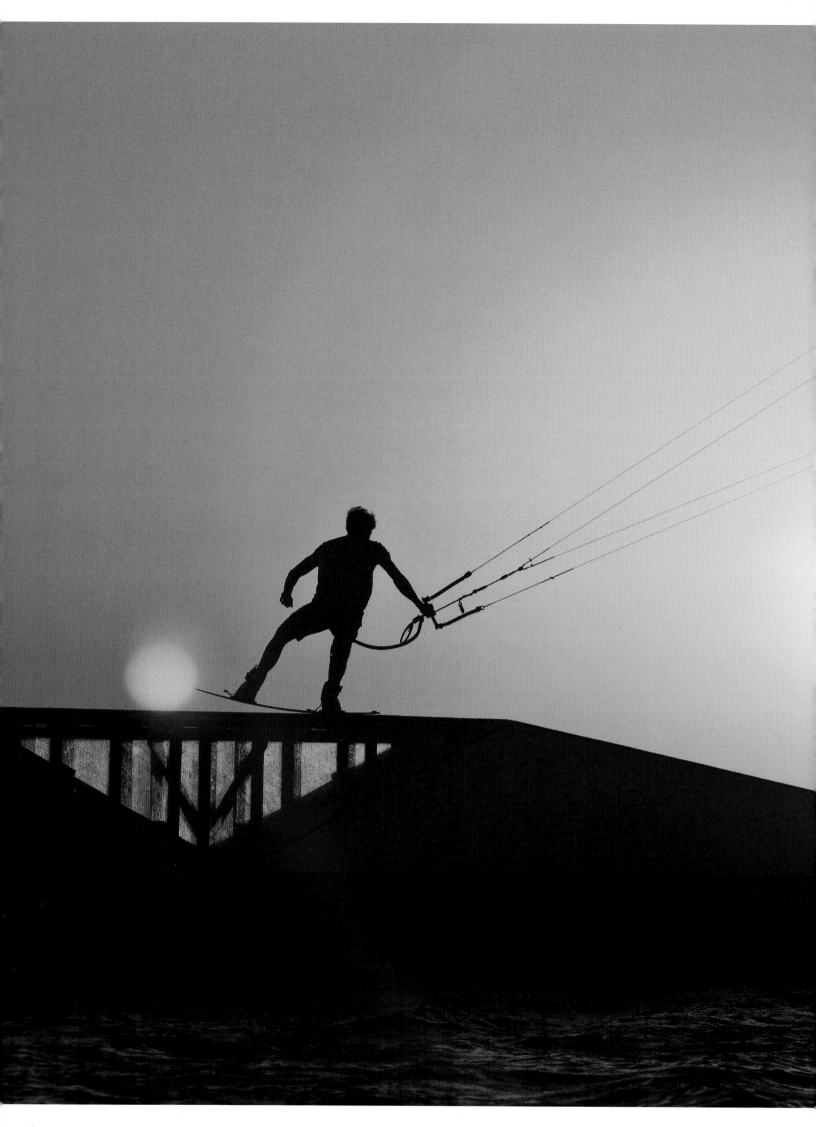

PLACE
CAPE HATTERAS

The REAL deal

TRIP FORMAN, CO-FOUNDER REAL WATERSPORTS

AND REAL SLIDER PARK

'**I moved to Cape Hatteras in 1991. I was just windsurfing and surfing back then and wanted to be in the water every day – the Cape had a much more doable winter than Long Island (NY), where I'd come from.** I first kited here with two friends in 1998 – we got to throw the first kites ever into the air in Cape Hatteras – it's pretty crazy looking back now, both in terms of how big the sport has grown, and looking at the size of the REAL centre nowadays.

For kiting here, the set-up is pretty unbeatable – we're on the Cape Hatteras National Seashore, which is a 70-mile-long island that is only a mile wide at its widest point. This is great for two reasons. First, as we're more than 25 miles from the mainland we get clean wind from every direction. And second, we have all bases covered for riding – inside the island it's totally sheltered, shallow and there is completely flat water (you can be riding in

ABOVE: *Photo: Toby Bromwich.*
LEFT: Aaron Hadlow and a Hatteras sunset. *Photo: Nate Appel.*

30 knots or more and still find perfect sheet glass), yet on the other side is the Atlantic coast, with consistent and often world-class surf.

Matt Nuzzo and I started REAL back in 2001. The slider side of things began pretty early on – we were fooling around with little PVC sliders and upside-down plastic kayaks and that kind of thing, so we had small stuff that we could just load in the back of the truck. Then when we secured the location we have now and the boat basin, we were able to build larger structures and leave them in the water, and that's when things really took off. In 2003, we had a bunch of guys who visited here – all the original slider guys, like Mauricio Abreu, Bertrand Fleury, and Moe Gould along with our team guys Jason Slezak, Sam Bell and LLew Simmonds – they stayed for a few weeks and helped us

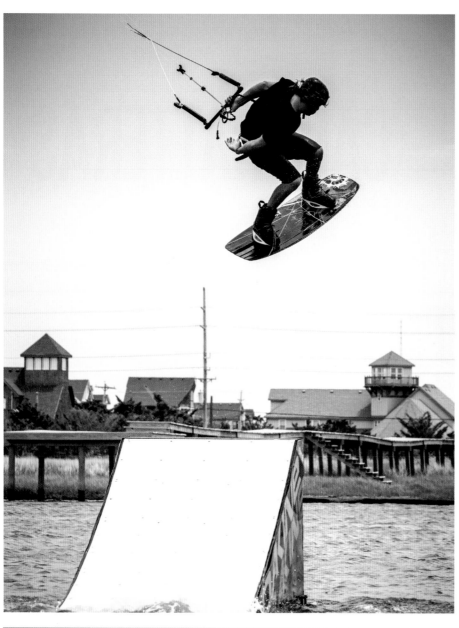

to plan and build out a lot of the original park features. The biggest one that we did was the original Red Bull Fun Box in 2005. The thing was literally the size of a small house! It was over 80 feet long and in two sections. We used it in the first Triple-S in 2006 and it was kind of the dividing line of the riders – just seeing who took it on full speed and rode it well.

The trouble we came up against with all these monster sliders was that over time they just didn't hold up that well. You'd get different expansion and contraction rates when you used different materials and things would just start pulling out and breaking up – especially at that size. So we had a company in Florida that was building a lot of rails for the cable parks build us a new John Wayne Cancer Foundation rail. That was the first aluminium-framed/high-density-polyethylene (HDPE) sheeted feature in a kite park. It was like looking at a Volvo Open 70 boat next to a Chinese junk! When we hosted the Triple-S that year, everyone either sessioned the new John Wayne or the kicker. Everything else was cancelled.

In 2011, we got slammed by Hurricane Irene and the whole slider park was more or less destroyed. It was pretty devastating, but we saw it as an opportunity to rebuild the whole park

TOP: The Dakine kicker, Alex Fox. *Photo: Toby Bromwich.*
BELOW: Greg Norman Jr., 2006. *Photo: courtesy REAL Watersports.*

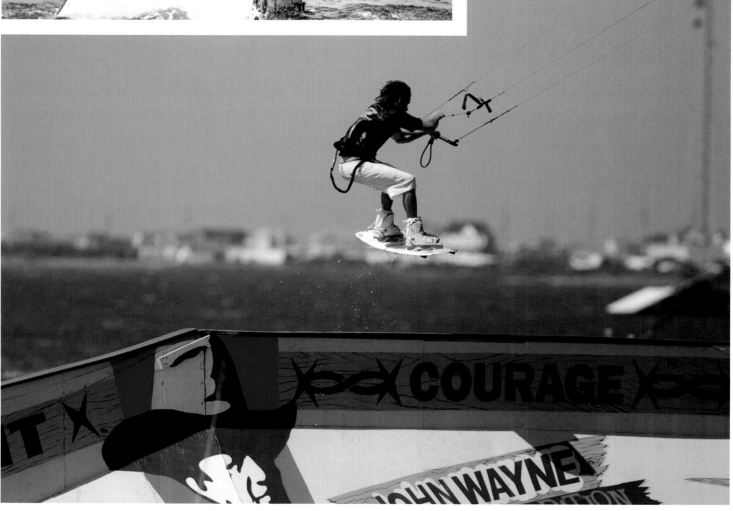

with HDPE-framed and sheeted features – the next evolution of slider construction, producing rails that will probably outlive us all. We looked at a whole bunch of contractors to rebuild the park and ended up working with Joby Cook, one of the invited Triple-S riders. Things were pretty tight time-wise, and for the Triple-S 2012 everything was finished and rolled into the water in the final two days before the event. And that is where we are now. We have the best-built and most respected slider park around and people come from all over the world to session it. Our local riders, such as Jason Slezak, Brandon Scheid, Eric Rienstra and Lulu Vroman are here a good amount of the year, and a lot of the main wakestyle riders, guys like Andre Philipp, consider it their second home. We find that every year a lot of riders come earlier for the Triple-S and stay later! But at any time the vibe in the water is pretty chilled – although everyone pushes each other – and the level of riding, especially in the last few years, has gone completely through the roof. And for us, the REAL Watersports centre keeps getting bigger and better – we now employ 90 people who all live, work and most importantly *session* here.'

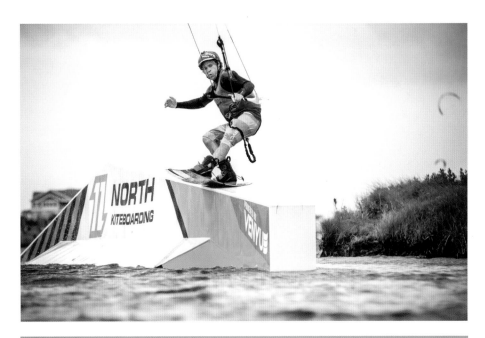

TOP RIGHT: James Boulding enjoying one of the latest additions to the park. *Photo: Toby Bromwich.*
RIGHT: *Photo: Bryan Elkus.*
BELOW: *Photo: Toby Bromwich.*

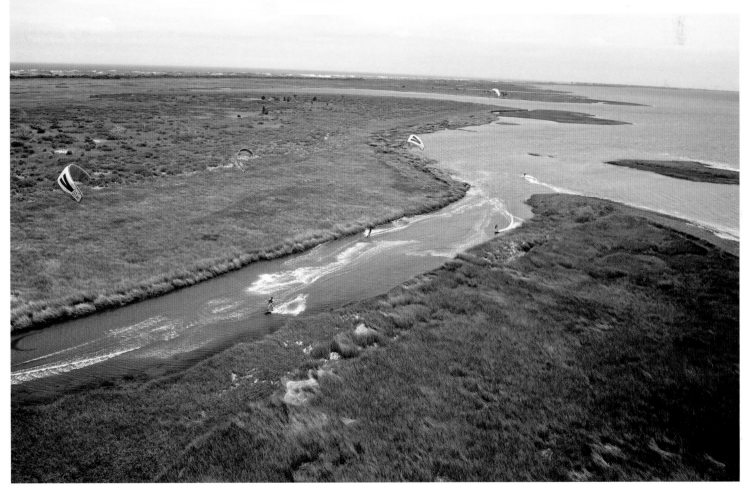

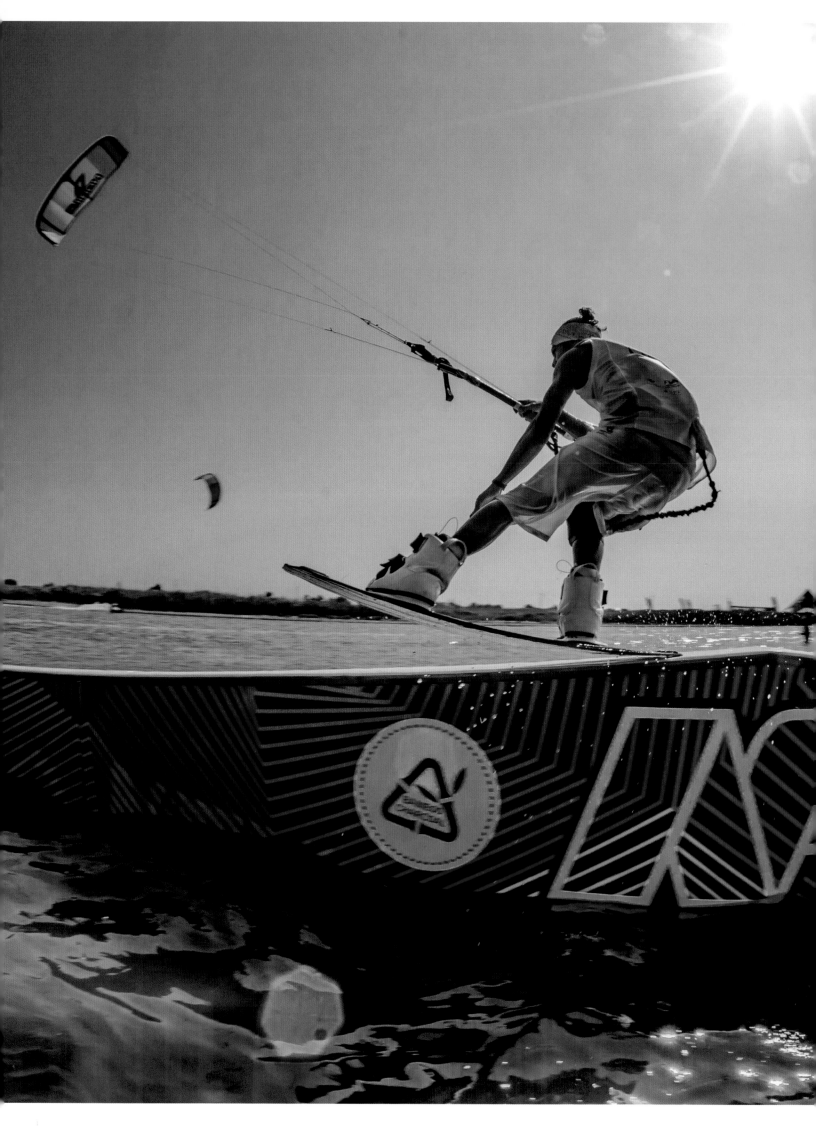

PLACE
ANAPA, RUSSIA

Slider heaven

SAM LIGHT, SLINGSHOT RIDER

'Compared to all the other destinations I travel to, Russia is like the great unknown. I first travelled there in 2012, when I was the first and only non-Russian to attend the Russian Rail Masters.** I had no idea what to expect and I certainly didn't expect what I found: a climate similar to that of the Mediterranean, great wind conditions and the biggest "kite park" in the world. Anapa is on the Black Sea and it is easily one of the best flat-water kiteboarding locations I have ever been to.

The spot was first discovered by kiteboarders around 2008. Before that there were just a few tourists, now there are hundreds of kiters and kite schools – it is like the Tarifa of Russia. The set-up is perfect as there is a long spit of sand that stretches out between the Black Sea and a large lagoon, similar to the "outer banks" of Cape Hatteras. One side of the lagoon is very shallow and flat, and the other side of the spit is the Black Sea that stays very calm throughout the summer and looks and feels like a swimming pool. The spit is around 15km long, and varies in width from 50m to 200m wide, making it easy to kite both sides depending on the conditions. It's covered in sand dunes and is inhabited by hundreds of Russian tourists on their summer holidays, kiting or just hanging in the sun. It feels like California, with long hot sandy beaches and a laid-back "beach life" atmosphere.

ABOVE: *Photo: Tom Court.*
OPPOSITE PAGE: Yan Valiev, Russian Rail Masters 2013. *Photo: Gyunai Musaeva.*

The wind is like nothing I have experienced before. They get two winds blowing in opposite directions: a sea breeze that is generated from the cold air on the Black Sea being sucked over the warm land, and a land breeze that is generated from the huge mass of land that is Russia. Generally it's windiest in the morning and evening when the temperature is lowest; as the temperature builds throughout the day, so does the sea breeze that tries to cancel out the prevailing land breeze. The wind is hot, making it very forgiving and great for learning, and it's windy most days. But you need to take a big kite.

The kite park is erected slowly during the summer months by riders as they arrive for the Rail Masters competition that takes place at the end of August. By the time the competition comes around they have the biggest kite park in the world. On my trips over,

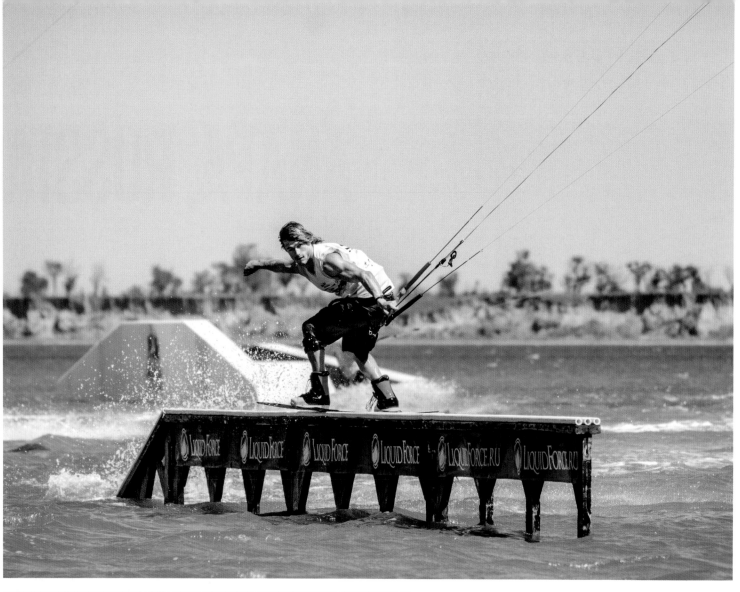

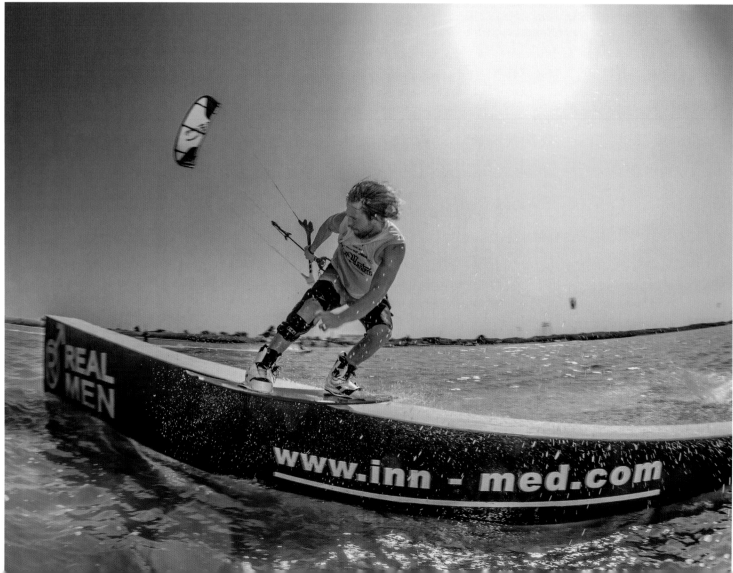

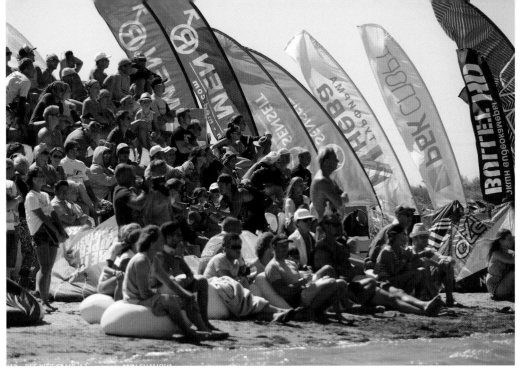

there have been around ten features during the competition. There is no tide and the wind is almost always from the same direction, making it an ideal set-up for learning to hit rails and progressing your rail-riding. Elsewhere in the world it is very rare to have rails set up in the same place every day.

On the water and there are so many people riding at a good level. In most countries and competitions freestyle is the focus, but here the conditions are so good for riding rails that features come first. There are a lot of individual styles, and the fact that they are passionate about life really shows in their riding. Many Russians make the pilgrimage to ride the rails and live on the beach for days, weeks and even months. They construct some of the best beach camping set-ups I've ever seen, using wood to build huts on the beach. It's really hard to explain and understand the culture; there seems to be the old-school Soviet Union attitude that Russia doesn't need anyone else and it's more about survival of the fittest, and then there's the younger generation who are keen to hook up with foreigners, to diversify, and to learn from other cultures. One thing that strikes you is that they don't exchange pleasantries like us Brits do! They will make their opinion known and they're not bothered how it comes across – this works great when you're trying to get rails into position.

Most Russians don't have much interest in speaking English so it makes it hard to get by. Last time I went I actually had a full-time translator, and I would have been stuck without him. One thing is for sure though, over the next few years Anapa will start appearing on more kiteboarder's radars. The Rail Masters is a great contest and the spot has it all. Plus it's pretty raw travelling – definitely not your "normal" kite trip.'

OPPOSITE PAGE
TOP: The UK Crew's Tom Court.
Photo: Ann Shahova.
BOTTOM: Helter Tobias, Russian Rail Master.
Photo: Gyunai Musaeva.

THIS PAGE
TOP LEFT: *Photo: Ann Shahova.*
TOP RIGHT: *Photo: Tom Court.*
CENTRE: Aaron Hadlow finds the kicker.
Photo: Ann Shahova.
RIGHT: *Photo: courtesy Sam Light.*

PLAYER DRE

Dre grew up windsurfing, surfing and wakeboarding in Antigua. When his friend Eli Fuller first brought a kiteboarding set-up over in 1999 it was love at first sight – Dre had his first lesson at Jabberwock Beach and never looked back.

His name will always be synonymous with style and the kind of riding that looks too easy, but is actually a masterclass in making the incredibly technical look effortless. His reputation, forged over a decade of riding at the sharp end of the sport, is that of a genuinely likeable legend and a rider who has been at the nucleus of the sport – particularly the wakestyle scene – since the beginning.

Dre's first mainstream sponsor was Cabrinha and he had an instrumental role at the heart of the Maui-based brand until 2013, when he left to begin work on his own kiteboarding brand, Tona. He now spends most of his time at home on Antigua, which picks up a mellow Caribbean trade wind and where the water is always clear and warm and, as Dre says, 'Why leave paradise to find it?'

ALL ABOUT ME...

- **Trophy cabinet:**
 King of the Bay 2001 – my main rival was Sky Solbach but I ended up winning!
 PKRA 2003 – 2nd
 Triple-S 2005 – 1st
 Triple-S 2006 – 1st
 Triple-S 2007 – 1st
- **In the bag:** Slingshot RPM 10, 8, 7m; Tona Flow, Tona Driftwood.
- **Best spot:** There are so many good spots around the world but at the moment my favourite is home turf – Jabberwock beach, Antigua, with its warm crystal-clear waters and steady trade winds. The crew normally has a ramp and a rail in the water to keep things interesting or there's the option of going down the beach to ramp off the shore break.
- **First set-up:** Naish AR5 11.5m; LF Trip Wakeboard.
- **Proudest kiting moment:** I'm always quite proud when people come up to me and tell me that I've inspired them. I do this sport because I love it and I want to see it grow, and to be able to inspire people along the way is a good feeling, so that makes me proud.

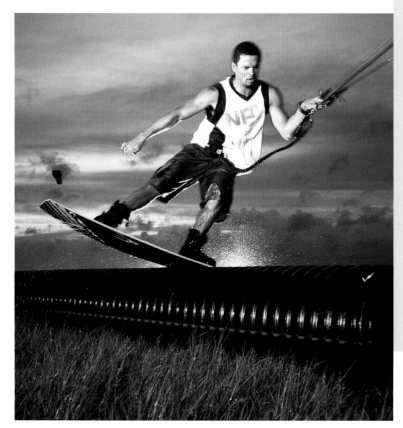

TOP: *Photo: Dre.*
LEFT: *Photo: Bryan Elkus.*
OPPOSITE PAGE: *Photo: acquafilms.com.*

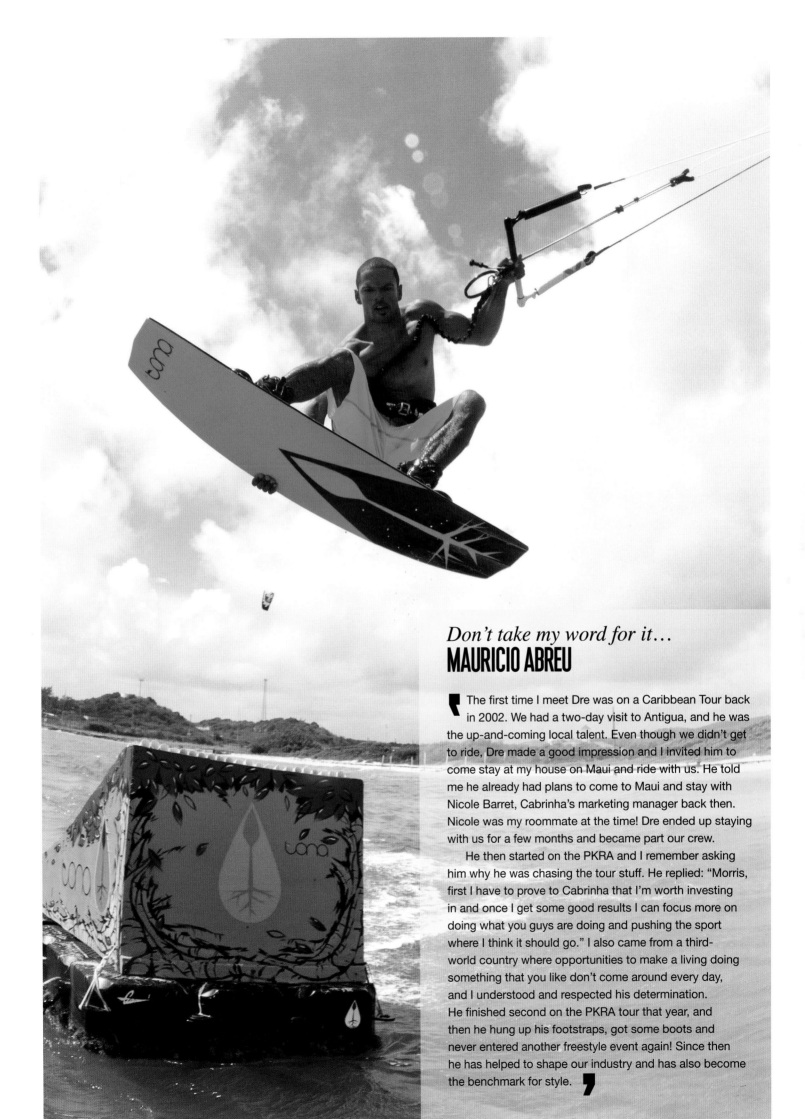

Don't take my word for it…
MAURICIO ABREU

❝ The first time I meet Dre was on a Caribbean Tour back in 2002. We had a two-day visit to Antigua, and he was the up-and-coming local talent. Even though we didn't get to ride, Dre made a good impression and I invited him to come stay at my house on Maui and ride with us. He told me he already had plans to come to Maui and stay with Nicole Barret, Cabrinha's marketing manager back then. Nicole was my roommate at the time! Dre ended up staying with us for a few months and became part our crew.

He then started on the PKRA and I remember asking him why he was chasing the tour stuff. He replied: "Morris, first I have to prove to Cabrinha that I'm worth investing in and once I get some good results I can focus more on doing what you guys are doing and pushing the sport where I think it should go." I also came from a third-world country where opportunities to make a living doing something that you like don't come around every day, and I understood and respected his determination. He finished second on the PKRA tour that year, and then he hung up his footstraps, got some boots and never entered another freestyle event again! Since then he has helped to shape our industry and has also become the benchmark for style. ❞

PLAYER SAM LIGHT

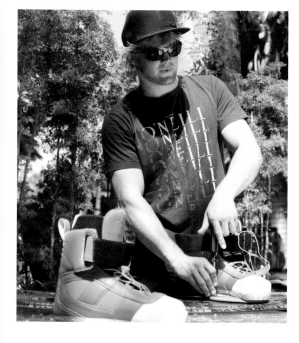

Sam Light is the most successful competitive wakestyle-rider of recent times. His 100 per cent commitment to the wakestyle cause has earned him multiple titles and maximum respect across the kiteboarding community, and has ensured his status as something of a legend within this element of the sport. From small beginnings on Hayling Island in the UK, Sam has turned himself into a kiteboarding icon.

His commitment to pressing sliders is also matched in his faultless professional attitude towards his career. No slacking with Sam and, first with Naish and now with Slingshot, he can be depended on to put in the legwork in terms of supporting his sponsors and ensuring they are getting maximum bang for their buck. Early on in his career Sam paid out of his own pocket to fly to Maui to help out with then-sponsor Naish's product shoot. It was a good move – having seen his motivation and work ethos they signed him on to the international team and he hasn't looked back.

On the water, Sam's style and attention to detail has been honed through putting in the hours at the cable park as well as on the water to get his solid repertoire dialled in and ready to bang out on the big stage when the time comes.

ABOVE AND OPPOSITE PAGE: *Photo: Mo Lelii.*
BELOW: *Photo: Lance Koudele.*

ALL ABOUT ME...

- **Trophy Cabinet:**
 BKSA National Champion 2009
 H.I Park Jam 2011 – 1st
 Slider Party 2012 – 1st
 Ro-Sham Throw Down 2012 – 1st
 Russian Rail Masters 2012 – 1st
 Triple-S Sliders 2013 – 1st
 Triple-S Overall 2013 – 1st
- **In the bag:** 7, 9, 11m RPM; Slingshot Asylum 141
- **Best spot:** Hayling Island. There's no place like home!
- **First set-up:** Naish ARX 7m; local pro Chris Bull's old F-ONE board
- **Proudest kiting moment:** 2013 at the Triple-S – winning the sliders and the overall title was pretty amazing! To do it with so many riders that I respected so much at a time when wakestyle was growing, progressing, and more competitive than ever made it feel really special.

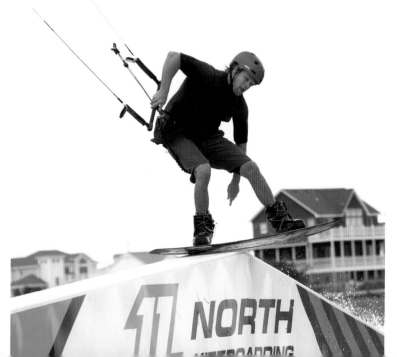

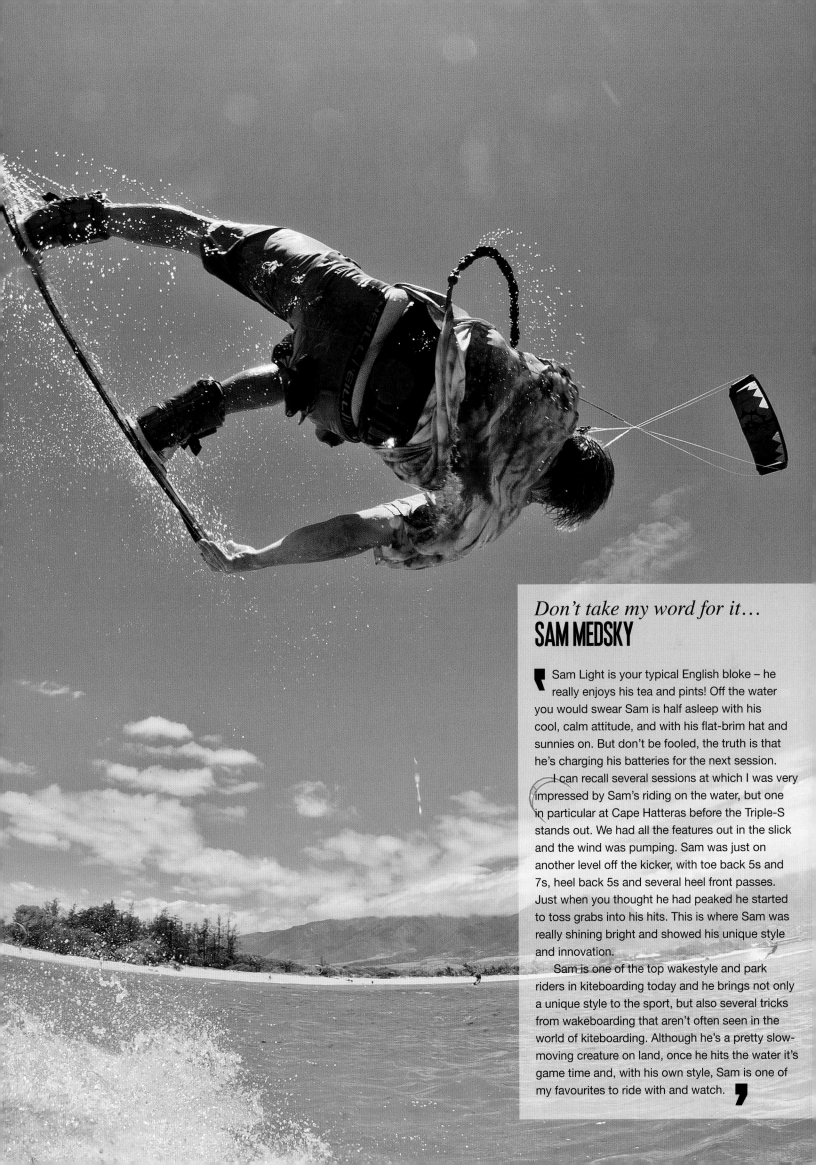

Don't take my word for it…
SAM MEDSKY

❝ Sam Light is your typical English bloke – he really enjoys his tea and pints! Off the water you would swear Sam is half asleep with his cool, calm attitude, and with his flat-brim hat and sunnies on. But don't be fooled, the truth is that he's charging his batteries for the next session.

I can recall several sessions at which I was very impressed by Sam's riding on the water, but one in particular at Cape Hatteras before the Triple-S stands out. We had all the features out in the slick and the wind was pumping. Sam was just on another level off the kicker, with toe back 5s and 7s, heel back 5s and several heel front passes. Just when you thought he had peaked he started to toss grabs into his hits. This is where Sam was really shining bright and showed his unique style and innovation.

Sam is one of the top wakestyle and park riders in kiteboarding today and he brings not only a unique style to the sport, but also several tricks from wakeboarding that aren't often seen in the world of kiteboarding. Although he's a pretty slow-moving creature on land, once he hits the water it's game time and, with his own style, Sam is one of my favourites to ride with and watch. ❞

PLAYER
ERIC RIENSTRA

As far as recognisable and respected kiteboarders go, there are few as iconic as **Eric Rienstra.** The US's best-known wakestyle rider has been at the core of the park scene since day one, and you would be hard pushed to find anyone with more commitment to the cause. A typical year for Eric is to return from somewhere tropical in springtime ready to hit up the REAL slider park and compete in the Triple-S. Then it's on down to Hood River and Slingshot-team HQ to pick up his new kit and spend a few weeks sessioning the slider park there, before – in the blink of an eye – it's time to dig out the passport and head south again as the temperature begins to take a dip.

Eric began riding boards – skate, snow and windsurf – aged five and first picked up a kite when he was 15. Slingshot signed him up in 2005 and he has been with them ever since, helping to develop the kit and to drive the brand forwards. He has a great reputation among the rest of the US and European crews, and they would no doubt agree with the one word that he thinks best sums up his riding style: precise. Eric is a case study in fluid, measured and effortless style.

ALL ABOUT ME...

- **Trophy cabinet:**
 Triple-S Overall, Sliders and Best Session 2012 – 1st
 Triple-S Overall and Sliders 2013 – 1st
 Gorge Blowout 2013 – 1st
- **In the bag:** Slingshot Fuel 7, 9, 11, 13; Asylum 141, Vision 140.
- **Best spot:** REAL Kite Park, Hatteras. The riding conditions are ideal and the quality of the park features is insane. The REAL Slick is flat as butter and the 100 per cent HDP features are bomb-proof and designed perfectly.
- **First set-up:** Slingshot Zeppelin, Naish Aero 10.
- **Proudest kiting moment:** Standing on the podium at the 2013 REAL Triple-S next to my buddies Alex Fox and Sam Light, having just swept the Overall and Slider Divisions for team Slingshot.

ABOVE AND OPPOSITE PAGE:
Photo: Lance Koudele.
LEFT: *Photo: Mo Lelii.*

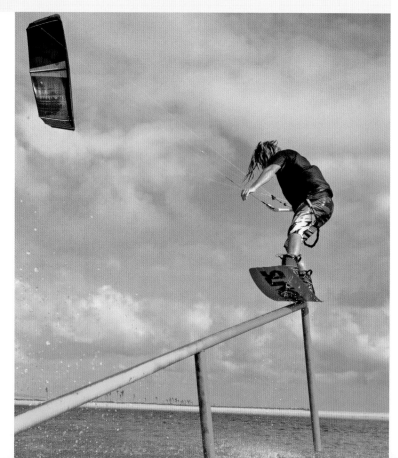

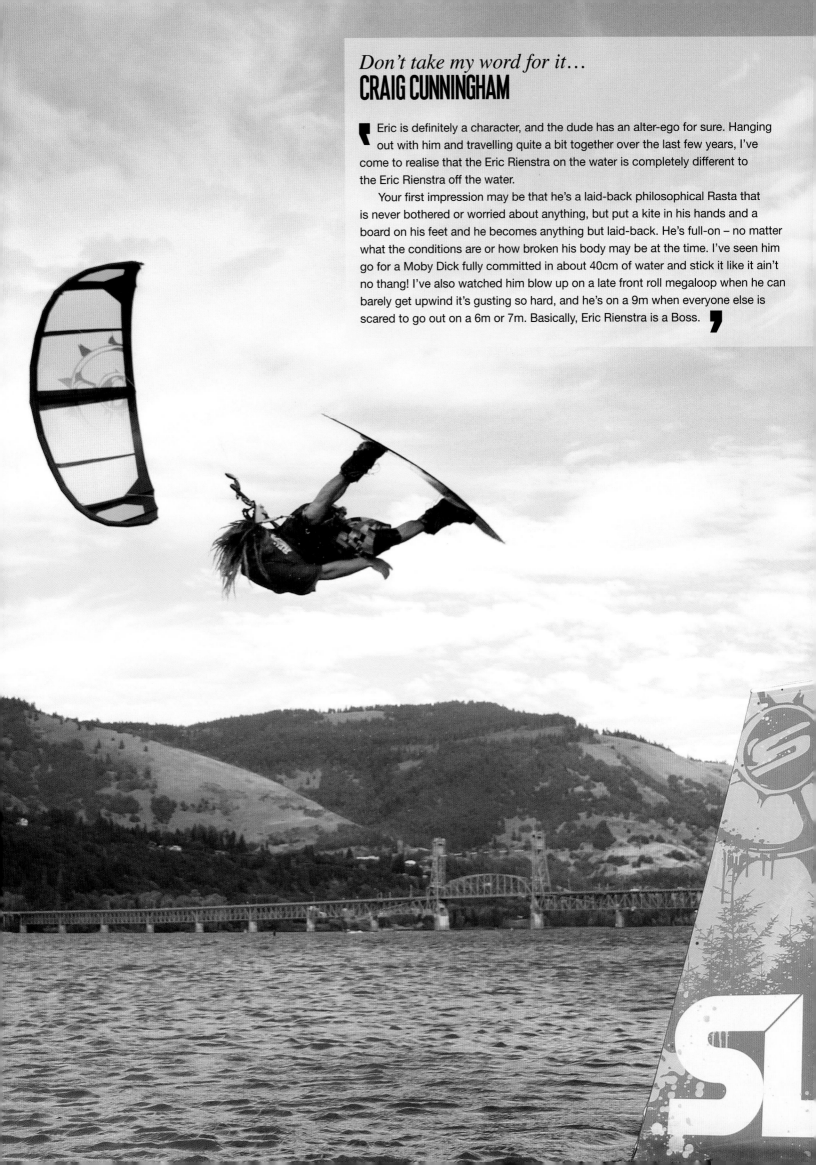

Don't take my word for it…
CRAIG CUNNINGHAM

Eric is definitely a character, and the dude has an alter-ego for sure. Hanging out with him and travelling quite a bit together over the last few years, I've come to realise that the Eric Rienstra on the water is completely different to the Eric Rienstra off the water.

Your first impression may be that he's a laid-back philosophical Rasta that is never bothered or worried about anything, but put a kite in his hands and a board on his feet and he becomes anything but laid-back. He's full-on – no matter what the conditions are or how broken his body may be at the time. I've seen him go for a Moby Dick fully committed in about 40cm of water and stick it like it ain't no thang! I've also watched him blow up on a late front roll megaloop when he can barely get upwind it's gusting so hard, and he's on a 9m when everyone else is scared to go out on a 6m or 7m. Basically, Eric Rienstra is a Boss.

TOM COURT

Tom has been riding since he was 12. Brought up on the Isle of Wight, a 150-square-mile mini-island off the south coast of the UK, he first started kiting with his parents. Competitive success followed, with Tom winning the Animal Windfest contest in the UK and the BKSA Under 18s title, before being picked up by North. With a foot in both the freestyle and wakestyle camps, he's gained recognition for his stylised approach to the sport. Be it a powered Mobe or a perfectly executed press, for Tom it's not the number of spins or the length of the hit – it's all about the style.

Recent years have seen him capitalising on his skills and his profile, and on a pretty non-stop travelling schedule. He hits most of the wakestyle events and spends plenty of time in his home-from-home, Fuerteventura, as well as taking on additional trips with his sponsors, or just for fun.

ALL ABOUT ME…

- **Trophy cabinet:**
 BKSA 2002 – 1st
 PKRA Best Trick Fuerteventura 2009
 Slider Party France 2012 – 2nd
 Russian Rail Masters 2013 – 3rd
- **In the bag:** 12, 9, 7m Vegas, Gambler 139 and X-Surf.
- **Best spot:** Fuerteventura. It has everything: wind, waves and lagoons. I spend a lot of time out there with my trusty Panda.
- **First set-up:** Wipika Classic 5m and Joos 6'4" board in 1999.
- **Proudest kiting moment:** Standing on the PKRA podium between Hadlow and Langeree having come second in the best trick. It was a great event and it was amazing to be on the podium with those guys for the first time.

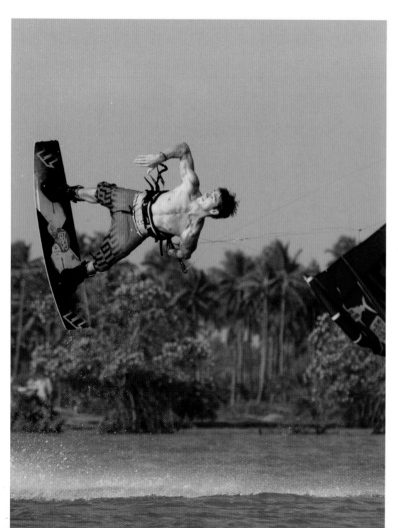

ABOVE: *Photo: courtesy Tom Court.*
LEFT AND OPPOSITE PAGE: *Photo: Toby Bromwich.*

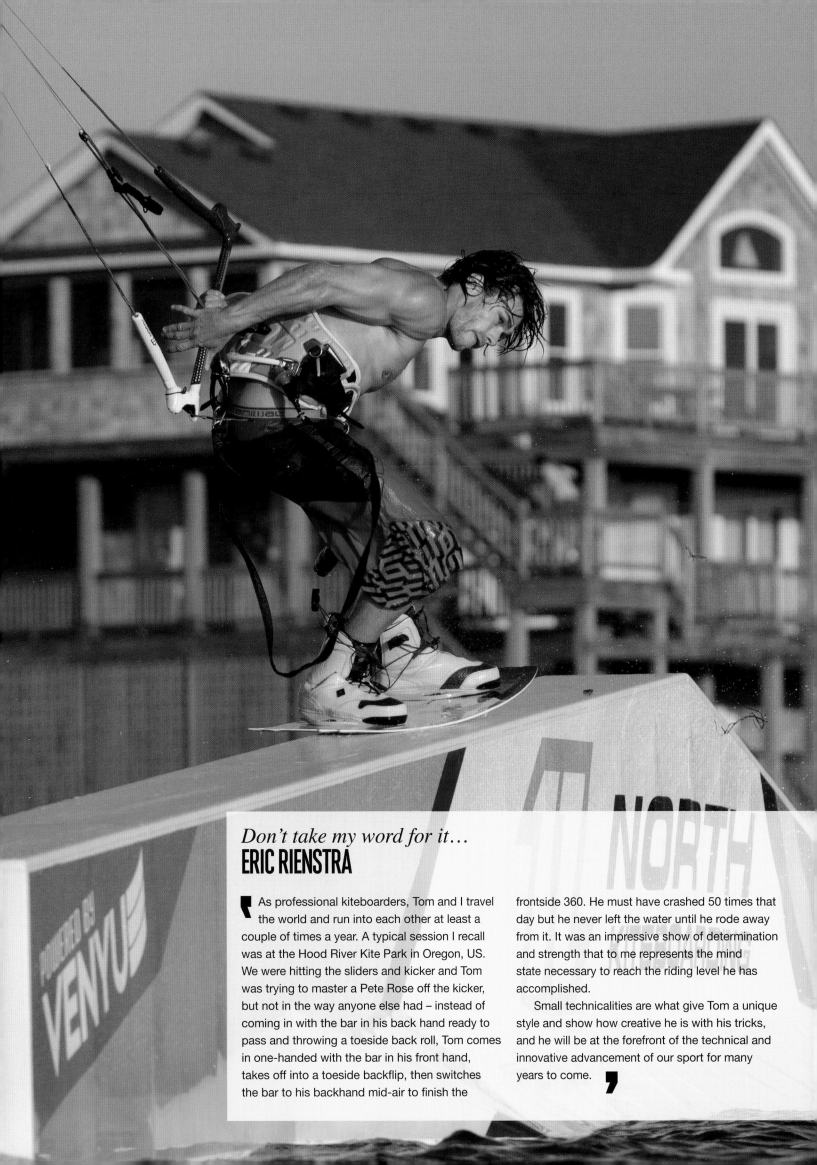

Don't take my word for it…
ERIC RIENSTRA

As professional kiteboarders, Tom and I travel the world and run into each other at least a couple of times a year. A typical session I recall was at the Hood River Kite Park in Oregon, US. We were hitting the sliders and kicker and Tom was trying to master a Pete Rose off the kicker, but not in the way anyone else had – instead of coming in with the bar in his back hand ready to pass and throwing a toeside back roll, Tom comes in one-handed with the bar in his front hand, takes off into a toeside backflip, then switches the bar to his backhand mid-air to finish the frontside 360. He must have crashed 50 times that day but he never left the water until he rode away from it. It was an impressive show of determination and strength that to me represents the mind state necessary to reach the riding level he has accomplished.

Small technicalities are what give Tom a unique style and show how creative he is with his tricks, and he will be at the forefront of the technical and innovative advancement of our sport for many years to come.

RO-SHAM THROW DOWN

JOBY COOK: FOUNDER OF THE SLIDER PROJECT

'We started on the road to the Ro-Sham back in 2003 when my brother and I built a kicker and rebuilt a 40-foot rail that the guy I was working for had us putting together. That kicker lasted a few years, until a massive landslide in 2006 formed the sandbar that we now have today. I think that old kicker is buried in the sandbar somewhere!

Back then we just wanted to kiteboard like we snowboarded and wakeboarded. From then on, pretty much every year we would build something new or fix something and session it on our kites. Things started getting a bit more popular and, in 2005, we put on an event called "Sliders In Tha Hood". It wasn't really an event – it was mainly Pierce Louis from the Wipika crew trying to turn it into something. He was pretty visionary and saw the potential from the beginning. There was a bunch of pros in town and some of them came and rode with our local crew. I think most of them had never hit rails or kickers and they were all riding footstraps – ours was the only crew wearing boots.

2007 was one of the coolest years where we had a bunch of ghetto rails built out of wood. We had a pretty tight crew. We built a rail on a Subaru, drove it down to the sandbar and jumped it and slid over it. That was the year that *The Most Underrated* film came out and was one of the best years ever in the Hood. There was a real home feel and everyone just down to ride. No business, no expectations. Dylan Thompson was at the top of his kiteboarding game and could have taken the sport over were it not for snowboarding.

In 2008, Forrest Rae and I got together to form the Slider Project in order to get some more money to build legit features that would last for longer, so we didn't have to keep wasting time rebuilding stuff. The goal of the Slider Project was (and still is) to create and maintain a free, open-to-the-public kiteboarding terrain park. We already had more and more pros coming out every year because they had heard about our crew and the scene

RIGHT: Sam Light, Ro-Sham winner 2012. *Photo: Jen Jones, Moxy International.*

in Hood River. That year I was also invited to the Triple-S at REAL and told all the guys there what we were going to be doing that summer. Having built a new rail we were going to use it to slide across a 40-foot limo with a rail built on top of it. More riders came. The next year we built a 70-foot funbox. Again, more people came. Matias Ricci from Maui heard about us and contacted us just to come and help build and ride with our crew. This was our biggest project to date. It cost us around $10,000 to build it, and it took about a month of guys showing up at Forrest's house every night after work to help construct it. All for the love – no one made any money.

The next year we didn't build anything but wanted to do something for the sport, and a bunch of guys wanted an excuse to come to the Hood, so we decided to put on an event called the Ro-Sham Throw Down. It was a heat-style contest with judges for the rails and kickers. It went pretty well and everyone was stoked. Judges were told to score riders based on powered tricks with the kite low and how well they utilised the variety of features in the terrain park. In 2011 we pretty much did the same thing.

Then, in 2012, we upped the game by doing a "slope-style" event at which only one rider was allowed on the course at a time. It meant that the judges could more precisely score each trick and it set a precedent for how a contest format should be. Most of the main wakestyle riders came along, the vibe was pretty chilled but a little more competitive than previous years. What was great about the Ro-Sham was that anyone could turn up and ride. So a "no-name" guy could get to compete against some of the top pros. The event played out pretty well – the toughest obstacle in the park was the Box to Down Rail gap, which everyone was trying to hit, but it was lined up wrong with the wind and there were only a couple of good hits on it during the comp. The final was made up of Craig Cunningham, Alex Fox, Sam Light, Sam Medysky, Eric Rienstra and Brandon Scheid – so all the main players who were all riding well. Alex Fox nailed a switch heelside backside 540 off the Slingshot kicker in the final, which went down well, but Sam Light had all bases (kickers, rails and flat water) covered and sealed the win pretty comfortably.'

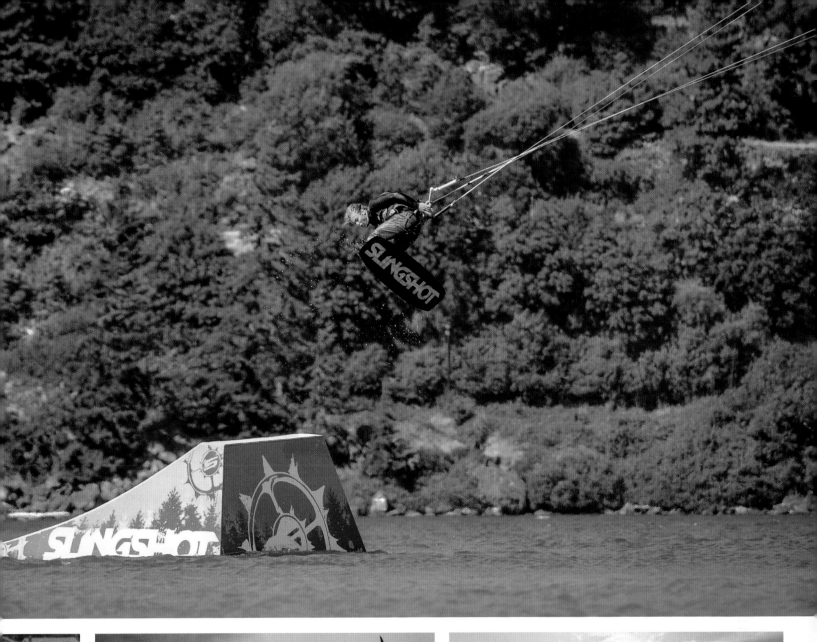

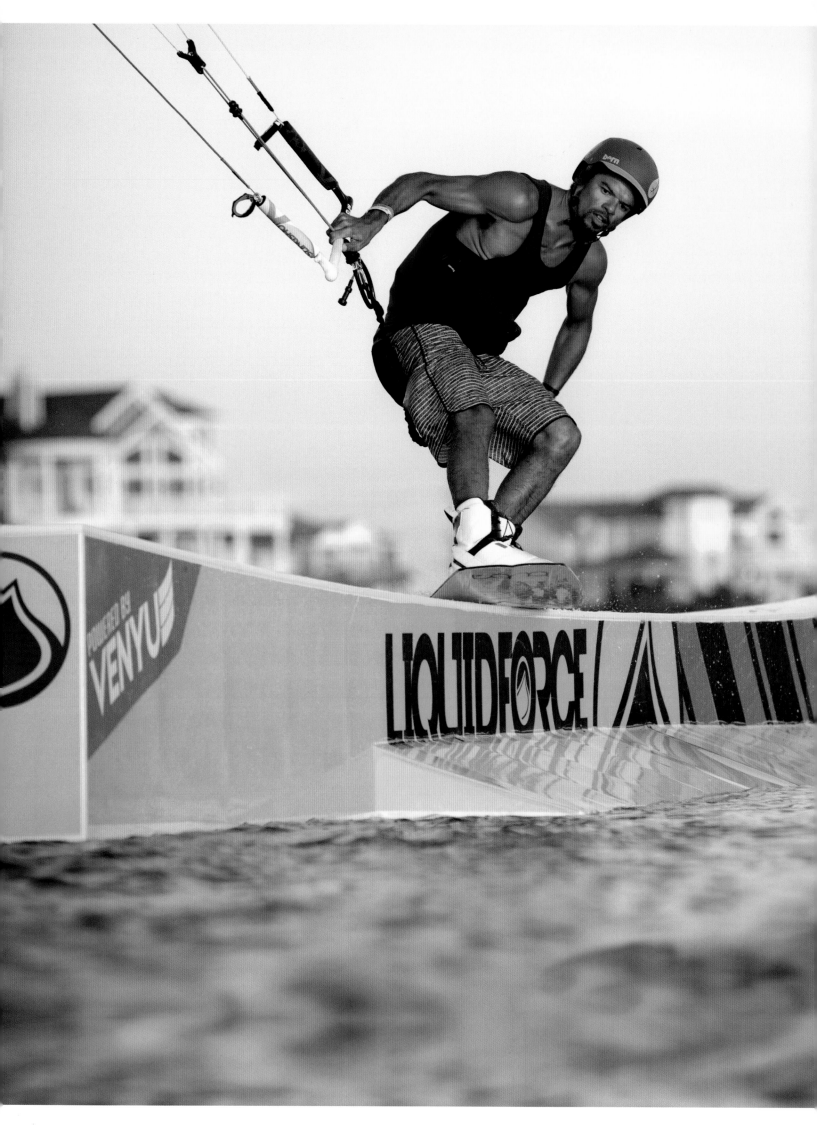

THE TRIPLE-S INVITATIONAL

BRIAN WHEELER, HEAD JUDGE

'**Three disciplines – Surf, Slicks and Sliders – have shaped the sport of kiteboarding more than just about anything.** Over the years, these surf- and wakestyle-oriented disciplines have endured the test of time, solidifying as the core of the sport, while the flash-in-the-pan fads such as board-offs and kite pants have faded into obscurity.

Hence this trio of riding styles is also the heart and soul of the annual Triple-S Invitational – one of the oldest, most deeply influential, and once-underground events on the planet. In recent years, the Triple-S has become a contest of legend, as numerous top-level pro kiteboarders consider it the most looked-forward-to event of their entire season and more and more big-name athletes have been submitting "wildcard videos" in the hope of scoring an invitation to the coveted competition.

An ever-evolving gravity that attracts and appeals to the most progressive kiters across the globe, the annual week-long Triple-S empowers inspired riders to influence

LEFT: Andre Phillip, Triple-S 2013. *Photo: Toby Bromwich.*
BELOW: *Photo: Bryan Elkus.*

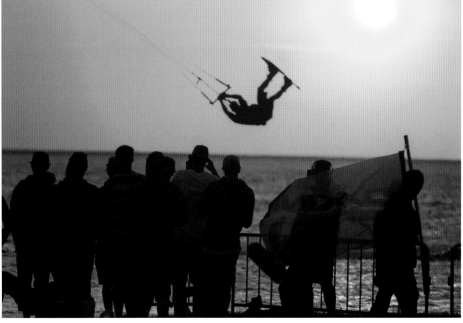

one another and the sport as a whole. A perpetual instigator of change, the vision of the Triple-S mirrors the direction in which the sport has steadily been heading for years and, in a lot of ways, the Triple-S is due credit for influencing and shaping the sport. The Triple-S has an unparalleled reputation for a great variety of reasons, ranging from its unique nature and epic parties to its location at the finest, most cutting-edge kiteboarding slider park on the planet.

The event began as a grassroots invitation-only jam back in 2006, where top wakestyle riders (and surf-oriented wave slayers) congregated in Cape Hatteras for a solid week of laid-back shredding. Featuring the smooth flat water of the Pamlico Sound (the largest waist-deep lagoon on the East Coast) and the epic offerings of the Cape's high-profile Atlantic surf, Cape Hatteras was the perfect venue, and since day one the sliders have been the highlight of the event (and just about every year the park grows even more mind-blowing and progressive).

Prior to 2006, REAL hosted a number of events that set the stage for the Triple-S. First, in 2002, they held an event called the "Glass Masters", where top pros enjoyed a week of riding and partying amidst world-class conditions. (That same year, REAL proclaimed the death of kiteboarding's sister sport, windsurfing, with their "Windsurfing Has Been Cancelled" bumper sticker.) Then, from 2003 to 2005, REAL hosted an annual qualifier event for Red Bull's King of the Air competition, and in 2004, they held the "No Contest Weekend", a prototype of the Triple-S Invitational. Back then, REAL's humble headquarters (a small shack) served as the

epicentre of the event. Today, however, that small building stands as a historical landmark amidst an 18,000-square-foot shop, four-storey luxury accommodation, backyard grass launch area, and an amazing restaurant and bar on REAL's idyllic 4-acre compound.

For the first seven years, the Triple-S featured the most laid-back and creative atmosphere imaginable: no heats, no scoring system, no judges, no requirements, absolutely no pressure. All riders had to do was show up and ride however and whenever they wanted. By the week's end, the pack of influential riders would cast their votes to determine first through third places in the trio of disciplines, plus an overall category.

But year after year, something new emerged: the pinnacle of wakestyle and kiteboarding materialised, wowing and inspiring athletes and spectators alike. Like a drawn-out freeride soul session

BELOW: *Photo: Lance Koudele.*
BOTTOM: Triple-S, the early years, 2006. *Photo: John Bilderback.*

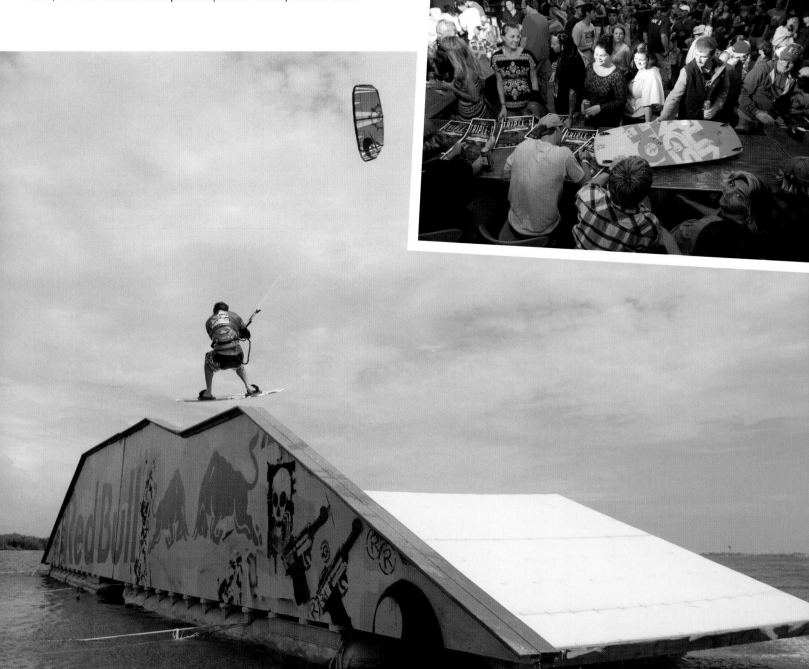

with 30 plus riders feeding off one another's energy – inspiring and encouraging each other like never before – the Triple-S has become notorious for its frenzies of stoke and progression, whether it goes down in the park, flat water or surf. Given such a tremendous pool of talent, and so much playful and competitive energy pulsing relentlessly for a week, each year without fail, new tricks are stomped, riders' abilities grow tremendously and the face of the sport matures. In short, the Triple-S' next-level action redefines the standards of the sport.

In addition to the mesmerising throwdown that takes place on the water every day, the Triple-S is equally known for its off-the-water action. Featuring an open and inclusive spirit, the event invites spectators to interact with the pros throughout the week, and is stacked with raging parties and different bands every night. With its unique blend of charging on and off the water, there is truly no other event like the Triple-S.

In more recent years, as the reputation and influence of the Triple-S has built up and evolved, so too has its format. Due to the growing popularity of the event, organisers introduced a number of major changes, including a hefty cash purse and the addition of a Triple-S Open qualifier, where 30 or more amateurs and pros from around the world compete for the final invitation or two to the main event. Even more notable, however, 2013 ushered in major changes with the introduction of a revolutionary new slopestyle format for the Slider category, as well as state-of-the-art scoring and judging systems for the other two disciplines.

With rider-based judging a thing of the past, one might wonder if the spirit and atmosphere of Triple-S has changed. In short, the

ABOVE: *Photo: Bryan Elkus.*
LEFT: The podium 2007.
Photo: courtesy REAL Watersports.
BELOW: Brandon Scheid maximising kicker time. *Photo: Toby Bromwich.*

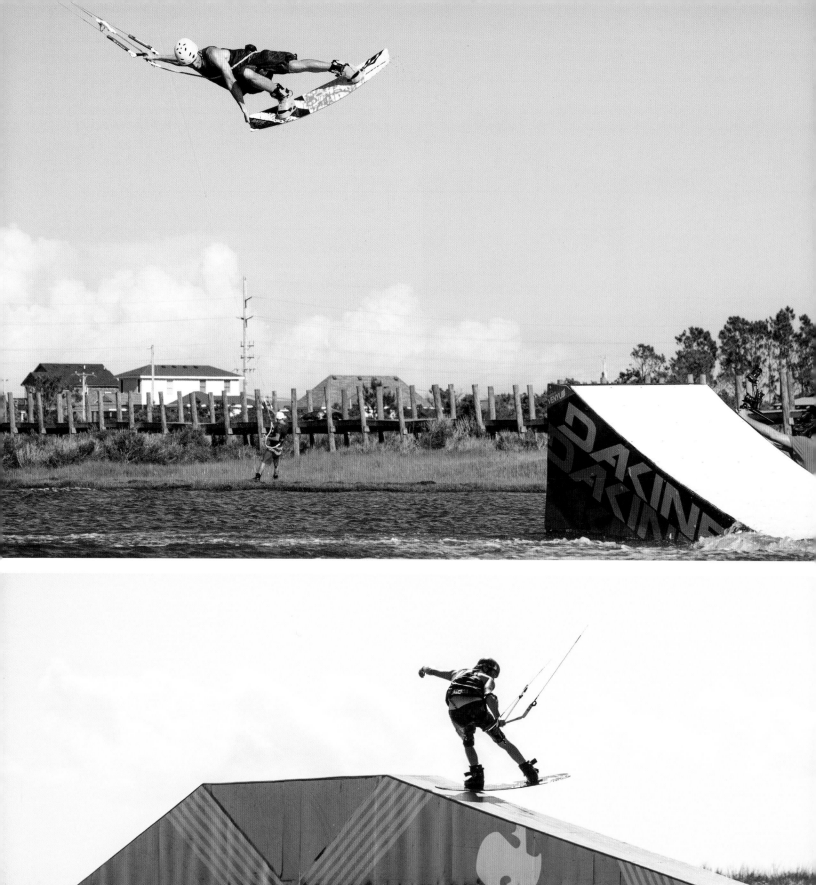
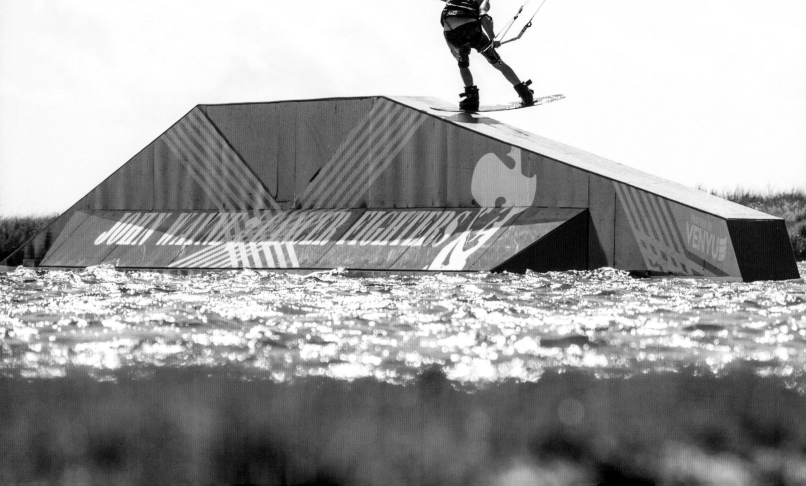

answer is yes and no. The vision and intention that started the Triple-S many years ago is still present, just in a slightly different form. The main difference is that there's a bit more structure nowadays.

Just as riders raise the level of the sport during the week-long competition, event organisers also continually reinvent the format. Each year the Triple-S crew introduces exciting new changes, whether it be an entire Triple-S Open qualifier for amateurs (beginning in 2013), a doubling of the prize purse to $40,000 (in 2014), one or more new state-of-the-art kickers and rails (which happens almost every year), or fun and exciting new ways to structure the competition. No matter how the event has grown from year to year, one thing remains constant: you can expect a major huckfest, where the water is abuzz with the heaviest and newest tricks going down left and right. Plus, the parties are as epic as ever and the slider park is always out of this world!

No other event or organisation has shaped the face of wakestyle as profoundly as the Triple-S and, as a catalyst of monumental change, the Triple-S has proven to be a major force in the sport, continually raising riding standards for top-level pros and the sport as a whole. So, whether you're an aspiring athlete, one of the world's best, or simply looking to watch and hang with the pros for a week, the Triple-S event is one you don't want to miss.'

ABOVE: The Podium 2013. *Photo: Bryan Elkus.*
FAR LEFT: Rick Jensen laid out.
Photo: Toby Bromwich.
BELOW: The more serious Triple-S, 2013.
Photo: Toby Bromwich.

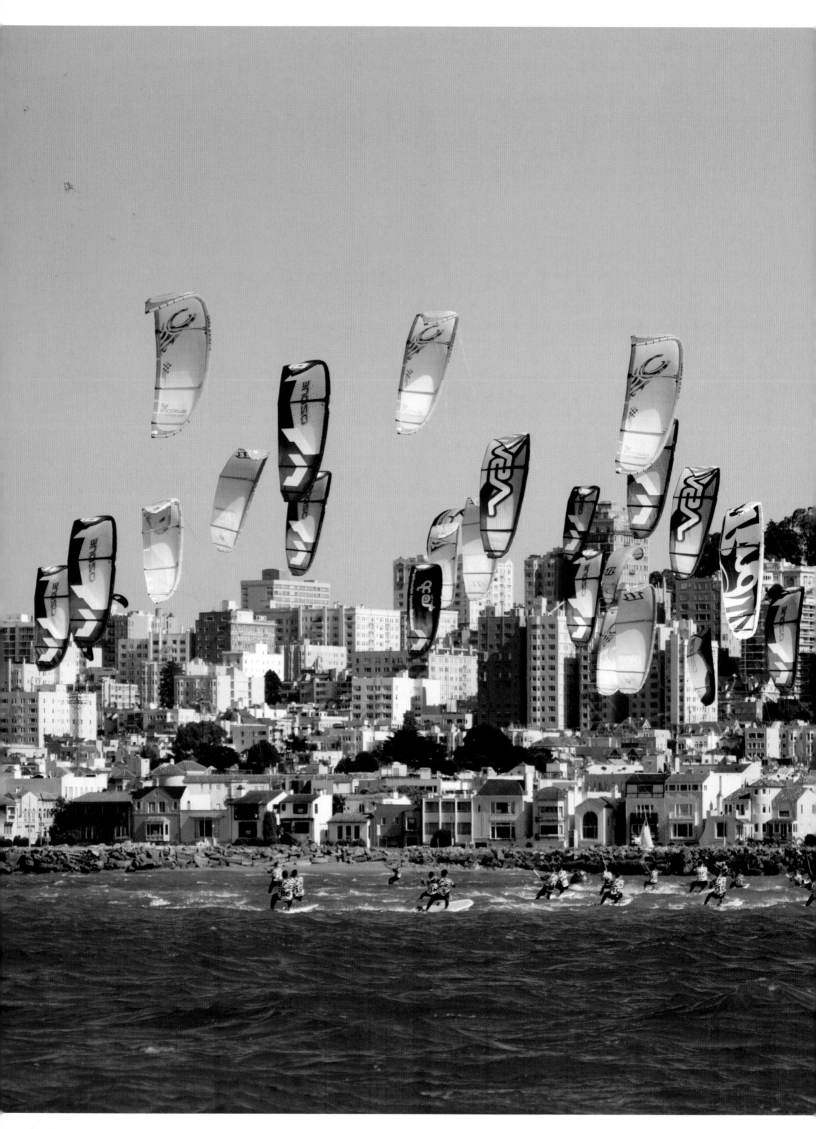

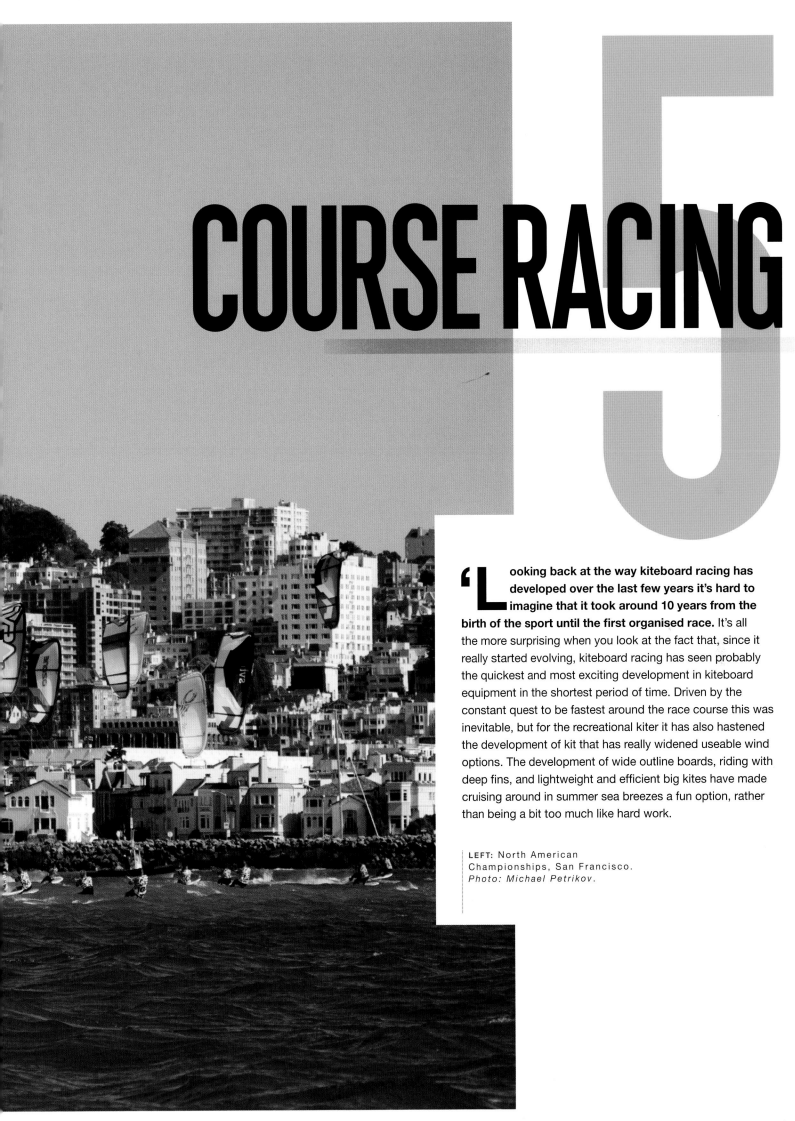

COURSE RACING

5

'**L**ooking back at the way kiteboard racing has developed over the last few years it's hard to imagine that it took around 10 years from the birth of the sport until the first organised race.** It's all the more surprising when you look at the fact that, since it really started evolving, kiteboard racing has seen probably the quickest and most exciting development in kiteboard equipment in the shortest period of time. Driven by the constant quest to be fastest around the race course this was inevitable, but for the recreational kiter it has also hastened the development of kit that has really widened useable wind options. The development of wide outline boards, riding with deep fins, and lightweight and efficient big kites have made cruising around in summer sea breezes a fun option, rather than being a bit too much like hard work.

LEFT: North American Championships, San Francisco. *Photo: Michael Petrikov.*

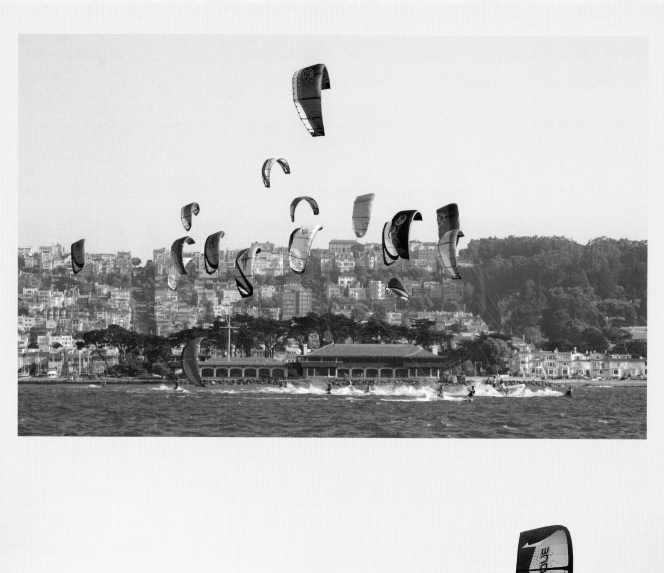

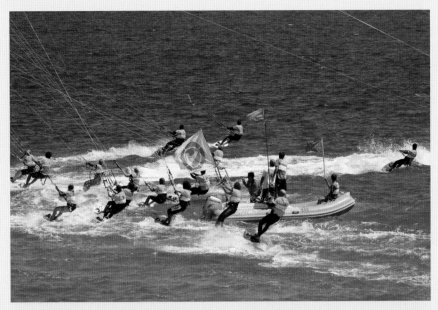

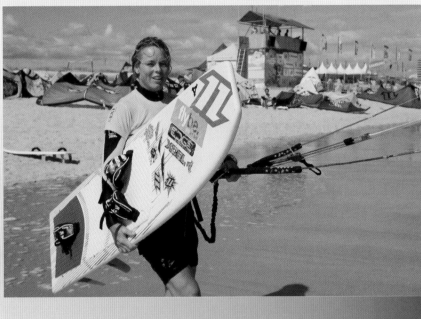

So what were the reasons for the late take-off for kiteboard racing? Primarily it was the drive during the early development of the sport towards smaller boards and smaller, high-aspect kites. Back in the early 2000s having a 16m kite in your quiver was pretty much the norm, and kiters were keen to ride in 10–12 knots of wind. But over the following years kites became better, people want to ride more powered, and for many recreational kiters a 12m became their biggest kite. This, combined with the use of smaller twin-tips, was in danger of making our sport a high-wind-only pastime.

Interest in racing (and in kiting in less wind) began to pick up again in the mid-2000s, with the arrival of the bow and then the hybrid kites. With much higher wind ranges and better upwind performance, at a time when more riders were adding a directional board to their quiver, the new frontier of upwind-riding, and consequently racing, was explored again.

The origins of the first organised kiteboard-racing events can be traced, as with most kiteboard evolutions, to both sides of the pond: in the US, in San Francisco Bay, and in Europe, in France. Initially the equipment being used was either big, wide, low-rocker twin-tips, or customised versions of waveboard directionals with flatter rockers, sharper rails and larger twin-fins.

The early years of kiteboard racing saw equipment evolution progressing at incredible speeds, with continuous development occurring at the same time that riders' skills were improving. The main areas of development were boards and fins. Fins in general got bigger and bigger. Most boards started with two fins, but this quickly progressed to four fins of around 20cm in length, which gave better performance upwind but provided more challenges riding downwind. Fins also changed in cant angle, from no angle, up to around 20 degree angles, and then back down to 2 or 3 degrees or no angle at all. The preferred option eventually standardised around tri-fin set-ups. With two large forward fins and a slightly smaller vertical centre fin at the back.

Boards also got incrementally bigger as it became clear that you could ride and control far larger boards than was previously thought, and that this extra width, length and volume all added up to astonishing upwind and light-wind performance. Until 2011 there were no restrictions on equipment, so to remain competitive meant investing a lot of time in getting the best equipment and then learning how to ride it. During this time riders such as Charles Deleau, Bruno Sroka and Sean Farley were all dominating in Europe, but even more

TOP LEFT: San Francisco, 2006. *Photo: Chris Raymain.*
MAIN PICTURE: Sergey Sablin and Igor Malenko. Soma Bay, 2013. *Photo: Michael Petrikov.*
TOP RIGHT: Start line, Portimão, 2009. *Photo: Courtesy PKRA.*
BOTTOM RIGHT: Steph Bridge, Portimão, 2009. *Photo: courtesy PKRA.*

rapid development was taking place in San Francisco where a high density of good riders, dependable wind and the local regular racing organised by the St. Francis Yacht club led to an explosion of talent that would come to dominate the sport for the next few years. The first World Championships were held in August 2009 in San Francisco and, true to form, the fleets were dominated by US riders (although the winners ended up being Sean Farley from Mexico in the men's, and Steph Bridge from the UK in the women's). 2010 saw the Worlds held in Texas and saw kiteboard pioneer and board-off king Adam Koch making a spectacular impression and going on to win the men's title, with the women's title going to Kari Schibevaag from Norway.

At this time the light-wind compatibility and exciting nature of the racing led many to start thinking that Olympic participation ought to be a major aim for the sport. This led to the development of the International Kitesurfing Association (IKA) headed by Markus Schwendtner. The aim was to make events more professional and to standardise championships.

Perhaps the most important development in the history of the sport to date, however, was the move towards production equipment for racing. The aim of this was to standardise equipment so that regular riders could buy competitive equipment at a reasonable cost and have a chance to race against and beat the sponsored riders. The IKA implemented the "box" rule for regattas starting in 2011. The box rule gave manufacturers some basic parameters that they had to design within. Fundamentally, it was that boards should have a maximum width of 70cm, a maximum length of 190cm and a minimum weight of 5kg. Boards would have to be built from a licensed mould, and minimum numbers had to be produced

for boards to be classed as "production". Kites also had to be production-ratified in a similar way. This was pretty controversial at the time, with many believing it would stifle development of this new racing class. However, in hindsight, it has proven to be very successful, with boards being developed and being refined within the box rule and, most importantly, off-the-shelf equipment being both competitive and not prohibitively expensive.

2011 saw the start of the era of Heineken Domination, with Johnny Heineken (a former 49er sailboat racer) starting to dominate the men's fleet at the Worlds. In Sylt, Germany, Johnny was almost unbeatable and won convincingly in very demanding conditions ahead of Adam Koch. In the women's fleet, Steph Bridge regained her world title from the Netherlands' Katya Roose.

By this time kite racing was starting to be taken seriously in most countries, with race events occurring worldwide. Kite racing also spectacularly replaced windsurfing as the selected board sport for the Rio Olympics. This good news only lasted six months, however, with the sailing federation reversing the decision after intense lobbying from the windsurf delegation. It seems likely though that it is only a matter of time before we have our first Olympic gold medallists in some form of kite racing.

As for the development of the sport in the future, it seems certain that box-rule racing will remain popular as it represents a good standardised racing format. It also seems likely that the rise in popularity of performance foil boards (especially following the 2013 America's Cup and the foiling catamarans) may well play a part in the next chapter of the rapidly evolving world of kiteboard-racing.'

Eric Bridge

BELOW: Olly Bridge at the front of the pack. World Championships, China. *Photo: Michael Petrikov.*

OPPOSITE PAGE
TOP: African Championships, Egypt. *Photo: Michael Petrikov.*
BOTTOM: European Championships, Italy. *Photo: Michael Petrikov.*

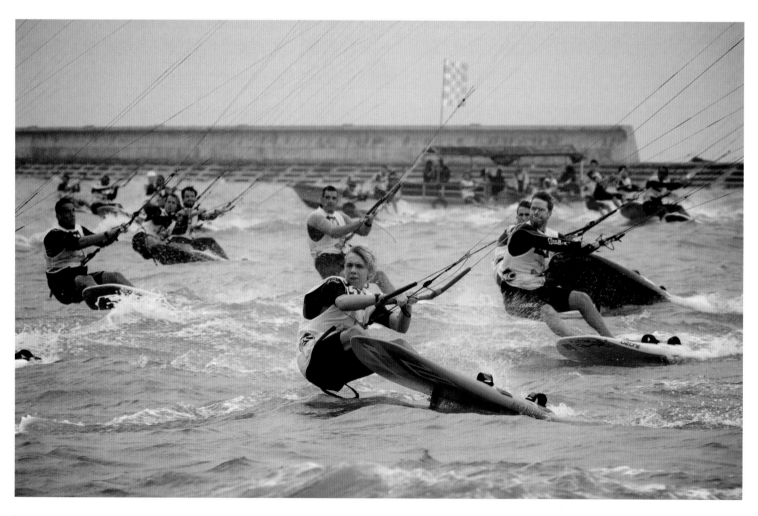

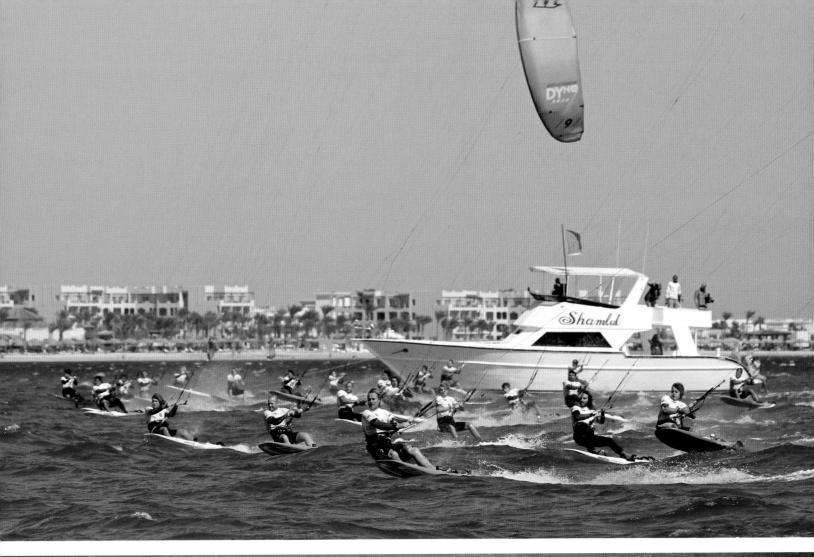

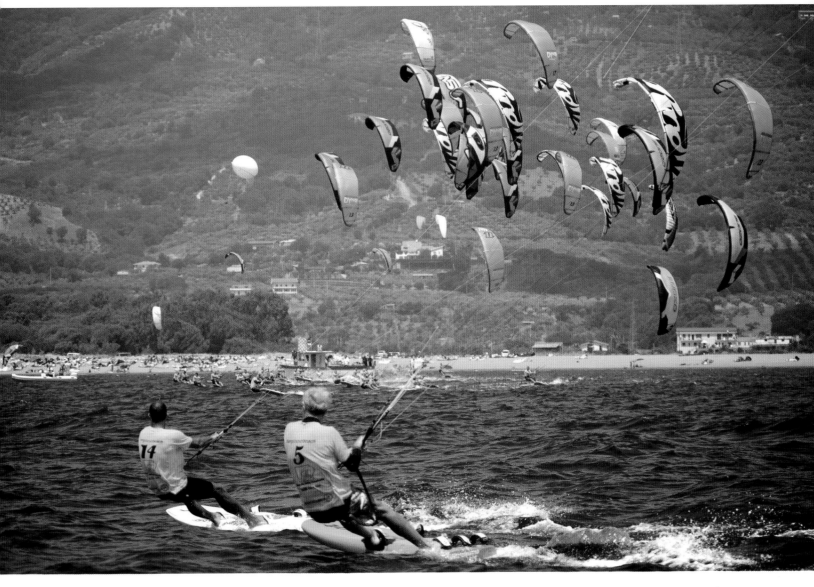

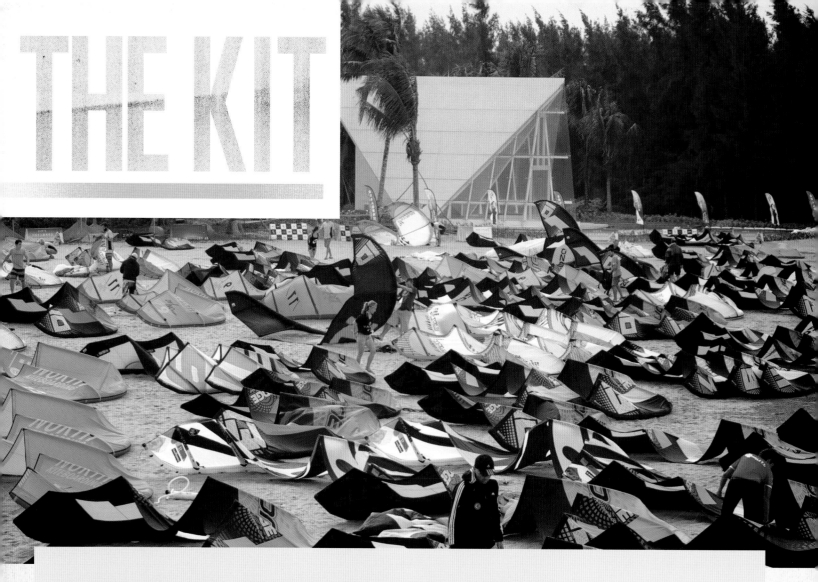

THE KIT

COURSE RACING KITES

In the early days of course racing, with such a huge concentration on board development, kites seemed to take a back seat with riders generally using the recreational high depower kite of their choice. Over the years, however, this has changed and as the brands have embraced this element of the sport they have begun to focus on developing kites specifically for racing. As the racing standard of the top riders has improved and board development is starting to slow, kite performance has become ever more important if you want to be winning.

So what goes into making a fast race kite? Firstly, light-wind performance is critical, and to be competitive you must have a kite that works well in 6 to 8 knots of wind. Consequently, for most brands an effective 17–19m kite is essential and probably the most prototyped and tested size. In these wind conditions, with flat water, the slightest equipment advantage will be critical. For kites to work efficiently in these challenging conditions, lightweight construction is essential, but as these kites are also production models for use by the everyday consumer, there is a balance to be found between creating the lightest possible kite, and a kite that is too fragile for general use. With these critical bigger kites the sizes are

developed downwards, with the smaller kites in a racer's quiver having more in common construction-wise with their generic 'mainstream' counterparts.

A critical area of race kite design is the ability of kites to develop high levels of power throughout all areas in the wind window, and whilst turning or looping, so there must be no 'soggy' spots, especially when riding downwind. Upwind the kite must maintain power and fly efficiently and as far forward in the wind window as possible. Design features that allow both of these characteristics include relatively high aspect plan shapes with smooth drawn back leading edge profiles. Canopy drafts near the centre of the kites are deep to develop plenty of power, and shallow near the wing tips for maximum efficiency. Strut and leading edge diameters are kept to a minimum for efficiency, whilst still being big enough to allow the kite to stay in shape when overpowered.

Lines and bars are one thing that riders can play with, so high performance thin lines, and easy to adjust depower systems are generally used. Line lengths vary between 23 and 30 metres, with longer lines being optimal for light winds to produce maximum power.

Photos: Michael Petrikov

COURSE RACING BOARDS

Ultimately the design of current race boards is governed by two factors: their speed, and their rideability around the race course. In 2012 the 'box' rule was introduced to the discipline which set parameters in terms of the size and weight of a race board. It also stated that boards must be 'production boards', so available to purchase for any rider, and with a minimum number produced. Since this time – as everyone is using production-registered equipment – the differences in board performance are smaller, so manufacturers have to work ever harder to provide the fastest kit for racers and customers.

To win races, speed and pointing angle upwind are massively important, and here the rocker, outline, rail profiles and volume distribution are all critical. Manufacturers have to find a good balance within these elements to make the board work both in flat water, low wind conditions, as well as in higher wind and rough seas. The next critical area is speed and control downwind. Recent generations of board are far easier to ride downwind than in previous years and this has two benefits: firstly, top level riders can ride faster and more comfortably downwind, and secondly, those new to this side of the sport can start to feel more comfortable and confident sailing downwind.

Once you have developed a board that works well both up and downwind, then other aspects are tweaked – such as footstrap and finbox positioning. Tri fin set-ups have become standard and fin development has probably become the main area that riders can concentrate on. High-aspect finely foiled fins with small cant angles for the front fins are now standard, with depths of about 42cm being an average. The rear fin is slightly smaller, around 39cm, and vertical. Different rakes, foil angles and profiles can all make significant difference in pointing, control and speed, and constant testing in a variety of conditions with similar-paced riders has been the key to fast fin development.

As for construction, full carbon foam sandwich is the standard. The main considerations here are weight and stiffness, balanced with durability. The box rule also has a minimum allowable hull weight so brands can still manufacture durable and competitive boards without the cost becoming too prohibitive. The box rule has been, in general, a positive thing for kite racing, and has allowed brands to concentrate hard on the fine details within these set parameters. The differences may not be great, but all the small improvements can add up to significant gains.

For an average rider who hasn't used these boards it's difficult to understand how different race boards are to ride, in comparison with twin tips and wave boards. Full power riding in 8 knots, both up and downwind, is remarkable to see. And getting to speeds of up to three times wind speed going upwind is something no one really imagined possible ten years ago, and places the sport right at the sharp end of modern racing.

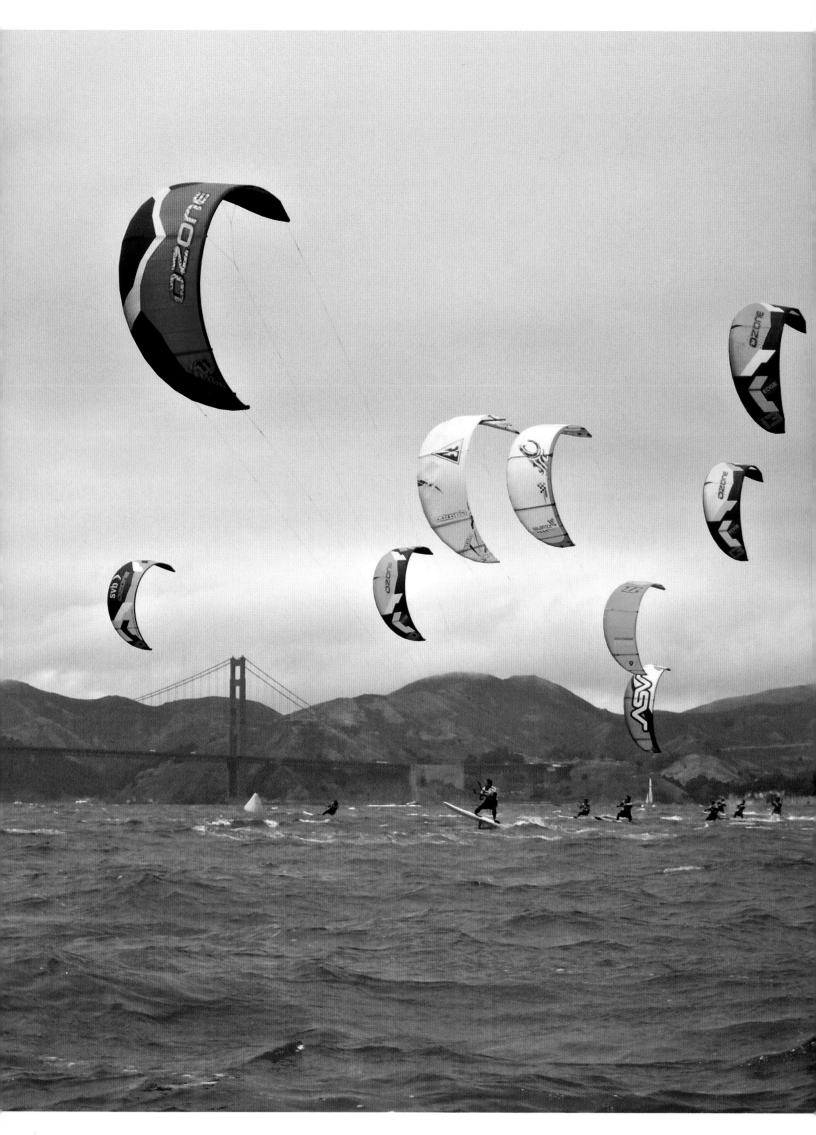

PLACE

SAN FRANCISCO

The World Champion training ground

ERIKA HEINEKEN, COURSE RACING CHAMPION

'San Francisco's summer weather is far from normal – you never know what you're going to get. Fog or sunshine, high fog or low fog, misty fog or breaking-up fog, 25°C or 10°C (it can switch in ten minutes when the fog rolls in), a flood tide or an ebb, a huge hole on shore and 25 knots in the middle of the bay, steady breeze or gusty and shifty ...** Then, when you think you've figured it out, you get an unexpected sunny day with 20–25 knots and a flat ebb tide and your whole theory of weather forecasting gets canned.

San Francisco benefits from a thermal wind nearly every summer day. The often 20°C gradient between the Pacific Ocean and the Central Valley, only 80 miles inland, sucks the ocean fog in through the Gate each afternoon. We see 20 knots or more most days, so the wind-obsessed sailors gravitate to Crissy Field, the westernmost beach in the Golden Gate National Recreation Area. On a good day you'll find 40 kites and 40 boards ripping around the bay.

I can't explain what it feels like to be under the Golden Gate Bridge all alone with only my kite, the wind and the water. From outside the bridge looking back, the red

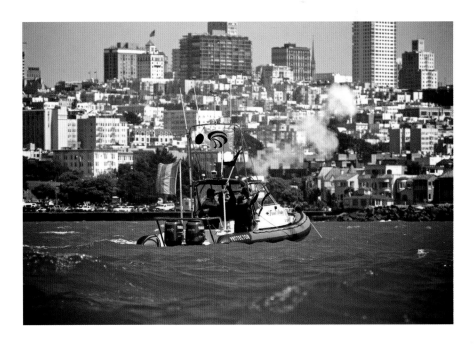

ABOVE: *Photo: Michael Petrikov.*
LEFT: Hosting the IKA North American championships.
Photo: Michael Petrikov.

towers frame the beautiful skyline: the City, Alcatraz, Angel Island and the Marin County hills. Sometimes a nice swell breaks under the South Tower and the ebb tide acts like an upwind escalator. Other times you can't even see the span of the bridge and the condensed fog droplets smack you in the face. Sometimes a tanker or ferry boat will come through and you can ride one long wave from the bridge to the beach.

Kiteboard course racing, which began in 2005, has a rich history here. Nowadays only the most foolish of kiters would attempt to race a twin-tip around a course, but that's how the sport of kite racing began here. Many of the early adopters were ex-windsurfers, who ditched the masts for two-string kites in the early 2000s, but still craved competition. The St. Francis Yacht Club, a few hundred metres down the beach from the launch, was known at the time for supporting "the boards". A few kiters who were club members approached the Race Director, and they were brave (or dumb) enough to give it a go. The races had to coincide with the favourable ebb tide, so they could actually make it upwind, but it worked.

Since then the race scene is ever developing, with new faces joining the local bi-weekly races on a regular basis. It's an absolute thrill to see men in their 50s and girls as young as 12 competing and sharing their passion together. Looking around before a race, it's crazy to think that these friends of ours are the real pioneers of kite-racing, and that they have paved the way for the fastest-growing sailing class to date.

We pride ourselves on the fact that we're an open group enjoying friendly competition, and you often hear hooting and hollering when someone has a good finish. A good race is rewarded with a thumbs-up after crossing the finish line, and a bad one is laughed about over beers with the guys who beat you. The pros may be

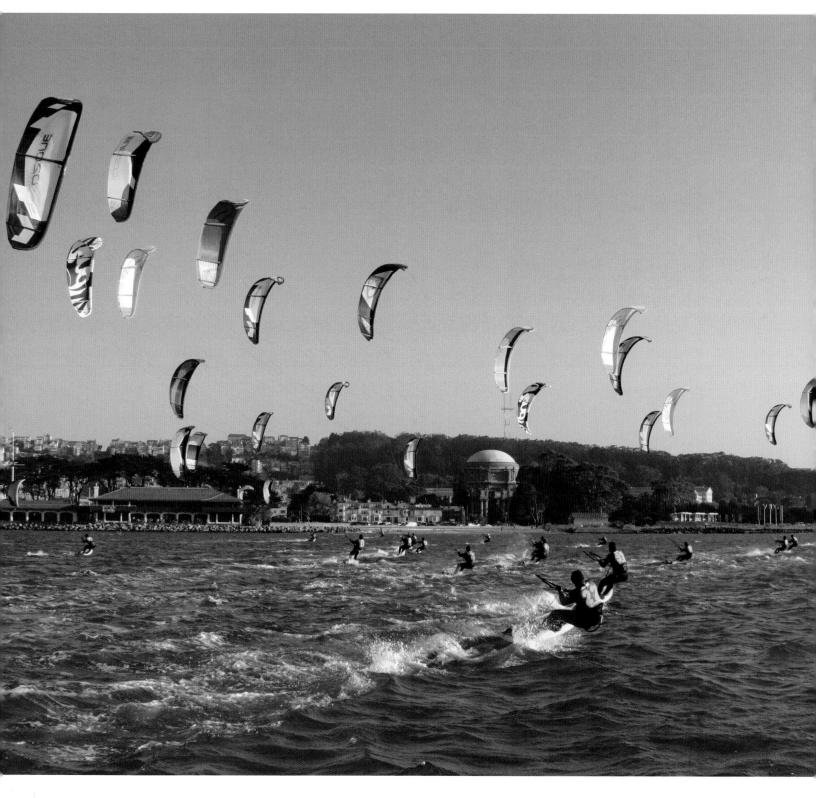

racing themselves at the top of the fleet, but the best part about our casual races is that everyone has competition. The fleet is incredibly competitive from top to bottom. I know, I was there, it's a full-on battle not to finish last place when you're just starting out!

The local crew has undeniably helped to push the limits of kiteboard course racing to where it is today. With massive amounts of talent and dedication, along with one of the best board-builders based around the corner, and direct access to kite and fin designers, we're always going higher and faster than we were yesterday. The sport has progressed from twin-tips, to surfboards, then to wider directional boards with long fins, and with so many tweaks along the way – anything to get that extra edge on the guy next to you. This fleet has been at the forefront of the sport's development from the beginning, and has been a major supporter of getting it to where it is today: a recognised and respected Production Sailing Class.

There seem to be no barriers within the limits of what we believe we are capable of achieving. The days of showing up to a race with a drastically different (and not necessarily improved) board may occur less often, but only time will tell when the next breakthrough will happen. Who knows, maybe it's already beginning – you'll have to pay a visit to San Francisco to see what we're up to.'

FAR LEFT: A typical race night turnout. *Photo: Chris Ray.*
TOP RIGHT: The 'Bridge to Bridge' race. *Photo: Chris Ray.*
BOTTOM LEFT: *Photo: Boriana Viljoen.*
BOTTOM RIGHT: *Photo: Jeff Finn.*

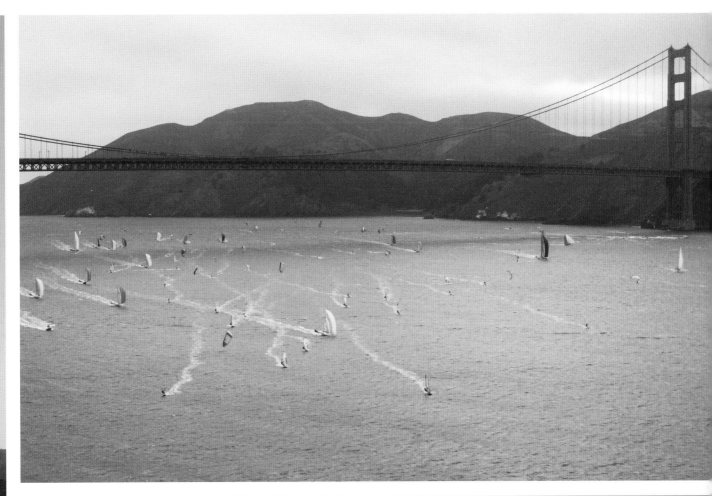

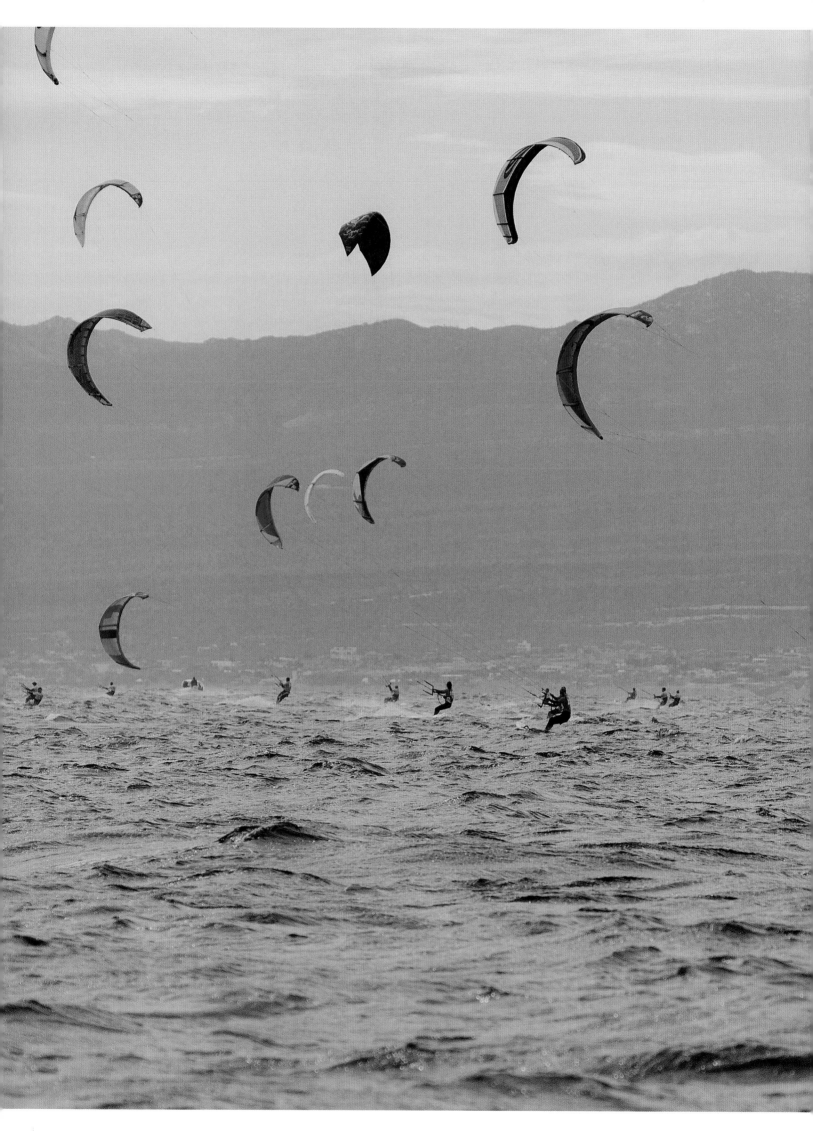

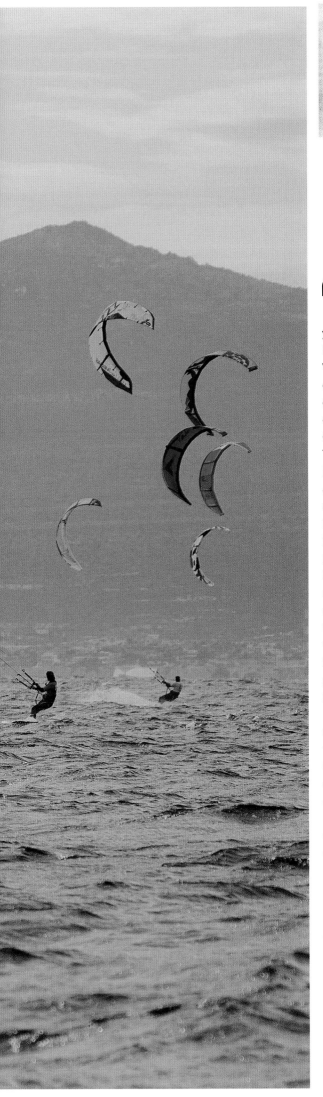

PLACE
LA VENTANA

Tacos and training

ADAM KOCH, COURSE RACING CHAMPION

'**A**s a World Champion and a focussed kiteboard racer, each year in the middle of winter I find myself headed to La Ventana, Mexico.** Endless days of wind in the enormous bay off La Ventana have me riding every kite size in my quiver. Other World Champions and Pro Tour Champions such as Bryan Lake, Sean Farley, Erika and Johnny Heineken can also be seen blasting across the waters here sooner or later. In racing it's important to test your skills in many different conditions. La Ventana ("The Window") offers everything – smooth rolling swell, steep chop, breaking waves, flat water. All mixed in with varying wind strengths. It is the perfect training and testing ground in the lead-up to the long racing season.

Baja is a huge point that is separate from mainland Mexico, towards the tip. The Pacific Ocean is to the west and to the east is the Sea of Cortez. An endless supply of sea-life meets nothing but endless beaches and

ABOVE: *Photo: Adam Koch.*
LEFT: The annual La Ventana Classic. *Photo: Paul Lang.*

cacti as far as the eye can see. World-class fishing and breathtaking scuba- and free-diving draw people from all over the world for more than just the wind.

La Ventana first became a racing training ground in 2009, right when course racing boards were being pioneered by riders like Sean Farley. One of the largest kiteboarding races in the world rested in this large open bay and that brought riders down. The La Ventana Classic was founded by Tim Hatler, owner of Palapas Ventana, many years before. With a winner-takes-all prize of $1000, many hopeful windsurfers and kiteboarders battled it out, fighting to prove which sport was faster.

No shoes, no shirt, no problem. The small town itself has a Wild West feel, with dirt roads and loads of gringo kite junkies. All the tacos and fresh seafood you can eat at crazily affordable prices make it easy on the budget and easier still to stay long periods of time. The common language here is English among tourists, which is actually most of the town. The wind season lasts from October to April, although the most crowded

months are January and February. There is no need to rent a car – the town is small enough that you can walk everywhere. La Paz is the closest airport – about 45 minutes away – making travel access to the United States and all over Mexico easy, and the closest international airport is three hours away in San Jose.

The wind is like clockwork. At 11am it turns on and stays all day until sunset. On calm mornings stand-up paddling, fishing and spear-fishing are on offer. You can swim out and spear a fish and be eating it for an early lunch before the wind fills in. Beyond that there is nothing there but what you bring. It truly is in the middle of nowhere.

Playa Central, located in the central part of town on a sandy beach, is where it's at. The racecourse is right out in front of the only grassy kite-rigging area around. You can smell the outdoor pizza oven as you rig up and check out the conditions for the day. Raceboard storage racks, kite racks and hot showers ... all within reach of a full bar and restaurant. Race series are run regularly, attracting up-and-coming racers who need a simple programme, no stress and nothing to do but go out and ride.

As with any well-established kiteboarding or windsurfing location you must be respectful of the locals. Here, that doesn't just mean the fishermen. Buzzing straight upwind and straight downwind through just about every skill-levelled rider is fun for us, but annoying for them. Luckily, there are miles of coastline with the wind running parallel to it, and plenty of buoys to make use of, so you can spread your wings and fly far from your launch site.

There is not a kite racer who has travelled to La Ventana for a good four-week training session who hasn't been launched into the top of the pack when they get back home. Everyone is welcome.'

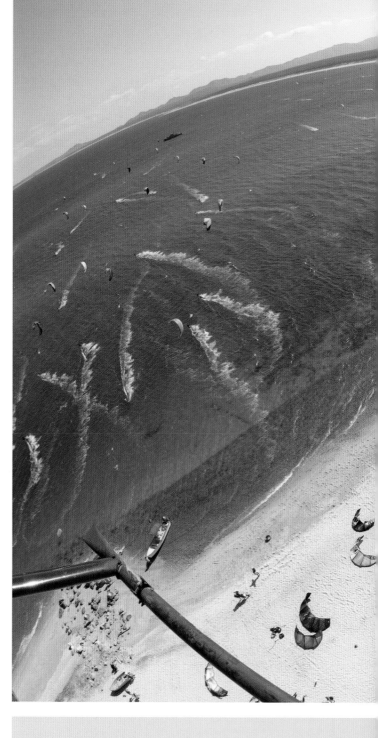

TOP RIGHT:
Warm water, wind and plenty of space.
All photos: Adam Koch.

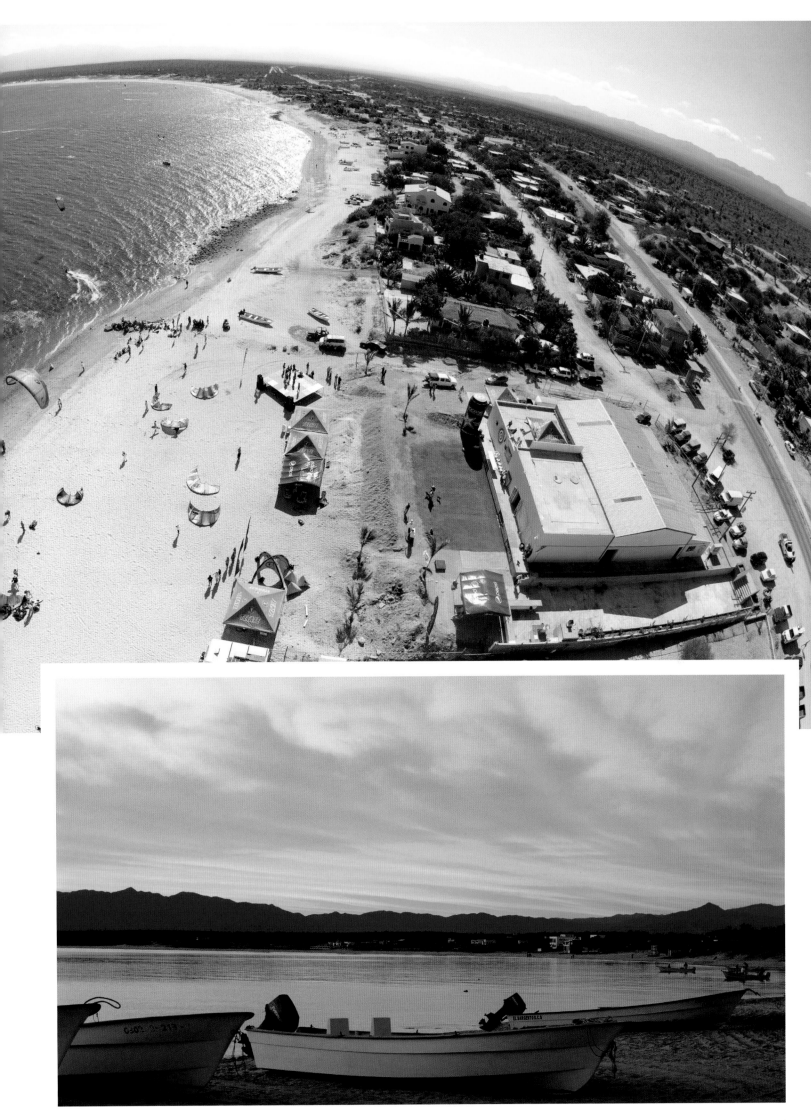

JOHNNY HEINEKEN

Johnny Heineken grew up on and around the water. His dad was involved with the windsurfing and sailing scene and Johnny soon realised that he wanted to follow the same path. He became a serious player on the high-performance dinghy scene, and then got on a raceboard at the 2009 Course Racing World Championships and hasn't looked back. From the outset he was scrapping at the front of the pack and, since 2011, has proven that he is the man to beat.

At a time when boards and fins were evolving at lightning speed, Johnny was instrumental in driving the developmental side of the sport, working alongside Ozone and Mike's Lab to keep ahead of the curve in the development of race kit and to help bring it to the relatively evenly balanced place it is at today. In 2012, Johnny was awarded the prestigious US Rolex Yachtsman of the Year award – a pretty staggering achievement in its own right, and also proof that his and his peers' performances had earned the approval of the sailing community.

When Johnny's not racing or training, he works on the mechanical team at Makani Power, helping them to develop their revolutionary airborne wind turbines. And the best piece of advice he ever got? That would be from his dad: 'Get a good start, go the right way, and don't screw up!' Wise words.

ALL ABOUT ME…

- **Trophy Cabinet:**
 Lord of the Wind 2011 – 1st
 PKRA Mexico 2011 – 1st
 Canadian National Championships 2011 – 1st
 North American Championships 2011 – 1st
 PKRA Germany – St. Peter Ording, Germany 2011 – 1st
 Course Racing World Championships 2011 – 1st
 Course Racing World Championships 2012 – 1st
 Course Racing World Championships 2013 – 2nd
 North American Championships 2013 – 1st
 La Ventana Classic 2011, 'The Crossing' – 1st
- **In the bag:** My entire quiver of Edges; Mike's Lab board.
- **Best spot:** I love kiting around San Francisco. There are always amazing conditions to be found – from the best racing venue in the world at Crissy Field, through to warm freshwater at Sherman Island, and world-class waves on the coast.
- **First set-up:** Naish torch 10m and a twin-tip got me through my first summer.
- **Proudest kiting moment:** Winning the 2012 World Championships with my sister Erika on the top of the women's podium. That was a really cool moment for both of us and one I'm sure we'll remember forever.

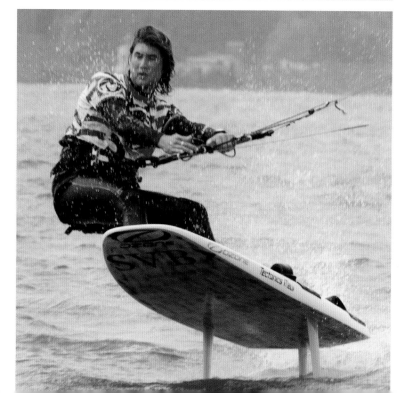

ABOVE: *Photo: Toby Bromwich.*
LEFT AND RIGHT: *Photos: Michael Petrikov.*

Don't take my word for it…
RICCARDO LECCESE

Johnny has such a consistent ride-through all over the course. He has an elegant and solid stance on the board and you can tell how much energy and power he puts in to make it run like a racehorse. San Francisco has been the cradle of kite racing, and Johnny and the other guys out there are the main ones responsible for creating this incredibly fast, efficient and enjoyable discipline.

Johnny has a non-stop commitment to winning races and he doesn't like to be behind – his precise strategy and tactics combined with his rapid decision-making are his signature and he is always right on the line when green flags comes up. Damn, he always gets a good spot! If you meet Johnny at a contest you might think he is a kind of cold professional hustler, but don't take it too seriously – you have to be like that to survive in this racing game. He's like a poker player and, when he's finished the contest, you'll find him with a beer in his hand, always smiling, open and friendly, and keen to talk about the races.

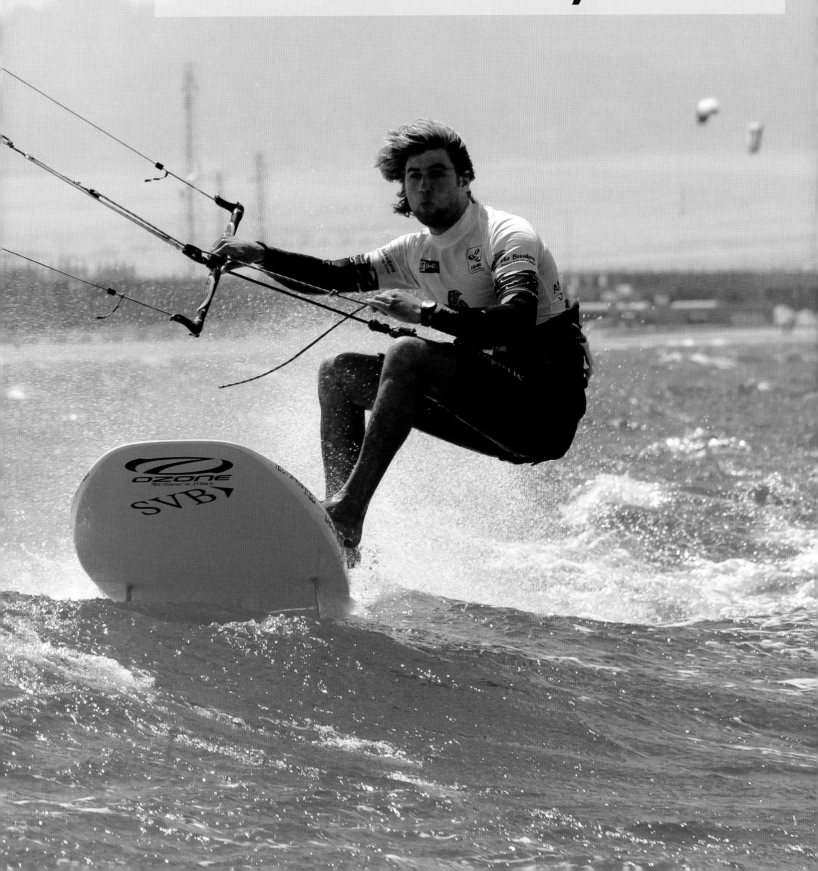

PLAYER
BRYAN LAKE

Bryan Lake first flew a kite from the end of a fishing pole when he was five. When he was 16 he saw Chip Wasson and Paul Buelow riding under the Golden Gate Bridge and that was the catalyst for a remarkable kiteboarding career.

From the outset, Bryan has pushed the limits of the sport. Back at an event in 2003 his truck had been stolen with all of his equipment in it, so he rode a skimboard strapless. He went out of the event in the first round, but scored a spread in *Kiteboarder Magazine* and can be considered one of the pioneers of the strapless revolution.

His travel schedule sees him kicking off the year in Baja until the Lord of the Wind contest is finished. He then goes back to San Diego for light-wind training (and to catch up on surfing and fishing commitments) through until May, before he heads to San Francisco for the second half of the year. Bryan races hard and is one of the fiercest competitors on the circuit, but on the beach he has a reputation for his laid-back attitude, chilled approach to life, and for good times.

ALL ABOUT ME...

- **Trophy Cabinet:**
 Ronstan Bridge to Bridge Race 2011 – 1st
 Lord of the Wind Showdown 2012 – 1st
 PKRA World Tour 2012 Racing Champion – 1st
 Beetle Kitesurf World Cup Racing 2012 – 1st
 MINI Kitesurf World Cup Racing 2013 – 1st
 Lord of the Wind Showdown 2013 – 1st
 North American Championships 2013 – 2nd
 Beetle Kitesurf World Cup Racing 2013 – 1st
- **In the bag:** 18, 13, 11, 9m Cabrinha Velocity; Mikes Lab 70, and of course a Tminus9 custom skimboard
- **Best spot:** The closest spot there's wind! And preferably with good Mexican food nearby.
- **First set-up:** Slingshot Fuel and Connelly Dually wakeboard
- **Proudest kiting moment:** When I got my first cover shot on the *Kiteboarder Magazine* in the States, no straps, unhooked. And when I won my first major PKRA World Cup in Germany in 2012. Actually, there are too many proud moments – getting my 40-year-old sister up and shredding is in there too!

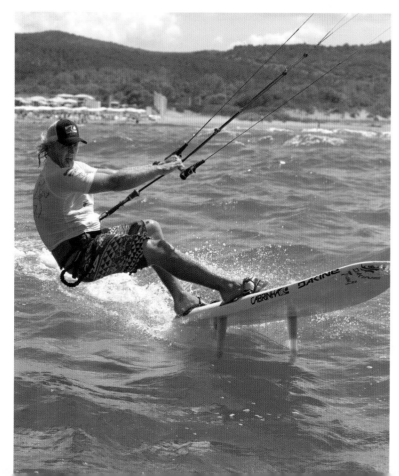

ABOVE AND LEFT: *Photos: Toby Bromwich.*
RIGHT: *Photo: Darrell Wong.*

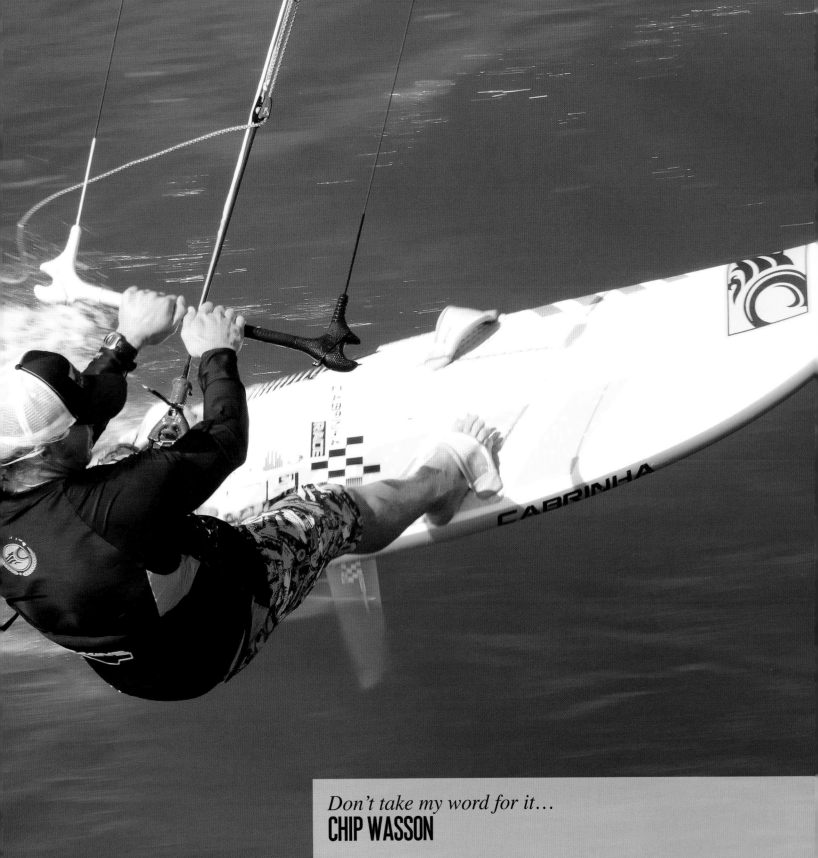

Don't take my word for it…
CHIP WASSON

❩ Bryan Lake (aka Bernie) is a charging innovator in kiteboarding and beyond.
Whether he is in the surf on his skimboard, winning a slalom event on his raceboard, or gliding on his foilboard, he is always looking for the next thing. On raceboards, it was historically thought that pointing high was the fastest way to the windward mark, until Bernie simply decided to go faster and get there sooner. Most recently I would say that one of Bernie's best achievements is his passion and participation in the slalom racing. Fast, aggressive, smart, smooth, and winning!

Bernie has this legendary aura that encompasses his persona and gives him star status at the beach. In spite of that he is one of the nicest guys you will ever meet. Bernie is a beacon in our sport and one to watch as our sport advances and unfolds. He also gives our sport a strong touch to the pro-surf world, and projects the fact that anything is possible in the sport of kiteboarding. One thing is for sure, you will always find him on the cutting edge, and he will always be going faster! ❩

STEPH BRIDGE

Coming from a wind-orientated dinghy-sailing background, Steph was on the case with kiteboarding as soon as it arrived in the UK. The Exe Estuary, on England's south coast, proved to be the perfect place to maximise water time, and she quickly rose through the ranks of the freestyle elite – winning the British Freestyle Championships in 2006 – and was also very competitive on the European and World circuits. It was when course racing emerged on to the scene, however, that Steph found her true calling within the sport. Her dinghy-sailing background and all-round fitness stood her in great stead and she proved herself to be pretty unstoppable around the racecourse, dominating the PKRA race circuit between 2007 and 2009 and continuing to dominate the highly competitive field when the course racing side of the sport moved to the IKA.

Steph has remarkably managed to juggle an elite kiteboarding career with running a successful kite shop and school with husband Eric, and with bringing up three boys. All of her kids now give her a run for her money on the water, with her eldest son, Olly, seeming to have picked up the course racing genes that have served Steph so well.

ALL ABOUT ME...

- **Trophy Cabinet:**
 UK Freestyle Champion 2006
 PKRA Race World Champion 2007, 2008, 2009
 IKA Race World Champion 2009
 IKA Race World Championships 2010, 2nd
 IKA Race World Champion 2011
 IKA Race World Championships 2012, 2nd
 IKA Race World Championships 2013, 2nd
- **In the bag:** 17, 15, 13, 11 9m Dyno; North Race Board 69. 9 and 7m Neo and North Pro surfboard for playing days!
- **Best spot:** Difficult question to answer as a huge amount of days and locations are special – they could be grey days with just family or friends or a special moment like when a big sea creature is around!
- **First set-up:** Wipika Freeair and Naish Sky Pirate
- **Proudest kiting moment:** The Kite Race Europeans in Italy in 2013 when Olly won the men's Europeans. I was on the beach having finished racing and Olly had gone into the Gold fleet with decent points, but then went and dominated the racing, aged just 15. That was pretty cool.

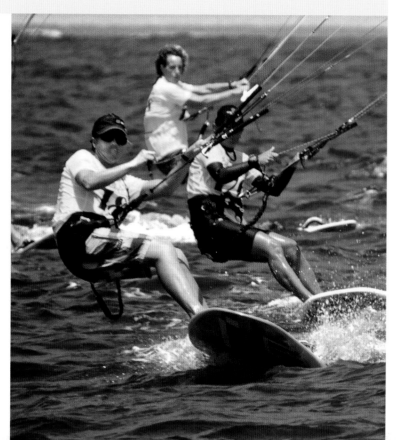

All photos: Michael Petrikov.

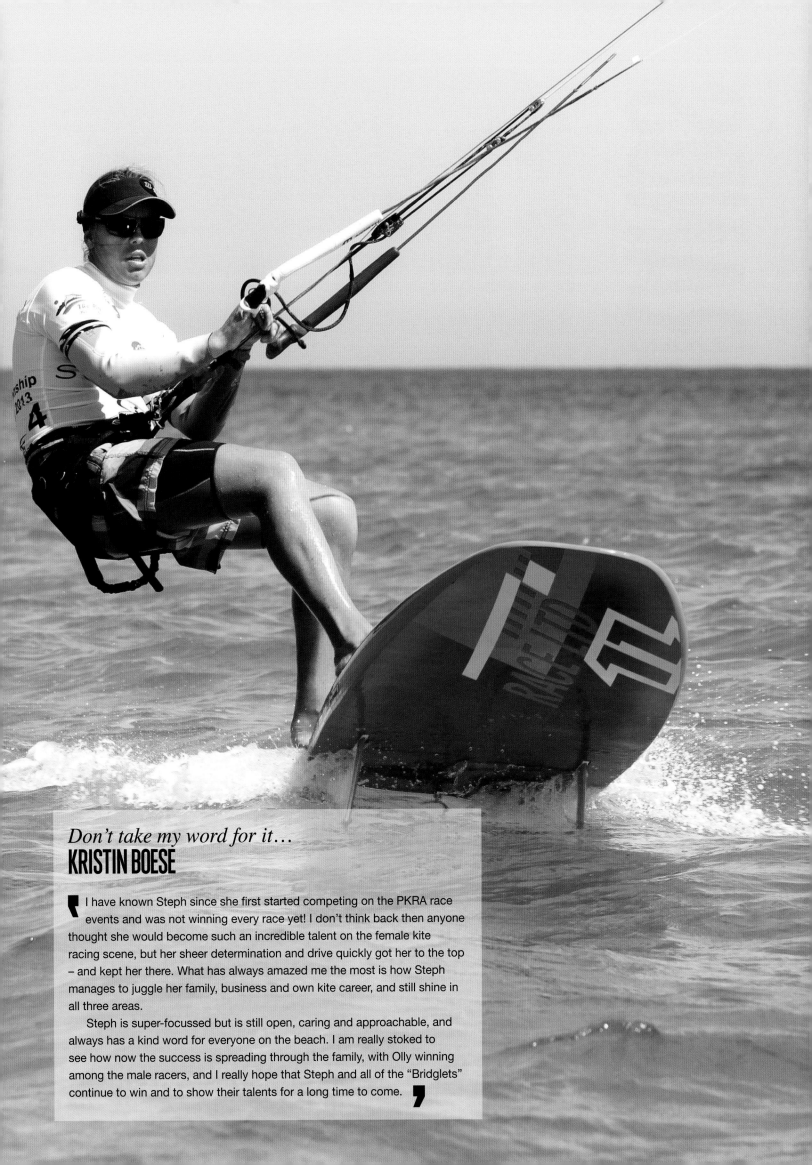

Don't take my word for it…
KRISTIN BOESE

I have known Steph since she first started competing on the PKRA race events and was not winning every race yet! I don't think back then anyone thought she would become such an incredible talent on the female kite racing scene, but her sheer determination and drive quickly got her to the top – and kept her there. What has always amazed me the most is how Steph manages to juggle her family, business and own kite career, and still shine in all three areas.

Steph is super-focussed but is still open, caring and approachable, and always has a kind word for everyone on the beach. I am really stoked to see how now the success is spreading through the family, with Olly winning among the male racers, and I really hope that Steph and all of the "Bridglets" continue to win and to show their talents for a long time to come.

THE BRANDS

6

Since its inception, the progression of kiteboarding as a sport has been entirely dependent on the development of equipment. From the very first days a 'healthy competition' between brands – many of whom are headed up by one of those early pioneers of the sport – has been instrumental in driving kiteboarding forward at the remarkable pace that has taken it to where it is today.

From day one the brands could see that the full potential of the sport was some way from being realised, and so the race was on to innovate, to explore, and to develop the potential of kites and of boards – and to stay one step ahead of the competition. Certain brands can take the credit for step-changing innovations – the developments which transformed the sport and could be found on every kite the following season – and kite companies who have come later to the market have the established brands to thank for the solid foundations on which the sport is built. (And for the fact that they'll never have to work out how to build a kite that can be turned down from 'full power'…)

This commitment and passion for the sport continues within the brands, and today they are not the faceless corporations that others in the world of 'extreme sports' have become. All of the kiteboarding brands have at their core kiteboarders, whether they began the brand in 1997, or whether they have recently discovered the sport. If you go to any office, any event, or any meeting then you will find that at every brand's heart is a genuine passion for kiteboarding, a complete dedication to driving the sport forward and, of course, an unwavering belief that their latest kite is the very best on the market.

Photo: Nate Appel.

BRAND

NORTH KITEBOARDING

HEAD ROOTS

Boards & More (B&M) is the world's leading company for kiteboarding, stand up paddle boarding (SUP) and windsurfing equipment. B&M was founded in 2000 and now fields a team of around 80 dedicated people who work on developing, realising and distributing products for customers who love their sports as much as B&M do. The most important brand under the roof of B&M is North Kiteboarding, which is the worldwide market leader of kiteboarding equipment. The brand was conceived in the US by Ken Winner and Jaime Herraiz, two outstanding characters in the development of the sport. Once the current boss and CEO of B&M, Till Eberle, joined the club, the brand took off and hasn't looked back.

THE BOSS

Till Eberle is the engine and entrepreneur of North Kiteboarding. He started the company from zero and has made it a world-leading brand. He is completely hands-on with the development process and, being an engineer, product development and ensuring that products are of the highest quality are his main aims.

THE RIDERS

Airton Cozzolino (bottom left) – Airton is World Champion in waveriding, a true waterman and one of the best human beings with a kite, surf or SUP board! He is one of the few riders pushing freestyle waveriding to the next level.

Tom Court (bottom centre) – UK legend and wakestyle-machine, Tom is probably one of the best obstacle-hitters on the planet, playing a major role in developing wakestyle kiteboarding.

Sky Solbach (bottom right) – One of North's best riders, Sky also shapes the surfboard range and helps with developing the Neo, Rebel, Dyno, and Juice with designer Ken Winner. Plus, he's still one of the best riders in waves, and competes in the KSP wave tour.

THE OFFICE

B&M are based in the south of Munich and comprises a core bunch of passionate kiteboarders alongside the business professionals. This core makes the work carried out by people all over the world possible. From Munich to Hawaii, South Africa to Italy and Mauritius to France, B&M is a truly global operation and employs over 100 people in total.

PHILOSOPHY

North Kiteboarding is True Kiteboarding. Anybody involved is living and loving its passion. North Kiteboarding wants to offer the best-functioning and best-looking products in any niche of kiteboarding. Their efforts in R&D are immense; they have the best riders and designers and are always trying to improve products and to develop the sport itself. To maximise their creativity they have two kite designers who work closely together but have their own concepts and approaches and are responsible for different kites in the range. They have the same approach to the look of the kites: NKB wants to be the leading company regarding graphics, never following and always evolving in its own way. North Kiteboarding is an international company, working together with the best people all over the world, who are responsible for the success of the brand today.

All photos: courtesy North.

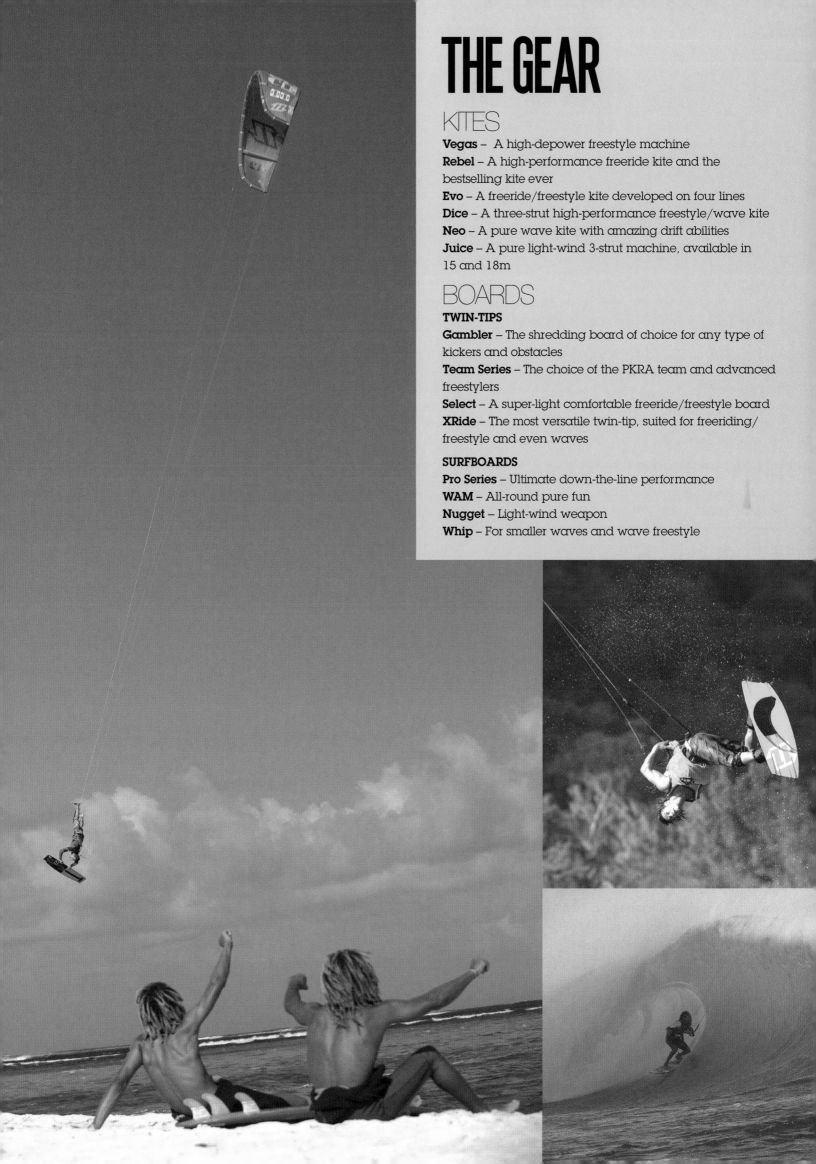

THE GEAR

KITES

Vegas – A high-depower freestyle machine
Rebel – A high-performance freeride kite and the bestselling kite ever
Evo – A freeride/freestyle kite developed on four lines
Dice – A three-strut high-performance freestyle/wave kite
Neo – A pure wave kite with amazing drift abilities
Juice – A pure light-wind 3-strut machine, available in 15 and 18m

BOARDS

TWIN-TIPS

Gambler – The shredding board of choice for any type of kickers and obstacles
Team Series – The choice of the PKRA team and advanced freestylers
Select – A super-light comfortable freeride/freestyle board
XRide – The most versatile twin-tip, suited for freeriding/ freestyle and even waves

SURFBOARDS

Pro Series – Ultimate down-the-line performance
WAM – All-round pure fun
Nugget – Light-wind weapon
Whip – For smaller waves and wave freestyle

BRAND AIRUSH

THE GEAR

KITES
Lithium – All-round performer
Varial X – Redesigned to redefine your ride
Wave – 100 per cent surf
Razor TEAM – No-nonsense C-kite

BOARDS
TWIN-TIPS
Switch – Premium freeride
Apex – Introducing aggressive freeride
Livewire – Boots, straps, wakestyle, freestyle
Livewire team – Ultra everything

SURFBOARDS
Compact – Versatile, strapped and strapless
Cypher – Onshore, strapless, sloppy waves
Slayer – Strapless, light-wind freestyle

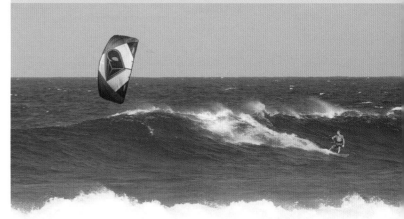

ROOTS

Airush Kiteboarding started on the island of Maui in 1999, creating bars and accessories to supply Wipika kites. They quickly became the brand to buy for bars, straps, bags and harnesses. In 2001, Airush started developing the most innovative boards with the support of Starboard- and famous-shaper Jimmy Lewis. By 2002, Airush had changed hands from Keith Baxter to the owner of Starboard, Svein Rasmussen, and were starting to introduce kites, making Airush a full-service brand. This marked the beginning of the journey that has led to where Airush is now: one of the most-respected and fastest-growing brands on the market.

THE BOSS

Brand manager Clinton Filen started as product manager of Airush Kiteboarding seven years ago. As the brand changed and progressed, Svein Rasmussen – owner of Airush and Starboard – made Clinton the brand manager. Over the last few years, Clinton has led the brand through the most progressive and innovative time in Airush's history.

THE RIDERS

Alex Pastor (above left) – Indisputably one of the best kiteboarders of the modern era, Alex has been at the top of the PKRA for many years. Quiet most of the time, he shouldn't be thought of as antisocial. He is an extremely focussed member of the team, and is team captain.
Bruna Kajiya (above centre) – The face of women's riding as we know it, Bruna is extremely powerful and has a friendly smile on the water. Oh, and she's 2009 World Champion!
Bear Karry (above right) – His carefree attitude is contagious – I guess that's the California way. When you see him on a surfboard you would swear there is Velcro on his feet. He's just naturally gifted, goes out and generally sticks new mind-blowing moves on the third attempt.

THE OFFICE

The Airush design office is located in windy Cape Town, South Africa. From conception and prototyping to testing, it all happens at locations within a five-minute drive of each other, making Airush one of a kind. Known as the hub for kiteboarding, Cape Town offers endless variations of conditions, from flat water to down-the-line wave riding, and everything from 15 knots to 35 knots. Beyond the office, testing is done by their pro riders, key schools and shops, who provide valuable feedback on some of the most crucial products in the range.

PHILOSOPHY

Design is at the heart of Airush; the team simply get out of bed every morning to create incredible products. There is often a misconception that products for international brands are mass-produced by people with no passion, or by machines that spit out product after product. At Airush, nothing could be further from the truth. Their focus is to make sure that every single product has been crafted with the same passion and care as one you would find in their custom workshops.

All photos: courtesy Airush.

BRAND SLINGSHOT

THE GEAR

KITES
Fuel – King of Air
RPM – Innovator of three-strut hybrids
Rally – Ultimate performance
Turbine – Making light-wind sessions fun

BOARDS
TWIN-TIPS
Asylum – Freestyle/wakestyle performance
Misfit – Ultimate crossover performance
Glide – Leader in light-wind performance

SURFBOARDS
T-REX – Modern noseless freestyle
Tyrant – High-performance
Celeritas – Exceptional 'all conditions' fun

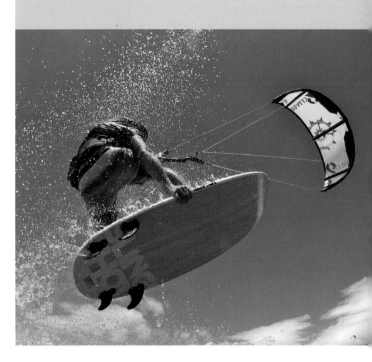

ROOTS

Slingshot was started in 1999 by brothers Jeff and Tony Logosz. However, their roots in performance board-making started far earlier than that – they actually began by making snowboarding equipment in Salt Lake, Utah. Today, Slingshot manufactures, designs and sells leading equipment in kiteboarding, wakeboarding and stand up paddle boarding from their base at one of the most iconic spots on the planet for watersports: Hood River, Oregon.

THE BOSS

Jeff Logosz manages and inspires the highly motivated team at Slingshot to make it the brand it is today. Tony Logosz leads the innovative charge to build cutting-edge products and designs that change the industries they work in.

THE RIDERS

Mauricio Abreu (above left) – 'Morris' is the Slingshot kite team manager and has been influential in the sport of kiteboarding from the beginning. He now leads and inspires a talented team of kiters, including most of the top wakestyle riders in the sport.

Karolina Winkowska (above centre) – Karolina has proven herself to be not only a pretty face on the tour, but also a fearless competitor. With a bag of tricks that can school most guys, Karolina has PKRA world titles to her name, and has set the new standard for female riding.

Sam Light (above right) – The most successful competitive wakestyle rider to date, has a unique style and is a real asset to the Slingshot team. Chilled out of the water, when he gets in his boots he's an entirely different animal.

THE OFFICE

The office, warehouse and board factory are located in the Columbia River Gorge. Their boards are made there, which ensures that they can follow the process from start to finish and produce exactly what they want. All of their products are tested there too, and then by the Slingshot team riders around the globe to ensure that they all perform in all of the conditions that their riders are using them in.

PHILOSOPHY

At Slingshot the team's energy and drive goes not only into the products they develop but also into the sports they support. From creating One Pump ten years ago, they have moved on and introduced features such as Split Strut, below-the-bar depower and many other features that allow them to provide a more pleasant kite experience for their customers. In 2007, Slingshot entered the wake market with a new innovative design from their US factory that has since initiated a whole new style of wakeboarding. It is this kind of dedication and innovation that keeps the sports going. This is only possible due to the small team that works countless hours on projects, not just because it is their job, but because it is their passion.

All photos: courtesy Slingshot.

BRAND

ROOTS

Naish began in Kailua on the Hawaiian island of Oahu in 1977 when Robby's father, Rick, began shaping windsurfers in their garage. Naish pioneered the sport of kiteboarding with the first modern four-line inflated-strut kites in 1999 and has since developed many of the sport's now-standard features. Naish began promoting the sport of stand up paddle boarding (SUP) in 2007 and is now a world leader in SUP. More than three decades after winning his first World Title, Robby's passion for boardsports is stronger than ever, and he lives by the motto that 'every day on the water is a good day!'

THE BOSS

Robby Naish is one of the first athletes to gain long-lasting fame in windsurfing. He won his first World Championship aged 13 and went on to win a total of 24 titles, adding two kiteboarding World Championships in his late 30s. As the owner of Naish, he leads a team of talented international engineers and team riders that live kiteboarding day in and day out.

THE RIDERS

Jesse Richman (above left) – Jesse is the waterman of kiteboarding. He is a two-time World Champion, won the Red Bull King of the Air on its return in 2013 and has been voted AWSI Kiteboarder of the year twice.

Kevin Langeree (above centre) – Kevin is a top PKRA freestyle contender and was crowned Red Bull King of the Air 2014. He is arguably the most powerful all-round kiteboarder in the world.

Jalou Langeree (above right) – Jalou holds the 2012 KSP World Champion title and is pushing waveriding to new heights, chasing the best waves and gnarliest conditions around the world.

THE GEAR

KITES

Torch – Pro-performance freestyle
Park – Performance freeride/freestyle/wave
Draft – High-performance freeride/race
Ride – All-round performance freeride
Trip – Travel/freeride/wave

BOARDS

TWIN-TIPS
Alana – Women's freeride/freestyle
Antic – Wakestyle/cable hybrid
Monarch – Pro performance freestyle
Dub – Freestyle/freeride

SURFBOARDS
Global – Performance wave
Skater – All-round strapless wave
Fish – Light-wind/wave
Custom LE – Performance strapless wave

THE OFFICE

The main office is located in Maui, Hawaii, minutes away from the iconic North Shore and much-frequented Ho'okipa surf spot. The bulk of their riding and testing is done on Maui by their R&D team and team riders in a variety of locations where water and wind conditions are drastically different. This enables Naish to put its gear through the widest possible assortment of testing conditions. Naish's gear is also tested thoroughly by their team riders on the US mainland, in Australia and in Europe.

PHILOSOPHY

Naish has been kiteboarding since the sport's absolute beginning. Although they are passionate about windsurfing and SUP as well, kiteboarding is a big part of who they are and is the core of their business. In a sport that has grown and evolved so quickly in such a short period of time, Naish is constantly looking for new ways to make it more fun, accessible and safe. Based in Maui, Hawaii, they embrace all aspects of kiteboarding, from the professional tour to everyday freeriding, designing kiteboarding gear that will make every session the best it can be, regardless of a rider's ability level.

All photos: courtesy Naish.

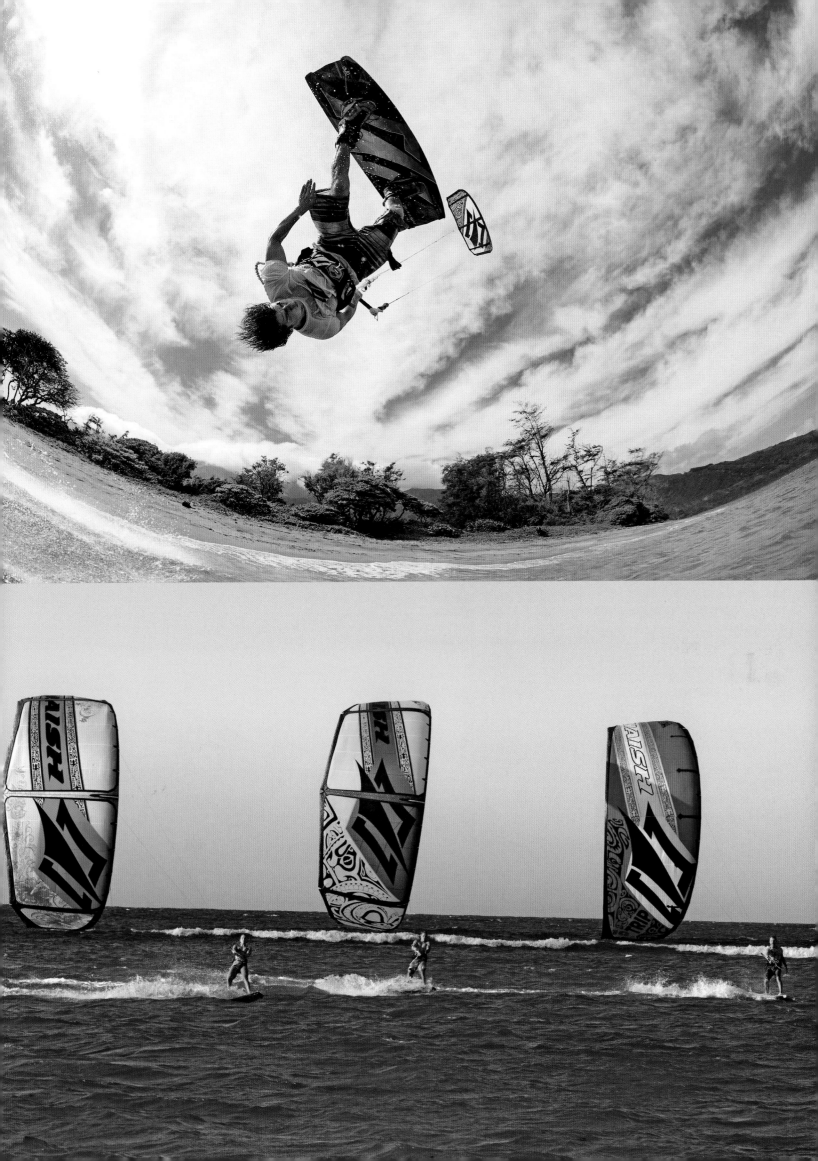

BRAND

NOBILE
K I T E B O A R D I N G

ROOTS

Nobile-branded kiteboards began in 2004. After years of producing boards for other companies, the boss of the factory, Dariusz Rosiak, decided to launch his own brand. The first kiteboards were built using snowboard technology and featured groundbreaking methods developed by Nobile R&D, including Elliptical Progressive Concave, Dynamic Asymetrical Shape, Hydrodynamic Rocker Line and later 3D Construction. Since then Nobile products have become famous for their astonishing quality and high performance.

THE BOSS

The Nobile brand, as well as the kiteboard factory, was established by Dariusz Rosiak. Dariusz started kiteboarding in 2001 and soon after then he developed the world's first kiteboard that utilised snowboard technology, which laid the foundations for modern kiteboards. Dariusz is the head of Nobile R&D, as well as being a keen kiteboarder, snowboarder and skier and a licensed pilot.

THE RIDERS

Eudazio Da Silva (top right) – Born next to Cauipe Lagoon, Brazil, Eudazio is a multiple champion of Brazil and a top five PKRA rider.
Kasia Lange (middle right) – Kasia is 2013 Kite Champion of Poland. She's a PKRA rider who loves to travel and to teach kiteboarding.
Jose Luengo (bottom right) – Jose is one of the originals – a kiteboarding legend and Master of The Ocean 2012. His 'best results' are too numerous to list here. He currently works as a KSP judge.

THE OFFICE

The Nobile office is located in Bielsko-Biała, Poland, in the centre of Europe. The office is in the same building as the kiteboard factory, so they have direct control over the manufacturing process and unlimited prototyping possibilities. Most tests are carried out by Nobile riders and Dariusz Rosiak in Tarifa, Cape Verde, Prasonisi (Greece) and the

THE GEAR

KITES
T5 – Smooth and precise freeride kite
50/Fifty – Hybrid C-freestyle kite
Training Kite – Perfect when beginning the kite adventure

BOARDS
TWIN-TIPS
50Fifty – State-of-the-art freestyle
NHP CARBON – Pushing the boundaries of performance
NHP Split – Super-comfy and travel-friendly
T5 – Versatile freeride classic

SURFBOARDS
INFINITY Classic – Explore the waves
INFINITY Splitboard – Split it, pack it, go kiting!

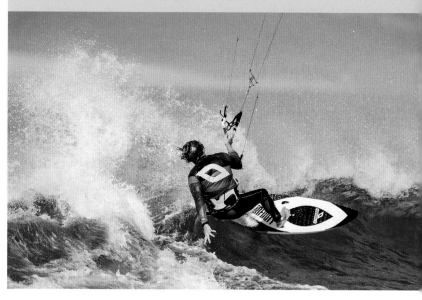

Hel Peninsula (Poland). They also have an experienced test team in Tarifa focussed on developing their kites.

PHILOSOPHY

With all the equipment Nobile have, they want to offer the maximum possible performance, but always keep in mind safety and comfort. Nobile Split Boards are the latest addition to their kiteboarding collection and each of these can be packed within seconds into a usual quiver or travel bag, still leaving enough space for other necessities, which helps to save on the travel expenses. At the core of everything they do is their 'Human Concept' philosophy, where everything is thought out to put you and your safety first.

All photos: courtesy Nobile.

THE GEAR

KITES

Switchblade – Freeride performance, knows no boundaries
Drifter – Drift surf stability
Chaos – High-performance freestyle and wakestyle

BOARDS

TWIN-TIPS
Caliber – Competition freestyle
Custom – Freestyle/wakestyle/cable crossover
Tronic – Big-air freestyle performer

SURFBOARDS
PC Signature Surfboard – Pure surf
Skillit – Skate-style surfing
Subwoofer – Kitesurfing fun

ROOTS

Since 2000, Cabrinha, a subsidiary of the Pryde Group, has climbed the ranks to take the position as the leading kiteboarding brand, selling in over 40 countries worldwide. Inspired and driven by Maui-based waterman, Pete Cabrinha, the company produces everything from kites and boards to accessories, and sponsors many of the top kiteboarders in the sport.

THE BOSS

Legendary waterman Pete Cabrinha garners respect from both athletes for his riding, and the industry for his contributions to the progression of the sport. A love of experimentation and adventure and the appreciation of industrial product design are the things that have driven Pete Cabrinha since the beginning of his career. As visionary and brand manager of Cabrinha Kites, Pete's day-to-day involvement continues with a hands-on approach.

THE RIDERS

Keahi de Aboitiz (top right) – Australian Keahi practically grew up in the water and is recognised as one of the most talented kiteboarders on the planet, most recently winning the KSP title in 2012 and 2013.
Susi Mai (centre right) – Susi grew up in the Dominican Republic and, with understanding parents, set her sights on kiting rather than university. She is an inspiration to kite girls everywhere.
Alberto Rondina (bottom right) – Alby has been competing on the PKRA tour since 2009 where he has a great rep, although his mild-mannered personality contrasts dramatically with his warrior-like approach to competition.

The office

The heart and soul of the company is in Maui, with Pete leading the charge as brand manager. Cabrinha's research and development facility in Maui is perfectly situated for testing in any and all wind and water conditions. This, combined with their own state-of-the-art production facility, ensures consistency and accuracy from design to production.

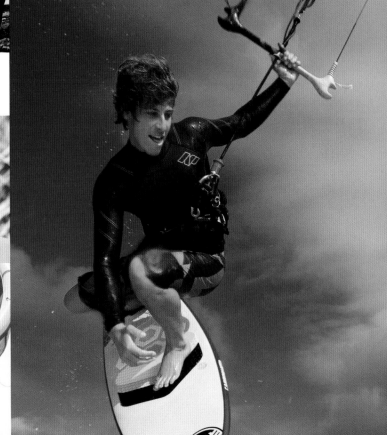

PHILOSOPHY

The Cabrinha approach to kiteboarding has evolved very much from the same philosophy that Pete has applied to his many years of surfing. By keeping an open mind to all styles of riding and embracing new technologies, Cabrinha has been able to lead kiteboarding into a new era of performance.

All photos: courtesy Cabrinha.

BRAND

ROOTS

F-ONE is a France-based brand that was created in 1994 by Raphaël Salles. The former professional windsurfer has been designing and developing kiteboarding gear since the very beginning and was one of the pioneers of the sport in France and worldwide. F-ONE has continually evolved and pursued new and groundbreaking developments within the sport, and has now branched out into the production of stand up paddle boarding (SUP) equipment, a complementary sport to kiteboarding.

F-ONE's goal is to answer the demand of all those passionate about watersports by producing better products every year, and to use constant innovation to ensure high quality, safety, comfort, power and manoeuvrability in all of its products.

THE BOSS

Raphaël Salles has spent 37 years of his life on the water. He is an ex-windsurfing pro rider, with an enviable collection of titles and silverware. There is no one more passionate about development and the technical aspects of kiteboarding, and he is in charge of the research and development of the brand. Today Raphael is over 50 years old but still spends 150 days every year on the water developing the F-ONE products and giving only the best to his customers.

THE RIDERS

Mitu Monteiro (above left) – Two-time World Champion Mitu Monteiro has been at the pinnacle of the waveriding scene for many years and is widely regarded as the best waverider of recent times.

Micka Fernandez (above middle) – Micka has been at the very heart of the F-ONE team for many years. Following a successful freestyle career, including winner the KPWT title in 2004, Micka now focuses on

helping F-ONE to develop the best possible kites and boards, where he has an integral role in the R&D process.

Alexandre Caizergues (left) – If you had to choose one word to sum up Alex then it would be: fast. He has three kitespeed world records and two world records in sailing 'all categories'. He is the most famous French kitesurfer ever, and is currently also the fastest man behind a kite, holding the record of 104.8 km/h since November 2013.

THE OFFICE

F-ONE is located in the south of France, in Montpellier, where the company employs 20 people. F-ONE tests its kites and boards most days, mainly on the closest beach, which is around ten minutes away on the Mediterranean coast, and where the Mistral/Tramontane winds blow regularly and are perfect for the testing process. Testing of wave equipment also takes place in the ultimate proving grounds of Cape Verde and Mauritius.

THE GEAR

KITES

Bandit – The original and the best
Trust – The ultimate freeride kite

BOARDS

TWIN-TIPS
Trax HRD Carbon Series – Professional freestyle board
Acid HRD Carbon Series – New-school weapon
Spicy – Ultimate wakestyle board

SURFBOARDS
Mitu Monteiro – Strapless model from Mitu
Signature – Compact shape, quad-fin set-up
Fish – Light-wind blasting, pure speed and very early planing

PHILOSOPHY

F-ONE is a brand run by passion and not by trends. They started at a time when people doubted the future of kiteboarding, and are now a melting pot of characters all committed to a common purpose. They are a kiteboarding and stand-up brand with a spirit of adventure and are always looking to the future and to push the limits – it's their job!

F-ONE are directly connected to the sport and they listen to schools, distributors, shops, pro riders and local riders to make sure that they are developing perfect products for kiteboarders. Their goal is to provide quality products with true innovations, and they employ the best technology and 100 per cent commitment to satisfy their customers with high-quality F-ONE products.

All photos: courtesy F-ONE.

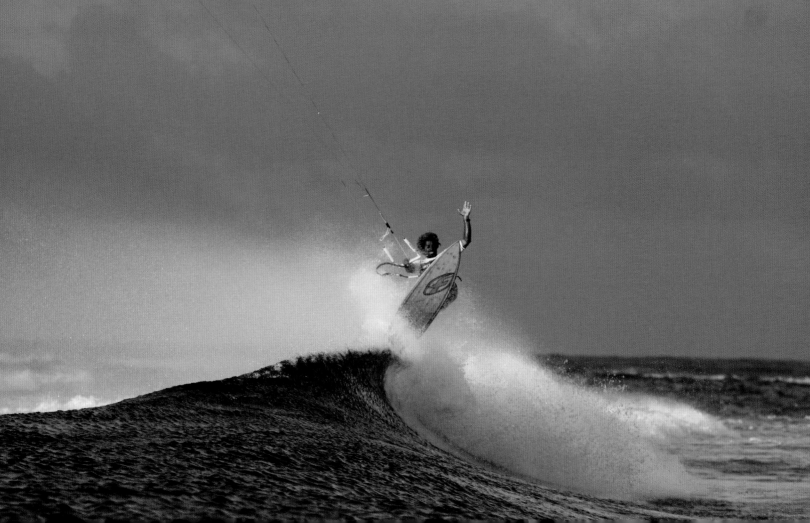

THE GEAR

KITES
Envy – Stable, easy, responsive
Solo – All-terrain power, simplicity and fun
HIFI X – Pure C performance

BOARDS

TWIN-TIPS
Drive – Efficient, progression, value
Focus – Freestyle perfection, affordable price
Influence – All-around high performance
Element – Next-level freestyle perfection

SURFBOARDS
Messenger – Revolutionary performance shape
CJ – Fast, fluid all-around shape
Quickness – Pure surf style

ROOTS

Founded in 1995, Liquid Force (LF) quickly became the leader in wakeboard products and apparel. Soon after, in 1999, Liquid Force entered into kiteboarding and became the benchmark in design and product progression. Starting off with revolutionary twin-tip board designs by Jimmy Redmon, LF twin-tips became the go-to board for progression. Soon after, LF launched kites in the two-line days and rapidly progressed to industry standard- and five-line designs. Liquid Force is dedicated to relentless innovation, progressive design, maximum functionality and unparalleled quality.

THE BOSS

Liquid Force is headed by visionaries Tony Finn and Jimmy Redmon. Their passion for wakeboarding flows directly into their kiteboarding products and marketing. On a day-to-day level, global brand manager Gary Siskar and kite designer Julien Fillion lead the charge in building superior and top-performing products for kiteboarders of all levels.

THE RIDERS

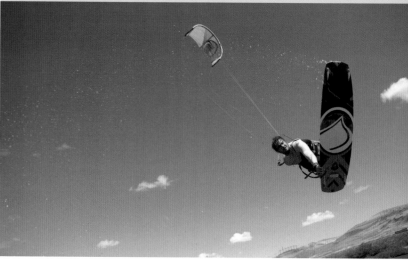

Jason Slezak (above left) – A jack-of-all-trades, master-of-everything pioneer of the sport, there is nothing that Jason 'sleezy' Slezak can't do with a kite in his hands. From charging surf to styling out sliders, he is always an attention-grabber.
Brandon Scheid (above centre) – The benchmark of wakestyle, with undisputed results across the globe in slider and wakestyle contests, Brandon's contribution to the limitless progression of kiteboarding is well noted worldwide.
Christophe Tack (above right) – PKRA freestyle specialist Christophe's calculated and progressive riding style has rapidly aided his quest for a world title.

The office

LF Kiteboarding is a truly 'global' brand, with offices in Encinitas, California; Broger, Denmark; Montreal, Canada; and Hood River, Oregon. Testing takes place globally – from the beaches of Maui to the long point-breaks of Peru, and from the Cape Hatteras Slicks to the river chop of the Gorge in Oregon.

PHILOSOPHY

AT LF, relentless innovation, quality and performance are the focus that runs deep in their DNA. Every day at LF they strive to bring products to kiteboarders that make kiteboarding more fun and safe, and offer kit for every budget, from high-end to affordable models. Their design team and skilled R&D group consist of riders of all levels, from their pro team to instructors from some of the most acclaimed lesson centres. This process ensures that LF is at the cutting edge of product-development and enables them to offer one of the most comprehensive ranges of kiteboarding products. Whether you're a first-time rider, PKRA specialist, surf-charger or wakestyle-ripper, Liquid Force has what you need.

All photos: courtesy Liquid Force.

ROOTS

Flysurfer began back in 2001. The founders, passionate paragliding pilots and kiters themselves, made it their goal to follow new paths in order to optimise methods of wind-powered locomotion, and they quickly became the synonym for bridled ram-air kite systems in the world of kiteboarding. Since then they have been committed to creating reliable products and offering extraordinary service and, since June 2013, have also brought a tube kite, the Cronix, to the market.

THE BOSS

Flysurfer has a team of four independent shareholders in the company, the most famous of which is designer Armin Harich. Armin comes from a paragliding background and was addicted to kiteboarding very early on. He immediately saw the chance to produce useful, easy and efficient products for the sport and the brand was built from there.

THE RIDERS

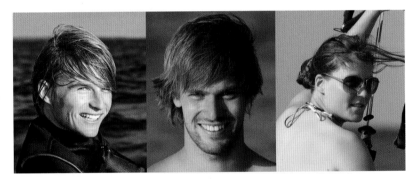

Dylan Van der Meij (above left) – Top-of-the-line freestyler, going hard in boots and always pushing himself into making tricks more stylishly, more powerfully, and with better execution.
Subastain Bubmann (above centre) – Sebastian holds his own on the water as well as the snow and is a past German freestyle champion. He really knows how to put on a show.
Christine Bönniger (above right) – Top-class racer with competition in her blood. What most people do not know is that she can put on an impressive freestyle show too.

THE OFFICE

Flysurfer are based in Marquartstein, Germany, where they develop three brands: Skywalk Paragliders, Flysurfer Kiteboarding and X-Gloo Inflatable Event Equipment. Kite and board testing is done on mountains, land and local lakes, as well as on the Mediterranean and in the North Sea. And by their riders who travel all over the world.

THE GEAR

KITES

Cronix – Flysurfer's LEI kite. Sublime all-round performance
Speed4 – Incredible performance in all conditions
Peak – Single-skin kite with an astounding depower range

BOARDS

Radical4 – High-performance freestyle
Flydoor4 – Ultimate light-wind weapon
FlySplit – The 'splittable' board for your normal luggage

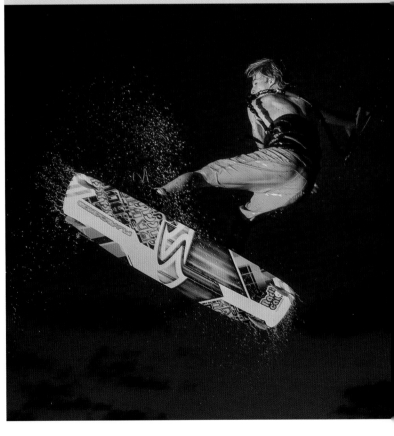

PHILOSOPHY

Kiteboarding is their passion. They want to kite forever, they live for this sport, and everything that they do has to meet their incredibly high standards. User-friendliness and safety are incorporated into each of Flysurfer's innovative products, and your kiting time is just as important to them as their own. They focus on high comfort and service. This is their philosophy and you should be able to feel this passion whenever you use Flysurfer products!

All photos: courtesy Flysurfer.

ROOTS

The quest for perfection led Bernie Hiss to launch Hiss-Tec Fehmarn in 2001 with the first brand Carved, which has developed from a garage-manufacturing operation to a technology leader in the production of carbon boards made out of CARTAN® Carbon. This know-how in custom board-building flows directly into the development and production of all CORE products, 'Designed and approved by Hiss-Tec in Germany', ensuring the highest levels of the company's cornerstones: Performance, Safety, Quality and Service.

THE BOSS (right)

In 1981, aged 14, Bernie Hiss shaped his first surfboard in his parents' garage, on the island of Fehmarn in northern Germany. Since then his life has been dominated by his fascination with wind and water. Striving for perfection in both quality and service, attention to detail and sustainable management will always be the hallmark of Hiss-Tec manufacturing.

THE RIDERS

Marilou Lavallée (above left) – Preferred CORE kite: 7m GTS2. Preferred board: Carved Imperator 130x41. Kiteboarding means: Freedom and adrenaline. Favourite spots: Roatán, Maui, Los Roques.

Thomas 'Beany' Burblies (above centre) – Preferred CORE kite: the latest one! Preferred board: Carved Tantrum 134x42. Kiteboarding means: Harmony, power and silence. Favourite spot: El Yaque.

Philipp Zach (above right) – Preferred CORE kite: new is always better. Preferred boards: Carved Imperator 132x41, Burner 5'10". Favourite spots: El Yaque, Maui.

THE OFFICE

Hiss-Tec's headquarters are based on the island of Fehmarn in northern Germany. In surfer circles it is fondly called 'The Hawaii of the Baltic Sea'! Hiss-Tec boasts a team of 18 developers and players on the island. Those who work for Hiss-Tec are passionate kiters and surfers, who are blessed with excellent conditions at local spots. The location allows various testing conditions during the warmer months. When freezing winter winds sweep over northern Europe, product testing is mainly moved to the Cape Verde Islands, Maui and Brazil.

THE GEAR

KITES

CORE Riot XR3 – The cross-ride kite with Big-Air power on demand. A true jumping machine

CORE Riot XR3 LW – Excellent agility and pure ride joy even in light winds

CORE GTS2 – Future-C, all-in-one kite with extra strength for kiteloops, unhooked riding and wakestyle

BOARDS

TWIN-TIPS

CORE Fusion – The high-tec Cartan® carbon crossride board

DELUXE Freeride – High-quality production boards: Unique visual elegance and well-engineered shape

Carved Imperator 5 SE – The Cartan® carbon legend. True jumping machine with easy landing

Carved Tantrum 5 Custom – The wakestyle choice of the team

SURFBOARDS

Carved Burner – True surf feeling with limitless control

CORE Ripper – The all-in-one waveboard

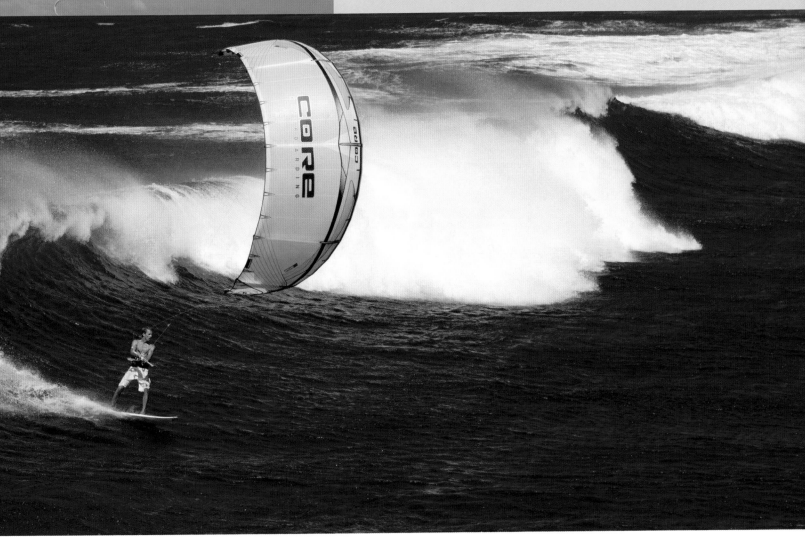

PHILOSOPHY

The entire ethos and thinking at Hiss-Tec is long-term, both in terms of the longevity and durability of their products and their responsible and conscientious business practices: short annual model cycles have always been a taboo for them. Instead, quality is their main driver. They've always been different – and this doesn't only apply to the colour of their kites – and they want to stay that way. Carved, Core and Deluxe are brands that stand for high technology and quality, without compromise.

All photos: courtesy Hiss-Tec.

INDEX

A

Abreu, Mauricio 66, 86, 117, 135, 179
aerial manoeuvres 70, 102
Airush Kiteboarding 74, 178
Alldredge, Ian 102–3
Anapa, Russia 131–3
Animal Windfest 140
Antigua 134
Australia 37–8, 54, 89–91
Autofocus (film) 117, 118

B

Baja, Mexico 165, 170
Baker, Grant 'Twiggy' 66
Bali, Indonesia 86
barrel-riding 19, 68, 75, 78, 96, 98, 99
 see also waveriding
Barret, Nicole 135
Baxter, Keith 178
Beetle Kitesurf World Cup Racing Championships
 170
Beg-Meil, Finistere, France 10
Bertin, Manu 12, 66
Best, Shannon 62
Bichler, Ninja 81–3
Bielsko-Biala, Poland 182
big air tricks 20, 56, 59
Big Bay, South Africa 58
Bilderback, John 68–9
BKSA (British Kitesurfing Association) National
 Championships 136
BKSA (British Kitesurfing Association) Under 18s
 Championships 140
Black Sea 131
Blakeney, Ryland 89–91
Blind Judges 62
Blouberg Kite Beach 28
board-offs 62, 114
boards
 brand overviews 174, 176–89
 course racing 153–5, 156, 159, 163, 168, 170,
 171, 172
 freestyle 16, 18, 24, 48, 50, 52, 54, 120
 wakestyle 114, 120, 134, 136, 138, 140
 waveriding 66, 69–70, 74, 98, 100, 102, 107
Boards & More (B&M) 176
Boese, Kristin 173
Bönniger, Christine 187
bow kites 69
box rule, IKA (International Kiteboarding
 Association) 156, 159
'Bozo Beach', Dominican Republic 34
Brazil 41–3, 50, 52, 63
Bridge, Olly 172, 173
Bridge, Steph 156, 172–3
Bubmann, Sebastian 187
Buelow, Paul 170
Bull, Chris 136
Burblies, Thomas 'Beany' 188
BWS 102, 107

C

C-kites 25, 68, 75
Cabarete, Dominican Republic 33–4, 48, 62
Cabrinha 75, 98, 134, 135, 170, 183
Cabrinha, Pete 66, 75, 113, 183
Cadiz, Alan 66
Caizergues, Alexandre 184
California, United States of America 93–5, 102
 see also San Francisco Bay, California, US
Canadian National Course Racing Championships
 168
Caños de Meca, Spain 46
Cape Doctor wind system 28, 59
Cape Hatteras, North Carolina, US 117, 118,
 127–9, 136, 138, 148
Cape Town, South Africa 27–8, 52, 178
Cape Verde 96–7, 184
Carved Kiteboarding 188–9
Chameaux wave, Mauritius 81
Cloudbreak wave, Fiji 104–7
Cobra 18
Colombia River 123–4
Connelly Dually 170
Cook, Joby 124, 129, 142–4
Core 188–9
Correia, Ines 101
course racing 56, 153–73, 187
Course Racing World Championships 156, 168
Court, Tom 140–1, 176
Cozzolino, Airton 112, 176
Crathern, Lewis 20, 59
Crissy Field, San Francisco, US 161, 168
Cunningham, Craig 139

D

Da Silva, Eudazio 182
Dakine 124
de Aboitiz, Keahi 75, 98–9, 183
Dein, Quincy 77–9
Deleau, Charles 155
directional boards 66, 69, 155
 see also boards
Dominican Republic 33–4, 48, 100
Dre 134–5
Drifter kite, Cabrinha 75

E, F

Eberle, Till 176
Encuentro, Dominican Republic 34
Esperance, Western Australia 89
Exe Estuary, UK 172
F-ONE 18, 96, 136, 184–5
Farley, Sean 155, 156
Fernandez, Micka 184
Filen, Clinton 74, 178
Fillion, Julien 121, 186
films, kiteboarding 19, 117, 118, 142
Finn, Tony 186

fins, course racing 155, 159
Flat 3s 34
flat-water kiteboarding 28, 48, 63, 85, 93, 127,
 131, 144
Fleury, Bertrand 62
Flexifoil 48
Flysurfer Kiteboarding 187
Forman, Trip 118, 127–9
Fox, Alex 49, 118–19, 138, 144
France 10, 155, 184
Freestyle Championships, UK 172
freestyle kiteboarding 16–65, 95, 100, 109–10,
 114, 172, 180, 184, 186, 187
Front Blind Mobes 50, 51
Front to Blinds 51
Fuerteventura 140
Fuller, Eli 132
Furness, Jason 48

G

Gaunt, Jim 45–6
Germany 156, 178, 187, 188
Glass Masters Championships, REAL 148
Gnarlaroo, Western Australia 89
Golden Gate Bridge, San Francisco, US 161–2,
 170
Goodman, Pat 75
Gorge, Hood River, Oregon, US 123–5
grabs 21, 62, 137
Groesel, Ralf 25

H, I, J

Hadlow, Aaron 21, 27, 48–9, 62, 140
Hamilton, Laird 12
handle-passes 19, 21, 25, 62
Harich, Armin 187
Harvey, Simon 46
Hastilow, Dave 75
Hatler, Tim 165
Hawaii 10, 12–15, 54, 77–9, 98, 112–13, 114, 135,
 180, 183, 188
Hayling Island, UK 136
heel backs 137
Heineken, Erika 161–3, 168
Heineken, Johnny 156, 168–9
Herraiz, Jaime 19, 46, 62, 176
Hidden Lines project 53
High (film) 117
Hiss, Bernie 188
Hiss-Tec 188–9
Hood River, Oregon, US 123–5, 138, 141, 142,
 144, 179
Ho'okipa Beach, Maui 13, 112–13
Howes, Graham 27–8
IIKA (International Kitesurfing Association) 156,
 172
Indonesia 85–7, 98
Jabberwock Beach, Antigua 134
Jacobsen, Nick 53, 59
James, Will 19, 62
John Wayne Cancer Foundation rail, REAL Slider
 Park, North Carolina 128
Jones, Kirsty 100–1
Joos 140

K

Ka'anapli, Maui 78
Kajiya, Bruna 178